BONNARD
and
the NABIS

Management: PAUL ANDRE
Managing editor: IRINA LVOVA
Design and layout: YEVGENY GAVRILOV
Computerization: NINA SOKOLOVA
Translators: IRINA WALSHE, PAUL WILLIAMS,
YELENA PETROVA and ALLA PEROVA
Editor of the English text: YELENA TABANIUKHINA
Editor's assistant: YELENA SHIPOVA

Printed by Sézanne Bron (69) for Parkstone Publishers
Copyright 1ˢᵗ term 1996
ISBN 1 85995 117 1

ALBERT KOSTENEVICH

BONNARD
and
the NABIS

FROM THE COLLECTIONS
OF RUSSIAN MUSEUMS

PARKSTONE
AURORA

PARKSTONE PUBLISHERS • BOURNEMOUTH
AURORA ART PUBLISHERS • ST. PETERSBURG

BONNARD

E Vuillard

F . VALLOTTON

K.X. roussel.

Bonnard

Maurice Denis

and the NABIS

ÉDOUARD VUILLARD

KER XAVIER ROUSSEL

MAURICE DENIS

FÉLIX VALLOTTON

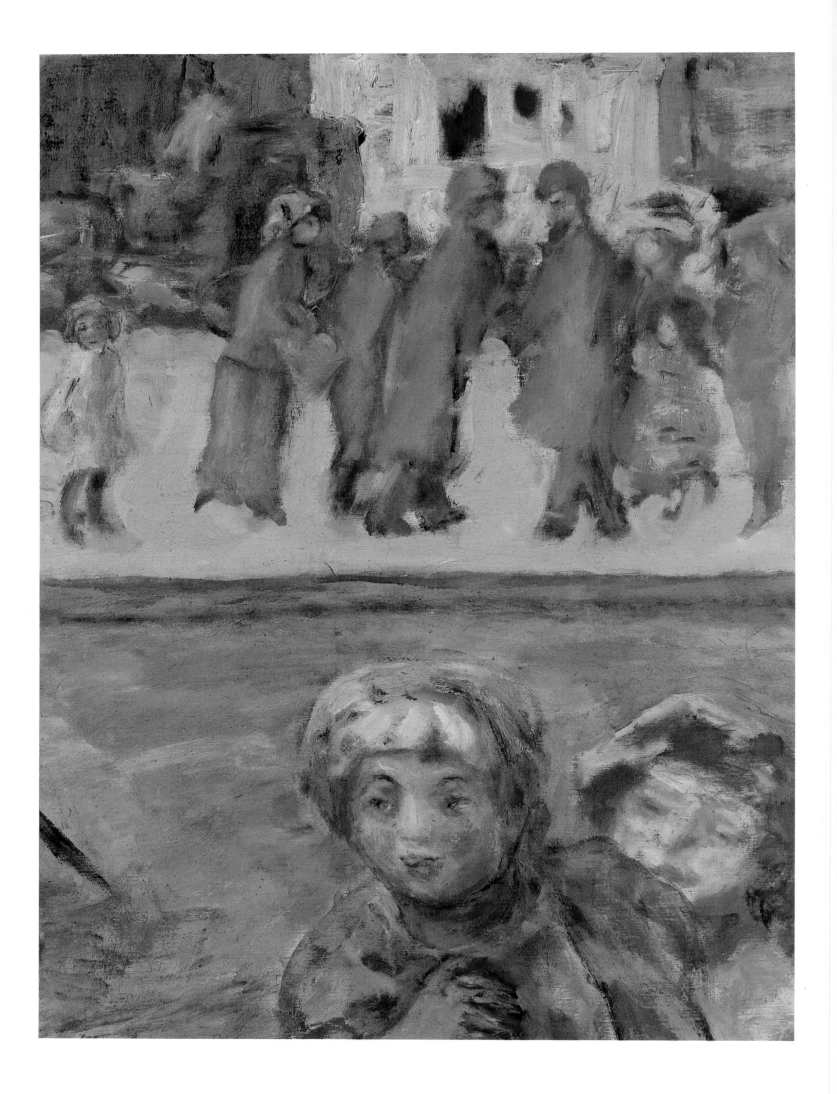

Contents

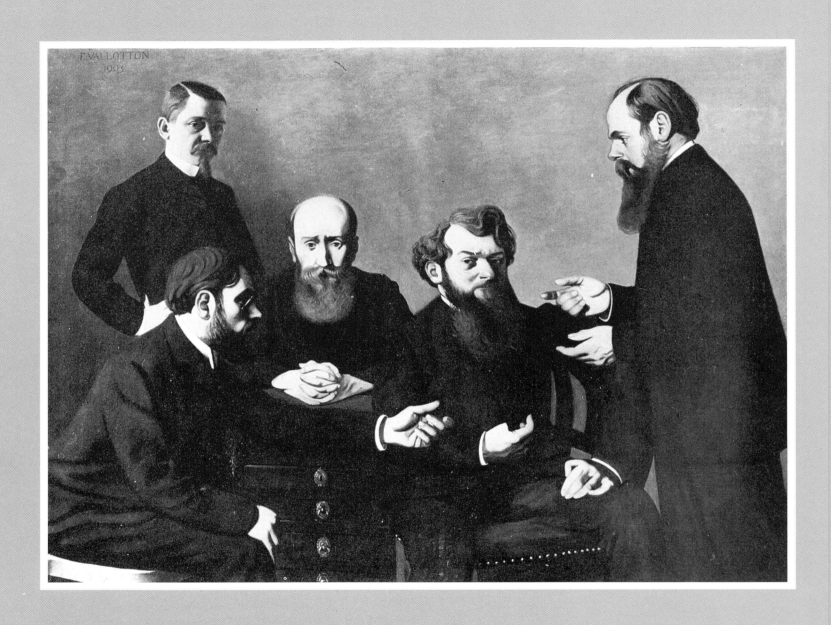

FÉLIX VALLOTTON
The Five Painters (The Nabis). 1903
Kunstmuseum, Winterthur

←PIERRE BONNARD *Evening in Paris*.
Detail

BONNARD and the NABIS

Although Bonnard, Vuillard, Denis, Roussel and Vallotton have gone down in the history of painting as artists belonging to a single group, their works, in spite of some common features, in fact display more differences than similarities. They were bound together in their youth by membership of a circle which bore a curious name – the Nabis (from the Hebrew *năbhi* – a prophet). Art historians, who see the Nabis' work as a special aspect of Post-Impressionism, have long resigned themselves to this purely conventional label. The word "Nabis" says next to nothing about the aims and methods of these artists, but probably on account of their very diversity, it has proved impossible to replace the label by a more meaningful term, or at least one which fits better into the established scheme of things.

The Hermitage in St Petersburg possesses a splendid collection of works by Bonnard and his friends. A much smaller collection of no lesser artistic merit is housed in the Pushkin Museum of Fine Arts in Moscow. All these works are presented in this book.

An interest in Nabi painting arose very early in Russia. Here, as elsewhere in Europe, it emerged not among art lovers as a whole, but among a tiny group of art collectors who were ahead of the general public in their appreciation of new developments. Works by Bonnard, Denis and Vallotton found their way to Moscow, and later to St Petersburg, soon after they had been painted, some of them even being specially commissioned. In those days the actions of Russian collectors of new French painting were a defiance of what was accepted as "good taste". In contrast to earlier times, these new connoisseurs of painting came not from the aristocracy, but from the merchant class. Several well-educated representatives of the new type of up-and-coming entrepreneurs, used to relying on their own judgement, also became highly active and independently-minded figures active in the art market. Two of them, Sergei Shchukin (1854–1937) and Ivan Morozov (1871–1921), formed collections which at the beginning of the twentieth century ranked among the best in the world.

The name of Shchukin is probably more widely known, and this is not surprising: his boldness, seen by many of his contemporaries as mere folly, soon attracted attention. He had brought the most notable works of Henri Matisse, André Derain and Pablo Picasso to Moscow before Paris had had time to recover from the shock that they caused. Even today specialists are astonished by Shchukin's unerring taste and keen judgement. He proved able to appreciate Matisse and Picasso at a time when "connoisseurs" still felt perplexed or even irritated by their paintings. The Nabis, however, attracted Shchukin to a lesser degree, perhaps because their work did not appear sufficiently revolutionary to him. He acquired one picture by Vuillard and several by Denis, among them the *Portrait of Marthe Denis, the Artist's Wife, Martha and Mary* and *The Visitation*. Later another canvas was added to these, *Figures in a Springtime Landscape (The Sacred Grove)* – one of the most ambitious and successful creations of European Symbolism. It was passed on to Sergei Shchukin by his elder brother Piotr. But Shchukin failed to notice Bonnard. Regarding Cézanne, Van Gogh and Gauguin as the key-figures in Post-Impressionism, Shchukin – and he was not alone in this – saw the works of Bonnard and his friends as a phenomenon of minor importance.

He did in fact make one attempt to "get into" Bonnard. In 1899 he bought Bonnard's painting *Fiacre* at the Bernheim-Jeune Gallery, but later he returned it. Today it is in the National Gallery in Washington. Shchukin used to say that a picture needed to be in his possession for some time before he made his final decision about it, and art dealers accepted his terms.

The man who really appreciated the Nabis and who collected their pictures over a considerable period of time was Ivan Morozov. His taste for their work must have been cultivated by his elder brother Mikhail, one of the first outside France to appreciate their painting. Mikhail Morozov owned *Behind the Fence*, the first work by Bonnard to find its way to Russia. He also had in his collection Denis's *Mother and Child* and *The Encounter*. When in 1903 Mikhail Morozov's untimely death put an end to his activities as a collector, his younger brother took up collecting with redoubled energy, adding to his collection judiciously. Seeing in Bonnard and Denis the leading figures of the Nabi group, the best exponents of its artistic aims, he concentrated on their work. As a result, Bonnard and Denis were as well represented in his collection as the Impressionists, Cézanne and Gauguin.

After purchasing Denis's picture *Sacred Spring in Guidel* at the Salon des Indépendants in the spring of 1906, Morozov made a point of becoming acquainted with the artist. That summer he visited Denis at his home in Saint-Germain-en-Laye, where he bought the as yet unfinished *Bacchus and Ariadne* and commissioned *Polyphemus* as a companion piece. In the same year or at the beginning of the next, he placed his biggest order with Denis – *The Legend of Psyche* – a series of panels for his Moscow mansion in Prechistenka Street. At Morozov's invitation, Denis came to Moscow to install the panels and add the finishing touches. Relations between the patron and the artist became firm and friendly. Morozov sought the Frenchman's advice; at Denis's prompting, for example, Morozov purchased one of Cézanne's finest early works – *Girl at the Piano*. Denis introduced Morozov to Maillol. The result of this acquaintance was a commission for four large bronze figures which later adorned the hall containing Denis's decorative panels, superbly complementing them.

The second ensemble of decorative panels commissioned by Morozov is even more remarkable when seen today. Created by Bonnard, it comprised the triptych *Mediterranean* and the panels *Early Spring in the Countryside* and *Autumn. Fruit-Picking*. At Morozov's suggestion Bonnard also painted the pair of works, *Morning in Paris* and *Evening in Paris*. Together with the triptych, these rank among Bonnard's greatest artistic achievements.

St Petersburg had no collectors on the scale of Sergei Shchukin and Ivan Morozov. Only Georges Haasen, who represented a Swiss chocolate firm in the then capital of Russia, collected new French painting. He was especially interested in artists like the Nabi group. Among other works, he had in his collection Bonnard's *The Seine near Vernon* and six paintings by Vallotton (all now in the Hermitage). Haasen knew Vallotton well: the artist stayed with him in St Petersburg and painted portraits of the businessman himself and of his wife. No complete list of the works in Haasen's collection has survived, but there is enough information to indicate that it was very well put together. The catalogue of the St Petersburg exhibiton "A Hundred Years of French Painting" held in 1912 contains a number of works by Bonnard, Vuillard, Roussel and Vallotton from Haasen's collection, that were not among those which in 1921 entered the Hermitage.

There was one more Russian collector who showed interest in the Nabis, Victor Golubev, but he took up residence in Paris. The two canvases, belonging to him at the 1912 St Petersburg exhibition – Vuillard's *Autumn Landscape* and Denis's *St George* – were actually sent from France.

The exhibition betokened a genuine recognition of new French art: on display were the finest works by Manet, Renoir, Monet, Cézanne and Gauguin. The salon idols, who still had many admirers among the public, were repre-

sented by only a few works, while there were 24 Renoirs, 17 Cézannes and 21 Gauguins. The Nabis were, of course, represented on a more modest but still creditable scale: six paintings by Bonnard, five each by Roussel and Denis, four by Vuillard and two each by Vallotton and Sérusier. Their works effectively formed the final element in the exhibition. They could no longer be

The music room in Shchukin's mansion.
Photograph

regarded as the last word in French art, but they were the latest thing considered acceptable by the organizers of this diverse artistic panorama which occupied over 20 rooms in Count Sumarokov-Elstone's house in Liteny Prospekt. This was doubtlessly one of the most significant art exhibitions of the early twentieth century not only in Russia, but in the whole of Europe. Even today one cannot help marvelling at its scope and at the aptness in the choice of many works. At the same time the catalogue shows its organizers' desire to avoid excessive radicalism. It was, after all, a purely St Petersburg affair, a joint venture of the *Apollon* (Apollo) magazine and the French Institute which at that time was located in St Petersburg. The Institute's director, Louis Réau, was a prominent art historian. The great Moscow collectors did not contribute to the exhibition, although Ivan Morozov was included in its honorary committee.

By that time in Moscow, where the artistic life was far more turbulent than in St Petersburg, painting of the type represented by the Nabis had been ousted by the more audacious and striking manifestations of the avant-garde, both Russian and foreign. Whereas at the 1908 "Golden Fleece" exhibition, Bonnard, Vuillard, Denis, Sérusier and Roussel were well represented, the

following year their pictures were no longer on show. However, the organizers of the 1909 exhibition included works by Matisse, Derain, Vlaminck and Braque. The "Izdebsky Salon", a fairly large international exhibition arranged by Vladimir Izdebsky which in 1910 visited Odessa, Kiev, St Petersburg and Riga, presented not only works by Matisse, Kees van Dongen, Vlaminck,

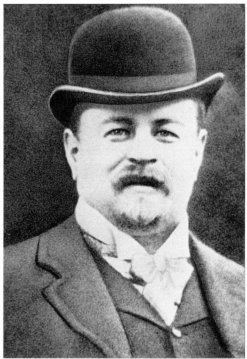

Ivan Morozov's mansion in Moscow. Photograph

Ivan Morozov. Photograph

Rouault and Braque, but also those by Larionov, Kandinsky, Jawlensky, Bechtejeff, Altman and many others. In sharp contrast there wère only a few Nabi paintings. Neither Russian nor Western European art lovers had turned their backs on the art of Bonnard and his companions, but it had receded into the background. The opinion took root that these artists were of minor importance, and several decades were to pass before this myth was finally dispelled. The reason for the rise of the myth was that the Nabis stood apart from the mainstream of the various antagonistic movements in art, torn by strife on the eve of the First World War. But Time, that great arbiter, has lifted the veil of obscurity from the Nabis, once again revealing the merits of their art and placing Bonnard among the most brilliant colourists that France ever produced.

The generation of Bonnard and his companions came to the fore in artistic life at the close of the nineteenth century. Nurtured by the colourful era known as the *belle époque*, they themselves contributed much to it. The history of nineteenth-century French art may be divided up in different ways. If however one is guided by the most fundamental cultural distinctions, a pattern of three periods approximately equal in length can be drawn. The first, which began when the principles of Classicism still reigned supreme, saw the emergence of the Romantic movement. The second was dominated by Realism which appeared sometimes on its own, sometimes in interaction with Romanticism and even with a form of Classicism lapsing into Academicism. The third period was marked by a greatly increased complexity in the problems tackled by the artists. Influences of earlier times could still be traced in the various artistic styles, but only to highlight the new and unusual artistic manifestations. The development of painting gathered an

unprecedented momentum. Its idiom became enriched by numerous discoveries. Impressionism assumed the leading role, in spite of the hostility towards it in the official circles, the general public and most painters.

The last three decades of the nineteenth century were among the greatest and richest in French art. They were staggering in their volcanic creative activity. One brilliant constellation of artists was followed by the rise of another. Younger painters rapidly caught up with their older colleagues, competing with them. Moreover, the appearance of a dazzling new movement in art was not followed by a lull, a pause in development, which could have a historical justification – to give that movement time to strengthen its influence. On the contrary, no sooner had the roar of one gigantic wave subsided, than another came rolling implacably behind it, and so wave after wave.

The main "disturber of the peace" in the 1860s was Edouard Manet. His works caused a revolution in painting, blazing the way for a new style – Impressionism. The 1870s were decisive years in the Impressionists' battle to assert their new, unbiased approach to reality, their right to use bright pure colours, wholly appropriate to the wonderful freshness of their perception of the world. The 1880s were marked by more developments. Proceeding from the discoveries of Monet and his fellow Impressionists, Seurat and Signac on the one hand, and Gauguin on the other, mapped out entirely new directions in painting. The views of these artists were completely different. The "scholarly" approach of the first two Neo-Impressionists ran counter to the views of Gauguin and the Pont-Aven group of which he was the leader. These artists owed a great deal to medieval art. Meanwhile Vincent van Gogh, who had by that time moved from Holland to France, led the way in another direction: his main concern was to express his inner feelings. All these artists had moved a good distance away from Impressionism, yet each owed a great deal to the revolution that Manet had brought on. When Seurat and Gauguin exhibited their pictures at the last exhibition of the Impressionists held in 1886, their divergence was already clearly marked. Naturally, among the "apostates" one ought to name the two contemporaries of the Impressionists – Redon, and, above all, Cézanne, who from the start recognized not only the enormous merits of Impressionist painting, but also saw traits in it which threatened to lead to shallowness and to the rejection of the eternal truths of art.

Soon a new term – Post-Impressionism – made its appearance. It was not a very eloquent label, but it came to be widely used. The vagueness of the label was not accidental. Some of the French artists who were initially inspired by the Impressionistic view of the world later left Impressionism behind, each pursuing his own path. This gave rise to an unprecedented stylistic diversity which reached its peak between the late 1880s and the beginning of the twentieth century. No name could possibly be adequate in this situation.

Even from anti-academic points of view Impressionism could seem narrow and insufficient as a means of artistic expression, yet it still remained a force which no artist of talent, at least in France, could ignore. Not only Seurat, Gauguin, Van Gogh and Toulouse-Lautrec came to be regarded as Post-Impressionists, but also Redon and Cézanne, and even Matisse and Picasso. For example, in 1912 the last two artists displayed their work at the second exhibition of Post-Impressionists at the Grafton Gallery in London. More recently, however, art historians have tended to limit Post-Impressionism to the nineteenth century.

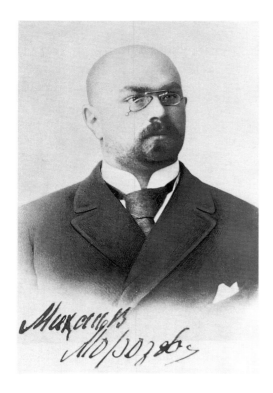

Mikhail Morozov. Photograph

The revolution brought on by the Impressionists, and its aftermath, Post-Impressionism, became the most important force in the development of art in the 1860s–1890s, and it would probably be no exaggeration to say that it influenced artistic evolution throughout the twentieth century.

Any really creative artist living in Paris who embarked on his career in the late 1880s, when Impressionism was drawing to its close, was almost inevitably "doomed" to become a Post-Impressionist. So it is hardly surprising that a small group of artists, calling themselves the Nabis – Bonnard, Vuillard and Denis among them – readily joined this broad new movement which speedily gained authority among painters outside the academic circle. With the advent of the twentieth century, when the age of Post-Impressionism was approaching its end, these artists would be faced with the necessity of making a new choice: either to follow the style of their youth or to rally to the banners of new, more radical movements. But for the Nabis, the question never seriously arose. All their background and artistic experience made them little disposed towards Fauvism and even less towards Cubism or any other modern style. Bonnard was a little more than two years older than Matisse, Vuillard was even closer in age, and though they sincerely respected Matisse as an artist, they could not share his ideas. This does not mean that their intention was to adhere assiduously to their earlier manner. They realized that by acting that way they would be doing no more than marking time, and consequently, condemning themselves to failure. The real alternative lay in each member of the group developing his own artistic personality. This was bound to conflict with the aspirations of the group as a whole and disrupt its joint efforts. The growing individuality in each artist's work undermined the group's unity. At the same time, this process clarified the position of these artists in the art world. It showed that some of them had become figures of European standing, while others were no more than members of a transient group.

Of course, the Nabi artists had never followed one particular style. Each member of the group pursued his own course, regardless of the stylistic, ideological and religious ideas of the others. In this respect the group was unique. This is not to say that the Nabis did not have a common artistic platform. Without it the group could hardly have formed and existed as long as it did.

The group came into being in 1888. The event was connected with the Académie Julian in Paris. The reader should not be misled by this high-sounding name: the word "académie" was used in the French capital with reference to all sorts of private studios. Among them the Académie Julian, founded in 1860, probably enjoyed the best reputation. Artists attended this studio because they could find a model there and many prepared there for entrance examinations to the Ecole des Beaux-Arts. The atmosphere in the studio was less formal than at the Ecole, but the professors as authoritative; in fact, often enough the same academic celebrities taught at the Académie and the Ecole. The students at the studio were a very mixed bag. Shared backgrounds, artistic temperament and talent very quickly drew them together into groups that came apart just as easily as they were formed. The centre of attraction was Paul Sérusier. He was, at 25, older than his fellow-students, the *massier* of the class and better educated than the rest. The painting exhibited at the 1888 Salon had gained him an honourable mention. With his inclination to discuss matters, his ability to express his ideas clearly and eloquently, he easily won listeners. The main subject of Sérusier's discourses was the experience he gained in Brittany from where he had returned in October 1888 deeply

PAUL SÉRUSIER
Landscape in the Bois d'Amour (The Talisman). 1888
Musée d'Orsay, Paris

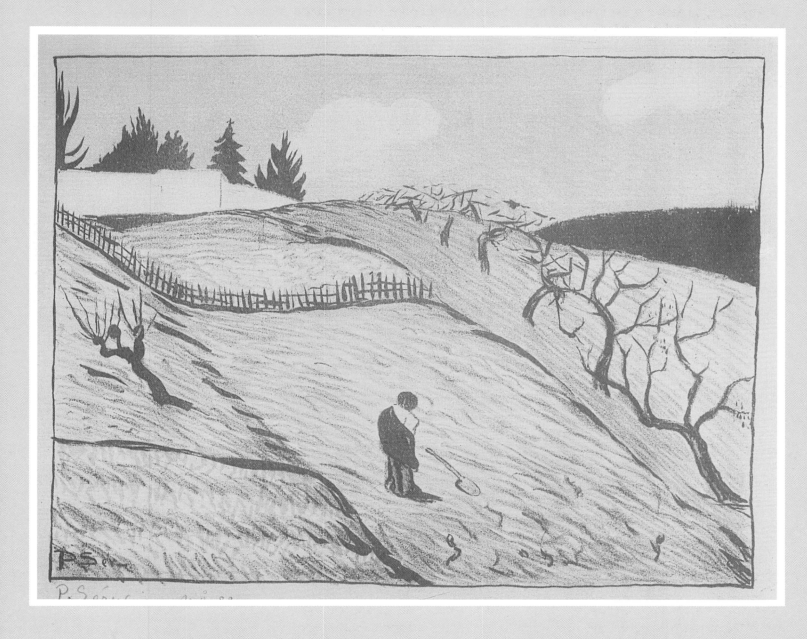

PAUL SÉRUSIER
Landscape. 1893. Colour lithograph
Hermitage, St Petersburg

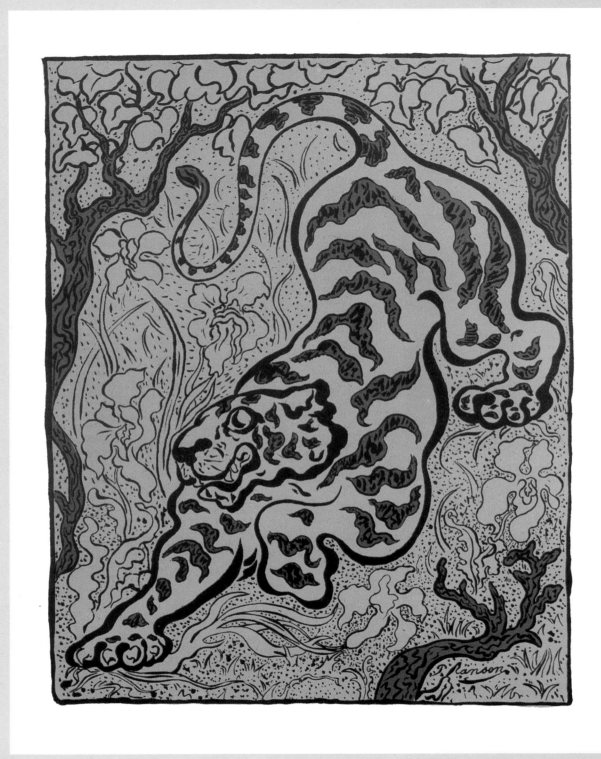

PAUL RANSON
The Tiger. 1893. Colour lithograph
Hermitage, St Petersburg

influenced by the ideas of Synthetism. He assumed the role of champion of "the last word" in painting passed on to him by Gauguin at Pont-Aven.

Sérusier was completely under the spell of his encounter with Gauguin. But the most important thing was that he brought back with him *The Talisman* (Musée d'Orsay, Paris). This small landscape study hurriedly painted on a piece of board was to become a true talisman for a small group of students at the Académie Julian. With a sacramental air, Sérusier showed the panel to Bonnard, Denis, Ibels and Ranson. Later Vuillard and Roussel joined "the initiated". The study, painted in the Bois d'Amour outside Pont-Aven, depicts autumnal trees reflected in a pond. Each area of colour in this work is given in such a generalized fashion that the object depicted is not easily recognized, and, turned upside down, the picture becomes an abstract. The study was made under the guidance of Gauguin, who demanded: "How do you see that tree? It is green? Then choose the most beautiful green on your palette. And that shadow? It is more like blue? Then don't hesitate to paint it with the purest blue possible." [1] The words are cited differently in different sources, but all versions contain the same main idea: an exhortation to simplify the methods of painting, beginning with the simplification of the artist's palette and an increase in its dynamism. "This is how we learned," recollected Denis, "that all works of art are a kind of transposition, a certain caricature, the passionate equivalent of an experienced sensation. This was the starting point of an evolution in which we at once became engaged." [2]

The seed had fallen upon fertile ground. Comparing *The Talisman* and the works of the Impressionists and their followers seen in the Durand-Ruel, Boussod and Valadon galleries with the popular paintings exhibited in the Musée du Luxembourg and the works of their own teachers, the young painters could not but fall under the spell of this new mode of painting, with its vitality and brilliant colour.

Of course, Sérusier and his attentive audience were by no means unanimous in their interpretation of the arguments of the leader of the Pont-Aven school. While for Sérusier the simplification of colour seemed a tempting gateway into the realm of symbols and Denis was ready to agree with him, Bonnard and Vuillard, who did not wish to leave the precincts of painting as such, hoped that these devices would help to open up promising decorative resources. Though their own artistic experience was still rather limited, all of them were able to appreciate the beauty of resonant colours, no matter how unorthodox the means used to achieve them were.

It so happened that those students of the Académie Julian who displayed the greatest talent in painting felt drawn towards one another and began by gathering round Sérusier. Among the other students, these young artists stood out with their superior cultural level: they were well-read, loved poetry and the theatre. This too helped to establish close ties between them.

Soon they started meeting outside classes. Feeling that their association had a special significance, they decided to call themselves the Nabis. This name, a password for the group and a mystery for outsiders, was suggested by one of their friends, Auguste Cazalis, then a student at the School of Oriental Languages.

The meetings of the Nabis were characterized by lively conversations on a wide range of subjects, more often than not connected with painting or literature. It is true that Sérusier and, to a lesser extent, Denis were inclined to give themselves airs, but the rest preferred a merry atmosphere and enjoyed a good joke. This was quite natural: they were all young. On Saturdays they

[1] M. Denis, *Théories. 1890–1911*, Paris, 1913, p. 162
[2] *Ibid.*

met in Ranson's studio, played charades (popular at the time), staged little puppet shows, read poetry. Once a month, and this with time became a ritual, they gathered in a small, modest restaurant called L'Os à Moelle (The Marrowbone). Each member of the group had a nickname. Paul Sérusier, for example, was called "Nabi à la barbe rutilante" (Nabi with the

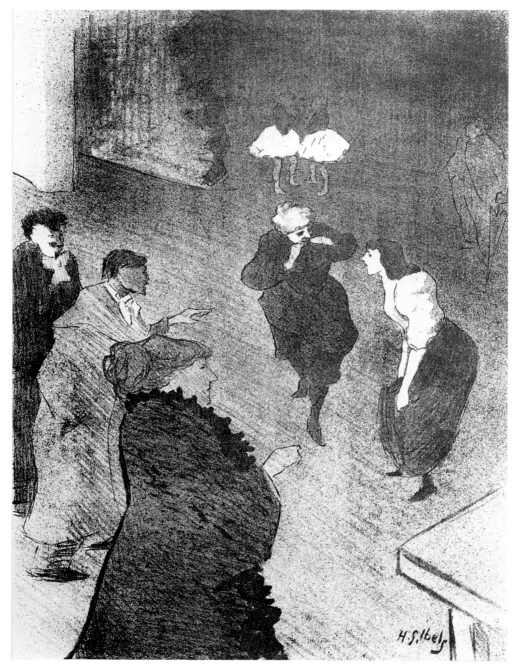

HENRI-GABRIEL IBELS
A Group of Actors on Stage. 1893. Lithograph
Hermitage, St Petersburg

HENRI-GABRIEL IBELS→
At the Circus. 1893. Colour lithograph
Hermitage, St Petersburg

HENRI-GABRIEL IBELS
Types at the Café-Concert. 1893.
From the *Café-Concert* series.
Lithograph
Hermitage, St Petersburg

sparkling beard), Denis bore the name "Nabi aux belles icônes" (Nabi of the beautiful icons), Bonnard's nickname was "Nabi japonard" (the Nipponized Nabi), Vuillard – "Zouave", Verkade – "Nabi obéliscal" (the obeliskal Nabi), and Vallotton, who joined the group in 1892 – "Nabi étranger" (the foreign Nabi).

From time to time the Nabis gathered in the editorial offices of the recently-founded magazines *Mercure de France* and *Revue Blanche* or in Le Barc de Boutteville's gallery, where at that time they usually exhibited their works. But their main meeting place remained Ranson's studio on the

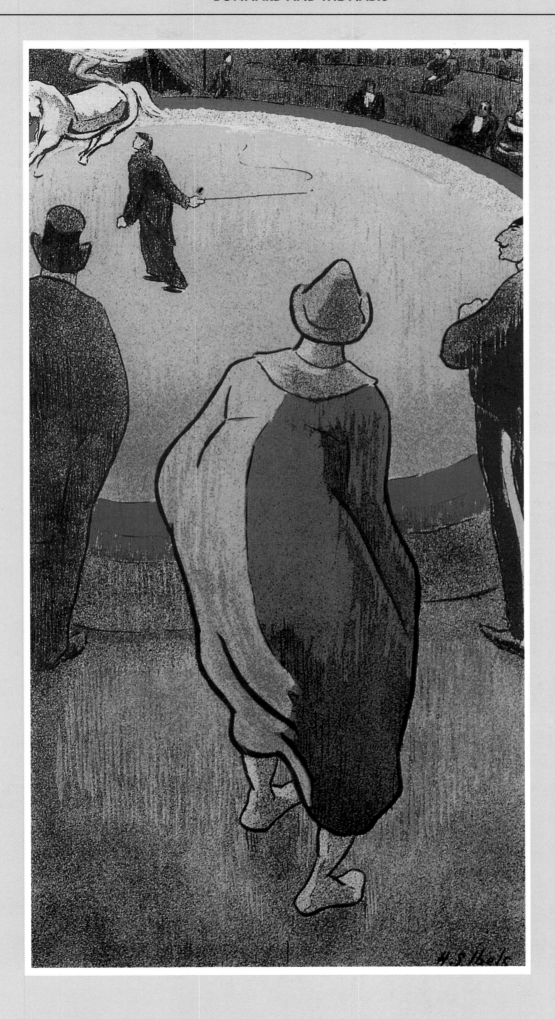

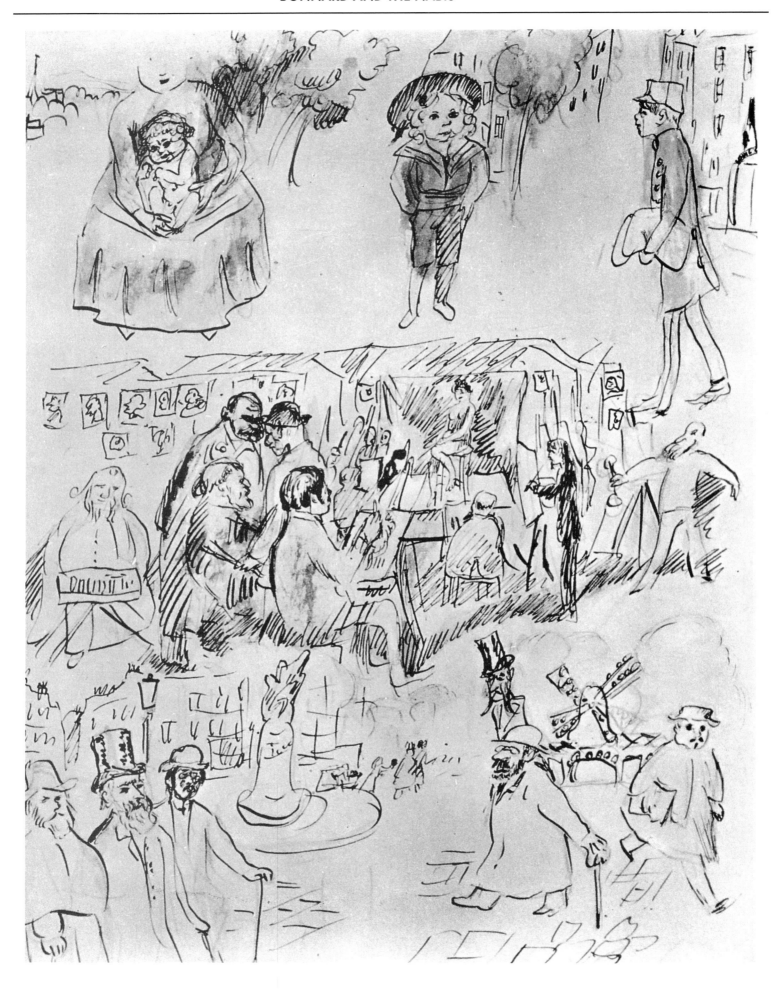

Boulevard Montparnasse, which they styled the "Temple". The walls of the "Temple" were adorned with decorative pieces by Denis, Vuillard, Bonnard and Roussel. They were executed on paper and, unfortunately, have not survived. In 1891, Bonnard, Vuillard, Denis and Lugné–Poë rented a workshop in the Rue Pigalle, which was frequented by other members

← PIERRE BONNARD
The Painter's Life. Ca 1910. Drawing
Top: Académie Julian (in the foreground, Bonnard; on the left, Sérusier; standing, in black, Vallotton)
Bottom: Place Clichy (left: Roussel, Vuillard, Bonnard; right: Toulouse-Lautrec, his cousin Tapié de Ceyleran and Denis)
Private collection

ÉDOUARD VUILLARD
The Tuileries. 1895. Lithograph
Hermitage, St Petersburg

ÉDOUARD VUILLARD
Gallery at the Théâtre du Gymnase. 1900.
Colour lithograph
Hermitage, St Petersburg

of the Nabi circle. With the coming of spring, they spent Sundays at Saint-Germain-en-Laye, in Denis's house, or at l'Etang-la-Ville, with Roussel's family. Unlike the rest of the Nabis, Ranson and these two artists had married and settled down to a more or less steady home-life. Even in summer the Nabis remained faithful to their fellowship. Sérusier, Verkade and Ballin, for instance, visited Brittany together. In 1895, Thadée Natanson, the publisher of the *Revue Blanche*, and his charming wife Misia, whom both Renoir and Bonnard painted many times, entertained Vuillard and Vallotton at their home in Valvin. The following year the couple moved to Villeneuve-sur-Yonne, where over the course of several years Bonnard, Vuillard, Roussel and also Toulouse-Lautrec were invited to their home.

Members of the Nabi group often entertained Maillol, whom they held in great esteem. Three or four times they were visited by Gauguin. The "Temple" was frequented by the composers Chausson, Hermand and Claude Terrasse (Bonnard's brother-in-law). Denis introduced to the Nabis his fellow-student from the Lycée Condorcet Lugné-Poë who was soon to gain prominence on the French stage both as an actor and producer. Lugné-Poë had introduced the Parisian public to Ibsen, Strindberg and other outstanding dramatists of the time. Through him the Nabis entered the theatrical world. They designed stage sets and theatrical programmes for Lugné-Poë's productions. They even appeared on the stage as extras, taking part, for example, in the much talked about *Ubu roi* by Jarry. Members of the Nabi group were

personally acquainted and often friendly with many contemporary French authors – Alfred Jarry, Francis Jammes, Jules Renard, Tristan Bernard, Edouard Dujardin and André Gide, so it is hardly surprising that they illustrated their books. While at the Lycée, Maurice Denis became acquainted with Marcel Proust. He was also on close terms with André Gide in whose

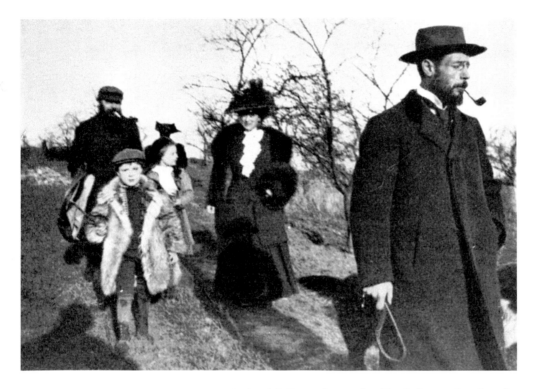

Ker Xavier Roussel and his children, Lucy Hessel and Pierre Bonnard. Ca 1909. Photograph

company he travelled all over Italy. Mallarmé taught English at the Lycée Condorcet. The Nabis greatly admired his poetry and some of them kept in touch with him after leaving the Lycée.

More than half of the Nabis attended the Lycée Condorcet, undoubtedly one of the finest in Paris and perhaps the best as far as its humanities programme was concerned. It played an important role in fostering a taste for literature in its students. Curiously enough, not one of the Nabis had ever won a prize for art at the Lycée, while Vuillard and Roussel gained the first and second prizes for history. A shared interest in literature, history and aesthetics helped to form firm ties between people of very different convictions. The friendship which sprung up in their Lycée years proved stronger than the artistic and religious differences which arose later.

Their fellowship expressed itself at times through naive and even childish features, like, for example, the ritual formula, modelled on those of ancient fraternities, with which they finished their letters : "En ta paume, mon verbe et ma pensée" (My words and thoughts are in your palm). On occasion these words were reduced to an abbreviation: "E. T. P. M. V. E. M. P." Whatever the reason, it is a fact that for many years their friendship was never dimmed by resentment, envy or estrangement.

In works on the history of art, the Nabis are at times equated with other groups and movements which existed for a short period and then dissolved. This conception is fraught with inconsistences. Can the Nabi circle be regarded as a distinct movement? Yes and no. Some common features may be traced in their work, but the kinship between them is at two removes if not more. It is not by chance that at some recent exhibitions painters of this group have been ascribed to different movements. For example, works

ÉDOUARD VUILLARD
Portrait of Mallarmé. Ca 1896. Drawing
Private collection, Paris

by Denis, Sérusier and even Vallotton were included in the widely representative exhibition of European Symbolism held in 1975–76 in Rotterdam, Brussels, Baden-Baden and Paris,[1] while neither Bonnard or Vuillard, nor Roussel were featured. It is true that some traces of Symbolism may be found in the works of the latter three painters, but they are so rare and so faint that

Edouard Vuillard and Ker Xavier Roussel. Photograph

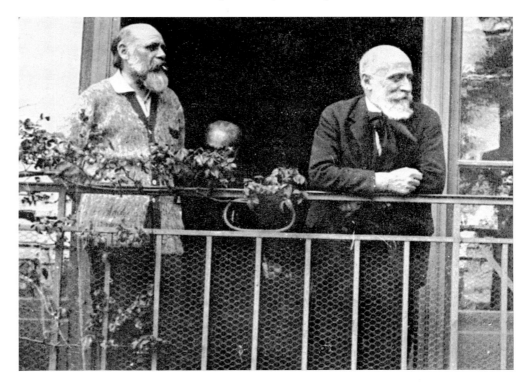

these artists cannot possibly be regarded as Symbolists. However, Bonnard, Vuillard and Roussel always paid considerable attention to the painterly aspects of their work and so they had certain points of contact with the Fauves. That explains why their works are now and again shown at the same exhibition. The exhibition of the Nabis and Fauves held in the Zurich Kunsthaus in 1983 [2] may serve as an example. It is noteworthy that paintings by Denis and Sérusier were not included in this exhibition.

The Nabis were not simply a group of artists using similar painterly devices and the same strategy in the struggle to exhibit their works, as was the case with the Neo-Impressionists or the Fauves. They were a kind of fraternity, hence their desire to be tolerant towards each other despite the many differences between them. It is difficult for such a fraternity based not on discipline but on shared aesthetic conceptions to survive for long. All the more surprising, then, is the fact that the group continued to exist until 1900. Personal relations and in certain cases family ties held the group together, though the activities of the group, or at least of some of its members, soon might well have appeared naive and even anachronistic.

In fact, the activities of the group were for most of the Nabis to some extent a kind of game, one that with time lost its attraction. Differences in temperament, in personal inclinations and outlook were sooner or later bound to affect the relationship between the Nabis. True, they all worshipped Baudelaire, Mallarmé and Verlaine, they loved Gauguin, sincerely admired such disparate artists as Cézanne and Van Gogh; they delighted in old stained-glass windows, Breton crucifixes and popular prints from Epinal (*images d'Epinal*); they were all interested in folk legends, traditional country festivals and ancient rituals. Yet though they shared these interests, each had

[1] *Le Symbolisme en Europe. Rotterdam, Museum Boymans–van Beuningen. Bruxelles, Musées Royaux des Beaux-Arts de Belgique. Baden-Baden, Staatliche Kunsthalle. Paris, Grand Palais,* Paris, 1976
[2] *Nabis und Fauves. Zeichnungen, Aquarelle, Pastelle aus Schweizer Privatbesitz. Kunsthaus Zürich. Kunsthaus Bremen. Kunsthalle Bielefeld,* Zurich, 1982

his own preferences. A certain coolness could not but exist between Sérusier, an ardent Catholic, and Roussel and Vallotton, who were confirmed atheists. Neither was it easy for Sérusier, with his inclination to doctrinarianism, to find a common language with Bonnard who would never thrust his opinions upon others. Perhaps of no lesser importance was that whereas

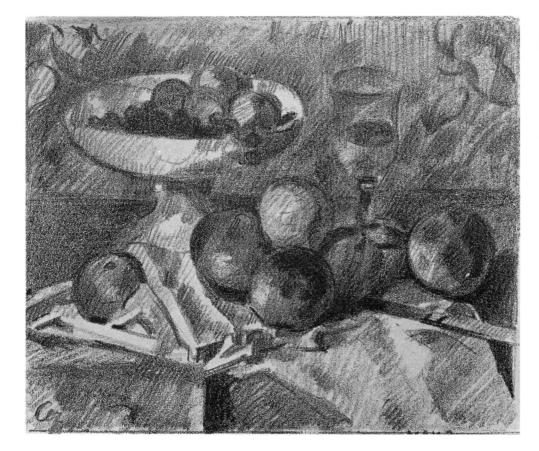

MAURICE DENIS
Still Life. Lithograph after a painting by Paul Cézanne
Hermitage, St Petersburg

the former was almost devoid of a sense of humour, the latter was endowed with a very strong one.

While admiring Gauguin and medieval art, Degas and Japanese woodcut prints, each member of the Nabi group saw them in a different way. Here preference was dictated by personal convictions and taste. These differences from the very beginning divided the group into two parties. Sérusier, Denis and Verkade wished to follow Gauguin and drew on the art of the Middle Ages, whereas Bonnard, Vuillard and Vallotton felt an affinity with Degas and Japanese artists. Thus the nicknames given to Bonnard and Denis, which they readily accepted, reflected their aesthetic inclinations. The names in each case defined the source of their art and, ultimately, that of the two Nabi parties, one of which gravitated towards a vivid, dynamic representation of life, the other – towards religious, stylized and symbolic representation.

Both wings agreed that art should not aim to copy nature. They saw it above all as "a means of expression" [1] and recognized that there was "a close connection between forms and emotions". [2] The theory of equivalences was the foundation of Nabi aesthetics. This may well provide the explanation for the respect which each member of the fraternity felt for the work of the others.

The fact that the Nabis regarded very different artists with equal esteem – Gauguin and Cézanne, Redon and Puvis de Chavannes – may be explained

[1] B. Dorival, *Les Peintres du XXᵉ siècle*, Paris, 1957, p. 16
[2] *Ibid.*, p. 17

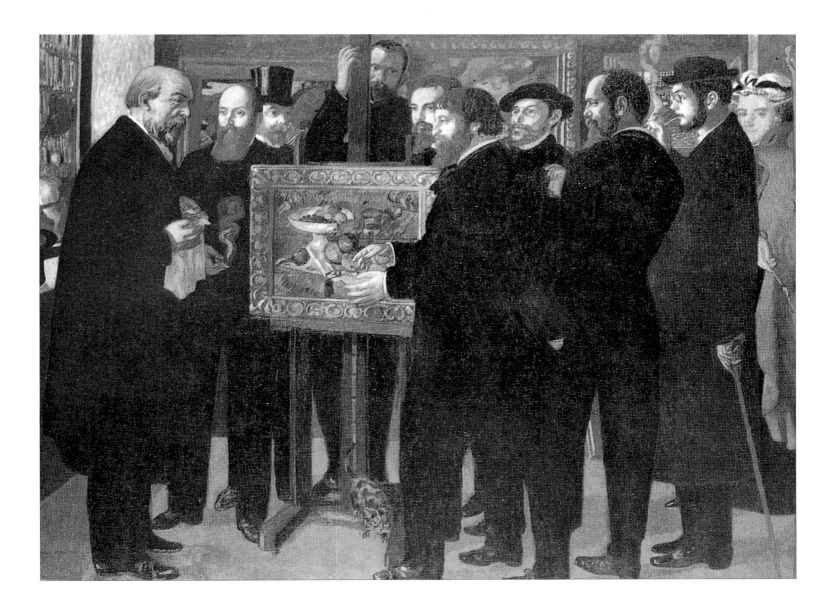

MAURICE DENIS
Homage to Cézanne. 1900
Musée d'Orsay, Paris

by their genuine respect for individuality. It is easy to see what attracted them in Odilon Redon with his air of mystery and subtle colour nuances, or in Puvis de Chavannes with his profound understanding of the essence of monumental painting. The works of the young Nabis from time to time betrayed a hint of the influence of these two artists. With Cézanne, whom they discovered very early, when his works could be found only in a small shop kept by Le Père Tanguy, the question becomes more difficult. Did he influence them? Neither Bonnard, Vuillard, Denis nor any other representative of the group can be considered followers of Cézanne. They moved in an entirely different direction from that taken by the vanguard Impressionist. Cézanne's work served them as an example of great skill. To be able to appreciate his art in the early 1890s, when with the exception of a few close friends, art lovers saw his canvases as nothing but daubs, not only proved independent judgement, but also revealed an uncommonly high degree of painterly culture.

It is thus not surprising that the writer Sâr Péladan, for example, an idol of Symbolism who was in great vogue about 1890, at least among a considerable section of the public, failed to impress the Nabis, although they themselves were by no means indifferent to Symbolism. They also remained unmoved by the English painters Dante Gabriel Rossetti and Edward Burne-Jones, who were much talked about in artistic circles throughout Europe.

The Nabis, particularly those who sided with Sérusier, doubtlessly shared some of the important ideas inherent in Symbolism. Since they discussed among themselves all notable artistic events in Paris, they were well acquainted not only with the works of Puvis de Chavannes, Redon or Gustave Moreau (whom they rated less highly, evidently because of his approach to colour), but also with the works of foreign Symbolists belonging to various trends. At the Exposition Universelle of 1889 they would naturally have seen the works of the British artists Burne-Jones, Millais, Watts and Crane, and of the Italian Previati. Moreover, Burne-Jones was a regular exhibitor at the Société Nationale des Beaux-Arts from the time of its foundation in 1890. In that year the Salon also featured works by the Belgian artist Léon Frédéric and the German Ludwig von Hofmann; in 1891, works by the Swiss artist Hodler and the Finn Gallen-Kallela. Foreign artists, including the Belgians Delville, Mellery and Khnopff, the Dutchman Toorop, were represented in the salons of the "Rose+Croix", arranged by Péladan from 1892 to 1897.

The Nabis' lukewarm reaction to these Symbolists was no manifestation of patriotism. Rather they found their works lacking in artistic merits. The French artists who joined the Symbolist movement always paid special attention to the use of colour. Not only Gauguin and Redon, whose achievements as colourists were so astonishing that that factor alone makes it impossible to regard their work solely within the framework of Symbolism, but also less gifted artists such as Seguin, who was close to the Nabis, and other followers of Gauguin produced works characterized by a more complex painterly texture, and by more subtle and original colour harmonies. The understanding of the role of colour evinced by the British, German and Belgian Symbolists seemed to the Nabis narrow, or simply dull and academic.

Many aspects of non–academic art also remained alien to the Nabis from a purely colouristic point of view. They were never tempted, for example, to try their hand at Neo-Impressionism. The exponents of this style aimed at achieving the utmost intensity of light, close to reality, using the technique of separate dabs of paint and the optical mixing of pure spectral colours.

MAURICE DENIS
Male Nude under a Tree. Lithograph after a painting by Paul Cézanne
Hermitage, St Petersburg

Colour for the sake of light – that was never an issue for the Nabis, nor was the choice between colour and light. Colour invariably remained of paramount importance for this group of artists. Their colour schemes were most often based on subtle, even elusive gradations of tones, and were in themselves usually rather subdued.

MAURICE DENIS
A Visit to Cézanne. 1906
(left, Roussel; right, Denis)
François Maurice Denis Collection, Alençon

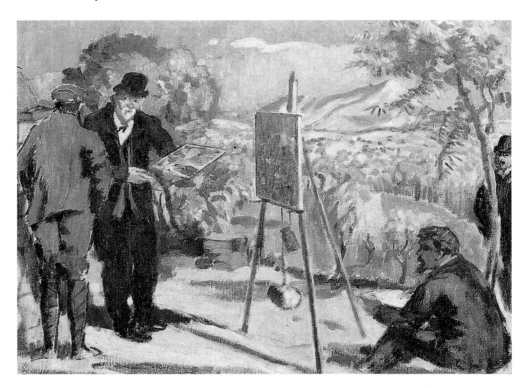

The colour solutions characteristic of the Nabis may be explained by the artists' attitude towards what they depicted. This attitude was far from the immediacy of the first Impressionists. While rejecting the rapid, casual approach of Monet and Sisley, they remained faithful to accurate visual perception. Their preference was for the eternal rather than the transient. A painting by Bonnard, Vuillard or Denis is, of course, correlated with the object it depicts, but not with it alone. In their works one can always discover a number of subtle associations which place the picture in a definite artistic and historical context. Works by the Nabis are always decorative, and this precludes a naturalistic interpretation of them. At the same time, this decorativeness shows that these paintings belong to an artistic system, which is structurally close to other systems. Those other systems may be far removed in time and space, but that fact is irrelevant to their art. In Bonnard's works we find parallels with Japanese prints, in Denis's – with the murals of the late Middle Ages and the early Renaissance.

Such a tendency to look back may at its worst have led to mere stylization. However, Bonnard and Vuillard established fruitful links with earlier art. It was not a matter of iconographic borrowing, though this did take place, but rather a kind of compression of artistic significations: a work is seen not solely as a reflection of the reality surrounding the artist, but also in the context of a long-existing, well-developed tradition, at times very unexpected for the artist's contemporaries. Denis, the chief theoretician of the group, even invented a word to denote this phenomenon, Neotraditionalism. It is easy to see that Denis's art does indeed fall under this heading. The issue is more difficult with such artists as Vuillard, but in his work too links with artistic traditions of the past are clearly evident. He owes a great debt to

eighteenth-century art, to Japanese woodcuts and to highly decorative French printed cloths. These correlations reveal a very important peculiarity of Nabi art. In comparison with the work of their immediate forerunners, it makes especial demands of the viewer requiring a good knowledge of the history of art. An Impressionist picture is easily understood without this as long as the viewer knows how to look at it.

A new understanding of the aims of painting, determined by a more complex approach to the inner meanings of the image, is one of the most distinctive marks of Post-Impressionism. In some cases the approach owed a great deal to the artistic systems of the East. Although oriental art was only one source of the stylistic changes taking place at that time, it is particularly clear that the Nabis, moving in the same direction as Van Gogh, Gauguin, Redon, and, partly, Toulouse-Lautrec, strove in contrast to Impressionism for a synthesis in art, a kind of synthesis which was entirely new in European art. The synthetism of Gauguin and other members of the Pont-Aven group, Redon's experiments which delighted Bonnard and his friends by "a unity of practically opposite qualities, the purest matter and extremely mystic expression",[1] the visions of Gustave Moreau, usually deliberately theatrical – all these artistic manifestations at the end of the nineteenth century betrayed an antinaturalistic mood. The Nabis inevitably came to share this mood, although their attitudes towards Redon and Moreau were various. It influenced their art considerably and gave rise to a situation where in a single painting vague allusions could unexpectedly be combined with almost post-like abstractions. Courbet and the painters of the Barbizon school had avoided using images which could be interpreted in different ways, in short images outside the world of painting. For the Nabis on the other hand, the interplay of various styles and images of the past, from the *millefiori* glass of the late Middle Ages to the colour prints of Hokusai and Hiroshige, motifs drawn from legends, mythology and the Gospel, all formed an integral part of their art. This tendency towards a synthesis of artistic concepts was entirely in keeping with the revival of the idea of combining painting with other arts and with architecture.

This idea was current all across Europe. It was not rejected by the academic and salon leaders, but what they offered was the construction of modern works of art based on copying Renaissance and Baroque examples, which merely led to a still-born "historicism". The creative young artists of Paris were concerned with something entirely different. They dreamt of a decorative and monumental painting which would absorb all the colouristic discoveries of the previous two decades. Later Verkade recalled: "Around 1890 a war-cry surged through the studios: 'We've had enough of easel-paintings, down with useless furniture! Painting must not usurp a liberty which isolates it from other arts! There are no paintings, but only decorations!'"[2]

What were they to be like, these new decorations? Even beginners in painting realized that merely copying the Old Masters would be no better than the thoughtless transfer of the Impressionists' brilliant colours onto walls. It was then that many artists' eyes turned towards Puvis de Chavannes. The seventeen-year-old Denis wrote in his diary: "Yesterday I visited the exhibition of Puvis de Chavannes's works. The calm, decorative aspect of his pictures is very beautiful: the colour of the walls is delightful, the harmonies of pale-yellow tones are superb. The composition is astonishingly well thought out and lofty: this suggests wonderful mastery. I am sure that above all it is the composition that influences the soul gently and mysteriously, elevating it and soothing."[3] Not only Puvis de Chavannes's murals in the

[1] A. Terrasse, *Bonnard*, Geneva, 1964, p. 54
[2] *Bonnard. Musée de Lyon. Exhibition Catalogue*, Lyons, 1954
[3] M. Denis, *Journal*, vol. 1, Paris, 1957, p. 67

Panthéon but also his easel paintings were seen as a lesson in decorative art. Gauguin made a copy of his *Hope*, and later, on Tahiti, he painted two versions of *A Poor Fisherman*, a work (now in the Musée d'Orsay, Paris) which was also copied by Maillol, who was close to the Nabis. Even many years later Anna Golubkina advising her friend and fellow artist L. Gubina what

ANDO HIROSHIGE
Saruwaka Quarter at Night. 1856. From the *A Hundred Famous Views of Edo* series. Colour lithograph

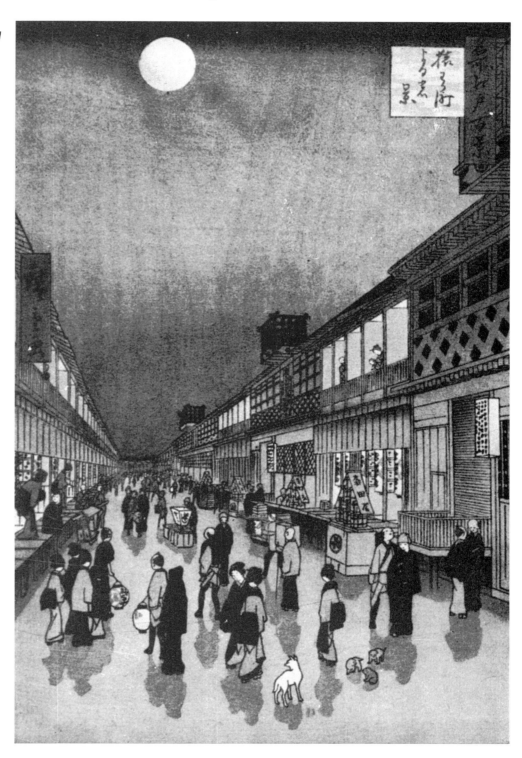

to see in Paris in the short time at her disposal, said: "Don't linger in the Panthéon – just look on the right for Puvis de Chavannes ... In the Luxembourg, don't forget Puvis de Chavannes's *Poor Fisherman*". [1] It is worth noting that the study for this picture was among the early purchases made by Sergei Shchukin.

[1] A. S. Golubkina, *Letters. A Few Words on the Sculptor's Profession. Reminiscences of Contemporaries*, Moscow, 1983, p. 79 (in Russian)

The deliberately restrained work of Puvis de Chavannes, by no means as daring in colour as the canvases of Manet, Monet or Degas, was destined to become a kind of banner for the following generation of artists. This generation dreamt of murals, of an "eternal" type of art; the young painters were fascinated by the promise which Puvis de Chavannes's painting held; they

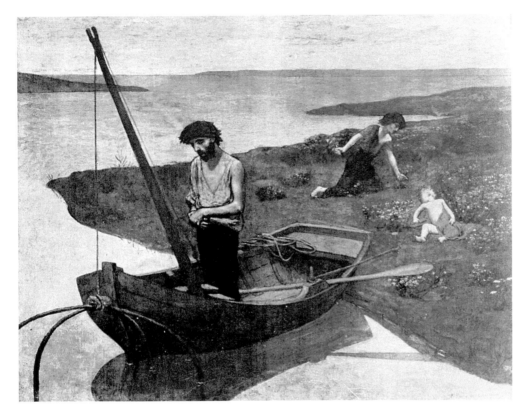

PIERRE PUVIS DE CHAVANNES
A Poor Fisherman. 1881
Musée d'Orsay, Paris

saw that contemporary easel painting could stimulate meditation on life, breaking through the realm of purely visual facts. Maurice Denis, who loved to express himself in the language of a manifesto, formulated the aesthetic credo of his milieu in the following way: "We insist on the idea that the visible is a manifestation of the invisible, that forms and colours are indications of the state of our soul." [1]

The kind of painting the Nabis evolved was an art with a complex orientation. Individual traits became more accentuated. Each artist strove to establish a more direct relationship with life without divorcing the external and the commonplace from the spiritual. The idea of merging art and life, the intrusion of art into life inspired many artists and writers throughout Europe. This was most marked in Symbolism, determining many of its merits and its failures. But for other artists too who were on the immediate fringes of Symbolism, this idea proved important and fruitful.

The words of Vladislav Khodasevich concerning the Russian Symbolist poets apply equally well to the Nabis: "Life here was very specific ... Here they tried to turn art into reality and reality into art. Events in real life ... were never seen as simply belonging to life: they at once became part of the inner world and part of creative work. And the other way round: something written by any of them became part of life for everyone. So, reality and literature were created by the collective efforts of the forces – at times hostile to each other, but united even in hostility – of all those who happened to find themselves part of this extraordinary life ... Incessant enthusiasm, continuous movement was all that was required from anyone who entered this order

[1] M. Denis, *Préface du catalogue "L'Ecole de Pont-Aven et les Nabis". 1888–1908. Galerie Parvillé*, Paris, 1943, p. 3

(and in a sense Symbolism was an order), the aim did not matter. All roads were open, and there was only one requirement – to move as quickly as possible and as far as possible. That was their only dogma. You could worship God or the Devil. You could be obsessed by anything you liked. The sole condition was that you be obsessed completely." [1]

The attitude of rejection here, natural for a writer of the following post-symbolist age, only serves to highlight the expressively acute definition of the main "dogma". Without taking into account this insistent cult of the creative personality, it is hardly possible to explain the peaceful coexistence of artists so different in temperament, frame of mind, aesthetic views and historical preferences we find among the Nabis and among other groups at the close of the nineteenth century.

The idea of self-development postulated by the Nabis from the outset inexorably generated centrifugal tendencies in their artistic work. Understandably, therefore, with the advent of the twentieth century the divergence of positions among the, by now former, members of the group became more marked. Since painting always remained of paramount importance for them, each member either gained or lost in authority, depending on his achievements in that field. After more than a decade from the time the group formed, the standing of each of its members had become clear. Bonnard, Vuillard and Denis stood out not only as representatives of very different trends, but also as the most gifted among the Nabis. And as the century advanced, the amazing originality of the most significant artist of the group, Bonnard, became even more evident. Today there can be no doubt that he ranks among the most remarkable artists of the twentieth century. His canvases reflect his own time, as do those of other artists of his circle. Painting had made itself the image of the age. The image had many facets: poetic and simple, full of wonder in Bonnard's work; excessively ornamental and therefore somewhat mysterious in Vuillard's; voluptuously dream-like in Denis's; somewhat bitter and acerbic in Vallotton's. One point ought to be clarified here. In Bonnard's work, the transient, belonging to the receding past, is in some unfathomable way fused with the eternal, belonging to no particular age. It is that which sets Bonnard apart from the other Nabis.

[1] V. F. Khodasevich, *Necropolis. Reminiscences*, Paris, 1976, pp. 10, 11 (in Russian)

PIERRE BONNARD

1867–1947

Bonnard

PIERRE BONNARD
Family Scene. 1893.
Colour lithograph
Hermitage, St Petersburg

In October 1947 the Musée de l'Orangerie arranged a large posthumous exhibition of Bonnard's work. Towards the close of the year, an article devoted to this exhibition appeared on the first page of the latest issue of the authoritative periodical *Cahiers d'Art*. The publisher, Christian Zervos, gave his short article the title "Pierre Bonnard, est-il un grand peintre?" (Is Pierre Bonnard a Great Artist?). In the opening paragraph Zervos remarked on the scope of the exhibition, since previously Bonnard's work could be judged only from a small number of minor exhibitions. But, he went on, the exhibition had disappointed him: the achievements of this artist were not sufficient for a whole exhibition to be devoted to his work. "Let us not forget that the early years of Bonnard's career were lit by the wonderful light of Impressionism. In some respects he was the last bearer of that aesthetic. But he was a weak bearer, devoid of great talent. That is hardly surprising. Weak-willed, and insufficiently original, he was unable to give a new impulse to Impressionism, to place a foundation of craftsmanship under its elements, or even to give Impressionism a new twist. Though he was convinced that in art one should not be guided by mere sensations like the Impressionists, he was unable to infuse spiritual values into painting. He knew that the aims of art were no longer those of recreating reality, but he found no strength to create it, as did other artists of his time who were lucky enough to rebel against Impressionism at once. In Bonnard's works Impressionism becomes insipid and falls into decline." [1]

It is unlikely that Zervos was guided by any personal animus. He merely acted as the mouth-piece of the avant-garde, with its logic asserting that all the history of modern art consisted of radical movements which succeeded one another, each creating new worlds less and less related to reality. The history of modern art seen as a chronicle of avant-garde movements left little space for Bonnard and other artists of his kind. Bonnard himself never strove to attract attention and kept away altogether from the raging battles of his time. Besides, he usually did not stay in Paris for a long at a time and rarely exhibited his work.

Of course, not all avant-garde artists shared Zervos's opinions. Picasso, for example, rated Bonnard's art highly in contrast to his own

admirer Zervos, who had published a complete catalogue of his paintings and drawings. When Matisse set eyes on that issue of *Cahiers d'Art*, he flew into a rage and wrote in the margin in a bold hand: "Yes! I maintain that Bonnard is a great artist for our time and, naturally, for posterity. Henri Matisse, Jan. 1948." [2] Matisse was right. By the middle of the century Bonnard's art was already attracting young artists far more than was the case in, say, the 1920s or in the 1930s. Fame had dealt strangely with Bonnard. He managed to establish his reputation immediately. He never experienced poverty or rejection unlike the leading figures of new painting who were recognized only late in life or posthumously – the usual fate of avant-garde artists in the first half of the twentieth century. The common concept of *peintre maudit* (the accursed artist), a bohemian pauper who is not recognized and who readily breaks established standards, does not apply to Bonnard. His paintings sold well. Quite early in his career he found admirers, both artists and collectors. However, they were not numerous. General recognition, much as he deserved it, did not come to him for a considerable time. Why was it that throughout his long life Bonnard failed to attract the public sufficiently? Reasons may be found in his nature and his way of life. Bonnard rarely appeared in public, even avoidng exhibitions. For example, when the Salon d'Automne expressed a desire in 1946 to ar-range a large retrospective exhibition of his work, Bonnard responded to this idea in the following way: "A retrospective exhibition? Am I dead then?" Another reason lay in Bonnard's art itself: alien to striking effects, it did not evoke an immediate response in the viewer. The subtle-ties of his work called for an enlightened audience. There is one further reason for the public's cool attitude towards Bonnard. His life was very ordinary, there was nothing in it to attract gen-eral interest. In this respect, it could not be compared with the life of Van Gogh, Gauguin or Toulouse-Lautrec. Bonnard's life was not the stuff legends are made of. And a nice legend is what is needed by the public, which easily creates idols of those to whom it was indifferent or even hostile only the day before.

But time does its work. The attitude towards Bonnard's art has changed noticeably in recent years. The large personal exhibitions which took place in 1984–85 in Paris, Washington, Zurich

[1] Ch. Zervos, "Pierre Bonnard, est-il un grand peintre?", *Cahiers d'Art*, 1947, p. 1

[2] A. Terrasse, "Matisse et Bonnard: quarante ans d'amitié", *Revue de l'Art*, 1984, no. 64

and Frankfurt am Main had a considerable success and became important cultural events.

What was Pierre Bonnard's life like? He spent his early youth at Fontenay-aux-Roses near Paris. His father was a department head at the War Ministry, and the family hoped that Pierre would follow in his father's footsteps. His first impulse, born of his background, led him to the Law School, but it very soon began to wane. He started visiting the Académie Julian and later the Ecole des Beaux-Arts more often than the Law School. The cherished dream of every student of the Ecole was the Prix de Rome. Bonnard studied at the Ecole about a year and left it when he failed to win the coveted prize. His *Triumph of Mordecai*, a picture on a set subject which he submitted for the competition, was not considered to be serious enough. Bonnard's career as an artist began in the summer of 1888 with small landscapes painted in a manner which had little in common with the precepts of the Ecole des Beaux-Arts. They were executed at Grand-Lemps in the Dauphiné. Bonnard's friends – Sérusier, Denis, Roussel and Vuillard – thought highly of these works. Made in the environs of Grand-Lemps, the studies were simple and fresh in colour and betrayed a poetic view of nature reminiscent of Corot's.

Dissatisfied with the teaching at the Ecole des Beaux-Arts and at the Académie Julian, Bonnard and Vuillard continued their education independently. They zealously visited museums. During the first ten years of their friendship, hardly a day went when they did not see each other. And yet they addressed one another with the formal "vous", while Bonnard addressed other members of the Nabi group with "tu".

In the 1890s Bonnard was by no means a recluse. He loved to go for long walks with Roussel, even listened with pleasure to Denis's lengthy tirades, although he remained rather taciturn himself. He was sociable in the best sense of the word. One of his humourous reminiscent drawings (1910) shows the Place Clichy, the centre of the quarter where young artists, light-hearted and somewhat bohemian, usually congregated. Bonnard, Vuillard and Roussel are unhurriedly crossing the square. Some distance away, Denis is bustling along with a folder under his arm. Towards them, from the opposite direction, comes Toulouse-Lautrec, swinging a thick walking-stick. Toulouse-Lautrec was well disposed towards Bonnard and Vuillard. From time to time he would take their paintings, hire a carriage and drive to the art-dealers whom he knew personally. It was not easy to get them interested, though. Toulouse-Lautrec greatly admired Bonnard's poster *France-Champagne* published in 1891. Bonnard took the artist to his printer, Ancours, in whose shop Toulouse-Lautrec's *Moulin Rouge* was printed later the same year followed by his other famous posters.

The poster *France-Champagne*, commissioned by the wine-dealer Debray in 1889, was to play a special role in Bonnard's life. This work brought him his first emoluments. The sum was miserably small compared with the earnings of the then much-fêted artist Jean Meissonnier, but it convinced Bonnard that painting could provide him with a living. This small success coincided with failure in his university examinations. Perhaps he was deliberately burning his boats, abandoning a career in business for the sake of art. On 19 March 1891 he wrote to his mother: "I won't be able to see my poster on the walls

A page from the *Cahier d'Art* carrying Zervos's article about Bonnard with Matisse's handwritten comments

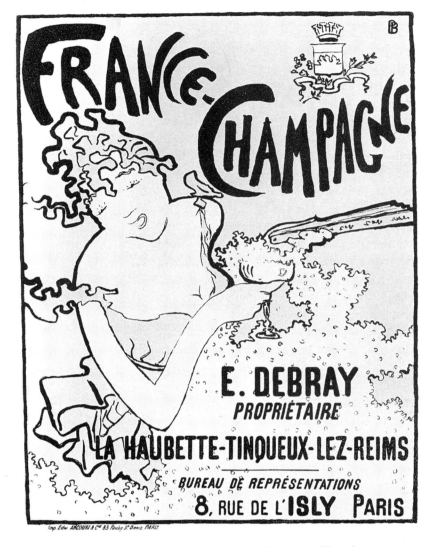

PAUL GAUGUIN
Portrait of Pierre Bonnard. Ca 1891
Present whereabouts unknown

PIERRE BONNARD
The poster *France-Champagne*. 1891.
Colour lithograph

just yet. It will only appear at the end of the month. But as I finger the hundred francs in my pocket, I must admit I feel proud." [1]
At about the same time he sent five pictures to the Salon des Indépendants. At the close of 1891 he exhibited his works together with Toulouse-Lautrec, Bernard, Anquetin and Denis at Le Barc de Boutteville's. When a journalist from *Echo de Paris*, who interviewed the artists at the exhibition, asked Bonnard to name his favourite painters, he declined to do so. He said that he did not belong to any school. His idea was to bring off something of his own and he was trying to forget all that he had been taught at the Ecole des Beaux-Arts.
One more event in 1891 played an important role in Bonnard's life. The journal *Revue Blanche* moved its editorial office from Brussels to Paris. Bonnard and other members of the Nabi group soon established a good relationship with the publisher Thadée Natanson, another former student of the Lycée Condorcet. Natanson managed to get the most gifted artists, writers

and musicians to work for him. The frontispieces of the journal were designed by Bonnard and Vuillard; inside there were the latest poems of Mallarmé, works by Marcel Proust and Strindberg, Oscar Wilde and Maxim Gorky; Debussy also contributed. On the pages of the *Revue Blanche* literary critics discussed the works of Leo Tolstoi. Natanson himself devoted his first article to Utamaro and Hiroshige. Without exaggeration, the *Revue Blanche* was the best French cultural periodical of the 1890s. The atmosphere in its editorial office, which the Nabis often visited, was stimulating. Natanson's personal support for the artists was also of no small importance. He was as young as the artists whom he backed and was not afraid to follow his own inclinations. Even Natanson's friends later admitted that at times they had doubts whether they could trust a person who decorated his home with works by Bonnard and Vuillard.
Natanson's printed reminiscences of Bonnard give perhaps one of the best pen-portraits

[1] Perucchi-Petri, "Das Figurenbild in Bonnards Nabis-Zeit", in: *Pierre Bonnard*, Zurich, 1984, p. 42

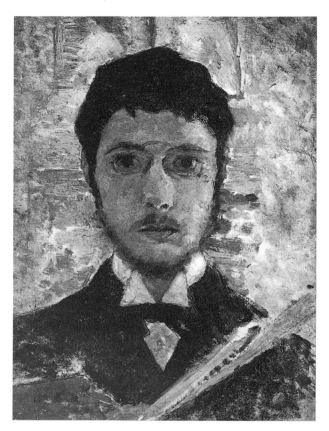

PIERRE BONNARD
Self-Portrait. 1889
Private collection, Paris

PIERRE BONNARD
Illustrations for Léopold
Chaveau's book,
Histoire du petit Renaud
(Paris, 1927)

of the artist. "Bonnard, when I first met him, was a gaunt young man who sometimes stooped. He had very white slightly protruding front teeth, was timid and short-sighted. His dark-brown rather thin side-whiskers curled slightly; perched on his nose, very close to his eyes with the dark pupils, was a small pince-nez in an iron frame, as was the fashion at the close of the nineteenth century. He spoke little, but was always ready to show the portrait of his fat grandmother in whose house he lived when he first came to Paris. The portrait had been painted in the Dauphiné and depicted the old lady with several white hens pecking at some feed close to her skirts. My new friend behaved in a very guarded manner when it came to discussing theories in painting, but he readily spoke about Japanese prints of which he was very fond. At that time such a taste could be easily satisfied. He also preferred checked fabrics far more than any other kind. His smile, with his white teeth showing slightly, was so winning that you wanted to see it again and to hold on to it. You wanted to catch the moment when it appeared. Bonnard smiled out of politeness, because of his shyness, but once he had tamed his smile, so to speak, he was no longer inhibited, and it was as if a tensioned spring had unwound...

Bonnard hardly changed from the early days of our friendship. He rarely livened up, even more rarely expressed his mind openly, avoiding any possible chance of letting his feelings come out into the open." [1]

"He was the humourist among us," Lugné-Poë recalled. "His light-hearted jollity and wit can be seen in his canvases". [2]

"Wonderfully gifted, but too intelligent to let us feel his superiority, he was able to hide the spark of genius within him," [3] was Verkade's recollection of him.

Bonnard's humour was perhaps not always taken as harmless. The Russian artist Alexander Benois said that his acquaintance with the painter in the late 1890s was short-lived because Bonnard's specifically French *esprit gouailleur* (mocking wit) made him feel ill at ease. [4] But Benois's reaction is exceptional. There was nothing of the born joker about Bonnard, and as he grew older he became increasingly reserved, even somewhat distrustful of others. In fact, throughout his life, even when he was a member of the Nabi group, he required the company of others less than his own, or rather what he needed was to be left alone with his art. Natanson was right when he said that Bonnard's misanthropy sprang from his innate kindness. [5] But even in his youth Bonnard was probably

[1] Th. Natanson, *Le Bonnard que je propose*, Geneva, 1951, pp. 16, 17

[2] A. Terrasse, *Bonnard*, Geneva, 1964, p. 24

[3] Dom W. Verkade, *Le Tourment de Dieu*, Paris, 1926, p. 80

[4] A. Benois, *My Reminiscences*, vol. 1, Moscow, 1980, p. 154 (in Russian)

[5] Th. Natanson, *op. cit.*, p. 100

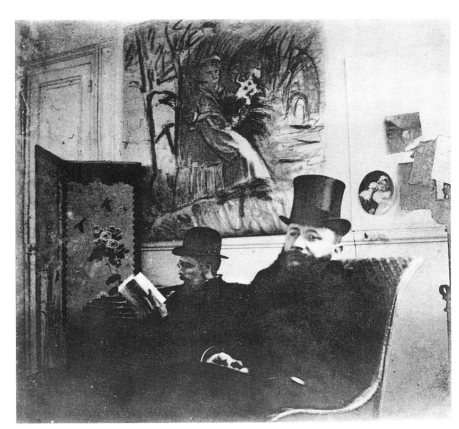

Il n'avait pas encore rattrapé avec le bout de sa queue l'endroit où se trouvait son nez quand il était parti, qu'il se sentit brusquement arraché du sol et soulevé à une hauteur formidable. Il aurait pu la mesurer en observant la baisse de son baromètre, mais il n'eut pas le temps d'en avoir l'idée, et il retomba dans un panier à moitié plein déjà d'escargots.

Le temps était si beau, bien humide, sans soleil, que les escargots, en foule, sortaient, et la paysanne qui portait le

Thadée Natanson
and Pierre Bonnard.
Photograph

a more complex personality than he seemed to his friends. His reserve and reticence hid traits which one could hardly suspect. In his self-portrait painted in 1889 (private collection, Paris) we see not a light-minded wit, but a watchful, diffident young man. The still eyes hide thoughts one does not usually share with others. His acquaintances saw him as a fine, jolly fellow. And that was true enough. But was that all? With age other hidden features of his nature became more evident. At thirty, when Benois met him, he was a different man from the one he was at the age of twenty: he was less light-hearted and showed less desire to surprise with paradoxes. So many of his early compositions were deliberately paradoxical.

In 1891 Bonnard told a correspondent from the *Echo de Paris* that painting should be predominantly decorative, that a talent revealed itself in the way lines were distributed. Three or four years later he began to move away from intricate decorative effects and deliberate complexity towards a greater liberation of colour and a living texture in painting, as well as towards its inner integrity. This was a turning point in his career, but it did not occur suddenly. Changes in Bonnard's painterly manner accumulated gradually, and for this reason it is impossible to draw a dividing line between one period and

another. But changes did take place. When looking at a picture executed in the new manner, one cannot help feeling that it is not so much a different picture as the earlier one transformed, that the newer picture represents a deeper understanding of what the artist was doing before. While developing his talent, Bonnard at the same time remained true to himself. Bonnard's invariable loyalty to himself, to his views on life is always expressed in his art. Throughout the sixty years of his career he remained true to the subjects of his youth, but none of his works is mere dreary repetition. His artistic individuality is easily recognizable in each new work.

Bonnard's intonations often have humorous overtones. Benois saw this as the source of the superficiality for which he reproached the artist. [1] There might have been an element of truth in this, if Bonnard's humour were present in all circumstances. But he used humour only when he wanted to avoid the direct expression of emotions. In a way, his special form of tact was akin to that of Chekhov. Though there was never any personal contact between these two men, they had much in common. Bonnard always added a touch of humour when he depicted children. The ploy reliably protected him against the excessive sentimentality often observed in this genre.

[1] A. Benois, *op. cit.*, p. 154

Bonnard had no children of his own. For many years he led a bachelor's life. This seemed not to worry him in the least. If, however, one looks at his works as a kind of a diary, a rather different picture emerges. In the 1890s–1900s he often depicted scenes of quiet domestic bliss. These scenes – the feeding of a baby, chidren bathing, playing or going for walks, a corner of a garden, a cosy interior – are both poignant and amusing. Of course, all these aspects of life attracted the other Nabis, too, which was in keeping with the times. But in Bonnard's work these motifs are not treated with stressed indifference, as in Vallotton's. Bonnard does not conceal the fact that he finds them attractive. Yet it is not easy to discern a longing for family life in his work. One might suggest it but without much confidence. Bonnard seems to remind himself, as always with humour, that family life is undoubtedly emotionally pleasant, but there is much in it that is monotonous and even absurd – a truly Chekhovian attitude. The many commonplace situations treated on account of banality with a degree of humour are summed up in the monumental portrait of the Terrasse family, a work unprecedented in European art. Bonnard gave the picture the title *The Terrasse Family* (*L'Après-midi bourgeoise*). It was painted in 1900 and is now in the Bernheim-Jeune Collection in Paris (another version is in the Stuttgart State Gallery). The title parodies Mallarmé's eclogue *L'Après-midi d'un faune*. The artist had an affection for his characters and not only because they were his relatives (Bonnard's sister Andrée was married to the composer Claude Terrasse). Yet he depicted the dozen or so of them in an ironical parade of provincial idleness, in all its grandeur and its absurdity.

Around the same time Bonnard painted his *Man and Woman* (1900, Musée d'Orsay, Paris), a work with a psychological dramatism quite unexpected for the artist. The psychological aspect of the work is not a piece of fiction or illustration of the then fashionable subject of the conflict between the sexes; it is a self-portrait of the artist with Marthe, his constant companion and model, in every respect a deeply personal work. Of course, this painting is not typical of Bonnard: there is no irony here, we are witnessing a dramatic episode easily identified as biographical. Both this work and the portrait of the Terrasse family are worthy of attention, because

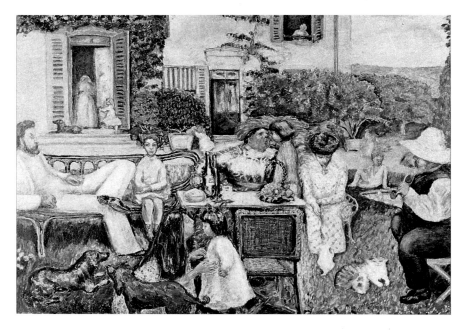

PIERRE BONNARD
The Terrasse Family
(*L'Après-midi
bourgeoise*). 1900
Bernheim-Jeune Collection,
Paris

they show Bonnard not only as a subtle painter but also as a very complex personality. Meeting Marthe brought many changes to Bonnard's life. This girl, who had come to Paris in search of work and a new life, did not belong to the same social milieu as Bonnard, and in comparison with him and his friends she was practically uneducated. Yet she became the artist's muse. In her Bonnard found an inexhaustible source of inspiration. She did not sit specially for him, and "there was no need for this because she was constantly with him. Her movements flowed out of one another with a naturalness that can be neither learnt nor forgotten. Some of Bonnard's most brilliant pictures were prompted by some pose of her body which he had noticed." [1] The presence of Marthe, the mistress of the house, is unexpectedly revealed in *Mirror in the Dressing-room*, now in the Pushkin Museum of Fine Arts in Moscow. In the mirror we can see the reflection of a small room in which Marthe is drinking coffee, completely ignoring the model who is in the act of removing her clothes.

They say that it was Bonnard's wife who compelled him to lead a secluded life, striving by one means or another to keep him away from his friends and from Paris. With the years she indeed became an intolerable person. But there is no evidence that Bonnard ever complained or expressed dissatisfaction. He was a patient man, and his love was a wise one. Perhaps he lacked firmness of character. "He was always afraid of her, her tactless behaviour," Matisse recalled. "She tried to cut him off from everyone. True,

[1] Th. Natanson, *op. cit.*, p. 24

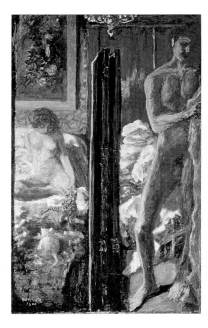

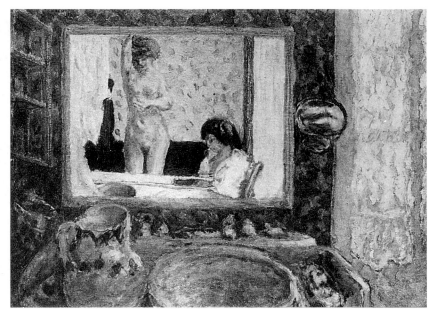

PIERRE BONNARD
Man and Woman. 1900
Musée d'Orsay, Paris

PIERRE BONNARD
The Mirror. 1909
John Herron Collection,
Indianapolis

she received me, saying, 'Oh, Matisse is only concerned with his painting.' I suppose she thought I wasn't dangerous." [1] Bonnard's friends were definitely convinced that he was under Marthe's thumb. But in actual fact he submitted himself to the imperatives of his art and Marthe never infringed upon them. He found it convenient to live in rural solitude and devote all his time to his work. After the First World War, if he visited Paris at all, he never spent more than two months in any year in the capital. "I go there to see what's happening, to compare my painting with that of other artists. In Paris I am a critic, I can't work there. There is too much noise, too many distractions. I know that other artists become accustomed to that kind of life. I find it difficult." [2] Bonnard had indeed changed; he seemed to have forgotten what fascination the rush and bustle of Paris had once held for him. Bonnard visited many foreign countries, but his travels left no noticeable traces in his art, which had grown on French soil, in a French atmosphere. Paris and the Île-de-France, Normandy, the Dauphiné, and the Côte d'Azur were places where Bonnard worked. In summer he usually went to some little town or village in one of these French provinces. He was particularly fond of Vernon and Le Cannet.

Bonnard was an artist of unusual integrity. A scholar who attempted to divide his work into periods would find himself faced with a formidable task. His early works are marked by a deliberate decorativeness, while towards the close of his life his paintings become more expressive, at times this expressiveness is accompanied by

dramatic overtones. However, it is impossible to establish a point when one tendency exhausted itself and another became a dominant feature of his art. One is forced inevitably to the conclusion that the whole of Bonnard's enormous legacy constitutes a single period. [3] The works painted between 1888 and 1890, about 15 in all (earlier works have not come down to us), already clearly indicate which genres the artist preferred: landscapes, still lifes and portraits. They also include his panel *The Peignoir* (1889, Musée d'Orsay, Paris), which is as decorative as a textile, and spontaneous, lively compositions containing human figures – the type favoured by the Impressionists. An example of the latter is *Street* (1889, Milliner Collection, Paris), the first of the artist's small genre scenes set in Paris, each of which is unique in its own way. This picture is the prototype for *Morning in Paris* and *Evening in Paris*, paintings now in the Hermitage.

Street and another painting of this period, *Woman in the Garden* (private collection, Paris), show that Bonnard not only was well acquainted with Impressionism, but he ventured into its territory as a polemist rather than a timid pupil: here characteristic Impressionist motifs are treated in a far from Impressionistic manner. It was only a short time before Bonnard painted these pictures that the Nabis learned the lesson taught by Gauguin. However, Bonnard and Vuillard with him were influenced to a lesser degree by Gauguin than their companions. While sharing Gauguin's opposition to Renoir, Pissarro and Raffaëlli, Bonnard and Vuillard drew support

[1] H. Matisse, *Ecrits et propos sur l'art*, Paris, 1972, p. 304
[2] Letter to Pierre Courthion (P. Courthion, "Impromptus – Pierre Bonnard", in: *Les Nouvelles Littéraires*, 24 June, 1933)
[3] See J. and H. Dauberville, *Bonnard. Catalogue raisonné de l'œuvre peint*, Paris, 1965–74, vols 1–4; F. Bouvet, *Bonnard. L'Œuvre gravé*, Paris, 1981; C. Roger-Marx, *Bonnard lithographe*, Monte-Carlo, 1952

not from Gauguin, but from oriental art, mainly from Japanese prints. French artists had become interested in Japanese art even before Bonnard was born. The influence may be traced in Manet's work and particularly in all the early works of the Impressionists. Originally it was no more than a taste for the exotic, but in the latter part of the 1880s this interest became more profound, and France was swept by a real wave of enthusiasm for Japanese art. Comparing French paintings of that period with Japanese prints, art historians have discovered that Monet, Degas, Redon, Gauguin, Seurat, Signac and others borrowed both motifs and elements of composition from these prints. Van Gogh painted his own versions of Japanese prints. He even went to Provence hoping to find a second Japan there. To one degree or another, all the Nabis used devices prompted by Japanese woodcuts. Yet it was no coincidence that one of them was singled out for the nickname: the Highly Nipponized Nabi (Nabi Très Japonard). It is quite reasonable to link Bonnard's early urban scenes, including his *Street*, and the works not only of the Impressionists, but also of Japanese artists – all the more so because the Impressionists themselves had been influenced by Japanese art. A painter of the city, Bonnard undoubtedly owed a debt to Hiroshige and Kiyonaga.

Japanese prints were by no means a rarity in Paris when Bonnard studied at the Académie Julian and the Ecole des Beaux-Arts. One exhibition of Japanese art was held at the Ecole itself in 1890 and there can be little doubt that Bonnard was among its most frequent visitors. Japanese prints were cheap enough for Bonnard and his companions to be able to buy the odd ones. Naturally, these were the latest impressions which differed considerably from the originals. In his old age Matisse would recall: "I knew the Japanese only from copies and prints of poor quality which could be bought in the Rue de Seine by the entrance of the shops selling engravings. Bonnard said that he did the same and added that he was rather disappointed when he saw the originals. This may be explained by foxiness and faded colours of the early print-runs. Perhaps if we had seen the originals first, we would not have been as impressed as by the later prints." [1]

"When I came upon these somewhat crude popular pictures," Bonnard said, "I realized that colour could express anything without resort to relief or modelling. It seemed to me that one could render light, shape, typical properties by colour alone, dispensing with values." [2] In order to understand Bonnard's first creative endeavours, it is essential to know that he, like the other members of the Nabi group, considered Japanese prints to be examples of folk art. At that time, he thought of creating not masterpieces for museums but popular art suitable for reproduction, in other words, something that was to an extent mass art. "During that period I myself shared the opinion that artists should produce works which the general public could afford and which would be of use in everyday life: prints, furniture, fans, screens and so on." [3]

Only a few of Bonnard's undertakings in the field of applied arts actually came to fruition. Among them were a stained-glass panel called *Motherhood*, which Tiffany's made from his

Marthe Boursin
on the terrace at
"Ma Roulotte". 1912.
Photograph

Pierre Bonnard and
Marthe at Vernon. 1912.
Photograph

Pierre Bonnard and
Marthe. Ca 1912.
Photograph

[1] H. Matisse, *op. cit.*, p. 83
[2] A. Terrasse, *Pierre Bonnard*, Paris, 1967, p. 10
[3] *Ibid.*, p. 23

cartoon, several screens, some of them painted, others decorated with colour lithographs. These screens and the design for a small cupboard with figures of two frisky dogs – probably Bonnard's only attempt to try his hand at furniture – clearly reveal a Japanese influence. Japanese prototypes are also in evidence in Bonnard's lithographs. Even his earliest print *A Family Scene* (1893) immediately brings to mind Utamaro, Sharaku and Kunisada. The works of these Japanese artists taught Bonnard the kind of stark simplicity and refinement that he could never have acquired at the Ecole des Beaux-Arts. Above all, they taught him to abandon the ideas of perspective, he had been taught to be bold in composition, to build up his picture as an arrangement of flat silhouettes, to appreciate the expressive power of a generalized patch of colour, at times unexpectedly giving close-up views and at times, on the contrary, arranging the composition in a friezelike manner. The free and at the same time energetic use of colour in Japanese woodcuts also brought Europe much both in graphic art and in painting .

"As for painting," Bonnard wrote to Suares, "I learned a lot working in colour lithography. You discover a great deal when you explore the relationship between different tones, with only four or five colours at your disposal, placing them next to or over one another." [1]

Incidentally, even before Bonnard turned to lithography, he tried to make do with a limited number of colours, applying them in a flat manner. The most telling example of this practice is *The Parade Ground* (1890, private collection, Paris). It would be hard to find a small painting in the battle genre to match this picture for richness of colour and decorativeness, although the work both belongs to and, with its Japanese features, parodies the genre.

With time the colours in Bonnard's paintings became more and more subdued. To some extent this was probably due to his work in lithography. By the middle of the 1890s the artist obviously began to prefer colour combinations in which grey and brown tones predominated. Vuillard was moving in the same direction.

A typical example of this manner is Bonnard's *Behind the Fence* (1895, Hermitage, St Petersburg). What is particularly interesting about this picture? It does not depict an amusing incident; the fine draughtsmanship is absent. We see some very ordinary brown-coloured houses, dark

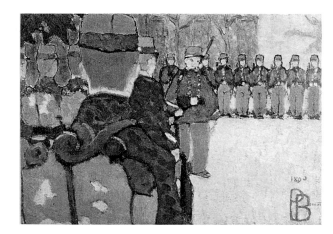

PIERRE BONNARD
The Parade Ground. 1890
Private collection, Paris

winter tree-trunks, a monotonous fence running across the whole composition. The viewer does not immediately notice benind this fence the solitary figure of a woman, who for some unknown reason has come out into the cold. Only the white splotches of snow which has just fallen and is already beginning to melt enliven the scene that does not catch the eye at all. Has this woman come out to call in a child still playing in the gathering twilight? Perhaps. She is not dressed to go far in such weather. But all these thoughts are unlikely to enter the viewer's mind. The painting is too generalized to enable us to read something in the woman's face. The main thing is, however, that the artist does assert that the scene he presents has some kind of narrative to it. It is just an unassuming corner in the outskirts of Paris made beautiful by the subdued colouring of the picture, with its shimmering grey tones.

Although Bonnard's painting lacks bright colour accents, it is nevertheless highly decorative. This effect is primarily achieved by the fence with its diagonal lines. As early as the 1890s the artist was fond of compositions where prominence was given to grids of lines crossing at right angles. Usually this is seen in a woman's dress, sometimes in a scarf (let us recall that Natanson specially noted Bonnard's love of check fabrics). The artist's innate talent as a decorator revealed itself above all in the way he carefully managed tension in a picture, skilfully alternating active, checkered areas with calm, empty spaces. Art historians often look on the use of checkered areas in Bonnard's early work as an extreme manifestation of his Japanism. We can, indeed, find something similar in Japanese prints, but the artist did not invent ornaments, rather he was stimulated when in the real world he came across the things he liked. (His sister

[1] A. Terrasse, *Pierre Bonnard*, p. 44

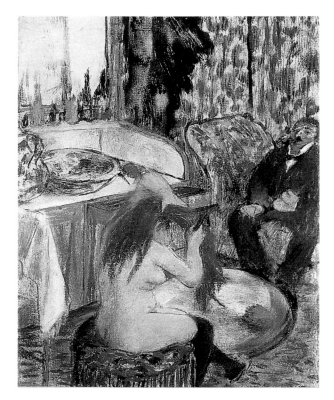

EDGAR DEGAS
*Nude Woman Combing
Her Hair.* Ca 1876–77
Private collection

Andrée also loved check fabrics: the pattern of her tartan dress, in which blue and red predominated, determines the main colour characteristics of a whole painting.) There should be no doubt that the very ordinary fence depicted in the picture *Behind the Fence* really existed. "You know, there is nothing in Bonnard's work that has not come from observation," Natanson noted. [1]

The middle of the 1890s saw a gradual change in Bonnard's art. Having begun as a convinced Post-Impressionist he now moved closer to the Impressionists, above all to Degas. In 1894 he painted a series of pictures devoted to horse-racing; in 1896 he turned to scenes in cafés and portrayed ballet-dancers; in 1897 he produced several circus scenes. The influence of Degas is evident in all these works. Bonnard did not reject the conventions of Japanese art, but adapted them to serve his own purposes: in his increasingly more realistic approach to the object of representation, his rendering of light, air and the depth of space.

Pissarro, who had expressed dissatisfaction with Bonnard's early work, now voiced a different opinion in a letter to his son. In 1898 Bonnard received a letter from Renoir following the publication of Peter Nansen's novel *Marie*. Renoir expressed his admiration for Bonnard's illustrations for the book: "You possess the gift of charming. Do not neglect it. You will come

across more powerful painters, but your gift is precious." [2] When staying in the south, Bonnard made a point of visiting Cagnes to call on the old master. The little painting with a dedication, which Renoir gave him, was Bonnard's pride and one of his most cherished possessions. When Bonnard moved to Vernon, he struck up a closer acquaintance with Claude Monet who lived in Giverny only a few miles away. Bonnard went to Giverny to enjoy Monet's beautiful garden, to look at the landscapes with water-lilies on which the leader of the Impressionists was then working, and to see again the canvases by Delacroix, Corot, Cézanne and Renoir in his collection. From time to time Monet's car drove up to Bonnard's house called "Ma Roulotte" (my gipsy-wagon). Monet wanted to see Bonnard's latest work. They spoke little, but Bonnard was content with a smile or an encouraging gesture from Monet. Bonnard continued seeing Monet and Renoir in later years, long after these two very discriminating elder masters had recognized their younger colleague as a painter of considerable standing.

At the turn of the century Bonnard seems to have been at a crossroads. He might have continued his experiments in decorative painting. He might have concentrated his attention on an ironical and psychological approach to the subject, not unlike that of Toulouse-Lautrec. (His *Terrasse Family* provides an excellent example of his capacity in that direction.) He might have yielded to the temptations of sensual subjects exemplified by the series of nudes he painted in 1899–1900. He might have focused on portraiture: his few efforts in that line reveal him as an astute student of the human soul. In fact, however, most of the works he created at that time and in the following decade show no marked preference for any one of these traditional genres. Nor do they show any extreme tendency in the treatment of the motif whether decorative, naturalistic or psychological. Later Bonnard would write to the art critic Georges Besson: "I am drifting between the intimate and the decorative." [3] Only a small number of Bonnard's works produced in the 1890s–1900s may be unreservedly classified as belonging to one particular genre: portrait, nude or landscape. His landscapes, for instance, generally contain people who are as important a part of the picture as the surrounding scenery. Looking at his townscapes

[1] Th. Natanson, *op. cit.*, p. 170
[2] Quoted from: A. Terrasse, *Bonnard*, Geneva, 1964, p. 40
[3] Quoted from: J. Bouret, *Bonnard. Seductions*, Lausanne, 1967, p. 26

one tends to wonder what attracted the artist more – the Parisian streets or their colourful crowds. In the majority of cases Bonnard does not single out either. The artist treats the streets with their specifically Parisian hustle and bustle and wealth of colour as a mixture of landscape and genre scene forming a single whole. With Bonnard's indoor scenes, we seem to face the same question. It is far from easy to decide whether we are looking at a depiction of a room enlivened by the presence of a human figure, or a genre scene where the interior serves as a background.

It was, in fact, quite natural for Bonnard to combine several genres in one picture. An excellent example of this is his *Mirror in the Dressing-Room* (Pushkin Museum of Fine Arts, Moscow). The painting is considered a still life, but the elements of interior, portrait and nude are stronger than they should be in that case. This places the work in a class of its own among European painting of the early twentieth century.

During this period Bonnard drew noticeably closer to the Impressionists. In their works, particularly in Degas's, he found numerous examples of an unorthodox attitude to genres. His affinity with the Impressionists expressed itself in the fact that landscape, which always predominated in Impressionist art, became an ever more important element of his painting. Moreover, it is also important to note that in his landscapes Bonnard no longer strove after decorative effect, at least that was no longer his main objective.

His *Landscape in the Dauphiné* in the Hermitage resembles a casual Impressionistic-style "snapshot view». The composition does not appear to follow a preconceived scheme and it is easy to imagine how it continues on either side. The painting has none of the earlier flatness, the eye is led far into the distance. The landscape, however, lacks the Impressionist luminosity. Unlike the Impressionists for whom light was of paramount importance, Bonnard valued colour above all. The *Landscape in the Dauphiné* does not attract attention immediately. It takes time to appreciate the modest beauty of the rather dirty green colours. Bonnard managed to catch the hues of the somewhat prosaic Dauphiné countryside, seen, as it were, through the eyes of a peasant. That is not to say that the treatment of the subject reflects the usual aesthetic tastes of peasants, who would

PIERRE BONNARD
Model. Lithograph
Hermitage, St Petersburg

probably not like the landscape. It is more the psychological aspect, a specific sense of place. To some degree, at least, Bonnard perceives the world as it is seen by his characters themselves – in the case of this painting by peasants working in the fields on a rainy autumn day.

Another illustration of Bonnard's ability to look at whatever he is depicting through the eyes of his characters is his townscape *A Corner of Paris.* In the centre of the composition is a small group of children out for a walk. The ingenuous curiosity and wonder with which they see the surrounding world is echoed by the bright posters pasted on a large board.

The humourous notes discernible in paintings like *A Corner of Paris* are absent in the landscapes containing no human figures, such as the two paintings of the Seine near Vernon, one in Moscow, the other in St Petersburg. It is noteworthy that landscapes of this type are both more lyrical and less decorative. In general, Bonnard's works are usually more decorative when they contain human figures.

It was when Bonnard was working on his *Corner of Paris* that the Fauves caught the public eye. Bonnard's paintings were less bright than the works of the Impressionists; next to the garish creations of the Fauves, constructed on a rolling crescendo of colours, they looked utterly faded, even timid. This impression was, of course,

deceptive, and Matisse, the leader of the Fauves, was well aware of this. But the public and even the critics found it difficult to discern the quiet melody of Bonnard's painting among the deafening trumpets of the Fauves.

It would be wrong to suggest that Bonnard was not influenced at all by Henri Matisse and his friends. The Parisian series he produced for Ivan Morozov in 1911 was painted in more vivid colours than *A Corner of Paris*. But Bonnard could never have become a follower of Matisse: his temperament and the circumstances of his artistic development, very different from those of the Fauves, precluded that.

It was not only Bonnard's tendency to approach his subject intimately that made him reject the scarcity of artistic means to which Matisse and Picasso had come in the first decade of the twentieth century and which had brought them world-wide recognition as the trend-setters in contemporary art. Bonnard did not consider Impressionism entirely passé, yet he wrote, "When my friends and I decided to follow the Impressionists, attempting to develop their achievements, we strove to overcome their naturalistic conception of colour. Art is not copying nature. We were more mindful of composition. We felt that colour should be used more effectively as a means of expression. But artistic development had gained such momentum that society was ripe to accept Cubism and Surrealism long before we had achieved our goal. We found ourselves in an uncertain position." [1]

It is hardly surprising that at the beginning of the twentieth century the young artists who joined the avant-garde considered the work of Bonnard and other artists of his circle rather old-fashioned and dull. They were completely overwhelmed by Matisse's *Red Room* and *The Dance* and by Picasso's Cubist experiments. Bonnard's *Mirror in the Dressing-Room* was painted at the time when Matisse and Picasso were creating some of their famous still lifes, including Picasso's *Composition with a Skull*, now in the Hermitage collection, and Matisse's *Red Room*, which is halfway to being a still life. Comparing all these works, one is bound to appreciate Matisse's and Picasso's unusual boldness, yet one is also sure to realize how much painting would have lost without Bonnard, already outside the mainstream of artistic development.

Mirror in the Dressing-Room is a wonderful illustration of how Bonnard used the lessons learned from the Impressionists, and from Degas in particular. At the same time it exemplifies the complete subordination of Impressionistic elements to a deeply individual and in essence non-Impressionistic conception. It would hardly be justified to speak here of the relationship between a pupil and his teachers. *Mirror in the Dressing-Room* clearly shows that structurally Bonnard's work was far more complicated than that of the Impressionists. Never in any of their still lifes did the Impressionists use so many motifs as well as compositional and spatial devices forming one integral whole; nor did they ever place such surprisingly diverse objects in apposition.

When Impressionism was in its heyday, Renoir painted an unusual still life, *A Bunch of Flowers in front of a Mirror* (1876, private collection, Paris). Looking at this fleeting vision of bright flowers, one finds it difficult to tell which of the two bunches is real; and the painter took pleasure in exploiting this effect. In Bonnard's work the mirror plays a different role. It has already been stated that no other feature reveals Bonnard's divergence from the Impressionists as clearly as his fondness for using a mirror in his compositions. [2] The rectangle of the mirror breaks the surface of the wall in practically the same way as an open window. Compositions containing open windows, so beloved of the Romantics, are easily understood. An open window leads the eye into the depths, giving added impetus to the view, while a mirror seems to cast the eye back into the space behind the viewer. The viewer feels himself to be not in front of the scene, but inside it. It takes some time to comprehend the relative positions of all the elements in the composition: those reflected in the mirror and thus behind the viewer, and those which are beside the mirror and hence facing the viewer.

A human presence is sensed in Bonnard's still lifes even when they contain no human figure. But the most important detail of the Moscow still life is the fact that the mirror – in the centre of the composition, and also its brightest spot – reflects the model and the artist's wife unconcernedly drinking her coffee. Thus this still life does not merely represent various toilet paraphernalia, but tells the viewer something about the artist, whose studio and living-room were

[1] A. Terrasse, *Pierre Bonnard*, Paris, 1967, p. 94

[2] R. Cogniat, "Pierre Bonnard ou le Miroir magique", in: *Pierre Bonnard*, Geneva, 1981

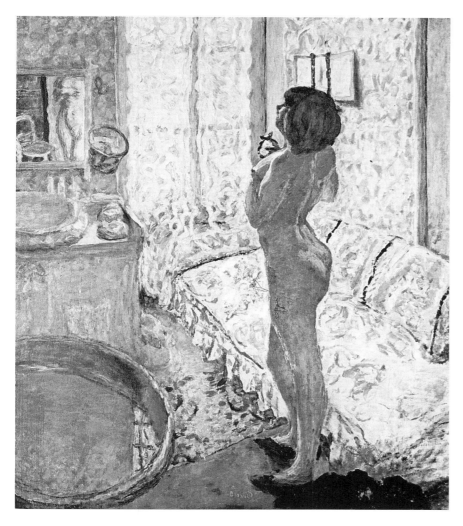

PIERRE BONNARD
*Nude against the Light
(The Dressing-Room)*. 1908
Musée Royaux des
Beaux-Arts, Brussels

Herself and *The Toilette* (1907, private collection;
D 473, 477) – the most important elements
are the nude figures, while the dressing-table
and mirror serve merely as a background.
In the next picture, *Nude against the Light*
(1908, Musées Royaux des Beaux-Arts, Brussels),
Bonnard depicted a young girl looking at herself
in a mirror with its "Japanese" frame already
familiar from the Moscow still life, and the com-
position is more complicated. The painting may
with equal justification be regarded as "a nude"
or "an interior", since the details of the room
are more than merely a background for
the figure. Together with the girl, they form part
of a colourful spectacle. Comparing this picture
with the *Mirror in the Dressing-Room*, one can
understand why Bonnard painted the latter
in greyish-blue colours. In *Nude against the Light*
a window is seen in the middle, while in the
Mirror, where the same room is depicted, the
window takes up only a narrow strip of the pic-
ture. Consequently all the objects in the first still
life, the table and the wall with the mirror, are
seen in backlighting. A further development
along these lines may be observed in *The Toilette*
(Musée d'Orsay, Paris, D 486), which may be
viewed as a preliminary version of the Moscow
still life. Here Bonnard draws even closer to a still
life free of the former limitations of the genre.
In 1909, 1913 and 1914 Bonnard again returned
to the mirror motif. In the *Dressing-Table with
a Bunch of Red and Yellow Flowers* (1913, D 772)
the size and the basic features of the com-
position are the same as in the *Mirror in the
Dressing-Room*, but the colour scheme deter-
mined by the inclusion of the flowers is different.
The next composition, *The Toilette* (1914, Art
Museum, Worcester, Massachusetts), is no longer
a still life but a pure interior with the same
dressing-table. However, the window next
to it has gone.

Depicting objects which were always at hand
or turning to outdoor scenes, Bonnard did not
strive to recapture an immediate impression.
As a rule, he started working on his painting only
when such impressions had taken root in his
mind and passed through the filter of the artist's
memory. Feeling no obligation to reproduce
an object of his observation precisely, he included
in his pictures only that aspect of it which could
be subordinated to the imperatives of art. In this
way he made every area of his canvases rich
in texture and colour.

one and whose creative activity was more than
just a job of work.
The mirror is an age-old element of the *vanitas*
type of still life traditionally linked with the motif
of a nude figure. Bonnard, however, did not
attempt to build up an allegory. The mirror gave
him an opportunity to correlate the details
reflected in it (his wife Marthe, the cup in her
hand, the model) with the various articles
on the washstand. With this diversity of details,
colour gains a special significance. Soft, muted
tones predominate. On the back of the picture
Bonnard wrote: "Do not varnish". The matt
effect is very important in this picture. Without
it the expressive range of bluish-grey tones
would have lost its wonderful subtlety and
richness. It is colour that ennobles articles
in Bonnard's still life. Natanson recollected that
Bonnard took great delight in watching reflec-
tions in a mirror as it, "like him, gave its caress
to objects." [1]
The Moscow still life belongs to a series of ten
pictures painted by Bonnard over a span of eight
years. In the first two canvases – *Girl Drying*

[1] Th. Natanson, *op. cit.*, p. 104

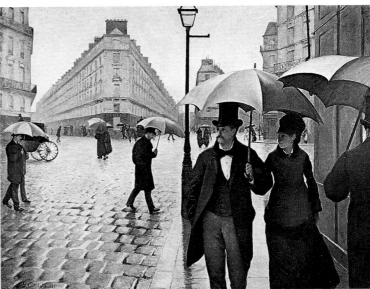

The impact Bonnard's works have on the viewer does not rest solely on his ability to reveal the most painterly aspect of an ordinary object, but also on the hidden metaphorical and universal meaning of the colours he used. For this reason Bonnard never tired of depicting the same objects, and turned again and again to the same motifs. Of course, this practice never amounted to mere repetition. His way towards revealing the beauty inherent in any object lay primarily through the rich expressive resources of colour, making a metaphorical link with what is precious. Bonnard believed that "a picture is a patchwork of colours which when combined with each other, in the final analysis form an object in such a way as to allow the eye to glide freely over it without encountering obstacles". [1] Bonnard delighted in walking the tight rope between the stylized decorative abstraction and the unstylized realism. His *Landscape with a Goods Train (Train and Fishing Boats)* provides a typical example. Each detail of the landscape may puzzle the viewer. It takes time to identify the tree in the right lower corner for what it is or the vineyard on the left. All details are governed by the ensemble of tones. That is why Bonnard is inevitably vague. It is as if he was reproducing the impression of a person walking down a path or, perhaps, looking at the scene from a moving train. For instance, it takes time to make out the fascinating figure of a little girl. This "sketchy" manner of painting is very characteristic of Bonnard. He tends to avoid a close scrutiny of his characters. Looking at the *Landscape with a Goods Train*, the viewer finds himself drawn into a system of resemblances. In pictorial terms as well as by some

inner meaning the head of the little girl, the clump of trees, the puffs of smoke coming from the engine and the tugs, and the clouds are linked in a common chain. For all the relative nature of brushstrokes or, perhaps, because of it, the viewer is made to feel himself inside the picture, as in the *Mirror in the Dressing-Room*. For this reason too, the foreground is more blurred than the rest of the picture. Here, in a panoramic landscape, Bonnard retains the intimacy typical of his work.

The *Landscape with a Goods Train* and *Early Spring. Little Fauns* address the viewer in the artist's usual quiet tones. They are imbued with his unique brand of lyricism and winning archness. With an ease typical of him, Bonnard introduces a group of fauns into his landscape, figures which could never have appeared in the canvases of the Impressionists. The puffed out cheeks of the faun playing the pipe is a delight. You do not immediately notice these little goat-legged creatures at the edge of the painting, but once you do, you cannot banish them from this convincingly real corner of the Île-de-France. And this unpretentious, yet endearing landscape seems alive with the gentle silvery sounds of the pipe. By introducing fauns into his landscape, Bonnard endowed it with metaphorical over-tones. A friend of the Symbolists, he used their poetical methods, at the same time gently mocking them. It is hard to decide what is more important in this picture, the humour or the joy at nature reawakening. It is this unity of poetic joy and gentle irony that makes the landscape of the countryside around Paris at the same time an embodiment of the mythical Golden Age.

PIERRE BONNARD
Fiacre or *The Boulevard des Batignolles*. 1895
National Gallery, Washington

GUSTAVE CAILLEBOTTE
A Paris Street in the Rain. 1877
Art Institute of Chicago

[1] A. Terrasse, *Pierre Bonnard*, Paris, 1967, p. 11

PIERRE BONNARD
Boulevard. 1895.
Colour lithograph

The nature of Bonnard's relationship with Impressionism, a key factor in his art, reveals itself most vividly in the subjects he chose and in his compositions. The Parisian townscapes may serve as an illustration. In comparison with his early pictures of Paris, the urban scenes executed in 1911–12, representing one of the peaks in Bonnard's art, are remarkable for their more complex composition. They contain more human figures, more space and more light, and they are richer in colouring. These features place them close to the works of Monet, Pissarro and Renoir. An Impressionistic flavour is strongly felt in his city scenes *Morning in Paris* and *Evening in Paris*, a pair of works painted for Ivan Morozov and seemingly bearing all the marks of a casually observed scene. In fact, of course, this was not the case. Both pictures were painted from memory, as was Bonnard's usual practice. In these two townscapes Bonnard was particularly attentive to composition and in this respect, as before, he demonstrated a closer affinity to Degas rather than Monet and Pissarro. Indeed in his very conception of street scenes Bonnard also followed Degas, or perhaps even Caillebotte, while Monet and Pissarro, the founding fathers of the Impressionistic townscape, were absorbed with a desire to show street life with its unceasing movement from a distance and avoided close-up or even middle-ground views of pedestrians. Yet unlike Degas (*Place de la Concorde*, 1873, Hermitage) and still less like Caillebotte (*A Paris Street in the Rain*, 1877, Art Institute of Chicago) Bonnard does not focus on the human figures and avoids depicting them in detail. The soft,

subdued patches of colour affect the viewer before he has become aware of what this or that patch actually represents. Bonnard's wonderfully orchestrated colour arrangements are not arbitrary. In *Morning in Paris*, the blue and pink tones of the sky, the cool hues of the foreground are so true to life that they alone, even without the scurrying pedestrians and the coal-merchant's cart with its early-morning load, clearly indicate the time of the day. But even after we realize the significance of the colour, that does not reduce its charm, quite the contrary, it is increased. The patches of colour do no more than "name" the objects depicted. They are sufficiently autonomous, and the beauty of their combinations could serve as a powerful justification for their independent existence.

At the same time, each masterly brushstroke and each patch of colour possesses a wonderfully keen and expressive force. The vagueness of Bonnard's painting does not reduce but intensifies that expressiveness. For example, the patch of colour representing a dog in *Morning in Paris* shows only its body and tail, but these details are enough to reveal the animal's behaviour with a striking liveliness and precision. In the same picture, the silhouette of the coal-merchant's donkey heavily and hurriedly moving its slipping legs may serve as another example. There is no animal painter of modern times who understood the character of animals better than Bonnard. With the alert eye of a master, Bonnard also catches a person's way of walking or behaving. The old flower-seller in *Evening in Paris* moves in a manner typical of her alone,

unhurriedly measuring each step. The children fooling about a bit in the street move as only children can.

The details of the picture are so arranged as to give an impression of the Parisian way of life. In *Morning in Paris* in the foreground the artist depicts people who have to rise early – the old coal-merchant, a group of young girls hurrying to work, a little boy loitering on his way to school. In *Evening in Paris* the movement of the figures is quite different. Here people are out for a stroll. In the first picture, Bonnard depicts a square, a junction of different streams of movement, in the second, a boulevard. In the first case, the artist needs an open space; in the second, a closed space. In the morning scene it is important to show the sunrise colours of the sky and the walls of houses catching the first rays of the sun; for the scene at dusk other details are necessary. "What is beautiful in nature", said Bonnard, "is not always beautiful in painting, especially in reduction. One example is the effects of evening and night." [1]

They say that Félix Fénéon, the manager of the Bernheim Gallery, once casually remarked to Bonnard that his Parisian street scenes were a success after which the artist stopped painting them. [2] This may have taken place in 1912, when the series of works commissioned by Morozov was on display for the first time at the gallery. Bonnard was always mistrustful of success; to his mind, it made an artist repeat himself. Whatever truth of the matter, Bonnard's last picture of this kind, *Place Clichy*, is dated 1912 (Musée des Beaux-Arts et d'Archéologie, Besançon). It is a large painting which appears to be a sort of the motifs in the Moscow works. The liveliness, the unassuming simplicity of the subject, an apparently casual composition which, however, always has a "framework" (Bonnard's word) and is well balanced, the mobility of texture, with each brushstroke vibrating in every patch of colour – all these elements are characteristic of an easel painting. It would seem from this that Bonnard had no special talent for monumental art, yet his large decorative panels are excellent. All the Nabis produced works in this field, but the most notable were by Bonnard, for his art is devoid of the deliberate solemnity nearly always present in monumental painting. Bonnard's most outstanding large work is undoubtedly the triptych entitled *Mediterranean*.

The main staircase in Ivan Morozov's Moscow mansion with the central part of Bonnard's *Mediterranean* triptych. 1920s. Photograph

Working on large paintings, Bonnard did not invent a new style. On the whole, his manner remained the same as in his small canvases. True, in this case he used simpler, clearer compositions and the overall tonality changed under the influence of the southern lighting. The artist's sincerity, his deeply personal and poetic vision of reality and his unerring feeling for colour helped him to work on large surfaces with undiminished confidence. Displaying a close affinity to the elderly Monet with his water-lilies series and his great panels for the Orangerie, Bonnard left a noticeable mark in decorative painting, although the path thus mapped out was not followed by succeeding generations of monumental artists.

The triptych forms, in fact, one picture – a landscape on three subframes. At the same time, each canvas is compositionally complete.

[1] A. Terrasse, *Pierre Bonnard*, Paris, 1967
[2] A. Vaillant, *Bonnard*, London, 1966, p. 113

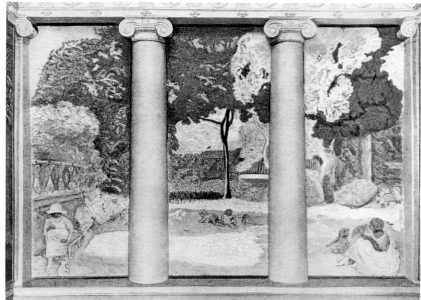

PIERRE BONNARD
Women in the Garden.
1890–91. A series
of four decorative panels
Kunsthaus, Zurich

Bonnard's *Mediterranean*
triptych in Ivan Morozov's
Moscow mansion. 1911.
Photograph

For this reason each panel requires space around it, "room to breathe". Bonnard knew that the staircase in Morozov's mansion for which the triptych was intended had semi-columns and he planned that they would act as spacers within the composition. The semi-columns served both as frames and as functional elements of the scene.

The subject of the triptych is a garden with a view of the Mediterranean. The garden is not empty: the central panel features an amusing group of children playing; each of the side panels includes a young woman. Although all the human figures are placed in shadow, the triptych would lose a great deal without these gently graceful, typically Bonnardian women and the funny, restless children. Yet, the landscape is more important here than the human figures, a landscape which is not wild and primordial, but cultivated, a landscape produced by hundreds of years of European civilization nurtured by the Mediterranean.

A great deal of space in the garden is taken up by the trees. Their theatrical and festive arabesques set the general, decorative tone of the pictures and create a feeling of luxuriant nature. In the background, which nevertheless seems somehow close to the viewer subordinated to the rules of flat manner of painting, is the alluring blue of the Mediterranean, the birthplace of European civilization. A comparison with *View of Saint-Tropez* (1909, Hahnloser Collection, Bern), the forerunner of the central panel, shows that in the triptych Bonnard omitted a number of details in the landscape and widened the opening to the sea. This made the composition more tranquil and even majestic. It is not just a view, but an image of the Mediterranean. In this respect the triptych painted for Morozov represents a new stage in Bonnard's evolution, although the stylized treatment of the trees goes back to the artist's experiments in the 1890s.

When Morozov commissioned two more panels to complete the triptych, Bonnard returned to already familiar subjects: early spring and the middle of autumn. These two panels flanked the triptych that represented summer time, and thus formed a seasons-of-the-year ensemble. *Early Spring in the Countryside* and *Autumn. Fruit-Picking* are inferior to the triptych, but they complement it admirably. Though Bonnard had not visited Moscow, he had a good idea of the setting in Morozov's mansion where the works would be hung. The triptych was to decorate the main staircase, extending its vista, and for that reason had to have additional depth. The two panels ordered later were to hang on the side walls. They are flatter and more restrained in colour, while the decorative treatment of the trees is reminiscent of ancient tapestries. The panels also display features linking them with oriental art. Clive Bell, an English art critic, once perspicaciously remarked that "Bonnard's pictures as a rule grow not as trees, they float as water-lilies. European pictures, as a rule, spring upwards, masonry-wise, from their foundation; the design of a picture by Bonnard, like that of many Chinese pictures and Persian textiles, seems to have been laid on the canvas

as one might lay cautiously on dry grass some infinitely precious figured gauze." [1]

In the panels representing spring and autumn, Bonnard obviously depicted gardens in the north, a fact to which the preliminary sketches also testify. In another panel – *Summer. The Dance* – painted in the same year and to a considerable extent related to Morozov's ensemble, Bonnard depicted a southern landscape. The artist admitted that he preferred the northern light, but to the viewer the difference between the north and the south is of secondary importance. Whatever the case, he sees first and foremost Bonnard's vision of nature, and only after that a definite landscape in Saint-Tropez or Vernonnet. However decorative Bonnard's representation of nature is, it never becomes a mere background subordinated to the human figures. The regally transformed world of vegetation is the embodiment of Bonnard's dream, his ideal, his joy, at times masked by a humorous and, at first glance, flippant irony. However, the beautiful nature in his paintings rejects dramatic or prosaic events, didactic subjects or subjects with a pathetic tinge. But it readily admits a group of children playing or women enjoying a chance to relax. Even the fruit-picking in the panel *Autumn* reminds one of a game rather than work.

In Bonnard's pictures of nature in festive mood only isolated features remind one of the real-world prototype. That is not to say that the artist felt no need of any original for his decorative paintings. These wonderful states of nature were not invented but observed. While painting his earthly paradise, Bonnard, however, did not feel obliged to reproduce all the details of a real scene. Depicting the landscape of Provence in *Summer. The Dance*, he introduced into it, without hesitation, a usual motif of his – the games and pranks of his sister's children, which he loved watching and even joining in. Of course, that did not take place in the south. The characters in the panel *Summer. The Dance* are not those depicted in the group portrait of the Terrasse family. They are imaginary, but they do make one think of their prototypes. Bonnard's fantasy, like that of any great artist, was founded on impressions from real life, and it is important to stress that on the whole these were happy, joyful impressions. In this respect Bonnard was a follower of Watteau, Fragonard and Renoir, and a fellow of his contemporaries, Matisse and Dufy.

Not only in his decorative panels, but also in his easel compositions depicting open-air scenes, Bonnard sacrificed the anthropocentrism deeply rooted in European art, to the joyous, happy world he created. An excellent example of this is provided by the Moscow picture *Summer in Normandy*. Here nothing has been invented. The work shows two women having a chat on the terrace of the villa "Ma Roulotte" in Vernonnet. The one on the left is the artist's wife. The dog Ubu, always nearby, is looking up at them from below with an expectation typical of dogs. In the background, the Seine glistens behind the trees. Although the two women are in the foreground, you do not notice them at once. The viewer's attention is attracted primarily to the garden and the fields in the background, since Marthe's figure is placed in the shadow, while that of her friend, who is sitting in the sun, is masked by a green dress. But even when you notice the women, you perceive them as an integral part of this wonderful corner of nature. There is nothing in this picture of the role formerly played by landscape – as a background for a human figure depicted in the foreground and thus inevitably dominant. The basis of the harmony at which Bonnard aimed was a happy coexistence of man and nature.

"One morning, on his way from 'Ma Roulotte', Bonnard instinctively walked towards two men discussing something near an ancient poplar tree, a tree which played an important role in the surrounding landscape and which he always greeted with a friendly smile whenever he happened to pass by. It turned out that the two men, the owner of the land and a timber-merchant, were discussing felling the tree. They seemed to have come to an agreement. Digging into his pocket, Bonnard produced more notes than the buyer could ever have offered, and the tree was saved. With his dachshund at his heel, Bonnard walked happily away, feeling the astonishment of the two men behind his back. He walked away with a light heart because the old poplar would continue to hold up that vital landscape." [2]

Today Bonnard's popularity is on the rise. The public is becoming aware of the unique beauty of his paintings and of the wise warmth of the artist's spirit. The delight Bonnard took in nature is perhaps appreciated all the more today when we find ourselves confronted with ecological problems at every turn.

[1] *Bonnard and His Environment*, New York, 1966, p. 11
[2] Th. Natanson, *op. cit.*, p. 87

1867
Pierre Bonnard born at Fontenay-aux-Roses
near Paris

1875
Enters the secondary school at Vanves, later attends
the Lycées Louis-le-Grand and Charlemagne. Spends
his summers at Grand-Lemps in the Dauphiné

1886
Enters the Law Faculty of Paris University

1887
Begins to study painting at the Académie Julian
where he meets Paul Sérusier, Maurice Denis, Paul
Ranson and Ibels

1888
Leaves the University and enters the Ecole des
Beaux-Arts

1890
The exhibition of Japanese prints arranged at
the Ecole des Beaux-Arts makes a deep impression
on Bonnard

1891
Shares a workshop with Vuillard and Denis in
the Rue Pigalle. Through Denis becomes acquainted
with Lugné-Poë, André Antoine and Paul Fort;
works for the theatre. Enjoys his first success with
the poster *France-Champagne*. Exhibits at the Salon
des Indépendants and at the Le Barc de Boutteville
Gallery

1892
Turns to lithography. Is noted by such well-known
art critics as Albert Aurier, Gustave Geffroy and
Roger-Marx

1893
Becomes acquainted with Marthe (Maria Boursin).
Produces lithographs for the *Petites Scènes Familières*
and the *Petit Solfège* by Claude Terrasse

1896
First one-man show at the Durand-Ruel Gallery.
Together with Vuillard and Maillol accepts an invita-
tion to take part in the exhibition "La Libre
Esthétique" in Brussels. Illustrates the novel *Marie*
by Peter Nansen, published in the *Revue Blanche*

1899
Vollard publishes an album of Bonnard's colour litho-
graphs entitled *Quelques aspects de la vie de Paris*.
Works on a large series of lithographs for Paul
Verlaine's book of poems *Parallèlement*

1900
Exhibits together with the other Nabis at
the Bernheim-Jeune Gallery. Works in Paris and
its environs: Montval, l'Etang-la-Ville, Vernouillet
and Médan

1902
Produces 156 lithographs for Longus's tale *Daphnis
and Chloë*. Takes part in the Bernheim-Jeune exhibi-
tion. In the summer works in Colleville

1904
Works at l'Etang-la-Ville and Varengeville. Illustrates
Jules Renard's *Histoires naturelles*

1905
Produces a series of nudes and portraits. Visits Spain

1906
Exhibits landscapes and interiors at the Vollard
Gallery. One-man show at the Bernheim-Jeune
Gallery. In the summer sails on Misia Edwards's
yacht to Belgium and Holland

1908
Visits Italy, Algeria, Tunisia and Britain. Illustrates
628-E-8 by Octave Mirbeau

1909
Works in Médan. In June goes to Saint-Tropez to visit
Manguin

1910
Works in the south where he regularly sees Signac
and Renoir

1911
Paints the triptych *Mediterranean* and the panels
Morning in Paris and *Evening in Paris* commissioned
by Ivan Morozov

1912
Buys "Ma Roulotte", a small villa in Vernonnet,
not far from Giverny. Often sees Claude Monet

1913
Visits Hamburg together with Vuillard

1916
Works on a series of large panels for the Bernheim-
Jeune Gallery. In November goes on a trip to
Winterthur

1918
The Jeune Peinture Française society elects Bonnard
and Renoir as honorary chairmen

1919
Fosca and Werth publish the first books devoted to
Bonnard

1925
Buys a small house at Le Cannet. Officially marries
Marthe

1926
Travels to the United States to act as a member
of the Carnegie Prize jury

1936
Receives a Carnegie Prize for the second time
(first award in 1923)

1939
Settles at Le Cannet

1942
Marthe Bonnard dies

1947
Pierre Bonnard dies at Le Cannet

Behind the Fence. 1895
Derrière la grille
Oil on cardboard. 31 x 35 cm
Signed and dated, bottom left: *Bonnard 95*
Hermitage, St Petersburg. Inv. no. 7709

This picture is typical of Bonnard's early period in which he used the decorative effect of checks and squares borrowed from Japanese art. A similar method of setting off a female figure against a diagonal pattern is employed in *Promenade* (private collection, Winterthur; D 57). *Kiosk on the Boulevard* also displays the same kind of design with its distinctive treatment of the black, bare trees, while its dimensions are practically the same (34 x 33 cm). Both the Winterthur and the Paris pictures were dated by the Daubervilles to about 1894; it would be more accurate, however, to date them to the year 1895, thus bringing them into line with the Hermitage picture, which can safely be regarded as a starting point in establishing the chronological order of Bonnard's work of that period. In fact, *Behind the Fence* is one of the two 1895 pictures dated by the artist himself. The same model is presumably portrayed in *Figure* (ca 1895; D 96).
Behind the Fence was the first oil painting by Bonnard to be brought to Russia (before 1903) and also the earliest work by him now in a Russian museum collection.

Provenance:
before 1903 M. Morozov Collection; 1903 M. Morozova Collection; 1910 Pavel and Sergei Tretyakov Gallery, Moscow (gift of M. Morozova); 1925 Museum of New Western Art, Moscow; 1934 Hermitage

Exhibitions:
1993 Essen, no. 73; 1993–94 Moscow– St Petersburg, no. 73

Bibliography:
Catalogue 1917, no. 3954; *Catalogue* 1928, no. 31; *Catalogue* 1958, vol. 1, p. 360; Dauberville 1965, no. 98; Izerghina, Barskaya 1975, no. 95; *Catalogue* 1976, p. 239

PIERRE BONNARD
Promenade. 1894
Private collection, Winterthur

PIERRE BONNARD
Figure. Ca 1895
Private collection

PIERRE BONNARD
Kiosk on the Boulevard. 1894
Private collection, Paris

Bonnard

2
Landscape in the Dauphiné. Ca 1899
Paysage du Dauphiné
Oil on panel. 45.5 x 56 cm
Signed, bottom left: *Bonnard*
Hermitage, St Petersburg. Inv. no. 7757

The picture belongs to Bonnard's early period, a fact which is borne out, among other things, by the obviously Japanese treatment of the landscape. While painting it, Bonnard apparently had in mind the sheet 18 from Hiroshige's series of woodcuts *69 Stations of Kisokaido*

KATSUSHIKA HOKUSAI
Hodagaya on Tokaido.
1823–29. Colour woodcut

(1837–42) and *Hodagaya on Tokaido* (1823–29) by Hokusai.

The 1965 catalogue raisonné of Bonnard's painting compiled by the Daubervilles dates the picture to about 1905.

The compilers knew it only from photographs and clearly had no documentary evidence to define the date, therefore they relied on the style alone. Yet it is stylistic features that set *Landscape in the Dauphiné* apart from those of Bonnard's works which indisputably do date from 1905.

The motif is similar to that of *Panoramic View (Dauphiné)* (1894, private collection; D 01744). Both paintings depict the same

valley in the foothills of the Alps near Grand-Lemps, where the artist spent his childhood in his grandfather's home and where he repeatedly returned later in life. The Hermitage picture seems to have been painted in the 1890s, but after *Panoramic View*, since it displays a greater skill and more assured execution. In all probability, this landscape was painted about 1899, when Bonnard again worked in Grand-Lemps. Incidentally, Vollard, who sold *Landscape in the Dauphiné* to Ivan Morozov, possessed quite a few of Bonnard's early works, including some dating from 1899.

Vollard wrote to Ivan Morozov on 28 June 1907 that he could let him know the titles of the pictures just handed over to him by the artist himself: "... the landscape-format picture is called *Paysage du Dauphiné*" (Pushkin Museum of Fine Arts archives). It is also known as *Green Landscape*, the title written on the reverse of the panel.

Provenance:
Vollard Gallery, Paris; 1906 I. Morozov Collection (purchased from Vollard for 1,500 francs); 1918 Second Museum of New Western Painting, Moscow; 1923 Museum of New Western Art, Moscow; 1934 Hermitage

Bibliography:
Makovsky 1912, p. 19; *Catalogue* 1928, no. 18; Réau 1929, no. 702; Sterling 1957, p. 158; *Catalogue* 1958, vol. 1, p. 362; Descargues 1961, p. 300; Dauberville 1965, no. 331; Izerghina, Barskaya 1975, no. 96; *Catalogue* 1976, p. 239

PIERRE BONNARD
Panoramic View (Dauphiné). 1894
Private collection

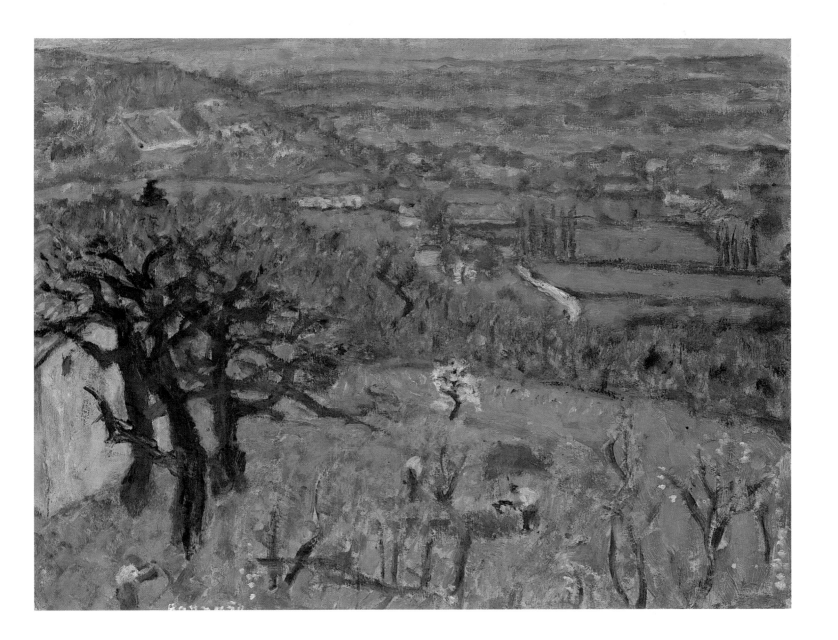

3
A Corner of Paris. Ca 1905
Un coin de Paris

Oil on cardboard pasted on parqueted panel.
49.2 x 51.8 cm
Signed, bottom, to the right of centre: *Bonnard*
Hermitage, St Petersburg. Inv. no. 9025

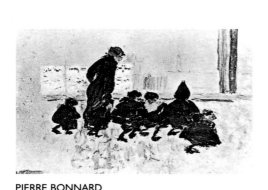

PIERRE BONNARD
The Schoolchildren. Ca 1895
National Gallery, Washington

Although this townscape clearly depicts
a particular place in Paris (probably
in the vicinity of the Rue Douai, where
the artist's studio was located), it is repro-
duced with only a slight degree
of concreteness, so that only upon close
examination can the details, such as
the posters on the wall or human figures,
be guessed at, rather than discerned.
The patches of the children's figures
almost merge with the background.
Bonnard had become fascinated by the
motif of flocks of children on the streets
of Paris as far back as the 1890s; we should
recall, in particular, two small-scale
pictures painted about 1898 (D 174, 175).
Regarding posters: Bonnard had always
been keenly interested in them and
turned his hand to this art form more
than once in his early days.
The Daubervilles' catalogue (1965) dates
the picture to 1905, which is borne
out by the manner of painting.
Vollard wrote to Ivan Morozov on 28 June
1907: "... I have the opportunity to give
you the titles of the pictures which
the painter has just handed over to me.
The portrait-format picture of houses
and trees is called *Un coin de Paris*".

Provenance:
Vollard Gallery, Paris; 1906 I. Morozov Collection
(purchased from Vollard for 1,000 francs); 1918

Second Museum of New Western Painting, Moscow;
1923 Museum of New Western Art, Moscow;
1948 Hermitage

Exhibitions:
1939 Moscow, p. 52; 1956 Leningrad, p. 8; 1966–67
Tokyo–Kyoto, no. 66; 1988 Tokyo–Kyoto–Nagoya,
no. 34

Bibliography:
Makovsky 1912, p. 19; *Catalogue* 1928, no. 19;
Réau 1929, no. 703; Sterling 1957, p. 154; *Catalogue*
1958, vol. 1, p. 360; Descargues 1961, p. 300;
Dauberville 1965, no. 332; *French 20th-century
Masters* 1970, no. 6; Kalitina 1972, pp. 118, 119;
Yavorskaya 1972, pp. 66, 67; Izerghina, Barskaya
1975, no. 97; *Catalogue* 1976, p. 239

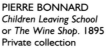

PIERRE BONNARD
Children Leaving School
or *The Wine Shop*. 1895
Private collection

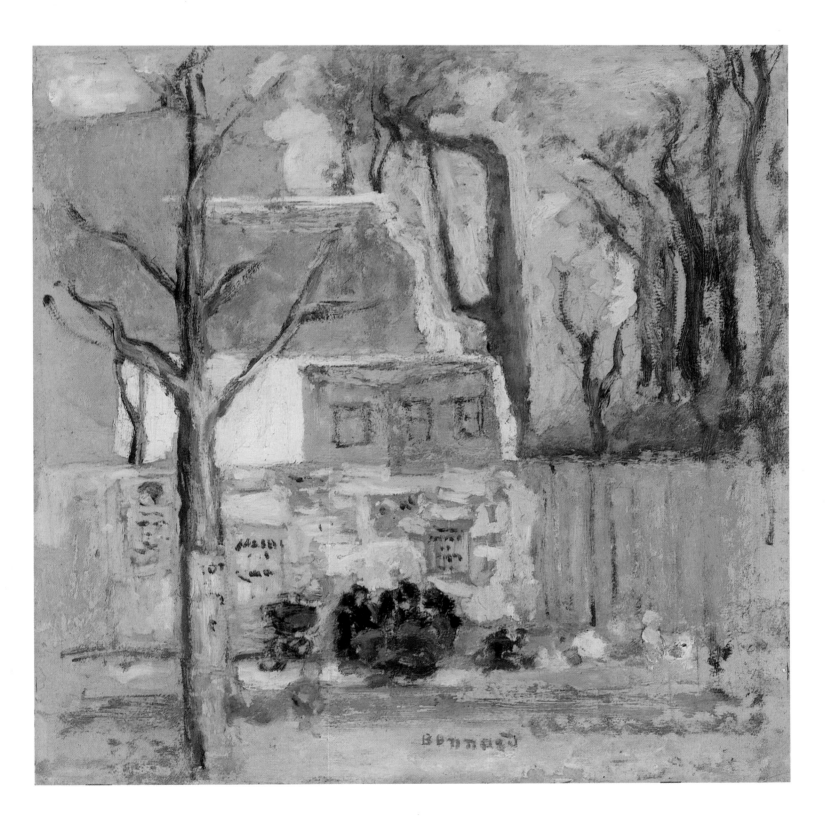

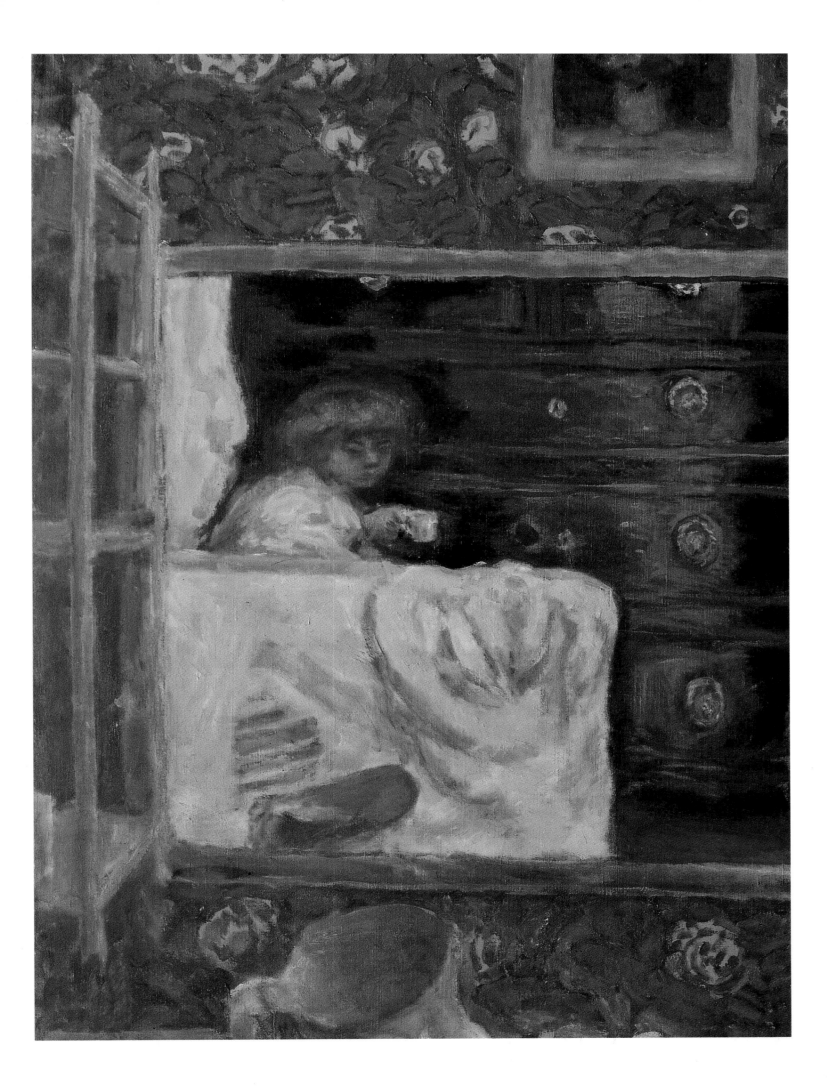

4
Mirror in the Dressing-Room. 1908
La Glace du cabinet de toilette
Oil on canvas. 120 x 97 cm
Signed, top right: *Bonnard*
Inscribed and signed on the reverse:
Glace cabinet de toilette. Ne pas vernir. P. Bonnard
Pushkin Museum of Fine Arts, Moscow. Inv. no. 3355

PIERRE BONNARD
Nude in the Mirror. 1908–09
Private collection

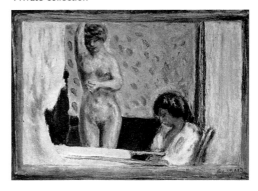

PIERRE BONNARD
*Dressing-Table with a Bunch of Red
and Yellow Flowers*. 1913
Museum of Fine Arts, Houston

Mirror in the Dressing-Room is the only still life by Bonnard in the Russian collections. It is one of the most wide-ranging of his works in terms of genre as well as one of the most captivating for its visual harmony. A painting as complex as this required not only daring, but also the considerable experience accumulated over twenty years of work. Bonnard's earliest still lifes, including student pieces dating back to 1888, were far removed from the solution of complex issues of genre and space; they are straightforward presentations of bouquets of flowers, colourful and attractive.

This painting is interesting for the fact that it records meticulously certain details of the artist's domestic environment. It might also be termed autobiographical because one of the women depicted is easily recognized as Bonnard's muse and lifelong companion Marthe (Marie) Boursin. The unforced naturalness of her pose – a unique way of holding a cup of coffee, which can be seen again in later depictions of Marthe – is captured with a striking persuasiveness. The painting leaves a question mark about Marthe's exact role: either mistress of the house or a model in a moment of relaxation. This is natural since Marthe posed for Bonnard more often than anyone else. A photograph has survived, taken by the

Marthe washing herself. 1908.
Photograph

artist himself, in which Marthe is seen washing herself in a basin against the background of the dressing-table. It dates from the time when this painting was produced. The juxtapositioning of two women, one naked, the other clothed, has about it an element of irony, which was highly characteristic of Bonnard. A somewhat unusual feature of this painting is the inclusion of the mirror. A detail of this kind already occurred quite often in the work of the Old Masters, most frequently as an element in *vanitas* compositions which through the idiom of juxtaposed objects spoke of the transitory nature of life and of human vanity. Sometimes a mirror was depicted in combination with a statuette of a half-naked woman which symbolized Art. However, this kind of object symbolism had lost its original meaning as early as the eighteenth century. In their still lifes Bonnard's immediate predecessors, the Impressionists, hardly ever used a mirror as a compositional element. The great exception is Edouard Manet's *Bar at the Folies-Bergère*, a work with a considerable number of still-life features in which the mirror is not so much a background as a spatial display screen – a device with which Bonnard was undoubtedly familiar.

The basic structural elements of *Mirror in the Dressing-Room* had formed long before 1908. For example, in 1894 the artist painted *The Cup of Coffee* (D 85) which depicts a girl at a little table holding a coffee-cup. The following year, in response to a commission for the decoration of a bathroom and boudoir, Bonnard produced a series of *grisaille* and red-chalk nudes in which we can detect the influence of Degas. Degas had been the first to depict nudes in huge basins or baths, at their toilette, without prettifying them in any degree. Particularly notable in this regard is his 1876–77 series of monotypes (some of them touched with pastel). It is quite probable that Bonnard saw one or other of Degas's nudes shown standing with a jug and basin at the dressing-table, her back to the viewer – either *After the Bath* (private collection) or *Woman at Her Toilette* (Norton Simon

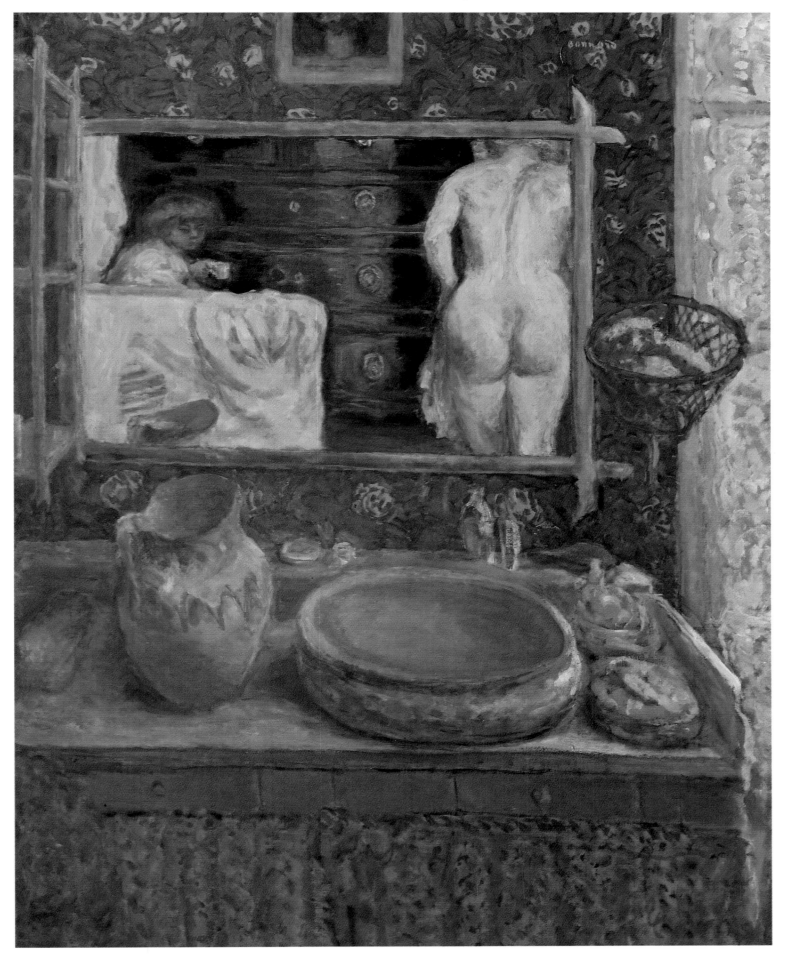

Foundation, Pasadena). The latter is very close to Bonnard's Moscow composition, even to the point of various details coinciding. The subject-matter may also have been prompted by other works by Degas whose love of unusual compositional arrangements and unexpected viewpoints in his depictions of nudes must surely have made a strong impression on Bonnard. Yet in *Mirror in the Dressing-Room* Degas's influence is less detectable than in the works which preceded it.

By 1908 Bonnard had emerged as an artist who engaged with assurance in a dialogue with his predecessors. Thus a detail such as the large basin on the dressing-table combined with the reflection in the mirror of the model, who seems proportionally considerably smaller, reminding us of the treatments given to similar motifs in Degas's work, bears a slightly ironic overtone.

The year 1902 is the approximate date given to *Nude Washing* or *Rural Toilette* (D 274) which with its depiction of the model from behind in backlighting is a prototype of the nudes of 1908, among which *Mirror in the Dressing-Room* can to a certain extent be included. Another of these prototypes is *Woman Undressing* (ca 1905; D 374), in which the model is presented against the background of a mirror.

A more immediate predecessor of *Mirror in the Dressing-Room* was the painting entitled *The Dressing-Room* or *Girl Drying Herself* (1907, private collection, Paris; D 473). The Moscow work looks

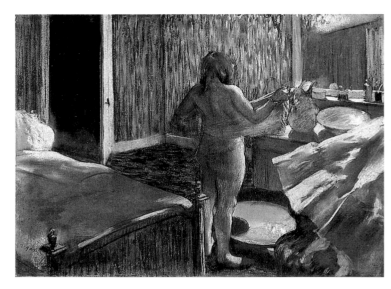

EDGAR DEGAS
Woman at Her Toilette.
Ca 1876–77
The Norton Simon
Foundation, Pasadena

EDGAR DEGAS
After the Bath. 1876–77
Private collection

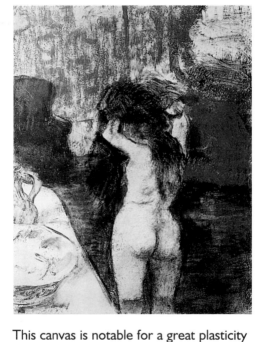

like a sort of inversion of this one in which rather than the model being caught in the mirror, the dressing-table and the toilet accoutrements serve as a background for her. It is possible that the same girl posed for that picture as for *Mirror in the Dressing-Room*. The following step must be numbered among Bonnard's greatest achievements. It is known by three different titles: *Dressing-Room with Pink Couch*; *Eau de Cologne*; and *Nude against the Light* (1908, Musées Royaux des Beaux-Arts, Brussels; D 481). The model, depicted half-turned from behind, is on the right, the dressing-table on the left: the two elements are intended to balance each other. In the middle there is a window whose silvery-azure light sets the colour key for the whole painting. Although the different titles for the Brussels canvas reflect, as it were, the difficulty of pinning it down to a particular genre, it must be acknowledged that it tends most towards the nude: the model remains the chief feature. *Toilette* or *The Dressing-Table* or *The Mirror* (1908, Musée d'Orsay, Paris; D 486) was produced almost simultaneously or immediately afterwards. This painting, dark and somewhat muted in colour compared to *Mirror in the Dressing-Room*, in all likelihood came directly before the Moscow still life. In any case the female figure and the objects on the dressing-table are arranged in a similar manner. Only the second figure is missing.

This canvas is notable for a great plasticity and softness of brushwork: the rounded shapes of the foreground objects find support in the reflections in the mirror and it is not mere coincidence that an armchair with a rounded back is introduced into the reflected space.

The Moscow painting differs positively from the variant in Paris not only in the freshness of the colour scheme, but also in a subtler and less forced resolution of the complex problems of illumination. It is a real symphonic poem of light. The window is on the right, so that the wall with the mirror is lit from behind,

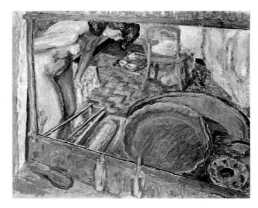

PIERRE BONNARD
Reflection in the Mirror or *The Tub.* 1909
Jäggli-Hahnloser Collection, Winterthur

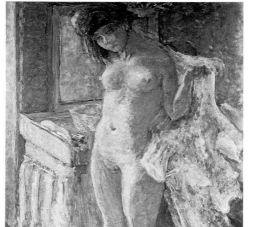

PIERRE BONNARD
Girl Drying Herself. 1907
Private collection, Lausanne

but the figures reflected in the mirror, the model and the young woman seated at the table, are made to stand out by the light pouring from the window, while the toilet articles appear lit from the side. Like all the Nabi artists, Bonnard had a dread of illusionism and strove to retain a sense of the flatness of the canvas. Nevertheless this painting is endowed with a tremendous feeling of space. The mirror enables the artist to record not only the wall that stands in front of him, and therefore in front of the viewer, but also the area behind his back. If it were not for the stylized manner of painting and the strictness of the compositional arrangement this would produce a dizzying effect. The central horizontal (the bottom of the mirror) and vertical (the border between full shadow and half-light on the commode) are clearly delineated. The entire composition is dominated by the interaction of various rectangles. One quite important detail which is not immediately striking is the reflection in the mirror of the neck of the jug standing on the dressing-table. This sort of spatial "cross-tie" unites the different planes even more boldly than the knife at the edge of the table in the still lifes by Chardin and later by Manet.
Mirror in the Dressing-Room lies at the centre of a large cycle of works which continued into the 1910s. *Nude in the Mirror* (private collection, Basel; D 484) was probably painted late in 1908. In it the artist deliberately narrowed

his task, limiting himself to the reflection alone. While a mirror in an interior is quite often, as in the Moscow work, a picture within a picture, the small within the large, *Nude in the Mirror* virtually does away with that relationship. Moreover, the second woman, the one sitting at the table, is not a repetition of the character from the Moscow composition. Not knowing the datings, one might be tempted to think of the Basel canvas as a study for *Mirror in the Dressing-Room*. In actual fact it is a postscript to it. It should be considered a study for *Mirror in the Green Room* or *Nude in the Mirror* (John Herron Art Museum, Indianapolis; D 529), which dates from January 1909. In that late variant of the Moscow composition the horizontal element is dominant. The format of the painting and the mirror are subordinated to one and the same module. Admittedly the mirror here is different, with a simple rectangular frame instead of the more elaborate one with protruding ends. The imitation-bamboo frame in the Moscow painting and some of its variants introduces a slight Japanese element, entirely natural for the "Nipponized Nabi". We should hardly interpret this alteration as meaning that Bonnard really did change the frame of his dressing-table mirror. While conveying the spirit and some particular features of his domestic environment, he felt under no obligation to merely copy

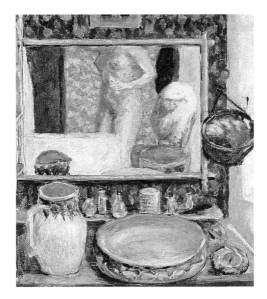

from nature and depicted the frame first in one way and then another, depending on what better suited the needs of the composition.
There is one further postscript to the Moscow still life – *Reflection in the Mirror* or *The Tub* (1909, Jäggli-Hahnloser Collection, Winterthur; D 531). In it only a small corner of the dressing-table is shown, but the viewpoint chosen means that the table-top with the basin is reflected in the mirror as well as the model and part of the interior. A few years later Bonnard returned to the motif of the Moscow painting in *Dressing-Table with a Bunch of Red and Yellow Flowers* (1913, Museum of Fine Arts, Houston; D 772) in which flowers in the jug become the centre of the composition and the mirror shows the model seated. The following year, in *The Dressing-Room* (Worcester Art Museum, Massachusetts; D 811) the table and mirror are no longer the main element but part of the larger interior. For all its positive qualities, this last canvas lacks the sharpness and ease which distinguish *Mirror in the Dressing-Room*.

Provenance:
1908 Bernheim-Jeune Gallery, Paris (purchased from the artist); 1908 I. Morozov Collection (purchased from the Salon d'Automne where it was displayed by the Bernheim-Jeune Gallery); 1919 Second Museum of New Western Painting, Moscow; 1923 Museum of New Western Art, Moscow; 1948 Pushkin Museum of Fine Arts

Exhibitions:
1908 Paris, no. 184; 1965 Bordeaux, no. 75; 1965–66 Paris, no. 73; 1983 Dresden, no. 19; 1984 Leningrad–Moscow, no. 11; 1993 Essen, no. 76; 1993–94 Moscow–St Petersburg, no. 76

Bibliography:
Makovsky 1912, p. 19; L. Werth, *Bonnard*, Paris, 1923; *Catalogue* 1928, no. 21; Réau 1929, no. 705; Denis 1957, vol. 2, p. 101; *Catalogue* 1961, p. 21; Terrasse 1967, pp. 78, 80; Dauberville 1968, no. 488; Yavorskaya 1972, p. 61; R. Geller, *Bonnard*, Budapest, 1975, pl. 25; Georgievskaya, Kuznetsova 1979, no. 215; Barskaya, Bessonova 1985, no. 210; J. Clair, "The Adventures of the Optic Nerve", in: *Bonnard. The Late Paintings*. The Phillips Collection, Washington D.C., Dallas Museum of Art, 1984, pp. 37–38; Bessonova, Williams 1986, p. 275

PIERRE BONNARD
The Dressing-Table or *The Mirror.* 1908
Musée d'Orsay, Paris

Bonnard

5
Early Spring. Little Fauns. 1909
Premier Printemps. Les Petits Faunes
Oil on canvas (relined). 102.5 x 125 cm
Signed, bottom right: *Bonnard*
Hermitage, St Petersburg. Inv. no. 9106

The picture can be assumed to have been inspired in part by Mallarmé's *L'Après-midi d'un faune* (ca 1865). All the Nabis were very fond of this joyous eclogue; yet in aiming to re-creating the spirit of Mallarmé's poetry Bonnard knew better than to produce a mere illustration. Besides, one cannot but recall Debussy's prelude of the same title (1894), which was also inspired by Mallarmé. Bearing that in mind, the musical theme of the Hermitage picture – the faun playing his reed-pipe – is not coincidental.

Bonnard first turned to pastoral motifs in 1902, when Vollard commissioned him to illustrate Longus's *Daphnis and Chloë*. He was preceded by Roussel, who had by that time made lithographs for the *Album of Landscapes* (1899), also to Vollard's commission. Bonnard appreciated Roussel's art and knew both the *Album of Landscapes* and *Fauns and Nymphs* (ca 1904, Bretegnier-André Collection, Paris). In 1907, he painted a small-size panel to a similar subject known under various titles: *Faun*, *Rape of the Nymph*, *L'Après-midi d'un faune* (private collection; D 471). A larger panel also exists called *The Fauns* (private collection, Switzerland; D 329). The Daubervilles dated it to 1905; however, the organizers of Bonnard's 1984–85 exhibition in Zurich seem to be right in dating it to 1910. Except for *Early Spring*, these are

the only two paintings by Bonnard which depict Dionysian characters. *The Fauns* is more decorative; it develops the theme of the Hermitage picture, the artist portraying several fauns instead of one and placing the goat-legged pipe-player (this time he is old, not young) in the bottom left-hand corner, after the pattern of *Early Spring*.

Early Spring was preceded by the small-scale companion panels *Mother and Child* and *Father and Daughter* (Lambert Collection, Brussels; D 458, 459), each depicting two figures against a landscape. The figure motifs of these panels were to be merged into the characters of the Hermitage composition, with the pipe-playing faun shown in the same pose as the mother in the Brussels panel, although originally this pose was struck by the figure of the father.

Early Spring was also preceded by *Thoughts* or *Early Spring* (1908, Phillips Collection, Washington; D 508), where the painter presented with a few minor alterations the same landscape he had seen in Vernouillet. Part of this landscape background also recurs in *Thunderstorm* (1908, Hahnloser Collection, Bern; D 509), with two children running from the storm. This subject was employed in quite a few Salon paintings in the last quarter of the 19th century.

Bonnard's substitution of mythological characters for the realistic figures in the

PIERRE BONNARD
Thoughts or
Early Spring. 1908
Phillips Collection,
Washington

Bonnard

1908 canvas yielded a result unprecedented in the artist's earlier work and recurring only once, if less conspicuously, in the painting *The Fauns*. The fauns and nymphs in his previous works were usually depicted against the background of an imaginary landscape, devoid of human presence; but placing the fauns in the real Vernouillet landscape with its recognizable architectural landmarks created a quite unexpected counterpoint.

According to Félix Fénéon, who ran the Bernheim-Jeune Gallery, Ivan Morozov dated *Early Spring* to 1903–04, and Charles Terrasse, the artist's nephew, to the 1910s; but the Daubervilles are undoubtedly right in thinking that the Hermitage picture was painted in 1909. In 1904 Bonnard visited Vernouillet, though not in spring. Besides, the style of *Early Spring* differs from other pictures of that period. Bonnard's sojourn at Vernouillet in the spring of 1909 was very fruitful (see also nos 10, 11). *Rainy Landscape* (Art Museum of the Ateneum, Helsinki; D 547), a picture painted, among many others, during his stay there, reproduces in part the landscape of *Early Spring*. The Helsinki painting was dated by Bonnard himself to 1909, which also supports the dating of the Hermitage canvas given above.

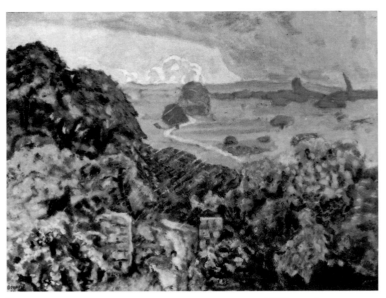

PIERRE BONNARD
Thunderstorm. 1908
Hahnloser Collection, Bern

Provenance:
1909 Bernheim-Jeune Gallery (purchased from the artist), A. Bernstein Collection, Paris; 1911 Bernheim-Jeune Gallery (purchased at the sale of A. Bernstein's Collection on 9th June 1911: sale catalogue no. 4); 1912 I. Morozov Collection (purchased from the Bernheim-Jeune Gallery for 5,000 francs; 1918 Second Museum of New Western Painting, Moscow; 1923 Museum of New Western Art, Moscow; 1948 Hermitage

Exhibitions:
1956 Leningrad, p. 8; 1978 Le Havre (no number); 1979 Tokyo–Kyoto–Kamakura, no. 25; 1982 Moscow, no. 87; 1984 Tokyo–Nara, no. 19; 1984–85 Zurich–Frankfurt am Main, no. 60; 1988 Tokyo–Kyoto–Nagoya, no. 35

Bibliography:
Makovsky 1912, p. 19; Coquiot 1922, p. 56; Terrasse 1927, p. 94; *Catalogue* 1928, no. 20; Réau 1929, no. 704; Ch. Sterling, "Notice biographique de Bonnard", in: *L'Amour de l'Art*, 1933, April, p. 89; G. Besson, *Bonnard*, Paris, 1934, no. 25; W. Georges, "Le Sentiment de l'antique dans l'art moderne", in: *L'Amour de l'Art*, 1935, February, p. 52; Sterling 1957, p. 154; *Catalogue* 1958, vol. 1, p. 360; Descargues 1961, p. 300; Dauberville 1968, no. 540; *French 20th-century Masters* 1970, no. 77; Kalitina 1972, pp. 119, 122; Izerghina, Barskaya 1975, no. 98; *Catalogue* 1976, p. 239; Kostenevich 1984, pp. 213, 214; Kostenevich 1987, no. 122

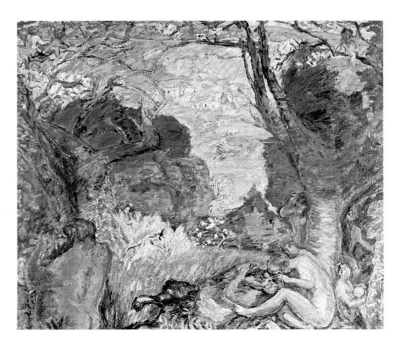

PIERRE BONNARD
The Fauns. Ca 1910
Private collection, Switzerland

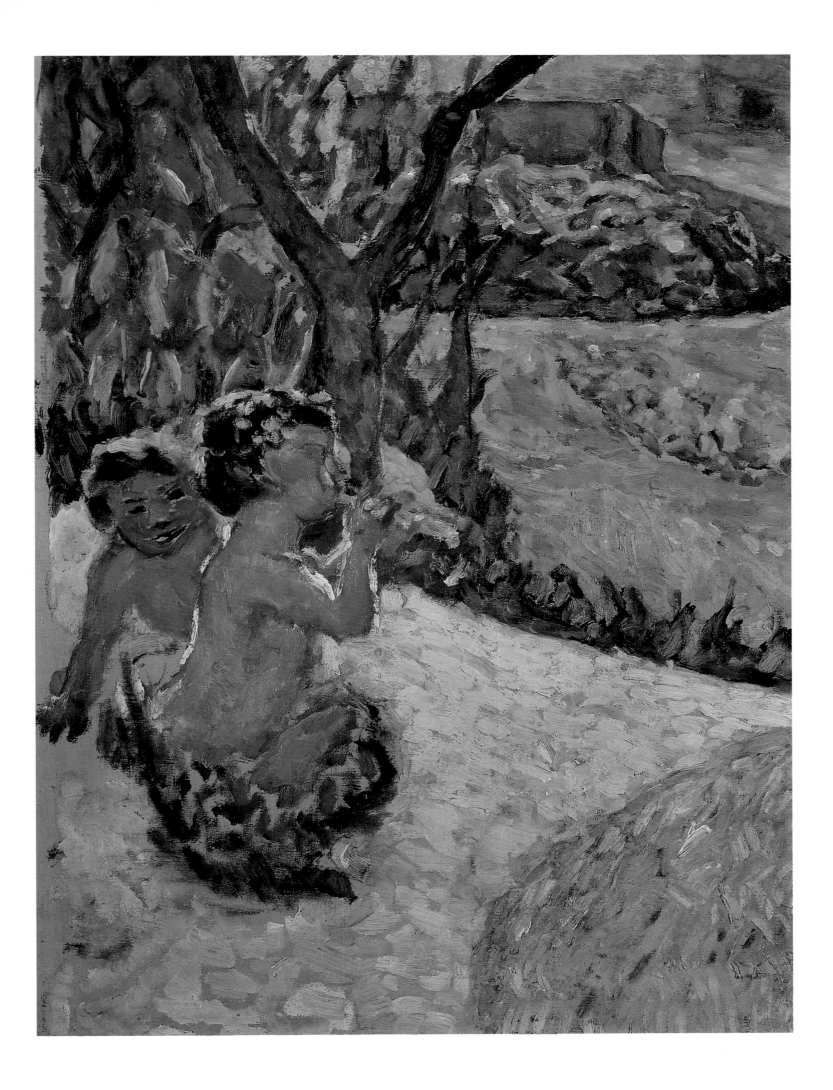

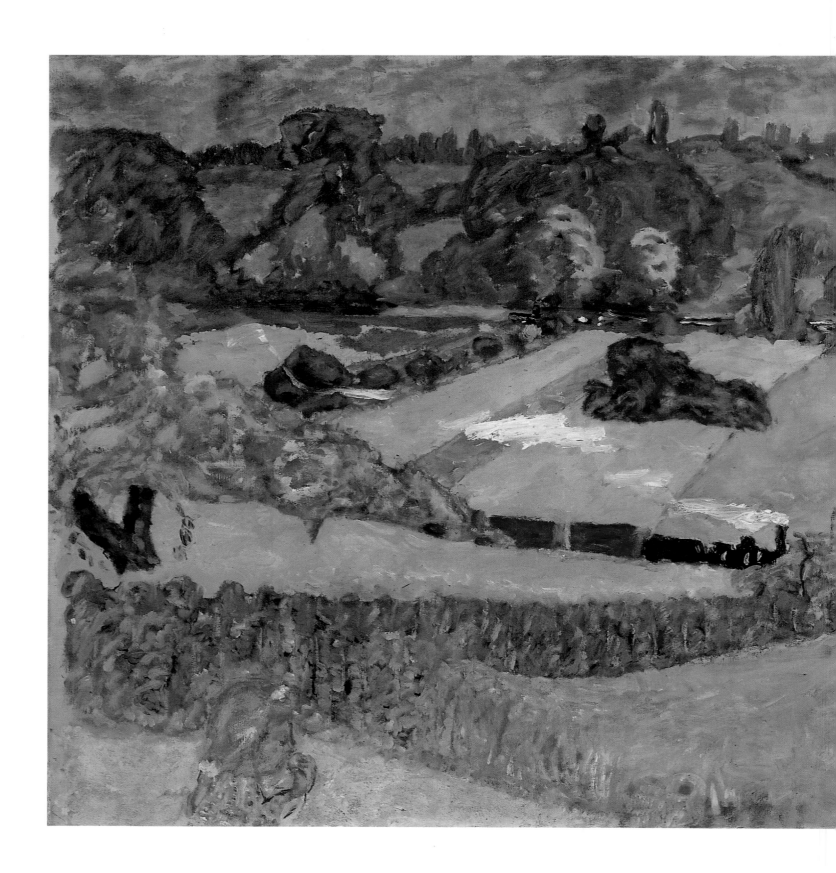

6
Train and Fishing Boats 1909
Le Train et les chalands
Oil on canvas. 77 x 108 cm
Signed, bottom right: *Bonnard*
Hermitage, St Petersburg. Inv. no. 6537

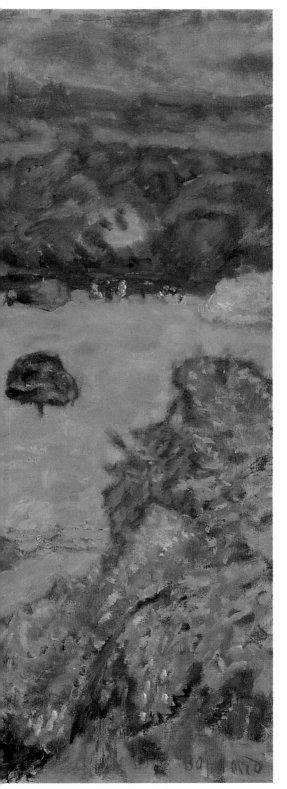

Under the title *Train and Fishing Boats* this picture was first exhibited at Bonnard's one-man show at the Bernheim-Jeune Gallery in 1910. However, Ivan Morozov, who purchased it from the exhibition, entered it in his manuscript catalogue as *Landscape with a Goods Train*, the title by which this painting has traditionally been known in Russia. When talking to Ivan Morozov, a representative of the Bernheim-Jeune Gallery gave the year it was painted as 1909. This date is to be found on the bar of the subframe. The painting depicts the countryside near Vernouillet, a small town on the Seine not far from Paris which is remarkable for its 18th-century church, a superb example of Roman architecture. Bonnard, however, ignored the local sights (he stayed there in the spring of 1907, 1909 and later). What appealed to him was the scenery lying outside the town. The motifs of the Vernouillet countryside are usually associated with springtime, e.g. *Early Spring* (1908, Phillips Collection, Washington) and a further development of the same theme, *Early Spring. Little Fauns* (1909, Hermitage, see no. 5). These two paintings are the most important Vernouillet landscapes. *Train and Fishing Boats* is probably the third depicting as it does late spring. Bonnard often links the theme of spring with images of children. This painting has a little girl in the bottom left-hand corner. She is deliberately out of focus: the figure becomes noticeable only if the painting is studied closely, but this detail strikes a significant note in the mood of the picture, adding to its air of ease. By placing the girl in the foreground the artist seems to have been waiting for the train to appear from behind the hill, in order to obtain an effect which is both humorous and deliberate, determined by the inherent structure of the composition, with the objects – the train, fishing boats and girl – all moving in the same direction prompting a comparison.

During the Bonnard exhibition at the Bernheim-Jeune Gallery in March 1910, this picture was noticed by Guillaume Apollinaire, who wrote: "Among the landscapes, there are some works that are powerful and devoid of brutality, such as *Le Train et les chalands*, whose effect is at once very strong and very light".

Provenance:
1909 Bernheim-Jeune Gallery, Paris (acquired from the artist); 1910 I. Morozov Collection (purchased for 3,500 francs); 1918 Second Museum of New Western Painting, Moscow; 1923 Museum of New Western Art, Moscow; 1930 Hermitage

Exhibitions:
1910 Paris, no. 18; 1955 Moscow, p. 21; 1956 Leningrad, p. 8; 1965 Bordeaux, no. 74; 1965–66 Paris, no. 74; 1969 Budapest, no. 20; 1971 Tokyo–Kyoto, no. 65; 1975 Saint-Paul, no. 79; 1978 Paris, no. 1; 1984 Tokyo–Nara, no. 20; 1987 Lugano, no. 27

Bibliography:
Makovsky 1912, p. 19; A. Salmon, *L'Art vivant*, Paris, 1920, p. 39; Coquiot 1922, p. 44; L. Werth, *Quelques peintres*, Paris, 1923, pp. 109, 110; *Catalogue* 1928, no. 23; Réau 1929, no. 707; Sterling 1957, p. 158; *Catalogue* 1958, vol. I, p. 360; G. Apollinaire, *Chroniques d'art (1902–1918)*, Paris, 1960, p. 70; Descargues 1961, p. 300; Dauberville 1968, no. 539; *French 20th-century Masters* 1970, no. 8; Izerghina, Barskaya 1975, no. 99; *Catalogue* 1976, p. 239; Kostenevich 1984, pp. 208, 209, 213

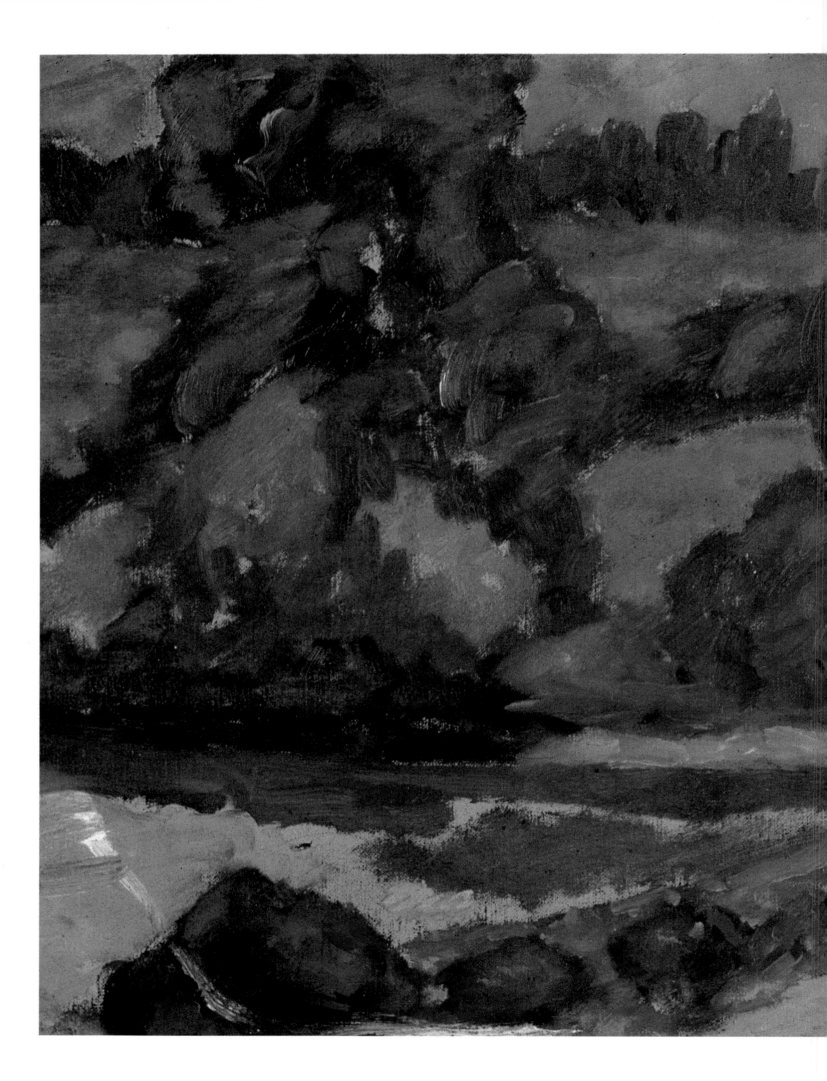

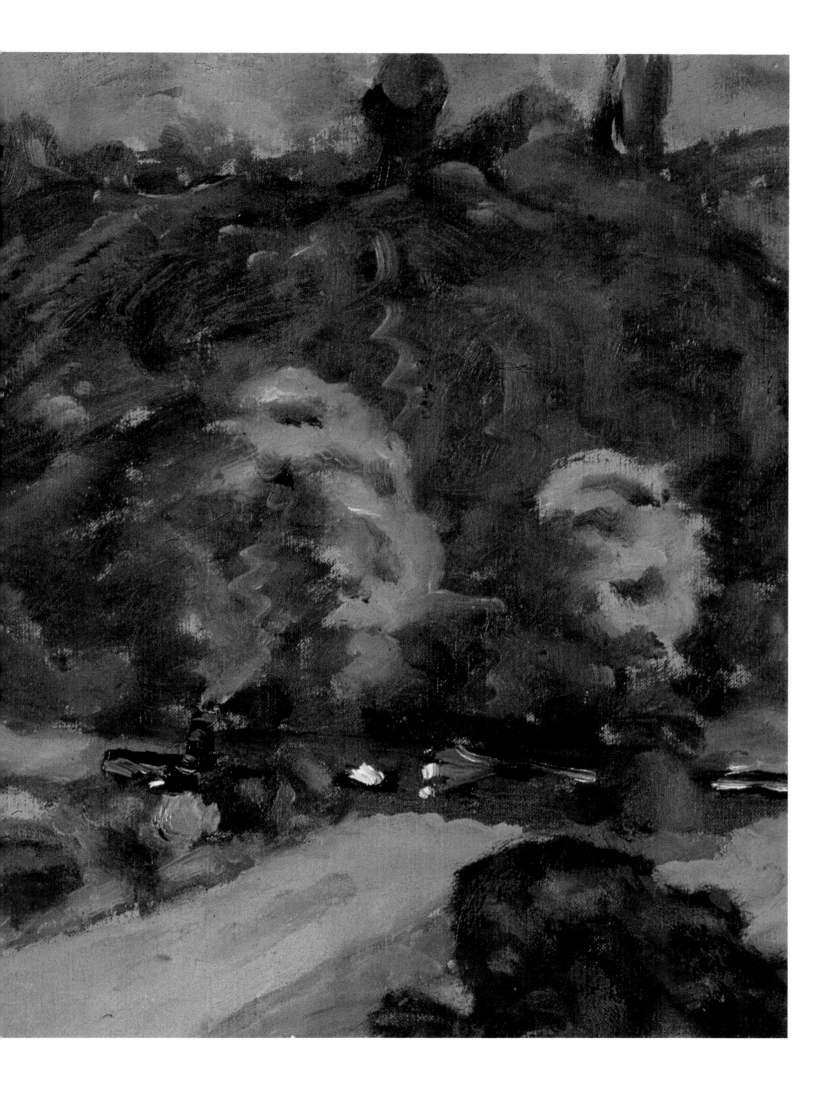

7
The Seine near Vernon. Ca 1911
La Seine près de Vernon
Oil on canvas (relined). 41.5 x 52 cm
Signed, bottom right: *Bonnard*
Hermitage, St Petersburg. Inv. no. 8700

PIERRE BONNARD
The Clouds or
The Seine near Vernonnet. 1910
Paul Vallotton Gallery, Lausanne

The catalogue raisonné of Bonnard's painting compiled by Jean and Henri Dauberville dates the picture to about 1906. The compilers make no mention of any other work in the same vein dating from that period. Yet it seems natural to include the Hermitage landscape with a group of later paintings united by a common compositional arrangement. Anna Barskaya linked the picture with the views of the Seine painted in 1910 and 1911 (D 619, 650, 658, 659). The artist discovered these views in the vicinity of "Ma Roulotte", a small villa he rented in 1910 and 1911 and bought the following year. It was located in Vernonnet, a village near both Vernon and Giverny. It would seem more accurate to date the Hermitage picture to 1911, by analogy with *The Seine in Vernon* (Hahnloser Collection, Bern; D 658) and, particularly, with *View of the Seine in May* (D 659). All three depict the same scenery, while the Hermitage picture is the same size as *Veiw of the Seine in May*. Bonnard would turn to this subject matter more than once in the years to come: in 1912 (D 732, 735), in 1914 (D 795), in 1915 (D 834, 843, 844), in 1917 (D 899), in 1918 and 1919 (D 940). Barskaya suggested that *View of the Seine* shown at the "A Hundred Years of French Painting" exhibition in St Petersburg in 1912, was in fact *The Seine near Vernon*. This hypothesis cannot be refuted any more than it can be proved. The dimensions of the picture are not given in the catalogue of that exhibition. *View of the Seine* once belonged to Haasen. The greater part of his collection remained in Petrograd, but some pictures, including those displayed at the "A Hundred Years of French Painting" exhibition, disappeared from view. The owner might have taken them out of the country when he emigrated.

Provenance:
G. Haasen Collection, St Petersburg; I. Rybakov Collection, Leningrad; L. Rybakova Collection, Leningrad; 1941 Hermitage (gift of L. Rybakova)

Exhibitions:
1956 Leningrad, p. 8; 1968 Yerevan (no catalogue); 1981 Mexico City, no. 1

Bibliography:
Catalogue 1958, vol. 1, p. 362; Dauberville 1968, no. 419; Izerghina, Barskaya 1975, no. 100; Catalogue 1976, p. 240

PIERRE BONNARD
Vernon. 1910–11. Drawing

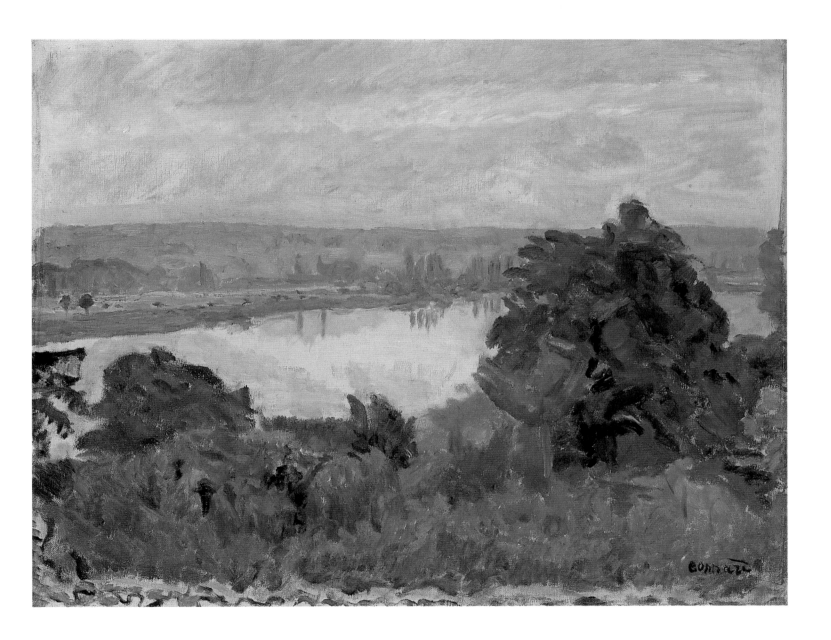

8
The Seine at Vernonnet. Ca 1910
La Seine à Vernonnet
Oil on canvas. 51 x 60.5 cm
Signed, bottom right: *Bonnard*
Pushkin Museum of Fine Arts, Moscow. Inv. no. 3357

PIERRE BONNARD
Spring Landscape. 1910
Private collection

This painting is also known as *The Seine by Vernon*. Vernonnet is a town on the Seine downstream from Paris not far from Vernon, between Normandy and the Île-de-France. Bonnard began working there in 1910, when he produced *The Clouds* or *The Seine near Vernonnet* (Paul Vallotton Gallery, Lausanne; D 619) and *Spring Landscape* (D 626). In the latter we can recognize the high river-bank featured in the Moscow painting.
The Daubervilles dated *The Seine at Vernonnet* to 1910–11; the Bernheim-Jeune label on the back seems to indicate more precisely 1911, the dating accepted in the Pushkin Museum. We know that in 1911 Bonnard worked at Vernonnet in May and June, while in 1910 he was there in March. This fact would tend to tip the balance in favour of the earlier date since the view is clearly one of early, rather than late spring. The date on the label may have been a mistake since it was only attached to the painting when it entered the gallery, which was apparently in 1912.
Vernonnet has no natural or man-made sights to distinguish it, but Bonnard was very fond of the place and for the following year he acquired a small estate called "Ma Roulotte" there. In the Moscow painting too, the landscape at Vernonnet appears fairly unprepossessing. The trees, which have still not turned green, almost merge with the sandy slopes, while the smooth greyish-blue sky blends with

the greyish-blue surface of the Seine. The only striking detail is the boat by the bank, providing a slight contrast of colour without which this very subtly painted work would become monotonous.
The artist turned fairly late to views of the Seine, which is surprising if we recall his strong ties to Impressionism – after all, working on the Seine was an important element in the development of the Impressionists' art. Probably one of the earliest paintings featuring the Seine is *Regatta* (ca 1896; D 142), followed a few years later by *Bridge in Paris* (Brody Collection, Los Angeles; D 289). But in both cases the river only provides a background for the scene depicted.
In short, while Bonnard lived in Paris he was far more attracted to the streets and squares of the city, and it was only when he settled first in Vernouillet, then in Vernonnet, that he really discovered the attractions of the Seine.

Provenance:
1911 or 1912 Bernheim-Jeune Gallery, Paris; 1913 I. Morozov Collection; 1918 Second Museum of New Western Painting, Moscow; 1923 Museum of New Western Art, Moscow; 1948 Pushkin Museum of Fine Arts

Exhibitions:
1939 Moscow, p. 52; 1976 Dresden, no. 25; 1976 Prague, no. 1; 1981 Mexico City, no. 2

Bibliography:
G. Coquiot, *Bonnard*, Paris, 1922, p. 44; Catalogue 1928, no. 25; Réau 1929, no. 708; *Catalogue* 1961, p. 21; Dauberville 1968, no. 639; Georgievskaya, Kuznetsova 1979, no. 216; Barskaya, Bessonova 1985, no. 216; *Catalogue* 1986, p. 30

PIERRE BONNARD
The Seine at Vernonnet
Private collection

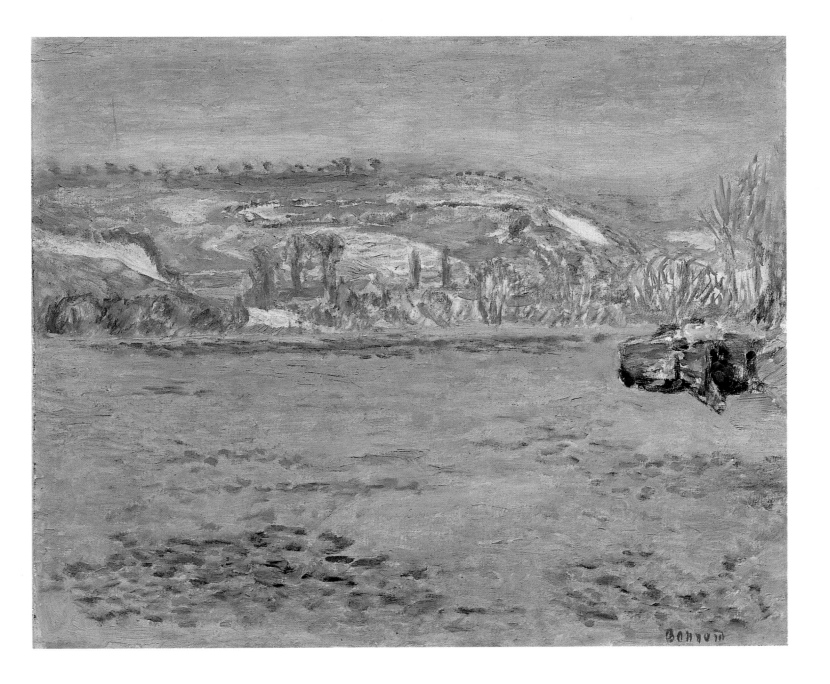

9
Morning in Paris. 1911
Le Matin à Paris
Oil on canvas. 76.5 x 122 cm
Signed, bottom left: *Bonnard*
Hermitage, St Petersburg. Inv. no. 9107
Companion piece to no. 10

The theme of Paris streets, introduced by the Impressionists, had been interpreted in a wide range of ways by the early 20th century: from the fleeting glimpses found in the works of the older Impressionists – Monet, Renoir and Pissarro, to the dry but amusing genre scenes of Forain. Among Bonnard's predecessors as a painter of Parisian scenes in general and these two companion canvases in particular, we can single out Gustave Caillebotte, who produced a monumental work *A Paris Street in the Rain* (1877, Art Institute of Chicago), and Jules Adler with his picture *The Tired Ones* (1897, Musée Calvet, Avignon), which attracted attention of the Salon exhibitions in the late 1890s. In *Street in Paris* Caillebotte, who had exhibited with the Impressionists, was preoccupied with dynamic possibilitles of perspective and the precise rendition of detail. This let him to depart from the fleeting impression and, in essence, to overstep the bounds of Impressionism. Adler was still further

JULES ADLER
The Tired Ones. 1897
Musée Calvet, Avignon

PIERRE BONNARD
Place Clichy or *The Green Tram*. 1906
Nathan Collection, Zurich

removed from that movement, as his paintings were socially committed and almost photo-realistic. While using compositional devices similar to those employed by these two artists, Bonnard, nonetheless, entered into a dispute with them, since he insisted on adherence to pictorial, even decorative, qualities. The other Nabis were moving in the same direction, especially Vallotton, whose *Street in Paris* (1895, Metropolitan Museum of Art, New York) features motifs close to *Morning in Paris*.

In January 1910, Bonnard was commissioned by Ivan Morozov, through the Bernheim-Jeune Gallery, to paint "two pictures based on Paris life", 2,500 francs apiece, the painter having the freedom to choose the subjects (the receipt from the Bernheim-Jeune company representative is in the archives of the Pushkin Museum of Fine Arts, Moscow). The two pictures were entered by Morozov in his handwritten catalogue as *Morning* and *Evening*. They were painted in 1911 and sent to Moscow the following year.

The two-piece set depicts a district which the artist repeatedly painted between 1893 and 1912. It was here, in the neighbourhood of the Boulevard de Clichy and the Boulevard des Batignolles, that his studio was located (in 1893, he rented a small studio at no. 65 Rue de Douai, and moved to no. 60 in 1907). The subjects of the pair go back as far as the earliest pieces produced in the studio in the Rue de Douai, *On the Boulevard* (1893; D 49) and *People in the Street* (ca 1894; D 52).

In 1899, Vollard published a 12-piece series of colour lithographs by Bonnard *Some Aspects of Paris Life*, which also played a role in establishing the genre and iconographic features of the future Moscow

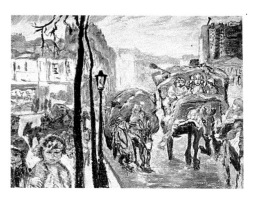

works. *A Street Corner*, one of this series, undoubtedly contains motifs that were later to appear in *Morning in Paris*: children, women, a small dog and a cart. From that time onwards, motifs seen in the Hermitage composition repeatedly cropped up in other pictures. For instance, *Place Clichy* (1895; D 90) features young women coming towards the viewer who are again placed in the bottom left-hand corner. A still greater similarity can be found in *Place Clichy* or *The Green Tram* (1906, Nathan Collection, Zurich; D 690) which has girls and a pedlar carrying his tray in the foreground, and dogs and children in the centre.

A fragment of the *Morning in Paris* background can readily be recognized in another 1911 painting, *Fog on the Boulevard des Batignolles* (D 638). This crossroads had already featured twice in Bonnard's art: in 1909, when he painted *The Cart* or *Rag-Pickers* (Barnes Foundation, Marion; D 555), and early the following year, in *Rag-Pickers* (Salz Collection, New York; D 640). The townscape in the background of the small-size painting *The Cart* is exactly the same as that of the Hermitage picture. In the foreground there is a rag-and-bone man pulling a heavily loaded cart. When the artist returned to this subject in *Rag-Pickers*, he re-arranged the composition of the foreground, placing the half-length oncoming figures of women at the bottom left and filling up the middle with the donkey pulling a coal-merchant's cart, a motif which was to recur, with a few alterations, in *Morning in Paris*, signifying that the scene took place early in the morning, when merchants used to deliver coal to their customers. However, the subject of the picture – the rag-pickers returning from the Central Market – was never subsequently repeated. Rejecting that kind of subject-matter, Bonnard confined his efforts to creating an accumulation of the signs of morning or, in the case of the twin composition, of evening, uniting them through the atmosphere of Montmartre at dawn and dusk. In order to make the theme clear and

PIERRE BONNARD
Rag-Pickers or *Returning from the Central Market*. 1910
Salz Collection, New York

Bonnard

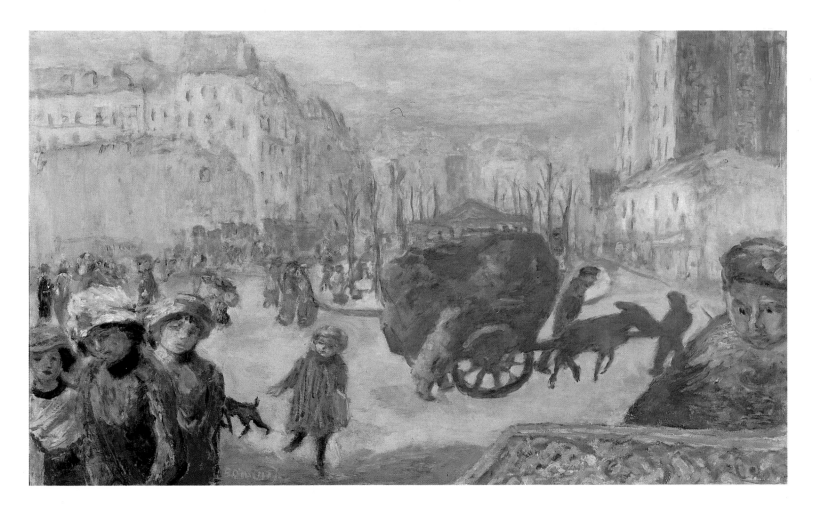

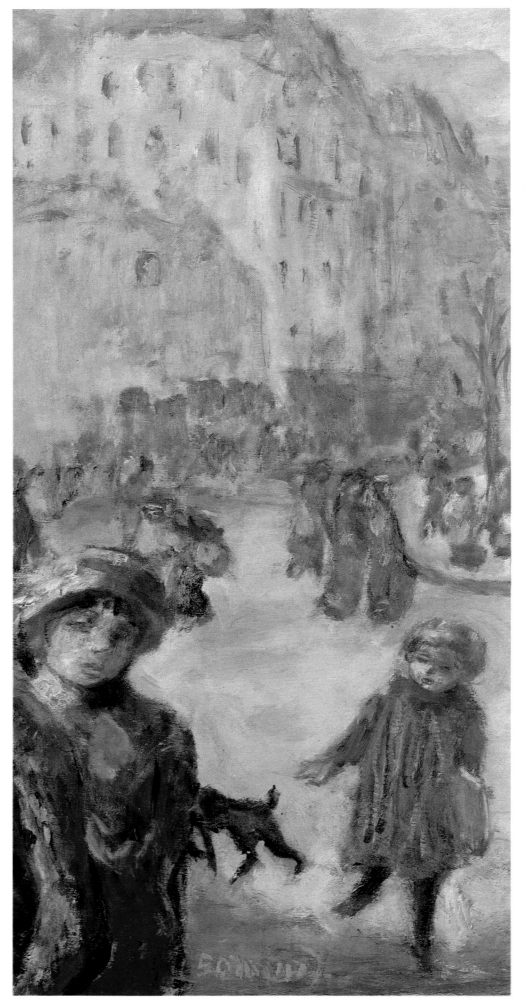

Bonnard's niece Renée
with a dog. 1898. Photograph

recognizable, the artist reduces the major details to readily understandable silhouettes. The pedlar-woman with her merchandise and the group of girls at the sides, the cart and the small boy are outlined in such a manner that each and every one of them indicates early morning. The last detail – the small schoolboy wrapped up in a huge muffler and carrying a large book – brings to mind what Charles Terrasse, the artist's nephew, wrote in his book on Bonnard: "I am fond of strolling along the streets of Montmartre, where I find my childhood; and there I find Bonnard again. The one and the other are mixed up in my recollections... the Rue de Douai, Rue Pigalle, Boulevard de Clichy. Most of all I enjoy walking along them in the morning. I can see myself again, well wrapped-up, setting out for the eight-o'clock class at the local lycée, in the fog, through the grey cottonwool of Paris in winter..." (Ch. Terrasse, *Bonnard*, Paris, 1927, pp. 69–70).

Provenance:
1912 I. Morozov Collection; 1918 Second Museum of New Western Painting, Moscow; 1923 Museum of New Western Art, Moscow; 1948 Hermitage

Exhibitions:
1912 Paris (not included in catalogue); 1967 Paris (not included in catalogue); 1975 Saint-Paul, no. 80; 1979 Tokyo–Kyoto–Kamakura, no. 26; 1984–85 Zurich–Frankfurt am Main, no. 67; 1993 Essen, no. 74; 1993–94 Moscow–St Petersburg, no. 74

Bibliography:
Catalogue 1928, no. 27; Réau 1929, no. 711; Sterling 1957, p. 154; *Catalogue* 1958, vol. I, p. 362; Dauberville 1968, no. 641; *French 20th-century Masters* 1970, no. 10; Kalitina 1972, p. 118; Yavorskaya 1972, pp. 68, 71; Izerghina, Barskaya 1975, no. 104; *Catalogue* 1976, p. 240; Kostenevich 1984, pp. 207, 211, 213; Kostenevich 1987, no. 123; Kostenevich 1989, nos 133, 134

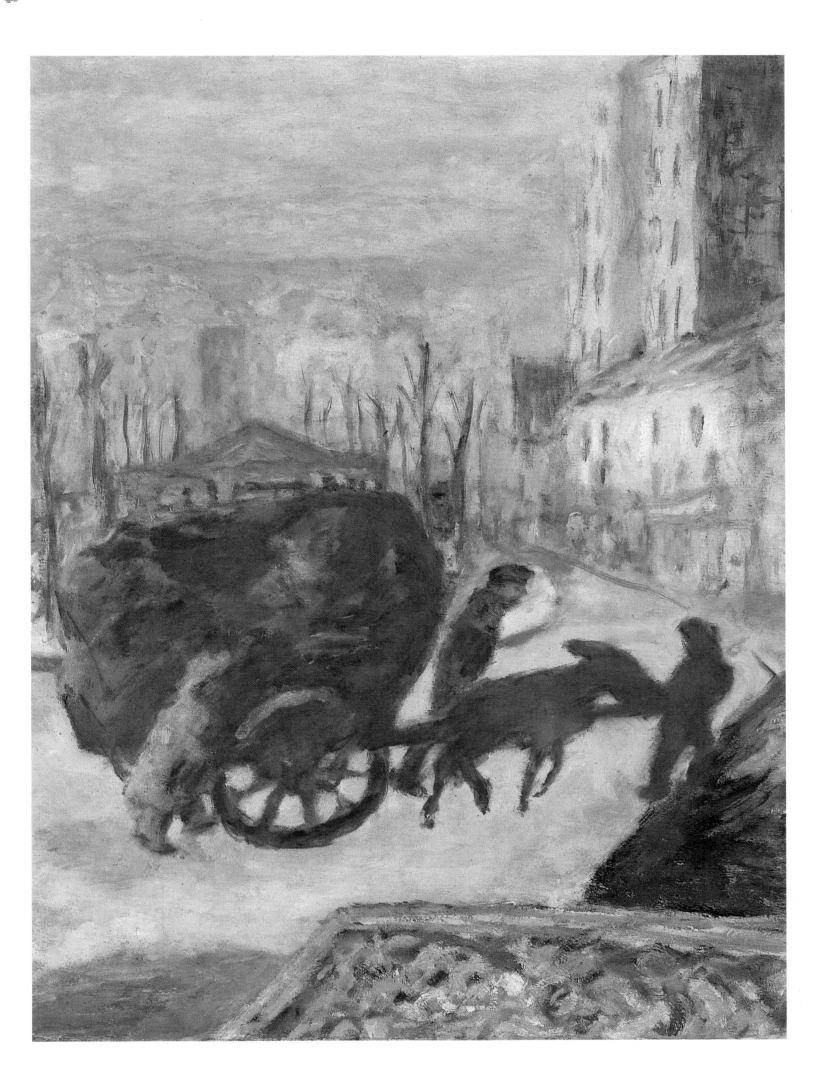

Bonnard

10
Evening in Paris. 1911
Le Soir à Paris

Oil on canvas. 76 × 121 cm
Signed, bottom right: *Bonnard*
Hermitage, St Petersburg. Inv. no. 9105
Companion piece to no. 9

Part of a set, rather than a diptych, *Evening in Paris*, like *Morning in Paris*, is a painting in its own right. Indeed the pair have at times been exhibited separately. But, it is only when they are placed alongside each other that they display their merits to the full.

Although *Evening* lacks the spatial depth of *Morning* and shows quite another scene, there is little doubt that it was conceived as a companion piece, something which is borne out, above all, by the similar arrangement of details in the foreground. The counterpart of the elderly pedlar on the right-hand side of *Morning* is the old flower-seller in *Evening*, and the oncoming girls are matched here by the figures of children. Another thing that unites the two canvases is the movement across the surface of each. The idea of painting two pictures instead of one, showing aspects of daily life in the Paris streets and linked by the traditional concept of the changing times of the day, was not coincidental. It was rooted in Bonnard's previous work and was suggested by his place of residence. The Rue de Douai leads almost to the Place Clichy, where the Boulevard de Clichy and the Boulevard des Batignolles meet. Even in Bonnard's day this was a very busy junction. During the late 1890s and early 1900s, Bonnard took a keen interest in depicting the bustle of the streets, constant movement that varied depending on whether it was morning, afternoon or night. He remained attached to the idea

of a many-piece series, which could render more impressions than a single canvas. In 1896 and 1900, he painted two triptychs depicting the Place Clichy (D 136, 237). The first is known as *The Ages of Life*. It gave him an opportunity to compare the different stages of a man's lifespan. This approach was retained in the Morozov set, with each picture portraying personages of three ages.

A group of paintings from 1895 can be regarded as the starting point for *Evening in Paris*. They include a small-scale canvas *Fiacre* or *The Boulevard des Batignolles*, now in the National Gallery, Washington (D 92 bis, with a tentative comment that it might depict the Boulevard de Clichy rather than the Boulevard des Batignolles), which has a background bearing a strong resemblance to that of the Hermitage picture, and also three lithographs from the *Some Aspects of the Paris Life* series (*Boulevard*, *Square in the Evening*, *Evening Street in the Rain*). These lithographs, and hence *Evening in Paris* too, contain reminders that Bonnard as the "Nipponized Nabi" drew inspiration from Japanese sources: the frieze-like composition is akin to Kiyonaga's techniques, while the evening street itself resembles Hiroshige's colour woodcut *Saruwaka Quarter at Night* from *A Hundred Famous Views of Edo* (1856) or the tenth sheet of his series *69 Views of Kisokaido* (1837–42).

Especially important among Bonnard's earlier works which paved the way

for *Evening in Paris* is *Flower-Seller* (ca 1905; D 322), depicting an old woman with a cart of flowers and two girls on the right.

Provenance:
1912 I. Morozov Collection; 1918 Second Museum of New Western Painting, Moscow; 1923 Museum of New Western Art, Moscow; 1948 Hermitage

Exhibitions:
1912 Paris (not included in catalogue); 1967 Paris (not included in catalogue); 1975 Saint-Paul, no. 81; 1984–85 Zurich–Frankfurt am Main, no. 68; 1985–86 Tokyo–Hiroshima–Kobe, no. 43; 1993 Essen, no. 75; 1993–94 Moscow–St Petersburg, no. 75

Bibliography:
Catalogue 1928, no. 28; Réau 1929, no. 712; Sterling 1957, p. 154; *Catalogue* 1958, vol. I, p. 362; Dauberville 1968, no. 641; *French 20th-century Masters* 1970, no. 11; Yavorskaya 1972, pp. 68, 71; Izerghina, Barskaya 1975, no. 105; *Catalogue* 1976, p. 240; Kostenevich 1984, pp. 207, 211, 213; Kostenevich 1987, nos 124, 125; Kostenevich 1989, nos 135, 136

PIERRE BONNARD
Flower-Seller. Ca 1905
Private collection

PIERRE BONNARD
Street. 1889
Milliner Collection, Paris

PIERRE BONNARD
Place Clichy. 1912
Musée des Beaux-Arts et d'Archéologie, Besançon

PIERRE BONNARD
The Ages of Life. Triptych. Ca 1896
Hessel Collection, Switzerland

Bonnard

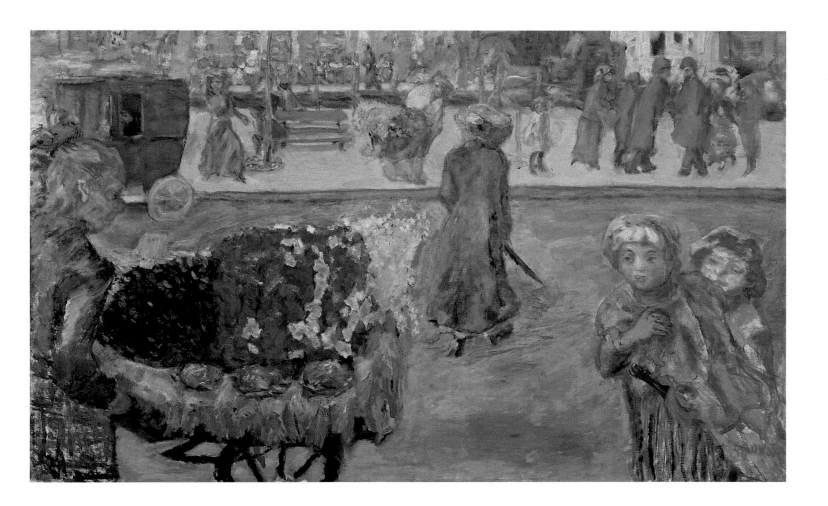

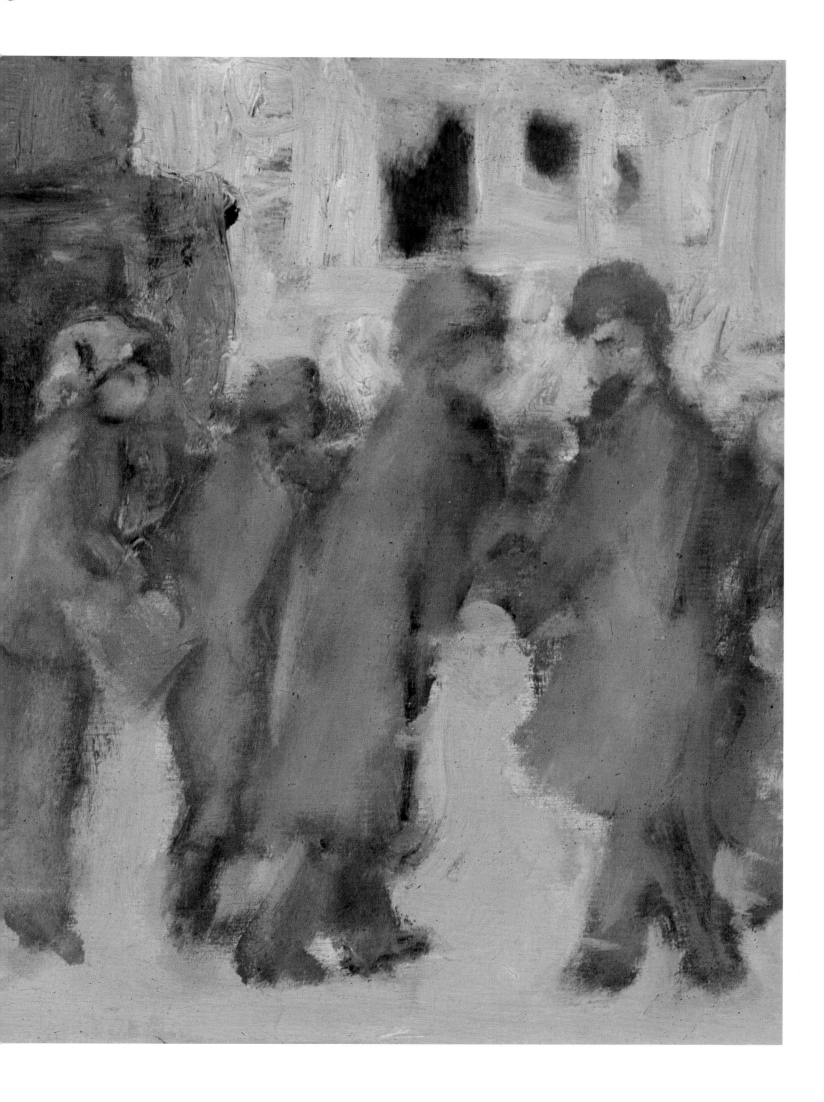

11–13
Mediterranean. Triptych. 1911
Méditerranée
Left-hand part. Oil on canvas (relined).
407 x 152 cm
Central part. Oil on canvas (relined).
407 x 152 cm
Right-hand part. Oil on canvas (relined).
407 x 149 cm
Signed and dated, bottom centre: *Bonnard 1911*
Hermitage, St Petersburg.
Inv. nos 9664, 9663, 9665

The triptych was commissioned by Ivan
Morozov through the Bernheim-Jeune
Gallery for 25,000 francs and intended
for the staircase of his house in
Prechistenka Street, Moscow (now
the premises of the Academy of Arts).
Morozov sent the artist a photograph
of the staircase and gave its dimensions.
The parts of the triptych were to be
divided by semi-columns, a fact Bonnard
bore in mind when planning the whole
composition. The triptych was exhibited
at the 1911 Salon d'Automne under
the title *Mediterranean. Panels between
Columns*. The next year Morozov commis-
sioned Bonnard to paint another two
large-scale panels to go with the triptych:
Early Spring in the Countryside and
Autumn. Fruit-Picking (see nos 14, 15).
The main subjects of the triptych can
be traced back to Bonnard's early period.
He was depicting women and children in
gardens as early as the 1890s: *The Champs-
Elysée* (ca 1894; D 59), *The Terrasse
Children Playing in the Garden* (ca 1899;
D 203), etc. One work worthy of special
mention is his polyptych *Women in
the Garden* (1890–91, Kunsthaus, Zurich;
D 01715). One of the four decorative

PIERRE BONNARD
The Palm. 1910
Private collection, Zurich

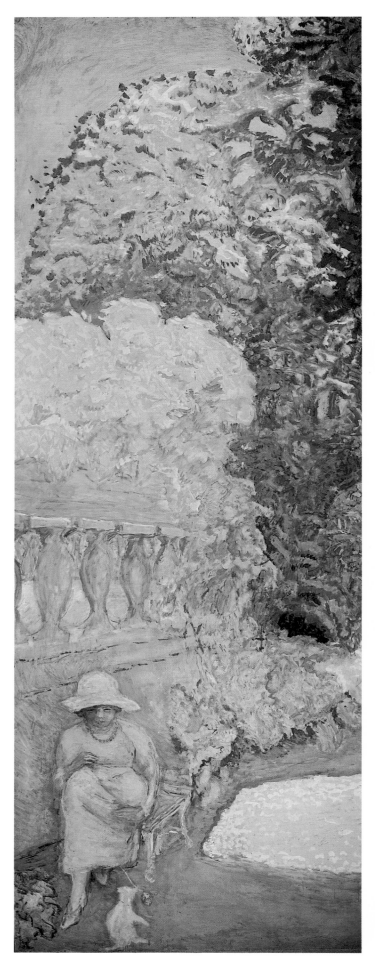

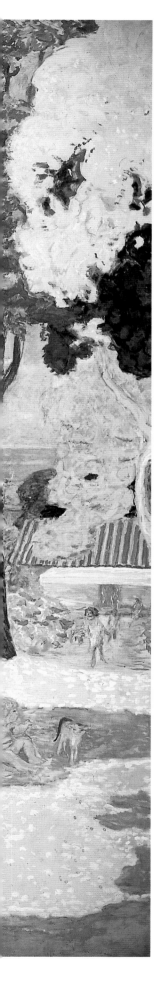

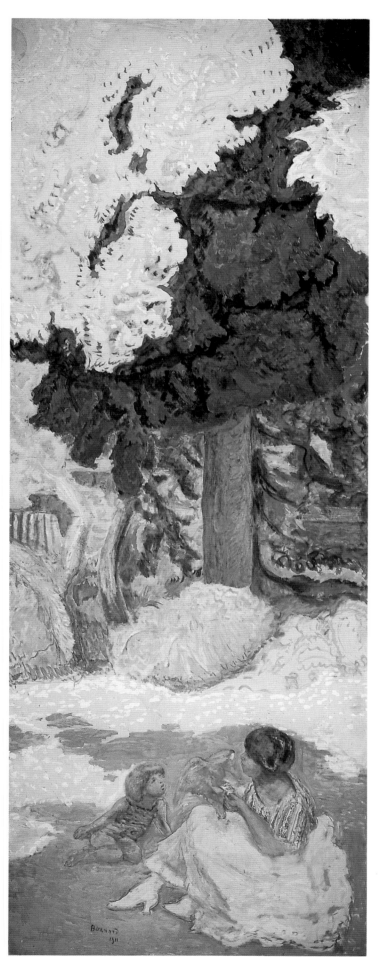

panels of this set, that of a woman with a cat, is the forerunner of the left-hand part of the Hermitage triptych, depicting a lady with a white cat.

The group of figures in the central part – children playing in a lively way – is typical of Bonnard, yet there are no direct counter-parts to the figures of the Hermitage triptych. By contrast, the woman with a parrot in the right-hand part is a rare type of character, which had previously occurred only once, in *Woman with a Parrot* (1910; D 605). Both that work and the present one seem to feature the same model, while the exotic bird, like the blue sea and the abundance of luxuriant vegetation, is intended as a reminder of the South.

Bonnard's early decorative works, such as *Women in the Garden* and even *The Terrasse Family in the Garden* (1896, Nationalgalerie, Berlin), follow Japanese principles of compositional arrangement. Later on, when painting large-scale deco-rative panels for Misia Sert's dining-room (1906–10; D 432–435), he drew on the design of Baroque tapestries (hence, among other things, the magnificent borders) and theatre curtains.

Bonnard would turn his mind to the art of old French and Flemish tapestry-makers and their treatment of the luxuriant tree-tops when he set to work on the Morozov triptych, but he never yielded to the temptation of stylization. The panels for Misia Sert are splendidly painted, but confused in content. In a compact space we find images from the Ancient World

PIERRE BONNARD
View of Saint-Tropez. 1909
Hahnloser Collection, Bern

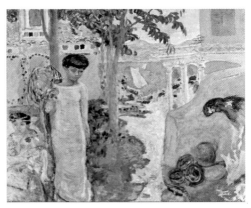

PIERRE BONNARD
Woman with a Parrot. 1910
Wildenstein Collection, New York

and contemporary life, from East and West. In this triptych Bonnard happily avoided the heterogeneity of subjects by using a simple and realistic motif. Bonnard found this motif in Saint-Tropez, where he stayed in June 1909 on a visit to Manguin at the Villa Demière. It was at that time that he painted *View of Saint-Tropez* (Hahnloser Collection, Bern; D 545), from which the central part of the triptych derives. The tree in the middle and the tiled roofs behind it were already depicted in this study; however, Bonnard altered the composition when he went on to paint the large-scale panel. *View of Saint-Tropez* looks somewhat cramped, while in the triptych the artist avoided this by changing the viewpoint and eliminating a number of details. The general tone also changed, taking on a light, ethereal quality. Bonnard is unlikely to have had *View of Saint-Tropez* before his eyes when he was working on the triptych, as it was sold to the Bernheims in 1910.

In September 1910, Bonnard re-visited Saint-Tropez, this time at the invitation of Paul Simon. In a letter to his mother he wrote that the South had struck him like a scene from the *Arabian Nights*. His impressions from this short trip

undoubtedly produced the triptych, which is set in autumn and not in spring. In the same letter he mentioned that during a visit to Simon's neighbours he saw a dark-haired girl with a large blue parrot; he went on to say that he had become aware of the shingle, the low walls, the olive trees and the oaks. Perhaps that is why the upper part of the right-hand panel is occupied by an oak-tree and the lower part – by a girl with a parrot, only the parrot is not blue, as it was in Bonnard's recollections and in his original depiction in *Woman with a Parrot*, but green; the change of colour was determined by the pictorial requirements of the composition.

There are a number of landscapes painted in Saint-Tropez in 1910 and in March 1911, when Bonnard visited it again. Among them only *The Palm* (1910; D 621) is close to *View of Saint-Tropez* and, consequently, to the central panel of the triptych.

The triptych was finished by May 1911. At any rate, it was shown at Bonnard's exhibition in the Bernheim-Jeune Gallery which opened on 17 May. After being displayed again at the Salon d'Automne, the triptych was sent to Moscow in November 1911. The canvases were pasted directly onto the walls between the columns on the first floor above the grand staircase, with their upper corners trimmed to fit the shape of the capitals on the columns.

In 1948, after the triptych was transferred to the Hermitage, the missing areas were restored, the canvases relined and placed on stretchers.

Provenance:

1911 I. Morozov Collection; 1918 Second Museum of New Western Painting, Moscow; 1923 Museum of New Western Art, Moscow; 1948 Hermitage

Exhibitions:

1911 Paris, no. 1; 1911 Paris, *Salon d'Automne*, nos 171–173; 1959 Leningrad, p. 10; 1974 Leningrad

(not included in catalogue); 1979 Paris, p. 524; 1981 Moscow, vol. 1, p. 307; 1994 St Petersburg (not included in catalogue)

Bibliography:

L'Art décoratif, 5 Nov., 1911 (reprod.); Makovsky 1912, p. 19; *Apollon*, 1916, no. 2 p. 25 (in Russian); Terrasse 1927, p. 118; *Catalogue* 1928, no. 26; Réau 1929, no. 710; G. Bazin, "Bonnard", in: *L'Amour de l'Art*, 1933, no. 4, p. 87; J. Rewald, *Pierre Bonnard*, New York, 1948, pp. 44, 136; Th. Natanson, *Le Bonnard que je propose*, Geneva, 1951, pp. 11, 236; Sterling 1957, p. 154; *Catalogue* 1958, vol. 1, p. 360; G. Apollinaire, *Chroniques d'Art (1902–1918)*, Paris, 1960, p. 201; A. Vaillant, *Bonnard*, London, 1966, p. 115; Dauberville 1968, no. 657; Terrasse 1967, p. 91; R. Negri, *Bonnard e Nabis*, Milan, 1970, p. 90; *French 20th-century Masters* 1970, no. 9; Izerghina, Barskaya 1975, nos 101–103; *Catalogue* 1976, pp. 239, 240; A. Kostenevich, *Bonnard*, Moscow, 1976, nos 15–17 (in Russian); Kostenevich 1987, nos 126–129; Kostenevich 1989, nos 130–132

Spring. Tapestry from *The Gardener's Children* series. After sketches by Charles Lebrain and de Sève the Younger. 1684–94
Hermitage, St Petersburg

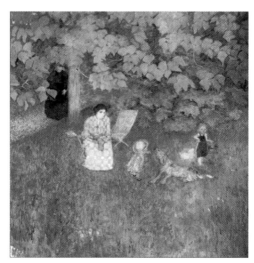

PIERRE BONNARD
The Terrasse Family in the Garden. 1896
Nationalgalerie, Berlin

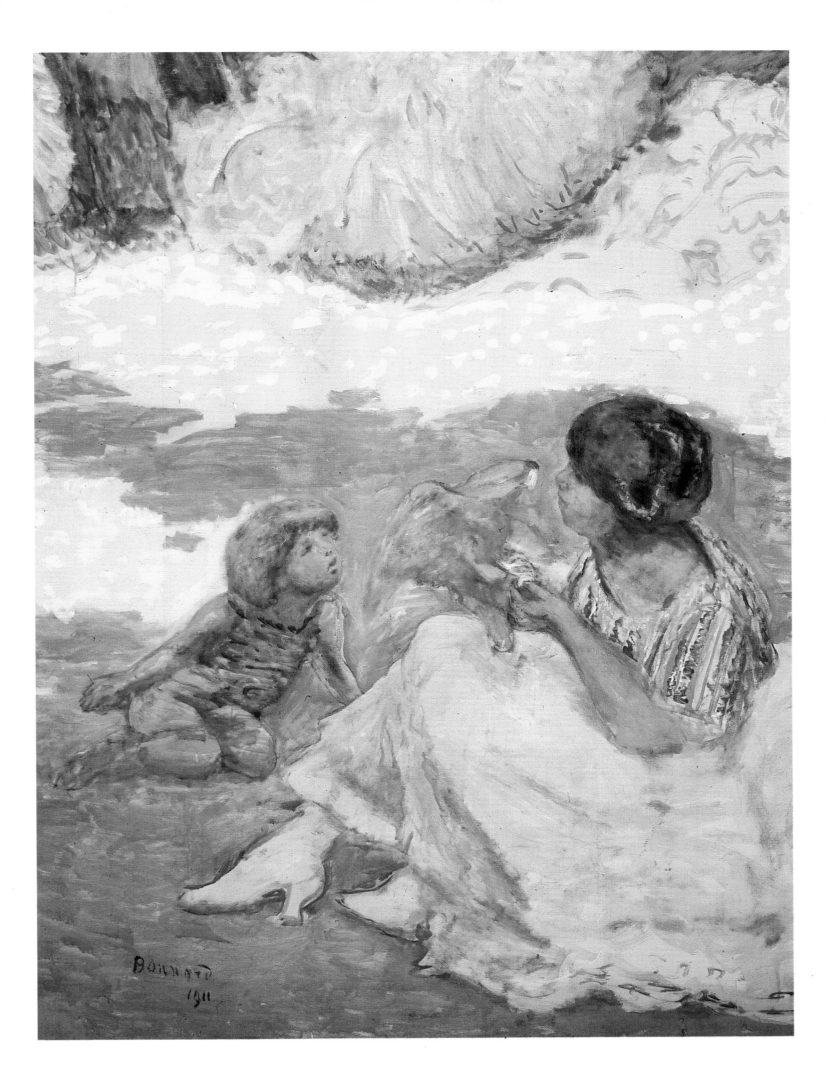

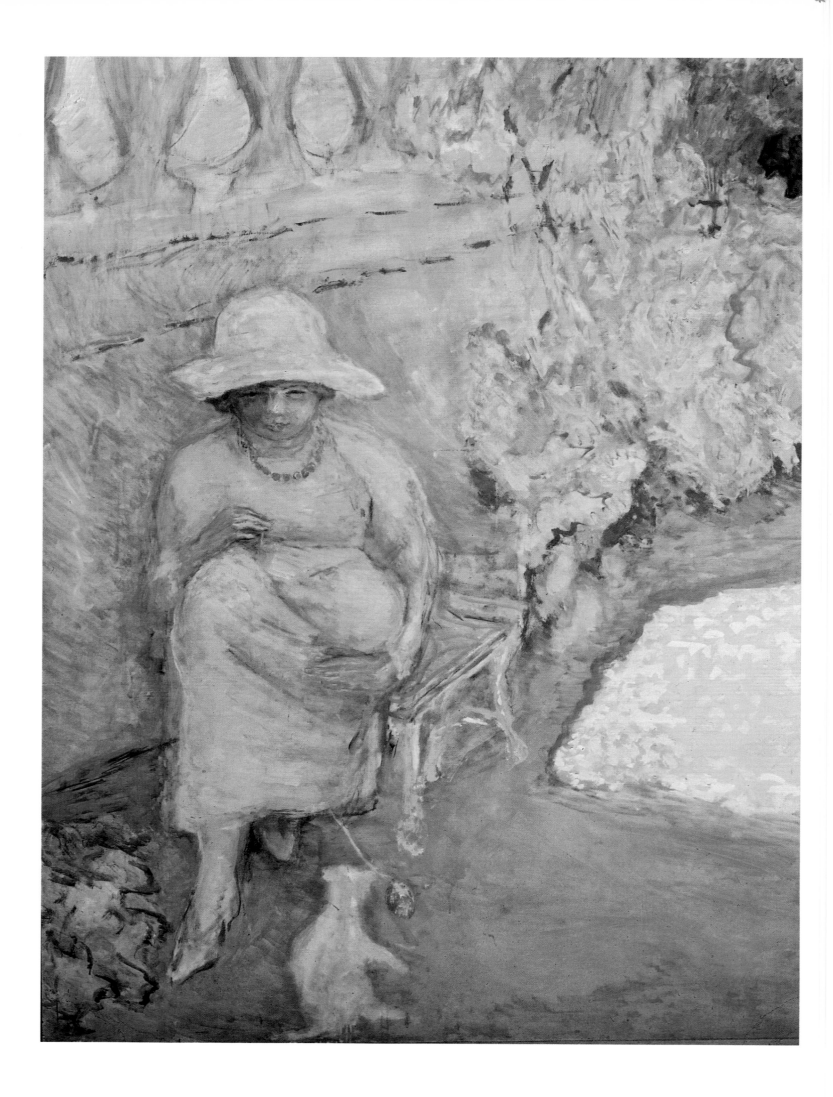

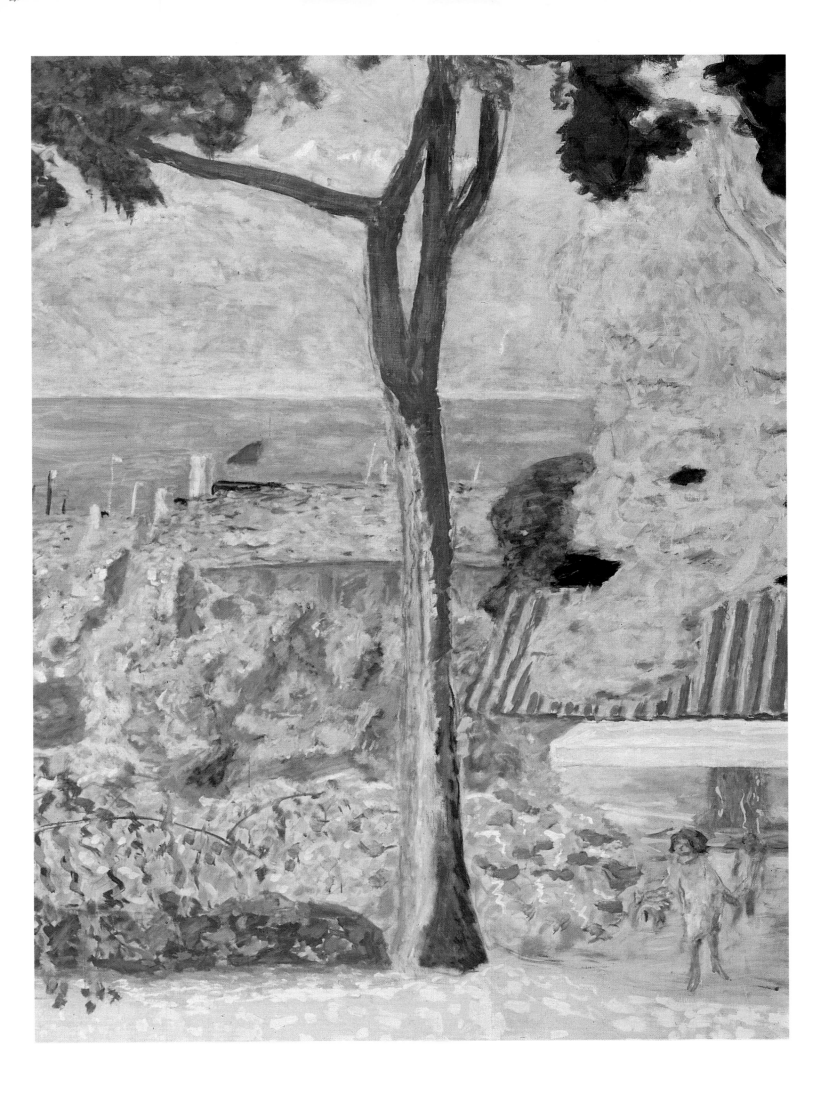

14
Early Spring in the Countryside. 1912
Premiers Jours de printemps à la campagne
Oil on canvas. 365 x 347 cm
Pushkin Museum of Fine Arts, Moscow. Inv. no. 3359
Companion piece to no. 15

When in 1912 Ivan Morozov commissioned from Bonnard two additional panels to go with *Mediterranean*, the artist, without deviating from the decorative-monumental chord he had already struck, produced works which both harmonize with the triptych and contrast with it. The main elements uniting the series were the extensive areas of colour formed by the crowns of trees treated in a generalizing manner. Yet, for all the similarity, one can sense that the trees in the new panels belong to a different, non-Mediterranean environment. Representing the North, in contrast to the South in the triptych, they turned out relatively dark, and when they were placed in the stairwell of Morozov's mansion, they appeared darker still.
Early Spring in the Countryside was on the left-hand side of the stairs. Visitors entering the house immediately noticed the radiant triptych, and only later turned their gaze to this "vernal" panel. Together with its autumnal pendant, this canvas was allocated a "supporting role", and for that reason, even if for no other, Bonnard certainly had no intention of creating works in exactly the same spirit as the triptych. The dramaturgy of the suite as a whole now became more complex, taking account of the different way its various parts would be perceived as a person climbed the stairs. One is inevitably prompted to make comparisons between this suite and the ensemble which Matisse produced, also without ever visiting Moscow, for Sergei Shchukin. There is justification for such comparisons since Shchukin commissioned *Music* and *The Dance* in response to *The Legend of Psyche* series which Denis created for Morozov. After the stir which Matisse's works aroused in Moscow, the ball was again in Morozov's court, and he chose Bonnard to play it for him. Matisse began with *The Dance* so that the movement of the dancing figures and the general energy of the composition would draw visitors upstairs. The second act was provided by *Music* with a majestic sense of calm. Bonnard could not be expected to come up with dynamics in the manner of Matisse, but the spectacle he "put on" in Morozov's mansion (without ever having been there) has in some ways a similar sort

PIERRE BONNARD
Spring. 1912. Sketch for the painting
Early Spring in the Countryside
Private collection, Paris

of logic to it. *Mediterranean* was also intended to lure people up to the first landing, although not as imperiously as Matisse's *Dance*, using the attractive power of light, the calm pale blue of the sea and the luxuriant southern trees. Once on the landing, the visitor would turn to the flanking panel and find himself transported spiritually to a world of a different kind, ruled by a different, northern light, where the very spatial environment seems to be "shifting". While *Mediterranean* is marked by strict proportionality, with the trunk of a tree in the central part which forms the axis of the triptych and the horizon which lies almost in the middle, in the flanking panels Bonnard followed the principle of old tapestries: he removed the line of the horizon above the edge of the canvas, heaving the surface of the Earth up towards the viewer, as it were, making it almost identical with the surface of the painting. This panel is woven from motifs deliberately shunned by "progressive" art at the beginning of the century – be it children's frolics, a love scene or a young woman's daydreams. Motifs of that kind were the stuff of cheap prints or, at the other extreme, of academic and salon compositions. Bonnard, however, had no qualms about using such material. He had no fear of hackneyed clichés, since an ironic intonation always came to his aid.

The work which we should in all probability consider the first attempt at developing a composition of this type is the triptych *The Public Garden* (ca 1897, present whereabouts unknown; D 148), which remained at the sketch stage, but already contained the "plot" of the work done for Morozov with the dense crowns of trees in the back ground, children playing and adults relaxing in the foreground. The impetus had clearly come from Vuillard, who had begun depicting parks with people relaxing in them considerably earlier. In particular, Bonnard was quite familiar with Vuillard's *Park* (1894, Jaffe Collection, New York) which then belonged to Thadée Natanson, and with his series of nine decorative panels, collectively known as *Public Gardens*, which were painted for Alexandre Natanson, also in 1894, and are now scattered among a number of private collections. Taking up the motif which Vuillard had worked many times, from the outset Bonnard treated it in a freer and more picturesque manner and, what is particularly striking, introduced more humour. With the painting *In the Garden at Grand-Lemps* (1898; D 180), by moving the location from Paris to his native Dauphiné, he took one more step towards the manner of painting which would eventually produce *Spring* and *Autumn* for Morozov. About that time, at Grand-Lemps, Bonnard took several photographs of his sister's children, of whom he was very fond. He liked to depict them in his works and often did so, indeed some of the photographs taken in 1897–99 were subsequently used when he was painting *Early Spring in the Countryside*. Most probably Bonnard had Grand-Lemps in his mind when he was creating his panel in Paris for the Moscow mansion. "The house at Grand-Lemps was brought to life by Claude Terrasse's children," Antoine Terrasse recollected. "Bonnard, who always came back there in summer, watched all their games, the hoop races, the donkey rides, petting the basset hound or the cats, bathing in the garden pool. He shared in all their joys, all their activities, catching their comic charms, their gestures, gracious and clumsy, and prolonged his amusement in the studio which his mother had organized for him on the

Bonnard

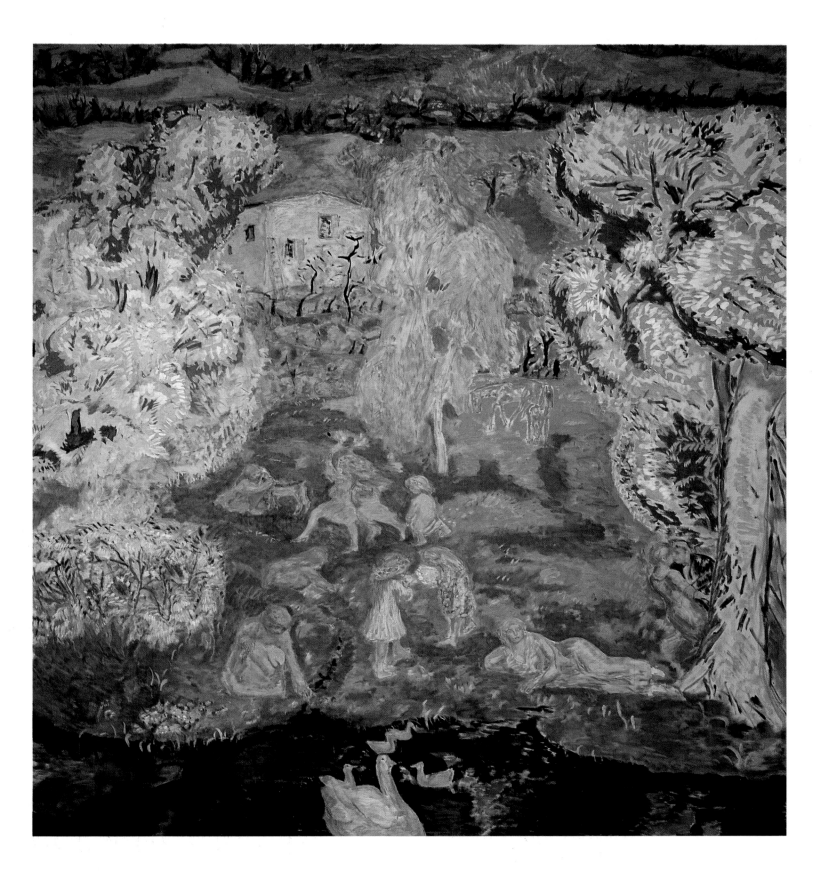

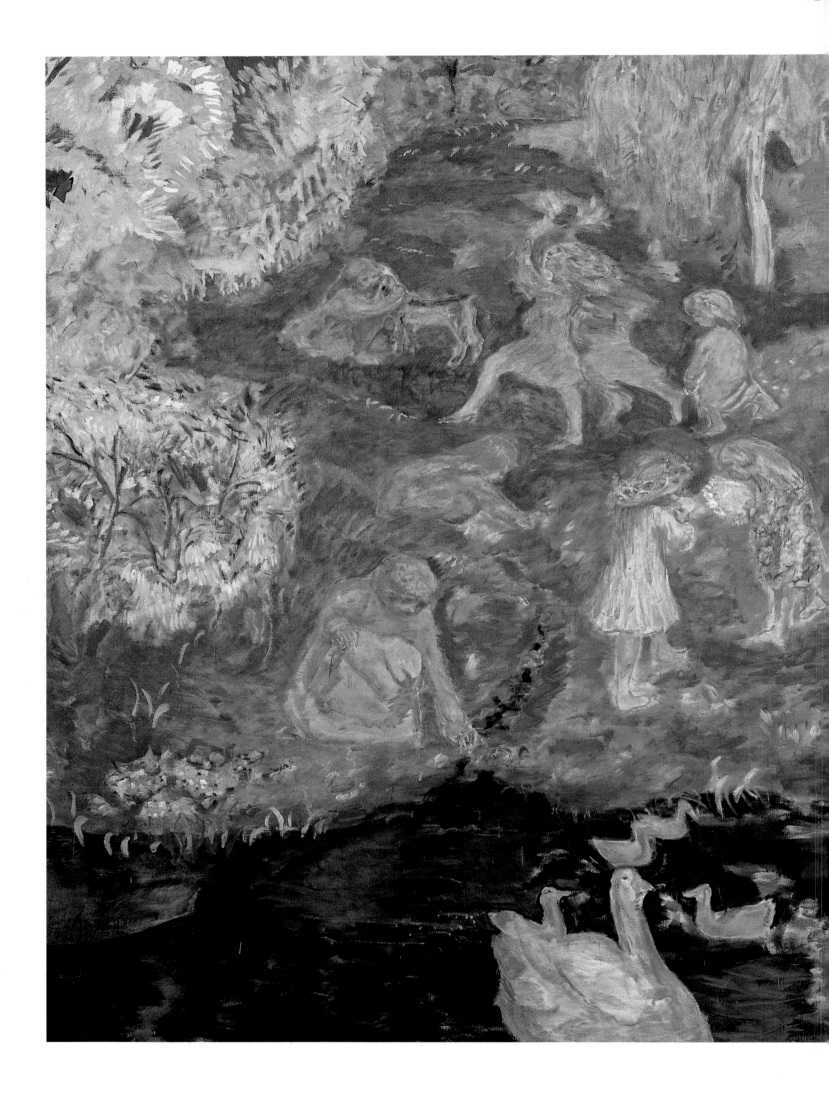

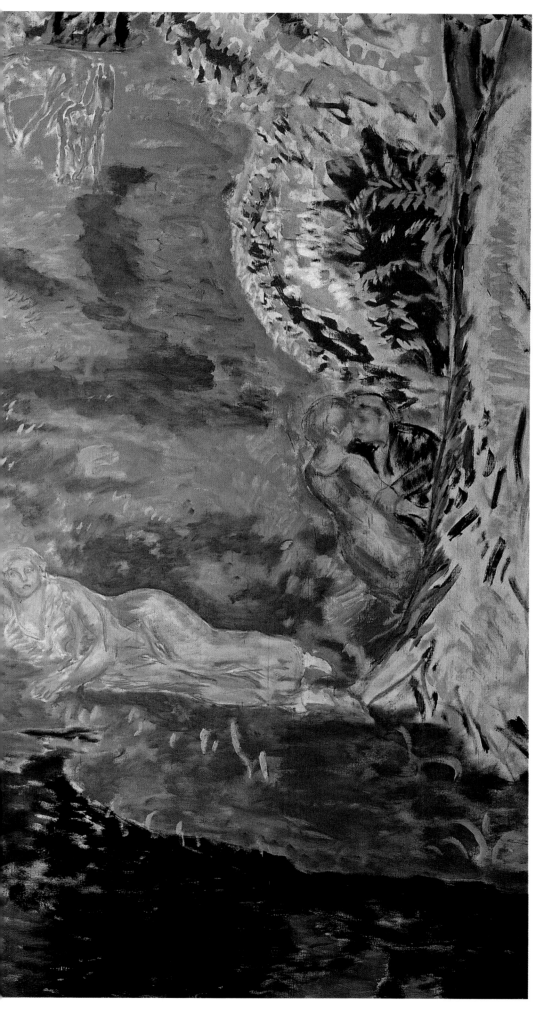

PIERRE BONNARD
Swan. 1904
Private collection,
Switzerland

second floor of the house." (A. Terrasse, *Pierre Bonnard*, Paris, 1967, p. 52)
The panel was preceded by a small (70 x 64.5 cm) study which is now in a private Paris collection (D 717). The proportions of that work are slightly different, somewhat stretched in the vertical direction. The study is not only less detailed: some of the elements are presented differently in it. In the panel some things have been changed, in particular, the reclining woman and the girl reaching out for the flower in the foreground have traded places. Bonnard probably wanted to separate the world of childhood from that of the adults and it is no coincidence that the resting woman, who seems to be daydreaming, is placed close to the pair of lovers behind the tree to the right. There are more children and their movement is stressed considerably more. This emphasis on the children's gesticulation is in part a recognizable desire to celebrate their boisterous indefatigability, but in part also a reflection of the influence of Japanese woodcuts, which quite often depicted jerky poses in motion less familiar to European eyes. In the panel the dark strip of water, which serves as a base for the whole landscape, was adorned with a swan in addition to the existing ducks – a detail which serves as a beginning and module for the painting.
When exhibited at the Bernheim-Jeune Gallery the painting was simply entitled *Spring*. The longer title became attached to the work after it was installed in Morozov's mansion.

Provenance:

1912 I. Morozov Collection (painted on commission); 1918 Second Museum of New Western Painting, Moscow; 1923 Museum of New Western Art, Moscow; 1948 Pushkin Museum of Fine Arts

Exhibitions:

1913 Paris, no. 4

Bibliography:

Catalogue 1928, no. 29; Réau 1929, no. 713; Dauberville 1968, no. 718; Yavorskaya 1972, p. 74f; Georgievskaya, Kuznetsova 1979, p. 365, no. 25; Barskaya, Bessonova 1985, nos 225, 226; *Catalogue* 1986, p. 30

Bonnard

15
Autumn. Fruit-Picking. 1912
L'Automne. La Cueillette des fruits
Oil on canvas. 365 x 347 cm
Pushkin Museum of Fine Arts, Moscow. Inv. no. 3360
Companion piece to no. 14

This painting completed the decorative group on the staircase of Morozov's mansion. As visitors climbed the stairs, the whole of the painting became visible.

In composition the panel is highly Impressionistic. It is a slice of nature, which the artist's gaze apparently seized on by chance, without thinking of the principles of construction required for monumental works. Here Bonnard's Impressionism, which expresses itself in the depiction of nature, is coupled with a variety of different features indicative of an accomplished master teasingly concealing his great artistic skill behind a seemingly unprepossessing view.

As in *Early Spring*, Bonnard without stylizing the work "*à la japonnaise*", recalls the lessons of Japanese art. The fore-ground characters, for example, are reminiscent of woodcuts by Yoshitora, a mid-nineteenth century artist. The composition itself is flat and unfolds or develops from bottom to top, like the tree depicted in it, which again evokes associations with oriental painting. The use of this device is perhaps more justified here than in *Early Spring*. The huge tree occupies so much space and seems ready to dislodge everything else, but it cannot be regarded simply as a background. It is the chief character of this unusual work of art. The tree with people apparently attached to it may call to mind old depictions

PIERRE BONNARD
Autumn. 1912. Sketch for the painting
Autumn. Fruit-Picking
Maeght Foundation, Saint-Paul-de-Vence

of the Tree of Jesse, although it is hardly likely that Bonnard had that idea consciously in mind. Undoubtedly, though, in *Autumn* the tree is perceived as a mighty symbol of nature.

More than the other parts of the monumental decorative ensemble, *Autumn* is a thematic work in the "four seasons" tradition in which the different times of year are represented by scenes of work appropriate to them. On the left an elderly peasant is picking grapes; in the middle below is a young girl with a basket of grapes. When Bonnard exhibited the

painting in the Bernheim-Jeune Gallery in 1913, it was given the double title *Autumn. The Grape-Harvest*. The very nature of the task here – to paint a panel directly or indirectly presuming the use of the calendar canons, in order to then practically disregard those canons – is a paradox quite typical of Bonnard. Puvis de Chavannes was the last major artist to treat the theme of seasonal agricultural labours in a traditional manner. Bonnard was undoubtedly familiar with his panel *Autumn* (1863–64, Musée des Beaux-Arts, Lyons). The woman stretching out to pick fruit in the right-hand part of Bonnard's *Autumn* comes across almost as a parody on Puvis de Chavannes's fruit-pickers. But in Bonnard's work, in contrast to his predecessor's, the human being is never presented in an idealized or heroic manner, and therefore the motif of labour may quite naturally dissolve into the landscape. The grape-pickers and other human figures tend not to be noticed immediately, as one's attention is caught by the spreading crown of the immense willow which stands out tremendously against the dark background.

Like *Early Spring*, the panel *Autumn* perpetuates memories of Grand-Lemps, Bonnard's mother's country estate. We can assume that somewhere in that area there was a great willow which stuck in the artist's memory since childhood, but the painting was of course a work of the imagination and not painted from nature. The banal scene of grape-picking was transformed into a composition so decorative that it puts one in mind of a theatre curtain.

The desire to paint a decorative panel on the theme of fruit-picking appeared as far back as 1899 and was generated by a stay at Grand-Lemps. At that time he produced two canvases entitled *Apple-Picking* (D 200; D 209) and another depicting *Plum-Picking* (D 204). Neither in their artistic merits nor in their scale are those earlier works comparable with the *Autumn* produced for Morozov, after which the artist never again returned to the harvesting theme.

The painting in the Pushkin Museum was preceded by a sketch (1912, 72 x 68 cm,

In the garden at Grand-Lemps. Ca 1899.
Photograph

Fruit-Picking at Grand-Lemps. 1899–1900.
Photograph

Bonnard

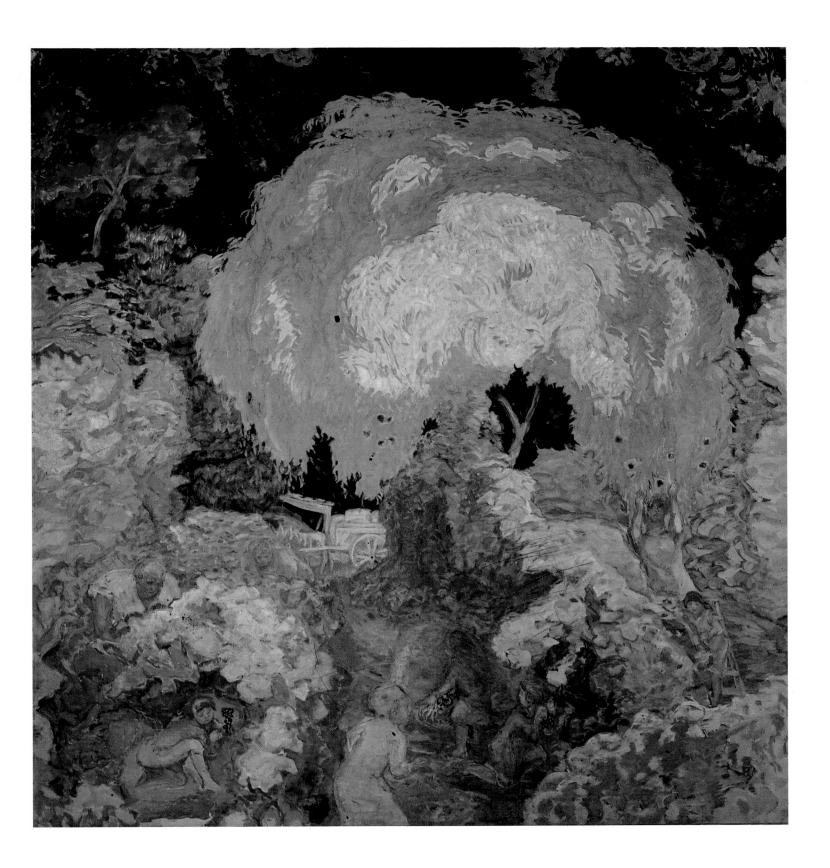

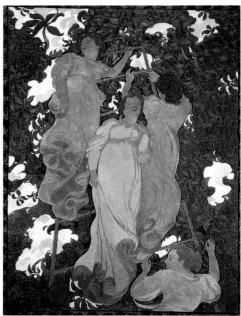

MAURICE DENIS
The Ladder in the Foliage. Ceiling painting. 1892
Musée du Prieuré, Saint-Germain-en-Laye

Maeght Gallery, Paris; D 715). The very
title of this sketch, *Landscape with Three
Figures and a Willow,* indicates that origi-
nally Bonnard was thinking of a pure
landscape composition which lacked
the figures on the left and in the centre
and also the donkey-cart in the depth
of the picture.

Provenance:
1912 I. Morozov Collection (painted on commis-
sion); 1918 Second Museum of New Western
Painting, Moscow; 1923 Museum of New Western
Art, Moscow; 1948 Pushkin Museum of Fine Arts

Exhibitions:
1913 Paris, no. 5

Bibliography:
Catalogue 1928, no. 30; Réau 1929, no. 714;
Terrasse 1967, p. 90; Dauberville 1968, no. 716;
Yavorskaya 1972, p. 74; Georgievskaya,
Kuznetsova 1979, no. 218; Barskaya, Bessonova
1985, no. 224; *Catalogue* 1986, p. 30

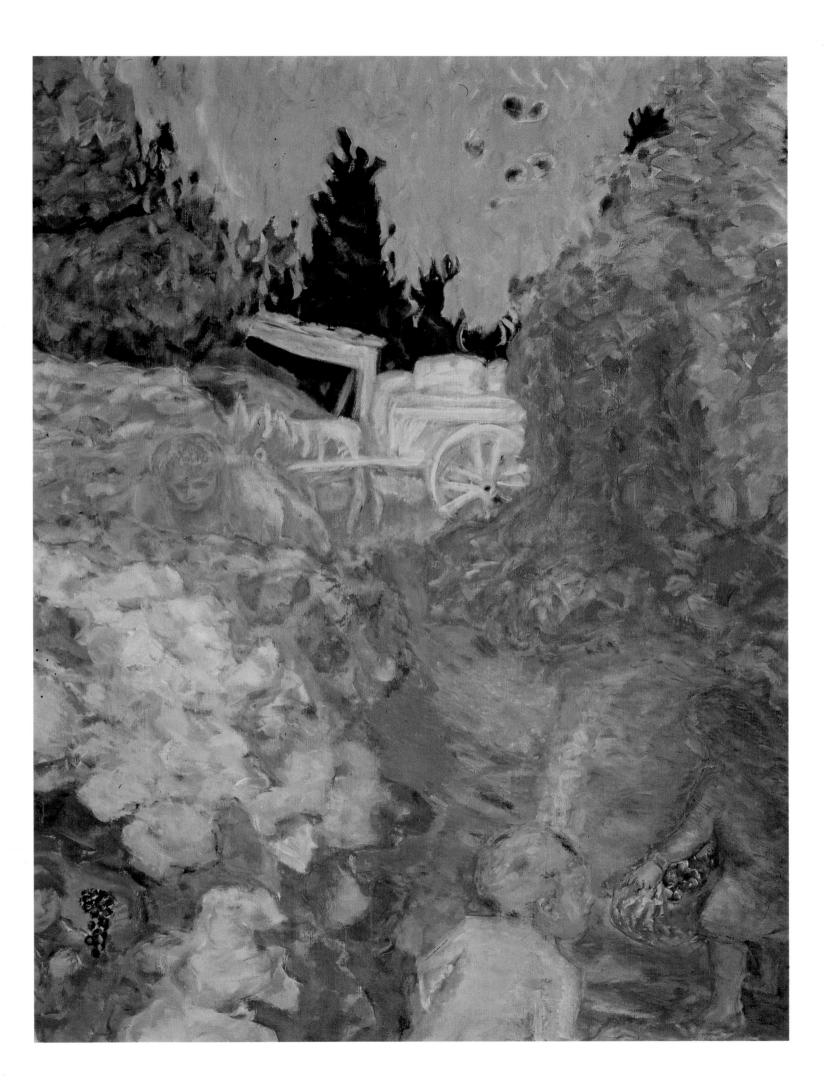

Bonnard

16
Summer. The Dance. 1912
L'Eté. La Danse
Oil on canvas. 202 x 254 cm
Signed, bottom right, on the stool: *Bonnard*
Pushkin Museum of Fine Arts, Moscow. Inv. no. 3358

In the early twentieth century, dance was a theme that attracted a great many avant-garde artists: from Edvard Munch to Derain, Picasso and Matisse. It also inspired Bonnard's friends in the Nabi group, particularly Denis and Roussel. Like them, Bonnard turned to this motif without any intention of making it an instrument of radical formal innovation as was the case with Picasso (*Dance of the Veils*, 1907, Hermitage) or Matisse (*The Dance*, 1910, Hermitage). In Bonnard's painting dance is not invested with symbolic functions. The motif of dancing has a subsidiary significance; at any rate, the painting was not designed around it. The figures here are entirely subordinated to the landscape. Their outlines echo the eccentric contours of the trees so strongly that at first glance one might take them for elements in the landscape, the more so since the patches of colour used to designate them are very close to the shades playing in the crowns of the trees or in the valley spreading out below.

An exception was made only for the woman in the black dress who is carefully supporting a small girl. This woman, the pivotal figure for the whole composition, is Marthe Bonnard. She and the artist were inseparable; she accompanied him on all his travels. The year before, when he spent three extended periods working at Saint-Tropez, he painted several portraits of Marthe against the background of the sea or the lush coastal

The Bonnard family estate
at Grand-Lemps

greenery. In *Summer* Marthe appears as a character in a genre composition, playing a role she never had in real life – that of a mother with young children. In late spring 1912, Bonnard went to Grasse where he began this large painting. He finished it after his return to Paris at the beginning of June, in time to include it in the exhibition of his latest works which opened in the Bernheim-Jeune Gallery on the 17th of that month. His stay in Grasse was a relatively short, but exceptionally productive one: the artist brought back from the south no less than ten paintings, the most important of which was the Moscow *Spring*.

The second most significant work created in Grasse was *Terrace* (1912, private collection; D 698), which presents in detail that part of the estate in Grasse with the balustrade which appears on the right in *Summer*. Bonnard, who was very fond of animals, did not resist the temptation to include the cats which featured in *Terrace* in the Moscow painting as well. The valley fringed with mountains near Grasse shown in the upper part of *Summer* is also depicted in *Mountain Landscape* or *Landscape at Grasse* (1912, private collection; D 722). The Moscow painting was evidently also preceded by *Landscape with Goats* or *Olive Grove* (1912, Museum Folkwang, Essen; D 721) with peacefully grazing animals and

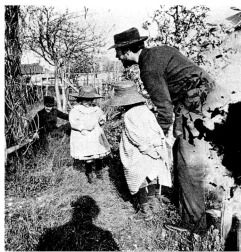

Pierre Bonnard, Ker Xavier Roussel, Renée and a little girl. 1900. Photograph

PIERRE BONNARD
Rural Scene or *Corner of a Village*. 1912
Dial Collection, Worcester Art
Museum, Massachusetts

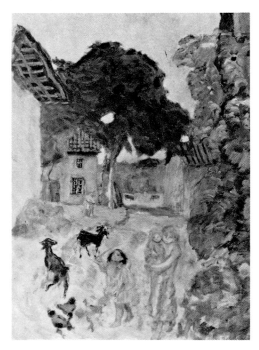

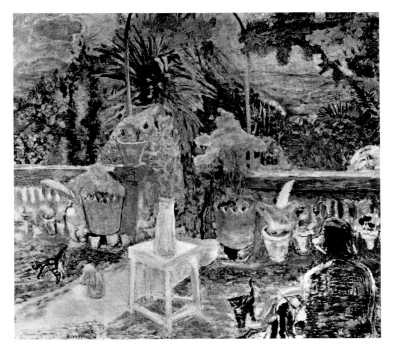

PIERRE BONNARD
Terrace or *Terrace
in Grasse*. 1912
Private collection

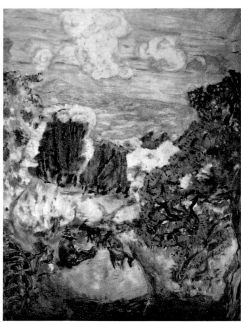

PIERRE BONNARD
Landscape with Goats or *Olive Grove*. 1912
Museum Folkwang, Essen

a sitting herdsman. In *Summer* these characters behave more actively: the goats are picking at a bush, while the herdsman plays a pipe, to the tune of which the girls are dancing. This last motif, which has given the painting its second title, was not, of course, Bonnard's invention. It was used by other artists belonging to the Nabi circle: Maurice Denis in *Shepherds* (see no. 51) and Roussel in *The Triumph of Bacchus* (see no. 25).

Some of the works painted in Grasse vividly captured the impressions Bonnard gained on strolls in the vicinity of the town. Such canvases include, among others, *Rural Scene* or *Corner of a Village* (1912, Dial Collection, Worcester Art Museum, Massachusetts; D 719), which is not a study for *Summer*, but one of the works which prepared the way for it. For the background of his composition, Bonnard chose the grounds of the Villa Antoinette near Grasse, which is where he himself lived. In doing so, he did not restrict himself to reproducing a single impression as a true Impressionist would have done, but composed *Summer* out of several happy occasions during his stay. The other Nabis also composed their idylls in a similar manner, albeit with less striking results.

In his work on the Moscow painting Bonnard developed the theme of the large panel with the same title which he had created three years earlier (*Summer*; 1909, Maeght Foundation, Saint-Paul-de-Vence; D 538). Although the later work is smaller in size, it is marked by a far greater feeling of space. *Summer* in the Pushkin Museum is remarkable for its panoramic quality, something which became stronger precisely during Bonnard's stay in Grasse.

Provenance:
1912 Bernheim-Jeune Gallery, Paris; 1913 I. Morozov Collection (purchased from an exhibition at the Bernheim-Jeune Gallery); 1918 Second Museum of New Western Painting, Moscow; 1923 Museum of New Western Art, Moscow; 1948 Pushkin Museum of Fine Arts

Exhibitions:
1912 Paris, no. 2

Bibliography:
P. Morand, "A propos du Musée d'Art Occidental Moderne de Moscou", *Les Nouvelles littéraires*, 21 Feb. 1925; *Catalogue* 1928, no. 24; Réau 1929, no. 709; Dauberville 1968, no. 720; Yavorskaya 1972, p. 74; Georgievskaya, Kuznetsova 1979, no. 26, p. 367; Barskaya, Bessonova 1985, no. 223; Bessonova, Williams 1986, p. 280; *Catalogue* 1986, p. 30

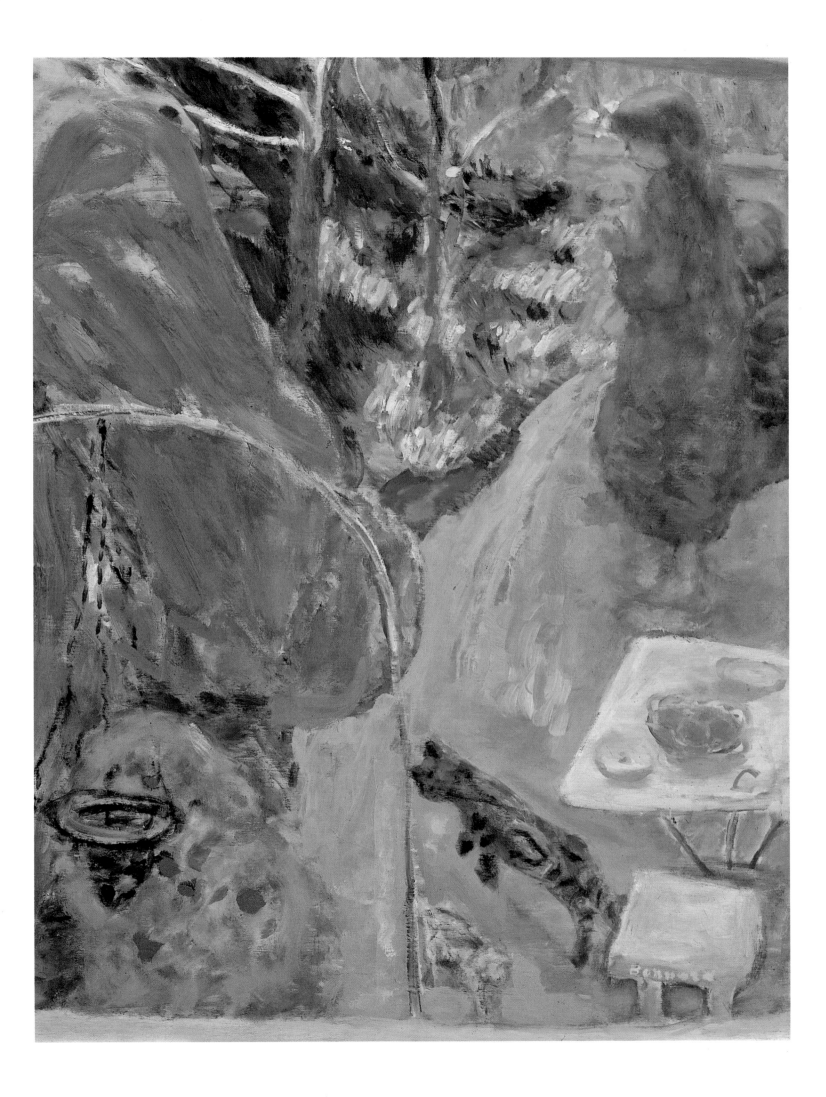

Bonnard

17
Summer in Normandy. 1912
L'Eté en Normandie
Oil on canvas. 114 x 128 cm
Signed, bottom right: *Bonnard*
Pushkin Museum of Fine Arts, Moscow. Inv. no. 3356

Maurice Denis began painting women in gardens, among trees, under the open sky before Bonnard, but in his work such depictions had as a rule a symbolic charge to them. Bonnard was not a devotee of the ideological or literary message, which Denis rarely managed to avoid, and when he became fond of painting such motifs from 1909 onwards, he satisfied himself with the simplest of subjects observed from nature. This enabled him to attain a maximum of unconstrained ease and freedom of expression.

Such compositions frequently feature the artist's wife Marthe, alone or with a friend. Marthe is quite often accompanied by a dog, either Ubu or Black; dogs were always a great object of affection for her. An example is *Woman Reading* or *Woman with a Dog* (1909; D 567). The subject of *Summer in Normandy* is a conversation between the two young women depicted in the foreground, but at the same time the landscape is not reduced to being merely the background for a genre scene. Here the artist used a device long-established in landscape painting – *repoussoir*, the darkening of the foreground – in a highly paradoxical manner, depicting the semi-recumbent Marthe and the dog settled at her feet in such a way that it requires some effort even to make out the details. Marthe becomes part of a sort of inner frame which the artist, not trusting an exterior frame to produce the desired effect, inventively introduces in order to give

PIERRE BONNARD
Evening or *Siesta*. 1914
Kunstmuseum, Bern

depth to the space. (The other elements of this frame are the poles of the awning and the protruding edge of the awning above.) Since the light falls on it, the figure of Marthe's friend is more readily recognizable, but it too comes close to blending into the surrounding landscape. Her green dress, slightly more vivid in shade than the grass and trees, might even be called camouflage, if the word is suitable for describing such an elegant piece of clothing. The colours of her fair hair and half-shaded face are once again close to the hues of nature.

Antoine Terrasse wrote of *Summer in Normandy*: "An enchanting painting with two figures, one in shade, the other in the light of a landscape, the majestic depth of which is stressed by its being framed in an awning. Is the shadow in the foreground a hill or a woman's body? One hesitates to say straightaway what

it is, so interconnected are these ripe curves. This is the puzzle posed to the dreamer or someone who suddenly wakes up in a landscape devoured by the sun." (A. Terrasse, *Pierre Bonnard*, Paris, 1967, p. 97)

In short, Bonnard's beloved theme – the harmony of man and nature – which determined the contents of the large decorative ensemble he created for Morozov, is here not simply presented, but reproduced in the language of shapes and colours.

The entire scene takes place on the terrace of "Ma Roulotte". Bonnard purchased this house the same year that *Summer in Normandy* was painted. It was situated in Vernonnet near Vernon, just across the Seine from Giverny where Monet lived. The two artists visited each other quite often and we might suppose that the proximity of the leader of the Impressionists stimulated Bonnard in a particular manner. In any case, *Summer in Normandy* is one of his most Impressionistic works, though he never in the slightest sought to imitate the founders of that movement. While conveying the smooth flow of air, the vibration and play of light, which in an Impressionistic manner penetrates everywhere, even into the dense shadows, Bonnard remains, as it were, at the boundary which prevents his painting from becoming a copy of nature, without ever being far away from it. The decorative quality which was an inherent feature of Bonnard's work is present here too, and probably reveals itself most eloquently in the depiction of the brickwork which the artist managed to turn into a highly attractive, picturesque detail.

Bonnard differs also from the first-generation Impressionists in his gentle, unimposing inclusion of a psychological aspect. The women's conversation was

PIERRE BONNARD
Woman in a Landscape or *Siesta in the Garden*. 1914
Nasjonalgalleriet, Oslo

Bonnard

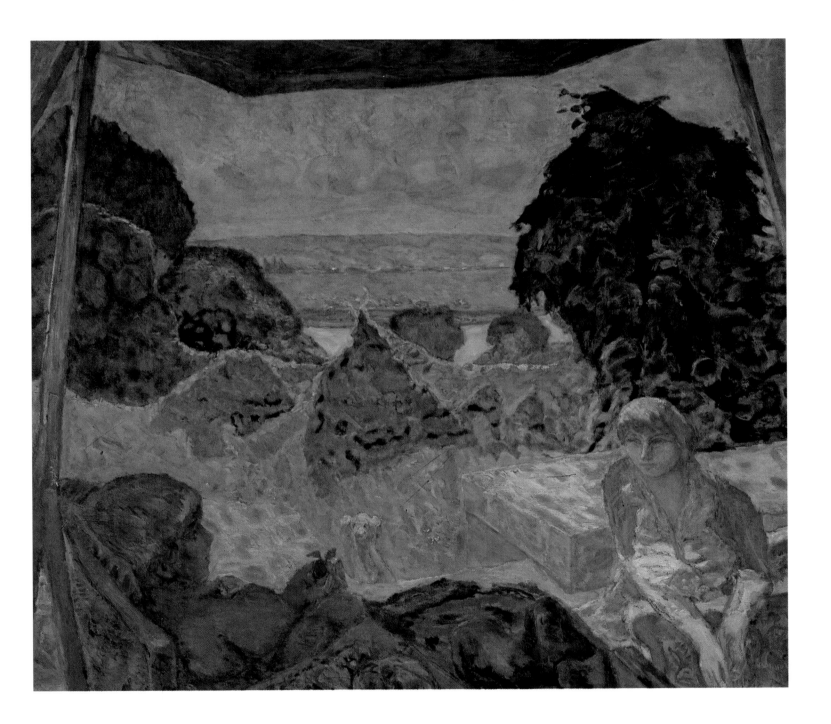

PIERRE BONNARD
Studies of a dog (Ubu). 1919
Private collection, Switzerland

recreated by a man with a real knowledge of female nature. On this occasion the artist avoids deliberate "Japanese" gesticulation which would have been entirely out of place in the presence of this enchanted and enchanting nature. The depiction of the dogs reveals a talented painter of animals, one who understands their psychology, and that too sets Bonnard apart from Monet, Renoir, Pissarro and even Degas.
In the foreground is Ubu, the artist's own beloved pet, whose presence enlivened many of his paintings and drawings;

behind is a light-coloured dog listening in an amusing way to the women's chat. This dog also appears in several of Bonnard's works, notably *Garden Scene at Grand-Lemps* (1912; D 694).

Provenance:
1913 Bernheim-Jeune Gallery, Paris; 1913 Denys Cochin Collection, Paris; 1913 Druet Gallery, Paris; 1913 I. Morozov Collection; 1918 Second Museum of New Western Painting, Moscow; 1923 Museum of New Western Art, Moscow; 1948 Pushkin Museum of Fine Arts

Exhibitions:
1913 Paris, no. 2; 1939 Moscow, p. 52; 1971 Tokyo–Kyoto, no. 60; 1972 Prague, no. 2; 1984–85 Zurich–Frankfurt am Main, no. 71

Bibliography:
Ch. Terrasse, *Bonnard*, Paris, 1927, p. 126, ill. p. 127; *Catalogue* 1928, no. 22; Réau 1929, no. 706; *Catalogue* 1961, p. 21; Dauberville 1968, no. 695; Yavorskaya 1972, p. 72; Georgievskaya, Kuznetsova 1979, no. 217; Barskaya, Bessonova 1985, no. 227; Bessonova, Williams 1986, p. 281; *Catalogue* 1986, p. 30

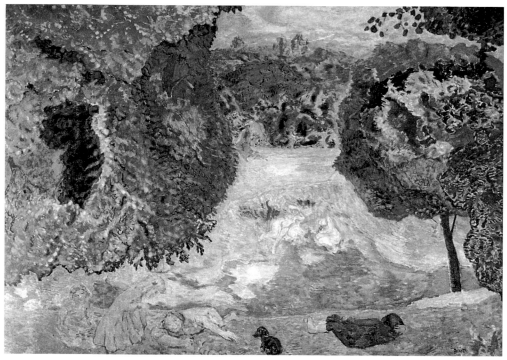

PIERRE BONNARD
Summer. 1917
Maeght Foundation,
Saint-Paul-de-Vence

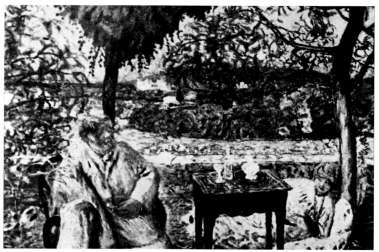

PIERRE BONNARD
Provençal Conversation. 1911
National Gallery, Prague

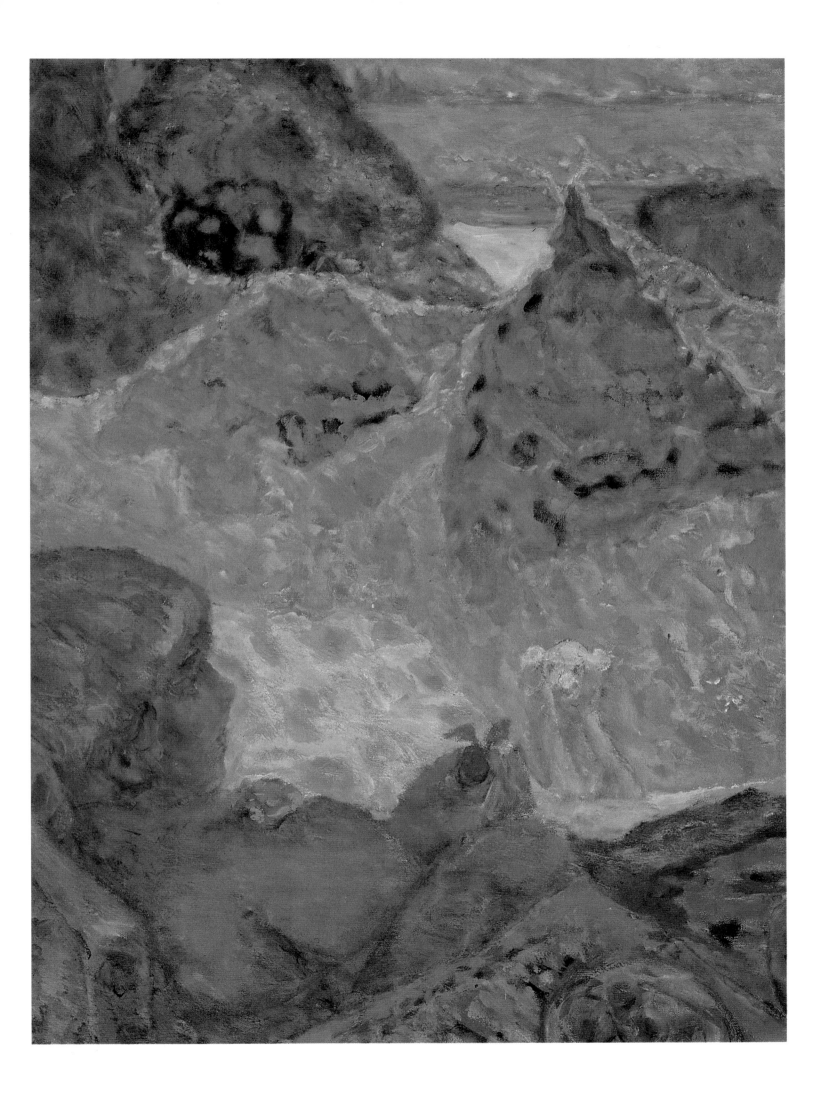

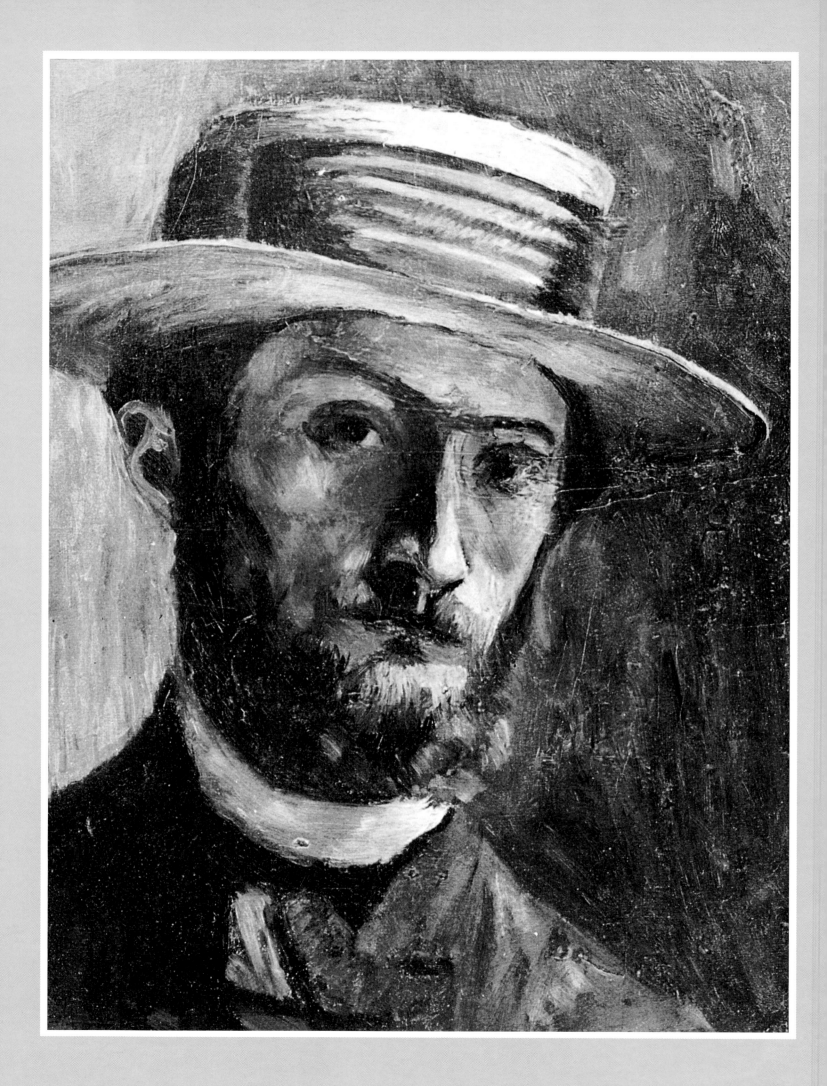

EDOUARD VUILLARD

1868–1940

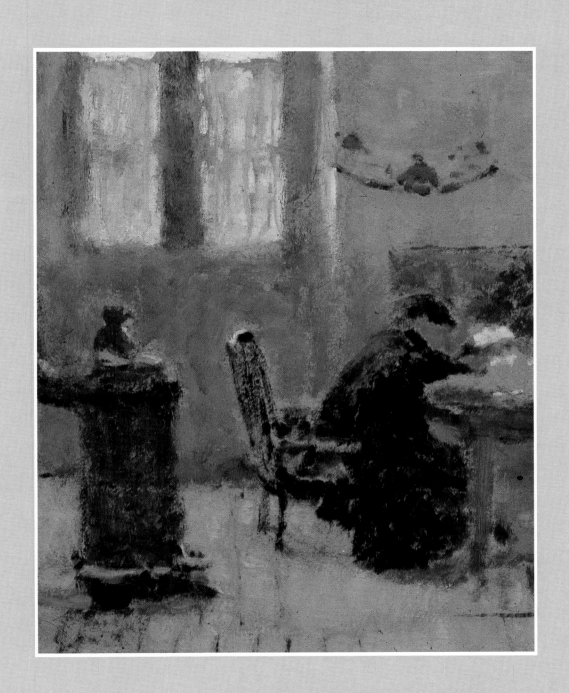

E Vuillard

The names of Bonnard and Vuillard were already firmly linked in the minds of those who appreciated new art by the beginning of the twentieth century. Even before that, there had been a considerable creative affinity between them, reinforced by a strong friendship. This bond was only broken by Vuillard's death, but their artistic paths, which at first ran side by side, noticeably diverged in the 1920s and 1930s. Vuillard's painting became somehow drier, more "natural", and quite often fell into repetition, especially in his society portraits. Perhaps sensing that something very important was slipping away from him, he began to tackle a broader range of themes. He might paint not only a game of cards but also, say, a medical scene, something inconceivable for Bonnard. In comparison with Bonnard he was always slightly lacking in emotional warmth, even in the early days when in terms of artistry he was the equal of his friend.

As a ten-year-old at the Lycée Condorcet Vuillard made friends with Roussel, Denis and Lugné-Poë. Supposedly it was Roussel who persuaded the young Edouard to enter the Ecole des Beaux-Arts. His first works are signed *Vuillard, élève de M. Gérôme*, but they already display distinct maturity and are far from the temptations of the academic painting with engaging narrative subjects which the celebrated *maître* himself practised.

Like all the Nabis, Vuillard was very well-read. He was fond of Baudelaire, Giraudoux and Valéry and adored Mallarmé who gave the artist a first edition of his *Divagations* and wanted him rather than anyone else to illustrate his *Hérodiade*. Vuillard took an interest in many things, but his own way of life was steady and uneventful. After losing his father fairly early he continued to live with his mother and never married. His art tends towards calm, but after first meeting him the perspicacious Signac saw him as "a clever, intelligent boy, a highly-strung searching artist".

"He showed me all his works from different periods, the searches he had gone through. His little sketches of interiors have a good deal of charm. He has a splendid understanding of the voices of things. His pictures reveal a fine painter. In their dull colour scheme there is always a flash of some bright colour establishing harmony in the piece. The contrast of tones, the skilfully arranged chiaroscuro balance out the different colours which, for all their dullness, are always refined, almost morbidly so." [1] Signac made that entry in his diary on 16 February 1898.

Within days, on 19 February, Vuillard wrote in a letter to Maurice Denis something we might consider his credo: "I have a fear or more precisely an awful terror of those commonly-held ideas which I have not reached myself. It's not that I deny their value, just that I would prefer humiliation to aping understanding." [2] Having no trust in accepted truths and fashionable theories, Vuillard only acknowledged an idea when it had matured within himself. In the same letter he also wrote that if he derived joy from his work it was because he had within him an idea in which he believed. But he never proclaimed his ideas. Like Bonnard he had a dislike of publicity and said on several occasions "Silence protects me". [3]

Somewhat condescendingly calling Vuillard a boy (he was in fact already about thirty), Signac noted "searches" and "periods" and was undoubtedly surprised at the metamorphoses in the other's work. By the end of the century Vuillard had indeed changed his artistic manner more than once and not, of course, following fashion, but following the dictates of his own inner development. His early still lifes exude admiration for Chardin. The Louvre, already familiar from frequent childhood visits, strengthened Vuillard in his love of Rembrandt, Lesueur and Prud'hon. Gauguin's teaching, which came to him through the *Talisman*, found in Vuillard a more committed follower than Sérusier himself. The Nabis' desire to paint "icons" took an unexpected turn in the small paintings of 1890–91 which are put together from a few small areas of colour that are completely flat and very bright. Their boldness anticipates Fauvism. Immediately afterwards Vuillard returned to calmer colours and abandoned absolute flatness without, however, resorting to the modelling devices used by the Old Masters. His painting becomes an ornamental pattern with a very complex rhythm. Impressions of Japanese woodcuts or old French *mille-fleurs* suggest themselves as possible inspirations, but the most probable source of all was contemporary cheap fabrics.

ÉDOUARD VUILLARD
Interior (Siesta). 1893.
Colour lithograph
Hermitage, St Petersburg

[1] "Extraits du journal inédit de Paul Signac. 1897–1898", *Gazette des Beaux-Arts*, 1952, April, pp. 276, 277
[2] M. Denis, *Journal*, vol. I (1884–1904), Paris, p. 137
[3] Edouard Vuillard, K. X. Roussel, *Orangerie des Tuileries*, Paris, 1968, p. 23

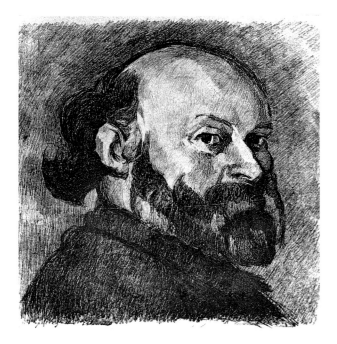

ÉDOUARD VUILLARD
*Portrait of Paul
Cézanne.* 1914.
Lithograph after
Cézanne's *Self-Portrait*
Hermitage, St Petersburg

At home and in the small dressmaker's studio which Vuillard's mother ran after her husband's death in order to feed the family, the future artist was surrounded from an early age by the unusual patterns and combinations of colours presented by jumbled offcuts of fabric. Moreover, Vuillard's mother's brother and father were both fabric designers. Vuillard did not, however, follow their example. He felt himself to be a painter and fabrics for him were only supplementary material, sometimes suggesting a new arabesque, sometimes becoming an object for depiction in its own right. There are paintings in which fabrics emerge as characters on a par with the human figures. Vuillard painted his mother and sister relaxing or performing their laborious work, presented a homely breakfast or simply an interior. His painting is consciously intimate, something encouraged by the choice of themes. As far back as 1892 Albert Aurier, the ardent advocate of the work of Van Gogh and Gauguin, considered the leading theoretician of the new painting, called Vuillard an "intimiste verlainien".[1] At that same time Gustave Geffroy in a review of an exhibition at Le Barque de Bouteville's pointed out the creative affinity between Bonnard and Vuillard stressing the way in which they masterfully handled the smallest gradations of colour capable of delighting the eye. "[They] possess a gift, of course, for nuances and the play of lines, symmetrical and disorderly, combining and diverging them with fascinating, exquisite taste for decorative painting."[2]

The manner which Geffroy described is one which Vuillard maintained for a long time. It did go through modifications, though, and the artist concurrently employed another manner marked by fairly strict geometricism and simplifications. The former is to be seen in his picture *In the Garden* (Pushkin Museum of Fine Arts) and paintings in both Moscow and St Petersburg depicting domestic interiors, the latter is represented by *Children* (Hermitage). An example of the combination of the two manners is found in the small work *On the Sofa* now in Moscow.

This ratio of works, with only one landscape to a number of interiors, reflects an important peculiarity of Vuillard's art: indoor scenes were more attractive to him than the open spaces of landscape. This preference for interiors made Vuillard a greater intimist than Bonnard. His landscapes too were usually to a greater or lesser degree intimate pieces.

"His subjects," the artist's biographer Jacques Salomon wrote, "were for a long period his room, his window, the view from his window: the yard or garden. ... He would not have put on his boots to go and paint snow, he would have gazed at it from his room, looking out. As for his portraits: he catches his models in their own homes in accustomed surroundings."[3] What makes the intimism of a Vuillard landscape? Partly the role played by his characters. Placed in the centre of *In the Garden* are two ladies seated comfortably round a garden table. Their conversation seems unhurried and routine, perhaps about knitting or domestic chores. Yet the female figures do not dominate the composition. The intimate effect of the picture is due to the general vagueness of details, the softness of colouring, the subdued opaque texture and the limited space, with the landscape reduced to the lawn instead of stretching to infinity and no room left for the sky whatever. This type of composition can be traced back to early Impressionism, or rather to Claude Monet (*Women in the Garden*, Musée d'Orsay, Paris, and *Lady in the Garden*, Hermitage, St Petersburg; both 1867). In those pictures, with an emphasis on pictorial effect, the subject-matter is already losing its significance. Three decades later Van Gogh and Gauguin, developing Monet's motifs while working side by side in Arles, painted, respectively, *Reminiscence of the Garden at Etten* (Hermitage, St Petersburg)

[1] A. Aurier, "Les Symbolistes", *Revue Encyclopedique*, Paris, 1892, no. 1, April
[2] G. Geffroy, *La Vie artistique*, 2e série, Paris, 1893, p. 382
[3] J. Salomon, *Vuillard*, Paris, 1968, p. 29

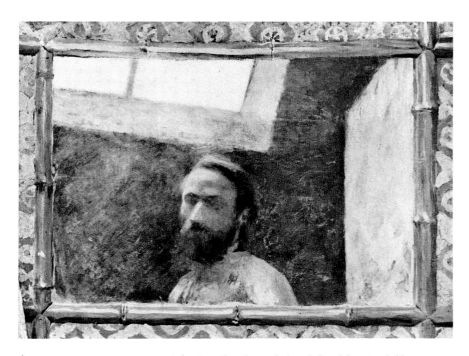

ÉDOUARD VUILLARD
Self-Portrait in a Mirror.
1880–90
Salz Collection, New York

of painting is to produce monumental works. Some time later Octave Mirbeau remarked in his preface to the sale catalogue of Thadée Natanson's collection, which included 26 paintings by Vuillard, "His magic needs walls". [1] Vuillard agreed with Lesueur, his favourite fellow artist, that monumental painting was the supreme art form, yet the best of his own work is easel painting, suggestive though it is of his decorative panels and stage designs. The very early painting by Vuillard called *On the Sofa* (Pushkin Museum of Fine Arts, Moscow) is marked with a rare artistic daring. It consists of two seemingly very different parts: the one on the right dominated by white and devoid of pictorial details, for it merely features a door and a wall; the one on the left – a juxtaposition of various pure colours and ornaments. It is remarkable that the two parts, however different, seem to belong together. All the details are well balanced, a quality which is especially important in paintings of interiors. The title *On the Sofa* is quite appropriate, as that piece of furniture is more significant than the woman reclining on it, who seems no more than a feature of the interior.

The human figures in Vuillard's painting behave with an extreme calmness. The woman in *On the Sofa* is asleep, the family in the picture called *In the Room* are engrossed in reading. The pleasures of the home, the unhurried domestic round – that is what Vuillard's art dealt with. The painter would not highlight the occupations pursued by his characters. The design depends on the models to strike a note of vitality, and they are always well-matched to the interior decoration. Only occasionally are they treated as individuals. They are, as it were, resultant forces in the system of colour patches and, consequently, they ultimately serve as colour patches, too.

The human figures are inseparable from their surroundings, sometimes to the point of merging with the background. Vuillard had the subtle intuition of a colourist, which led him to discover an abundance of artistic resources where they had formerly remained neglected: in the regular and simple routine, in the details of everyday life.

At times Vuillard might seem to be unthinkingly registering whatever caught his eye, unruffled by the ungainly or the unsightly, such as the black cast-iron stove and flue of *In the Room*.

and *In the Garden of the Arles Hospital* (Art Institute of Chicago). Vuillard might have seen one of these pictures, perhaps both. Each employs the Japanese type of design, avoiding depth, with the artist viewing the scene from above and placing the line of the horizon beyond the top of the composition. The difference, however, is more noticeable than the similarity. To Van Gogh and Gauguin, human presence is of paramount importance, therefore the female figures are clear-cut and large-scale. The powerful emotional message is parallelled by the effective picturesque qualities. Proceeding from Seurat's and Signac's methods, Van Gogh made his paintings extremely "tense" by applying large divided strokes of contrasting colours. Vuillard and his fellow artists did not like smooth surfaces either; nevertheless, Vuillard's divided strokes create an altogether different impression. His use of the cardboard's brownish colour, with the ground not completely covered by paint (a technique favoured by the Nabis as well as Toulouse-Lautrec), contributes not only to the effective economy of means, but also to a more subdued and softened pictorial quality. The painting is notable for its decorativeness. It is evident that Vuillard did not aim to create an illusion of reality. The decorative quality of the picture is of a specific type reminding us that the artist worked as a stage designer. Vuillard shared, at least in the 1890s, the idea of the Nabis and those artists who grouped round the *Revue Blanche* that the main purpose

[1] *Vente Thadée Natanson à l'Hôtel Drouot* (preface by Octave Mirbeau), Paris, 1908

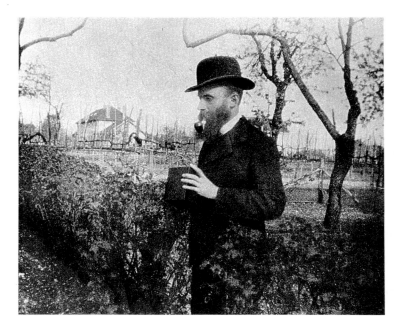

No detail is omitted here, and a closer look at the painting reveals not only the stove, tables and chairs, but also a number of minor objects, like the vases and the waste-paper basket. The viewer is unaware that the basket is "inelegant", because the material quality of things is erased and completely dominated by the pictorial pattern. The objects seem to dissolve, turning into patches of subdued colours, still they are there. Vuillard was second to none at grasping the beauty of soft tints, always immaculately suited to his peaceful interiors.

Like all the Nabis, Vuillard attached immense importance to colour effects. Both Vuillard and Bonnard managed to use them to enhance the intimate mood of a picture. Their contemporaries already detected the similarity between their gentle colour palettes and Debussy's music. Their awareness of fleeting nuances and waning undertints combined the Impressionist commitment to real subject-matter and the craving for the mysterious and the indefinite, which amounted to the most outstanding feature of art at the turn of the century. The latter tendency found its ultimate expression in Symbolism, but it influenced even those artists who were not involved in this trend.

For all the softness and delicacy of his art, Vuillard never disregarded the structure of his compositions, and this is something which distinguished him from the rest of the Nabis. Both *In the Room* and *Children* display a framework formed by bringing together the straight lines of the buildings and pieces of furniture.

The viewpoint selected in *Children* is such that a geometric pattern is formed by the screen, balcony, door and carpet, which links the patches of colour together. This is done so unobtrusively that the artist's concern for the structure of his composition remains unnoticeable.

Compared with *In the Room*, encumbered with objects to an almost psychopathic degree, *Children* reveals another aspect of Vuillard the painter: a gourmet turned ascetic, as Jacques Emile Blanche very aptly remarked. [1] Here Vuillard makes a bold use of empty spaces, relying on them to strengthen the whole composition. The pale patch of the floor takes up about a third of the canvas and nearly all of the foreground. The contrast between the empty light surfaces and the richly tinted and colourful details endows the painting with an inner significance. The artist did not have to resort to an unusual or exotic theme to achieve a rich decorative effect. His subject-matter was always at hand: mainly the life of his nearest and dearest.

Edouard Vuillard. 1900. Photograph

Edouard Vuillard and Pierre Bonnard's niece Renée. 1900. Photograph

[1] *Les Mardis. Stéphane Mallarmé and the Artists of His Circle*, The University of Kansas Museum of Art, 1966, p. 44

1868

Edouard Vuillard born into the family of a retired colonial army officer in Cuiseaux, Saône et Loire

1878

The Vuillards return to Paris. Edouard attends the Ecole Rocroy Saint-Léon, then the Lycée Condorcet. Friendship with Roussel. Meets Denis and Lugné-Poë

1884

Death of Vuillard's father. Mother runs a dressmaker's business to support the family

1887

At Roussel's instigation, refuses to enter the Saint-Cyr Military College, joins his friend instead at Maillart's studio

1888

Short period at the Ecole des Beaux-Arts (Gérôme's class), then attends the Académie Julian together with Roussel. Friendship with Bonnard, then Ranson, Sérusier and Denis. All dissatisfied with Bouguereau's teaching methods at the Académie Julian

1889

Impressed by Gauguin's paintings at the "Peintres Symbolistes et Synthetistes" exhibition in the Café Volpini

1891

Shares studio in the Rue Pigalle with Bonnard and Denis

1892

Paints first decorative panels for Desmarais

1893

Designs scenery for the Théâtre de l'Œuvre founded by Lugné-Poë

1894

Paints nine panels featuring parks of Paris for Alexandre Natanson, the publisher of the *Revue Blanche*

1895

Pays visit to Mallarmé. At the Salon, Tiffany exhibits a series of stained-glasses, one of them of Vuillard's design

1896

Makes four large-scale panels for the drawing-room of his friend Vaquez. Invited to exhibit with Bonnard and Toulouse-Lautrec at the "Libre Esthétique" show in Brussels. Commissioned by Vollard to make an album of lithographs to be published within two years

1898

Panels for novelist Claude Anet

1899

Summer: at Le Cannet with the Natansons. Visits Venice with Bonnard and Roussel. Exhibits with Bonnard at the Bernheim-Jeune Gallery until 1914

1900

In Romanel, Switzerland, meets Madame Jos Hessel, his future patroness, at Vallotton's

1901

First exhibits at the Salon des Indépendants

1902

Joins the Hessels for a trip to Holland. Stays with them in Normandy throughout summer

1905

Visits Spain with Bonnard

1906

Teaches at the Académie Ranson

1909

Panels for the Bernheim brothers and Lugné-Poë

1913

Decorates foyer of the Théâtre des Champs-Elysées. Visits Hamburg and Berlin with Bonnard

1914

Mobilized at the outbreak of war

1916

Military painter at Gérardmer

1917–24

Lives and works alternatively in Paris and at the Hessels' in Vaucresson

1928

Vuillard's mother dies

1930

In Spain with the Hessels and Jean Laroche

1936

Co-operates with Denis and Roussel on panels for the Palace of Nations, Geneva (*Peace Protecting the Muses*)

1937

Elected member of the Institut de France. Paints panels for the Palais de Chaillot

1938

Retrospective at the Musée des Arts Décoratifs, Paris

1940

Leaves Paris after Nazi invasion. Dies at La Baule

E. Vuillard

18

On the Sofa (In the White Room). Ca 1892–93
Sur le sofa (La Chambre blanche)
Oil on cardboard pasted on panel. 32 x 38 cm
Signed, bottom left: *E. Vuillard*
Pushkin Museum of Fine Arts, Moscow. Inv. no. 3441

ÉDOUARD VUILLARD
In Bed
Musée d'Orsay, Paris

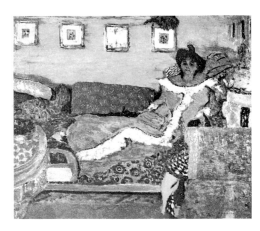

ÉDOUARD VUILLARD
Symphony in Red. 1893
Colin Collection, New York

ÉDOUARD VUILLARD
The Open Door
Private collection, Paris

The title traditionally given to this painting, *In the White Room*, is not entirely accurate: the room has striped decoration and only the wide doors are in fact white. In the early stage of his career Vuillard very often displayed an intense interest in this element of an interior, which also held quite an attraction for Roussel and Vallotton. Suffice it to recall a pair of small paintings also from the early 1890s now in private Parisian collections, *The Two Doors* and *The Open Door,* both depicting doors on the attic storey of the artist's family home in the Rue de Miromesnil. The partially glazed doors in the Moscow interior indicate another, richer, household, possibly that of the Natansons. The artist was on close terms with both the brothers.

In the era of Symbolism the motif of the door took on an almost self-sufficient significance. Denoting the boundary of the intimate enclosed world of the room, something close to the heart of each of the Nabis, at the same time it introduced into a composition some sort of allusion or element of mystery. In the Moscow painting the handle of the door stands out highly significantly against the white background, as if foretelling someone's arrival. On the other hand, the character which the artist has already "caused to arrive" here seems, as it were, to interest him less: the woman almost blends in with the furniture, remaining essentially just as much a feature of the interior as the corner sofa: the outlines of her body repeat the contours of the sofa cushions and rhythmically echo them.

This small painting might be taken as a study, were it not for the well-thought-out structure of the composition. In this period Vuillard, while showing a marked preference for small-size works, effectively did not paint studies: the logic of construction came to him immediately, determining not only the content of a work, but also the process of creating it. The Pushkin Museum dates the painting to 1890–93. That can be narrowed down to 1892–93. It was at that time that Vuillard made use of a distinctive kind of arabesque in which vertical stripes and "Baroque" patterns combine with broad rectangular surfaces. This can be found, in particular, in *Woman Sweeping a Room* (Phillips Collection, Washington), which, incidentally, also features a door with a brass handle. It would seem that the painting in the Phillips Collection might be of assistance in determining the time when the Moscow interior was executed, but its traditional dating, 1892–93, has recently been called into doubt and some scholars shift it to the end of the decade. There is justification as well for recalling another painting with a similar motif – *Symphony in Red* (Colin Collection, New York) which depicts a woman reclining on a sofa (among other things, she has the same hairstyle). Unfortunately, though, different scholars have put different dates on that work too – either 1893 or 1898.

Provenance:
Bernheim-Jeune Gallery, Paris; 1908 A. Liapunov Collection, Moscow (purchased from the "Golden Fleece" exhibition in Moscow); 1918 Tretyakov Gallery, Moscow; 1925 Museum of New Western Art, Moscow; 1948 Pushkin Museum of Fine Arts

Exhibitions:
1908 Moscow, p. 23; 1984 Tokyo–Nara, no. 21

Bibliography:
Catalogue 1928, no. 59; Réau 1929, no. 1160; *Catalogue* 1961, p. 46; Georgievskaya, Kuznetsova 1979, no. 214; Barskaya, Bessonova 1985, no. 206; *Catalogue* 1986, p. 51

E Vuillard

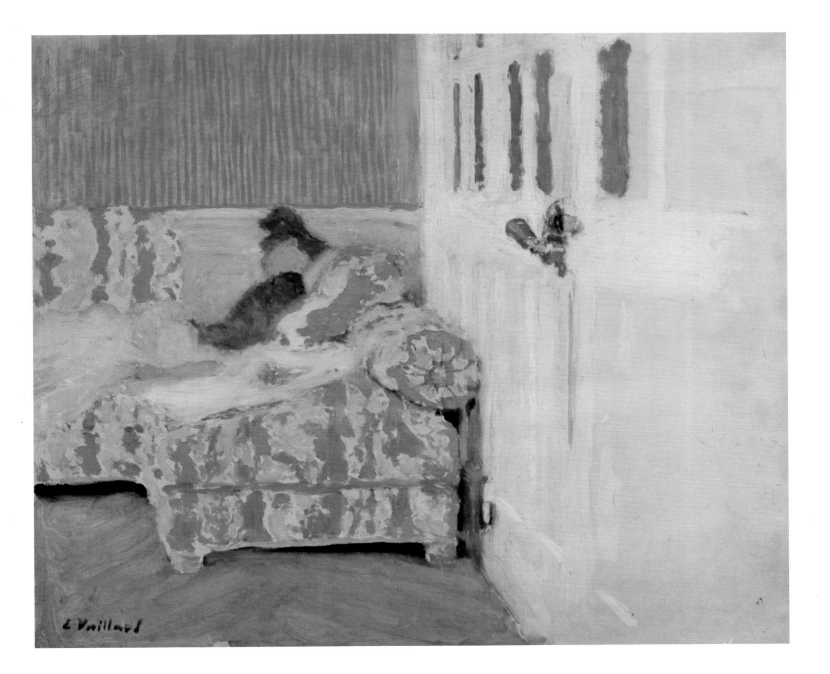

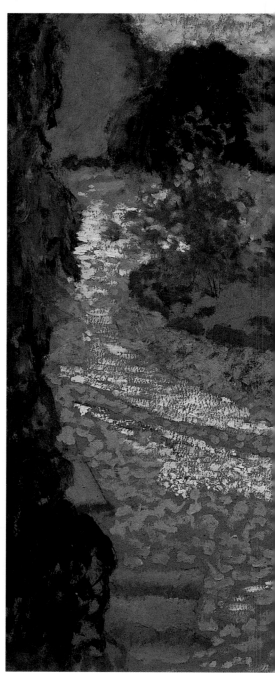

E. Vuillard

19

In the Garden. Ca 1899
Au jardin
Tempera on cardboard. 51 x 83 cm
Signed, bottom right: *E. Vuillard*
Pushkin Museum of Fine Arts, Moscow. Inv. no. 3447

Landscapes were a comparatively rare phenomenon in Vuillard's early work, at least less common than interiors. They share the intimate quality of the interiors, unless the piece in question was one of his large decorative panels. It was precisely the creation of such panels which raised the significance of the landscape in Vuillard's art. In 1892 he painted a series of *dessus-de-portes* for Madame Desmarais who was married to a cousin of the Natansons. One of them, *Nannies and Children in a Public Garden* (private collection, Paris), depicts women sitting on chairs against the green background of a large park, possibly the Jardin du Luxembourg. At that time Vuillard, who frequently visited the Louvre, was captivated by Watteau's *Society in a Park*. In replacing the ladies and chevaliers of the eighteenth century with nannies and children, Vuillard created an intentionally contemporary version of the *fêtes galantes*. Two years later, for the dining-room

in the home of Alexandre Natanson, the director of the *Revue Blanche*, he painted a series of nine large landscape panels entitled *Public Gardens* (1894; five are now in the Musée d'Orsay, one each in museums in Brussels, Cleveland and New York; the whereabouts of the ninth are unknown). Three of the panels in the Musée d'Orsay form a triptych developing the motif of the Desmarais *dessus-de-porte*. The central panel shows women conversing.

The Moscow painting, of course, depicts not a public park, but someone's private property. The link with the *Public Gardens* is undoubted, though. Vuillard referred to the first sketches for the *Public Gardens* as "tapestries" (*tapisseries*) and at that time he wrote in his diary: "to make a tapestry, to imagine an ornament with objects" (*Journal*, vol. II, p. 49b; quoted from *Nabis. 1888–1900*, Zurich–Paris, 1993, p. 336). There is much of the tapestry about the Moscow

KER XAVIER ROUSSEL
*Mother and Daughter
in a Garden*. 1905
Jäggli-Hahnloser
Collection, Winterthur

E Vuillard

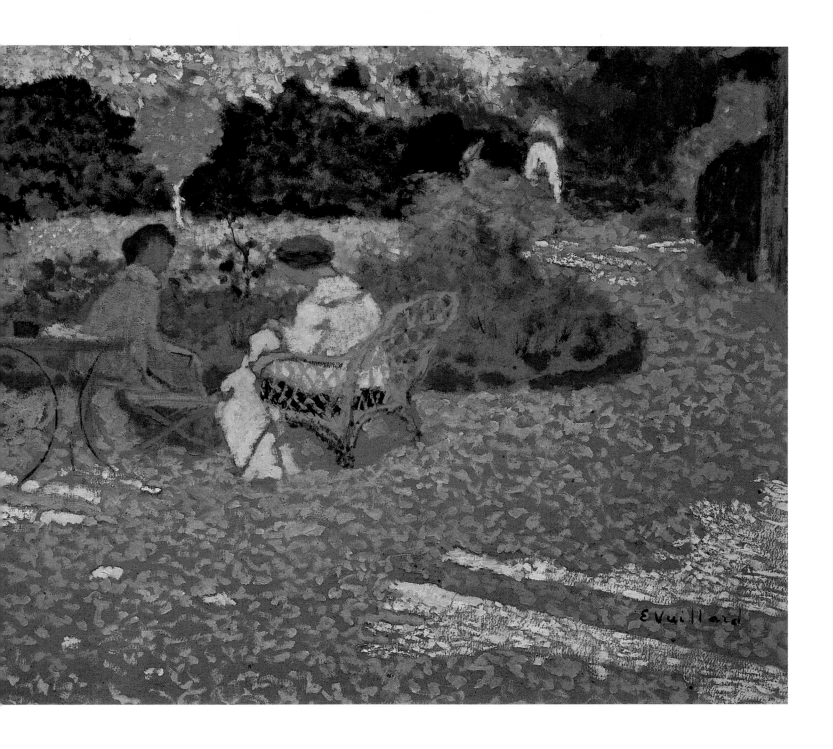

ÉDOUARD VUILLARD
Relaxing in the Garden. 1898
National Gallery, Washington

ÉDOUARD VUILLARD
Relaxing in the Garden. 1898
National Gallery, Washington

landscape – the deliberate flatness, the muted palette and, finally, the ornamentality with which the garden path or the trees are reproduced. This little painting is more tapestry-like than the large-scale panels. Indeed, it produces a completely different impression. In the decorative panels Vuillard, contrary to his own predilections, embraces a wide expanse of space. In the painting *In the Garden*, by contrast, all approaches to the horizon are blocked. It is an intimate landscape and the more restrained, darker, more muted tones are in keeping with that. Having chosen to work on brown cardboard, Vuillard did not cover it completely with paint, so that the natural colour of the cardboard is an active element in the colour-scheme, denoting a sandy path.

The Pushkin Museum dates this painting to 1895–98. The start of this range is founded on Charles Sterling's indication of the closeness of the Moscow landscape to the *Public Gardens*. The other boundary derives from comparison with the gouache *Relaxing in the Garden*, now in the National Gallery in Washington, which is known to date from 1898. This comparison is justified in terms of both motif and technique.

The organizers of the Paris–Munich retrospectives of Vuillard and Roussel in 1968 also linked the painting to the *Public Gardens*, dating it to 1895. There is indeed no doubt that the genesis of this work is bound up with that series. The only thing at issue is whether it was painted at the same time as the panels for Alexandre Natanson, immediately following them or after the passage of some time. Stylistic and technical features tend to place *In the Garden* among the works of 1898–99. That was the period when Vuillard, painting in gouache or tempera, turned to the technique of divided brushstrokes using a coloured ground, which was provided by brown or greyish-brown cardboard. Of course, Vuillard's methods are only remotely similar to those of the Neo-Impressionists who used divided brushstrokes in a carefully calculated manner, with regular, identical dabs of paint. Some support for the

proposed dating is provided by the appearance of analogous details in some paintings of 1898–99. For example, the same table is featured in the panel *Woman Reading in a Garden* (Dungdale Collection, Crathorne, England) painted in 1898 for the novelist Claude Anet. On the other hand, the design was typical of the last quarter of the nineteenth century and such tables were no great rarity. Twenty years earlier a round table with bent legs appeared in Caillebotte's *Orange Trees* (1878, Beck Collection, Houston). The compositional reminiscence of Caillebotte's work is such that it is hard to believe that Vuillard was not familiar with it. While they did not share

Caillebotte's photographic and naturalistic approach to the depicted object, the Nabis must inevitably have appreciated his compositional inventiveness.

One further connection needs to be made. The garden table in the Moscow painting with its bent legs and green top appears in Roussel's pastel *Mother and Daughter in a Garden* (1905, Jäggli-Hahnloser Collection, Winterthur; see *Nabis und Fauves. Zeichnungen, Aquarelle, Pastelle aus Schweizer Privatbesitz*, Zurich, 1983, p. 134), in which the landscape is very similar to that of the Moscow work, and the woman at the table is Vuillard's sister Marie, who was married to Roussel. The pastel depicts the garden of the Villa Jacannette at l'Etang-la-Ville near Paris, which belonged to the Roussel family. Roussel settled for good at l'Etang-la-Ville in 1899, although he worked there at times before that. This fact may provide further evidence in favour of a later date for the Moscow painting, which, more likely than not, also depicts the garden of the Villa Jacannette. Remembering its trees and paths, Jacques Salomon called it "*merveilleux*".

Provenance:
Prince S. Shcherbatov Collection, Moscow; 1918 Rumiantsev Museum, Moscow; 1924 Pushkin Museum of Fine Arts; 1925 Museum of New Western Art, Moscow; 1948 Pushkin Museum of Fine Arts

Exhibitions:
1939 Moscow, p. 52; 1968 Paris–Munich, no. 55

Bibliography:
Catalogue 1928, no. 58; Réau 1929, no. 1159; Sterling 1957, pp.158, 221, note 137bis; *Catalogue* 1961, p. 46; Georgievskaya, Kuznetsova 1979, no. 213; Barskaya, Bessonova 1985, no. 201; Bessonova, Williams 1986, p. 258; *Catalogue* 1986, p. 51

GUSTAVE CAILLEBOTTE
Orange Trees. 1878
Beck Collection, Houston

20

The Room. 1899

Intérieur

Oil on cardboard pasted on parqueted panel. 52 x 79 cm
Signed and dated, top right: *E. Vuillard 99*
Hermitage, St Petersburg. Inv. no. 6538

ÉDOUARD VUILLARD
Man with a Pipe (Cipa Godebski). Late 1890s
Private collection, Paris

The painting is variously dated 1893 or 1899, because the last figure of the date is indistinct. As there were no essential changes in Vuillard's artistic manner during that period, it is difficult to tell exactly when the work was painted. However, the date 1899 seems to be more correct, since in the late 1890s the artist preferred to use grey, ochre and neutral tones which dominate this composition. Besides, the interiors painted in 1898–99, such as *Two Armchairs* (1898, private collection, Paris) or *Drawing-Room with Three Lamps* (ca 1899, Zumsteg Collection, Zurich), have the similar arrangement of figures and furniture. Lastly, the Hermitage picture is close in style to Vuillard's colour lithographs in the *Landscapes and Interiors* series published by Vollard in 1899. The organizers of the Vuillard and Roussel exhibition in Munich and Paris in 1968 titled the painting *Interior with a Stove* and dated it to 1899.

The man at the table in the centre of the picture may be Cipa Godebski, whom Vuillard depicted more than once. At any rate, the central figure in the Hermitage painting resembles the *Man with a Pipe* (late 1890s, private collection, Paris) who is known to be Godebski.

Provenance:
S. Shchukin Collection (acquired before 1908); 1918 First Museum of New Western Painting, Moscow; 1923 Museum of New Western Art, Moscow; 1930 Hermitage

Exhibitions:
1956 Leningrad, p. 15; 1968 Paris–Munich, no. 105; 1988 Tokyo–Kyoto–Nagoya, no. 33; 1993 Essen, no. 71; 1993–94 Moscow–St Petersburg, no. 71

Bibliography:
Muratov 1908, p. 137; *Catalogue* 1913, no. 5; Tugendhold 1914, p. 38; Tugendhold 1923, p. 62; *Catalogue* 1928, no. 56; Réau 1929, no. 1158; Sterling 1957, p. 158; *Catalogue* 1958, vol. 1, p. 367; *French 20th-century Masters* 1970, no. 4; Izerghina, Barskaya 1975, no. 106; *Catalogue* 1976, p. 245; Kostenevich 1987, no. 120; Kostenevich 1989, nos 138, 139

ÉDOUARD VUILLARD
Drawing-Room with Three Lamps. Ca 1899
Zumsteg Collection, Zurich

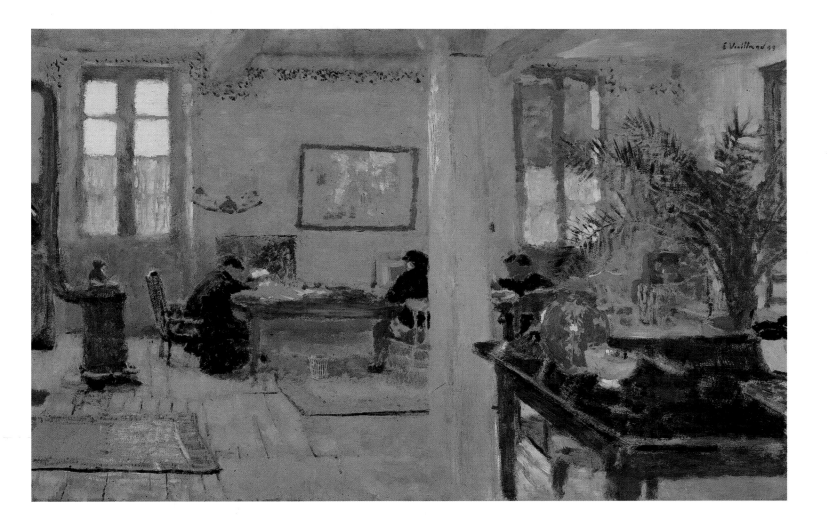

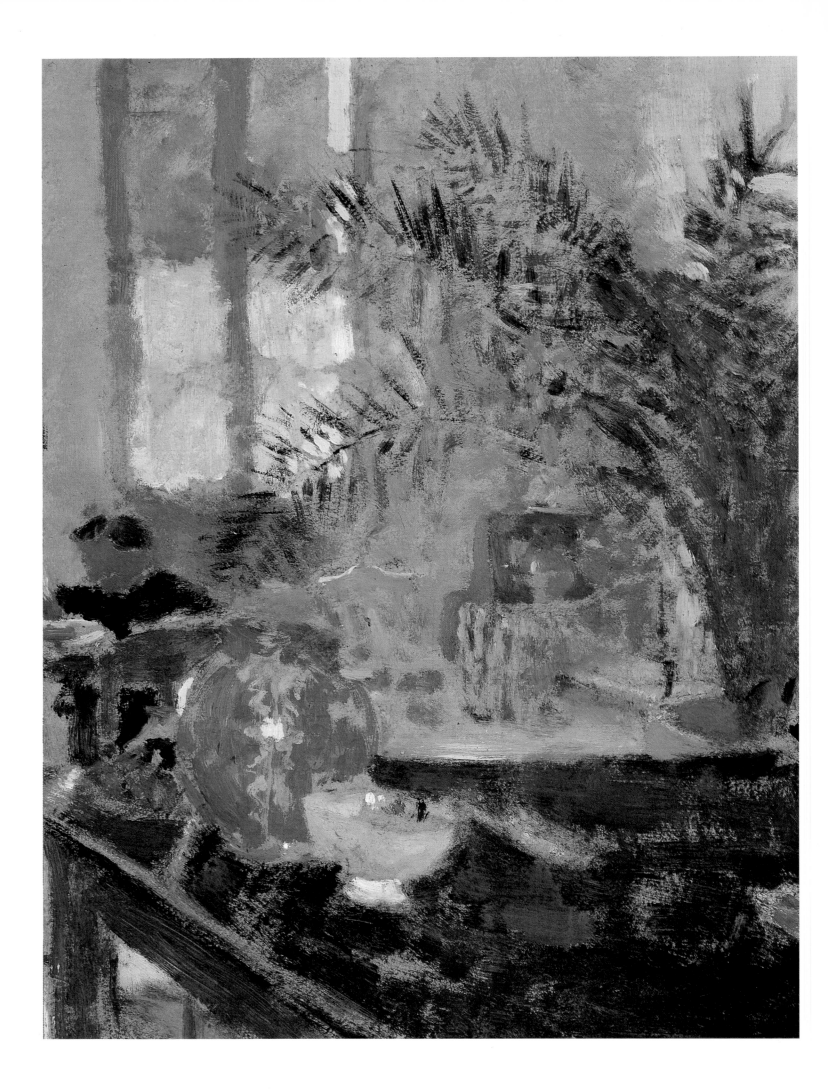

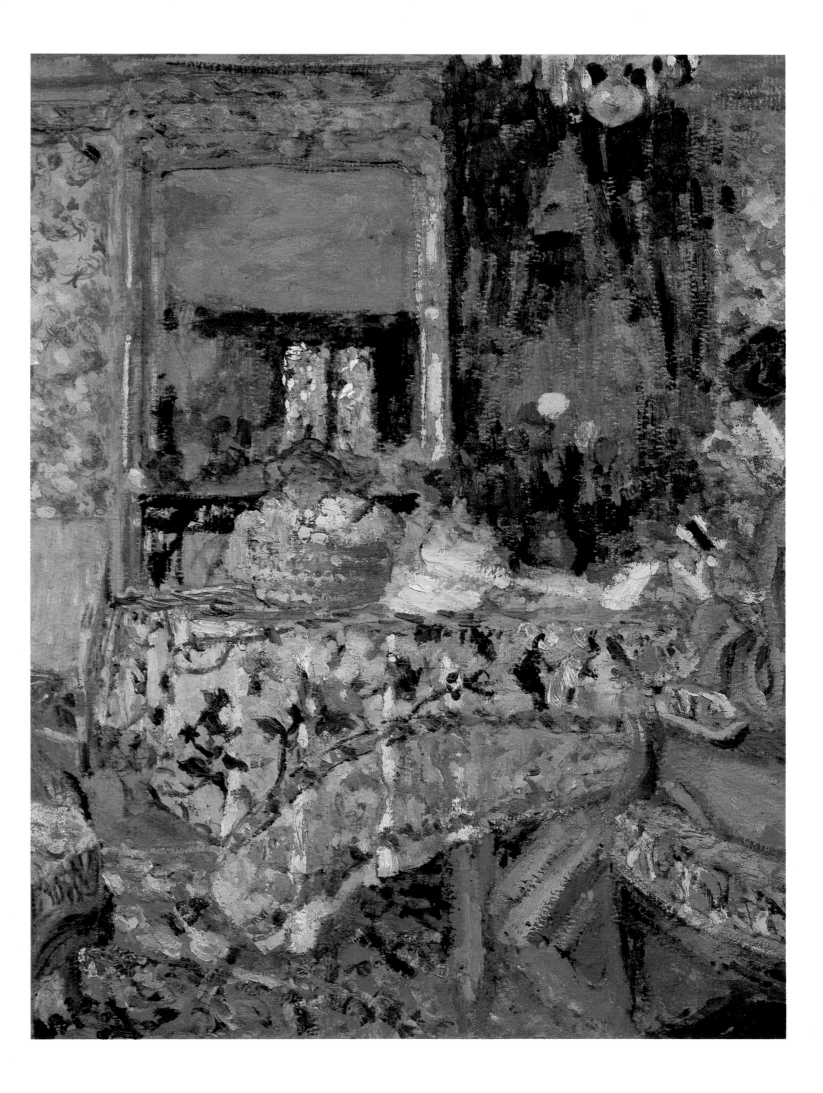

E Vuillard

21
In the Room. Ca 1903
Dans la chambre

Oil on cardboard. 50 x 77 cm
Signed, bottom left: *E. Vuillard*
Pushkin Museum of Fine Arts, Moscow. Inv. no. 3366

Although the painting in the Pushkin Museum was not produced at the same time as the Hermitage interior, the two have much in common, beginning with their dimensions and ending with compositional devices. Yet the feelings they produce are completely different. The one is as laconic and unsophisticated as the other is opulent and full of detail. Renoir in his time "dealt out" the same motif in deliberately disparate circumstances. That is how he was able to produce the pair of paintings *Dance in the Town* and *Dance in the Country*. At the same time Renoir did not attempt to give his subject any social colouring; he simply sought and found different types of attraction. Something similar occurred a quarter of a century later with Vuillard's interiors. It is a fact, though, that in Russia – where the special concerns of the intelligentsia meant that art, even at the turn of the century, continued to retain great social preoccupation – this picture acquired by Ivan Morozov was looked on if not as an example, then as a reflection of "bourgeois narrow-mindedness". It is interesting that such a refined critic as Yakov Tugendhold, whose opinion even the independently-minded Sergei Shchukin

took into consideration, wrote in 1912: "What dull narrow-mindedness, what a lack of spiritual inspiration there is in these objects! How obtrusive and inflexible the patterns of Vuillard's oilcloths, tablecloths, wallpapers and cups are!" If even Tugendhold failed to detect the unique picturesque quality in Vuillard, who was able to turn any object into an attractive patch of colour, then what hope was there for the rest?

The genesis of the Moscow interior goes back to such works of Vuillard's as *Married Life* (1894–95, private collection, Paris) and *The Roussel Family* (ca 1895, Mrs Charles Vidor Collection, New York). In the second half of the 1890s, the artist moved on to larger formats and more complicated constructions. At the beginning of the decade he was usually satisfied with the depiction of one, or less often two characters, as a rule in the relatively modest interior of his own home. In 1896 Vuillard painted four decorative panels, *Figures and Interiors*, for Doctor Vaquez (Petit Palais, Paris). The work on these opened up new horizons to him and the following year he produced *Large Interior with Six Characters* (Kunsthaus, Zurich), which he

presented to Félix Vallotton. The Pushkin Museum painting can to a certain extent be considered a variant of the Zurich work, although considerably inferior to it. At the same time, in common with the other Nabis, Vuillard followed the example of Monet, who never lost his appeal for him, and based a number of his interiors on the founder of Impressionism's *The Artist's Family at Dinner* (1868–69, E. G. Buhrle Collection, Zurich). Jacques Salomon's archive contains a photograph of the Moscow painting which is inscribed on the reverse: *Intérieur à Vasouy*. Vuillard spent the summer of 1903 at Vasouy, which is situated near Honfleur. This indication by Salomon, who had a great knowledge of the artist's work, enables us to correct slightly the 1904 dating traditionally assumed in the Pushkin Museum.

Provenance:
1904 Bernheim-Jeune Gallery, Paris; 1904
I. Morozov Collection (purchased from the Salon d'Automne); 1918 Second Museum of New Western Painting, Moscow; 1923 Museum of New Western Art, Moscow; 1948 Pushkin Museum of Fine Arts

Exhibitions:
1904 Paris, no. 1290 or 1295; 1979 Tokyo–Kyoto–Kamakura, no. 27; 1989 Helsinki, no. 30; 1993 Essen, no. 72; 1993–94 Moscow–St Petersburg, no. 72

Bibliography:
Makovsky 1912, p. 19; Ya. Tugendhold, "The Problem of the Still Life", *Apollon*, 1912, nos 3–4, p. 33 (in Russian); *Catalogue* 1928, no. 57; *Catalogue* 1961, p. 45; Georgievskaya, Kuznetsova 1979, p. 407, no. 604; Barskaya, Bessonova 1985, no. 204; *Catalogue* 1986, p. 51; C. Freches-Thory, A. Terrasse, *The Nabis. Bonnard, Vuillard and their Circle*, Paris, 1990, p. 293

ÉDOUARD VUILLARD
Luncheon at Villeneuve-sur-Yonne (Misia and Cipa Godebski). 1897
Private collection, London

E Vuillard

22

At the Window (Interior. Woman at the Window). Ca 1907–08

Coin de fenêtre. Intérieur. Dame à la fenêtre

Oil on cardboard. 40.2 x 33 cm
Signed, bottom right: *E. Vuillard*
Pushkin Museum of Fine Arts, Moscow.
Inv. no. 4256

In composition and manner of execution this painting is close to *Woman in an Interior* (1907, Leo M. Rogers Collection, New York) and so we can date it to roughly the same time.

The title *Woman at the Window* is better than *Interior* as the female figure is more than a detail or feature of the interior. She is placed in the foreground and presented as if posing for the artist rather than going about her own life. It is possible to suggest that this small painting, donated to the Pushkin Museum by the noted Parisian dealer and collector Max Kaganovitch, was a study for a portrait which was never produced.

Provenance:
Max Kaganovitch Collection, Paris; 1978 Pushkin Museum of Fine Arts (gift of Max Kaganovitch)

Exhibitions:
1978 Moscow, no. 23; 1982 Moscow, no. 493

Bibliography:
Barskaya, Bessonova 1985, no. 207

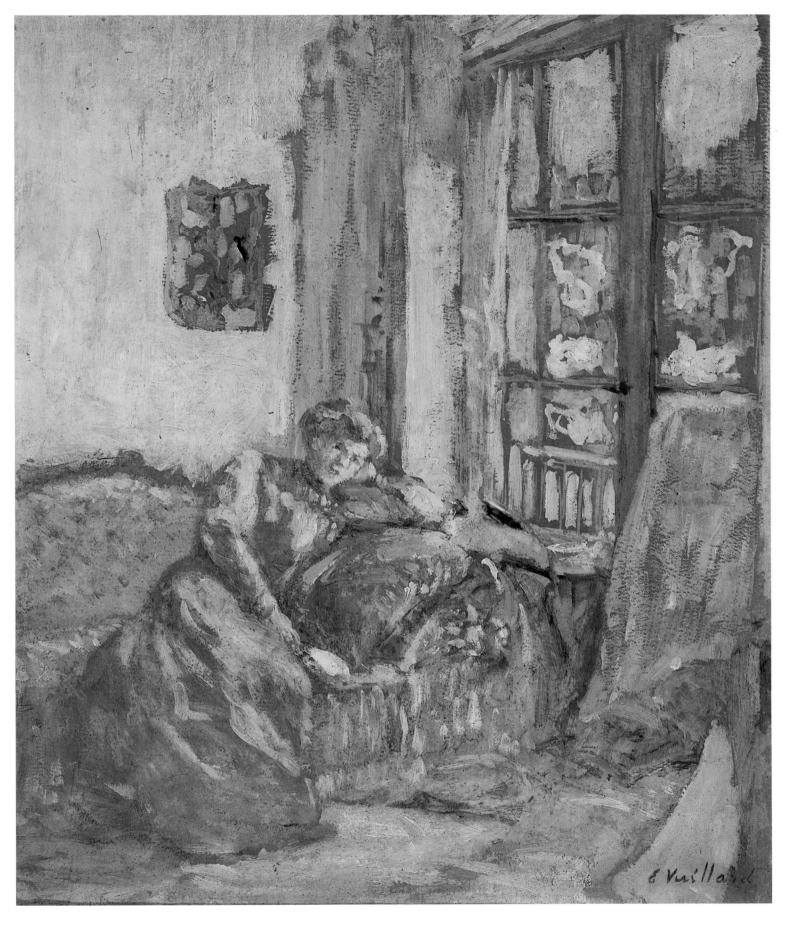

23
Children. 1909
Les Enfants

Tempera on paper pasted on canvas. 84.5 x 77.7 cm
Signed, bottom right: *E. Vuillard*
Hermitage, St Petersburg. Inv. no. 42153

ÉDOUARD VUILLARD
Children. Sketch for the painting
of the same name
Private collection

ÉDOUARD VUILLARD
Child in a Room. Ca 1900
Art Institute of Chicago

This picture stands somewhat apart in Vuillard's oeuvre: his interiors are usually much more cluttered with details, at times almost as if he had a phobia of empty space. They rarely display the openness seen in *Children*. The generalization and boldness in the use of large patches of colour make the painting different from other works that the artist created at the same time. These qualities can in part be attributed to the use of "Japanizing" principles in the construction of space, and the use of an elevated viewpoint in particular. The Japanese screen in the right-hand part of the room serves only as an additional reminder of the Nabis' previous interest in the art of Japan which even in the 1900s remained as strong as ever. A similar screen can, incidentally, be seen on an 1895 photograph of Thadée Natanson and Bonnard taken in Vuillard's home (published in Th. Natanson's book *Le Bonnard que je propose*, where it is no. 1 in the section *Bonnard en images*).

Vuillard had tackled a similar motif – the depiction of a child in an interior with a carpet on the floor and a "headlong" foreshortening of perspective – some years earlier in the painting *Child in a Room* (ca 1900, Art Institute of Chicago). The painting was created in Saint-Jacut-de-la-mer, a village on the Normandy coast to which Vuillard was invited by Alfred Natanson. A slice of the landscape at Saint-Jacut can be seen beyond the balcony. The artist maintained close connections with all three Natanson brothers, the sons of a rich banker who had between them founded the *Revue Blanche*. Each of them showed a very keen interest in Vuillard's painting. Alfred, the youngest brother, possessed several of his works. In 1900 Vuillard painted a portrait of him and his wife. Alfred Natanson was also active as a man of letters (under the pseudonym Alfred Atis) and collaborated with Tristan Bernard. Alfred Natanson's daughter Annette recalled the summer of 1909 at Saint-Jacut with Vuillard painting her and her sister Denise, while in the next room her father and Bernard worked on the new play *Les Costauds des Epinettes*.

There exists a pencil sketch for this painting (private collection; published on page 96 of B. Thomson's book *Vuillard*), which was undoubtedly done from life. The general features of the composition are already present in it, but a comparison of that draft with the painting shows that the real-life impression served only as a starting point which was then considerably modified in the course of work. The two sisters have changed places; the carpet has shifted from right to left. The Japanese screen with its free, "drifting" composition has appeared, introducing an extremely important note, which one might describe as greater freedom to breathe. In the sketch it is quite obvious that the children are sitting on a sofa. When looking at the painting, that is something one can only guess. It was the desire to depict the children which prompted Vuillard to take up his pencil. In the painting, however, the children play a noticeably less important role than in the sketch. Their faces cannot be seen, and they themselves have turned into patches of colour, no more significant than the others – the carpet, screen or door.

Provenance:
Bernheim-Jeune Gallery, Paris; M. Tsetlin Collection, Moscow; Rumiantsev Museum, Moscow; 1925 Museum of New Western Art, Moscow; 1934 Hermitage

Exhibitions:
1956 Leningrad, p. 15; 1985–86 Leningrad, no. 7

Bibliography:
Catalogue 1928, no. 60; Réau 1929, no. 121; Descargues 1961, p. 230; Izerghina, Barskaya 1975, no. 107; Kostenevich 1987, no. 121; B. Thomson, *Vuillard*, London, 1988, pp. 96f; Kostenevich 1989, no. 137

E Vuillard

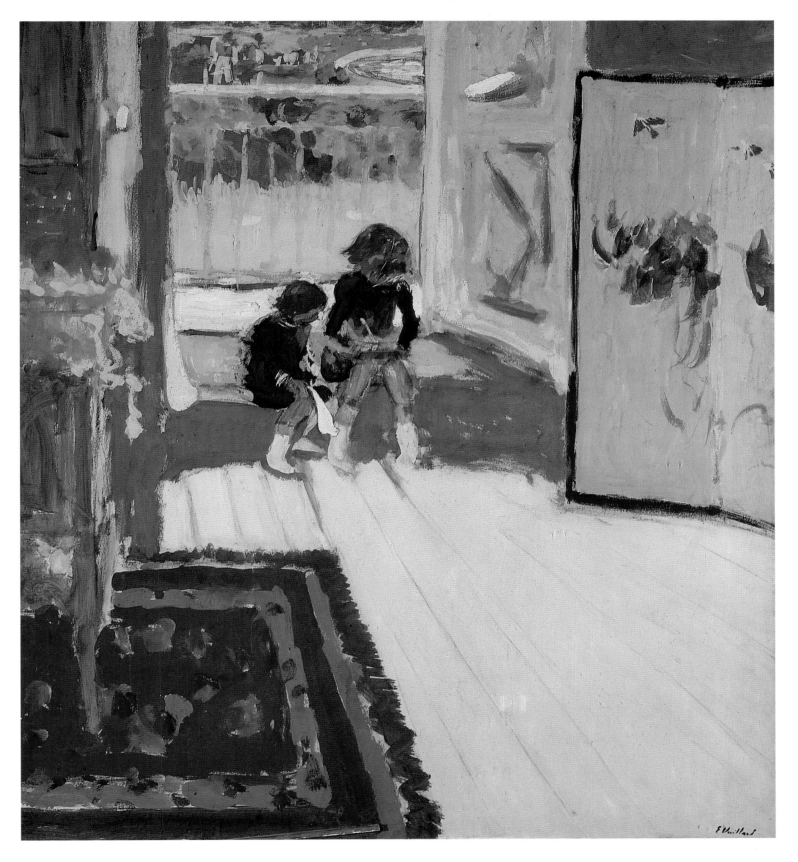

KER XAVIER ROUSSEL

1867–1944

KER XAVIER ROUSSEL
In the Snow
(Training the Dog). 1893.
Colour lithograph
Hermitage, St Petersburg

Roussel was born into the family of a well-known Paris physician who worshipped the arts and had a wide circle of acquaintances among artists. Doctor Roussel entrusted his son's training to a friend of his, Maillard, winner of the Prix de Rome. Maillard's studio had once belonged to Delacroix, so Roussel would often hear the great Romantic's name mentioned there, and was to be influenced by his vigorous colours in the years to come, although Maillard himself was entirely committed to the academic manner of painting. Vuillard, Roussel's fellow student at the Lycée, followed suit and began studying under Maillard, too. It was with Vuillard's family that Roussel found refuge when his parents separated, and he subsequently married Vuillard's sister.

The 1890s saw a strong similarity between the creative activities of Roussel and Vuillard. Roussel, like Vuillard, began by painting meticulous still lifes and making sketches of figures, though he was totally indifferent to interiors. Compared to Vuillard, he was more easily influenced, more dependent on Japanese art and the work of Puvis de Chavannes. The early years of the twentieth century were the crucial point in his career, when the themes of his painting as well as compositional and pictorial devices were being established.

The subjects of Roussel's art were shaped by his literary tastes. In his younger days he used to carry a book of Virgil's poetry about with him, and a great many of his mature canvases seem to have been inspired by *Bucolics*.

As for contemporary poets, he had the greatest admiration for Mallarmé and was particularly impressed by his *L'Après-midi d'un faune*. When he was teaching at the Académie Ranson, he would bring with him a volume of Mallarmé and read out poems to his students, believing that they would stir their imagination better than any instruction or exhortation. The motifs of his own art were chiefly fauns and nymphs, Bacchanal dances and pastoral idylls.

Roussel obviously strove to create a modern version of the "historical landscape", not anaemic or sugary-sweet, like the works of the Salon *maîtres*, but vigorous and genuinely picturesque, and it was for that reason that he shared Cézanne's esteem for Poussin. He was also fascinated by Cross, whose pictures were a luscious blend of myth and reality. In 1906,

Roussel and Denis visited Provence and made pilgrimages to Cézanne at Aix and Cross at Saint-Clair. This trip became an important landmark in Roussel's career.

Making a record of their visit to Cézanne, Denis wrote that his studio was adorned with a reproduction of Poussin's *Arcadian Shepherds*. This painting provided a major starting point for Roussel. It is not known whether they spoke of Poussin at their meeting, but we do know that Cézanne's thoughts often turned to Poussin. His cherished ambition was to enliven Poussin by making use of a natural setting or transform him in concord with nature. In fact, Roussel had conceived the same idea long before the visit to Cézanne. In March 1898, Denis wrote in his diary, "Roussel says he wonders what made Poussin modify his beautiful sketches in such a way that the paintings turned out to be quite unlike the sketches".[1]

These modifications were chiefly the consequence of the artist's ideas not finding their ultimate expression until he put the finishing touches to his work when making a sketch into a picture. The point is that the Old Masters had a desire to be understood by their customers and other people sharing the same views, whereas the pioneers of new art who worked at the time of conflict between the Salon and avant-garde artists, used to look down on the general public and remained distrustful of the masses. Of course, Poussin knew the worth of the natural free and easy brushwork and application of colours, but for him these values were not decisive, much less the only condition for creating a work of art. Late-nineteenth-century artists were preoccupied with the idea of spontaneity, but they found themselves obliged to follow the precepts of the Old Masters when dealing with vast spaces, especially in decorative and monumental compositions. However, to do so did not necessarily mean to accept those precepts wholeheartedly. It was the urge for artistic spontaneity that made Roussel re-paint the finished canvases time and again, far from always improving the original version.

On the other hand, Roussel's ardent nature and individualism might well have been what kept him from resorting to banal stylization. Was it chance that politically he tended towards anarchism? He was keenly aware

[1] M. Denis, *Journal*, vol. 1 (1884–1904), Paris, p. 143

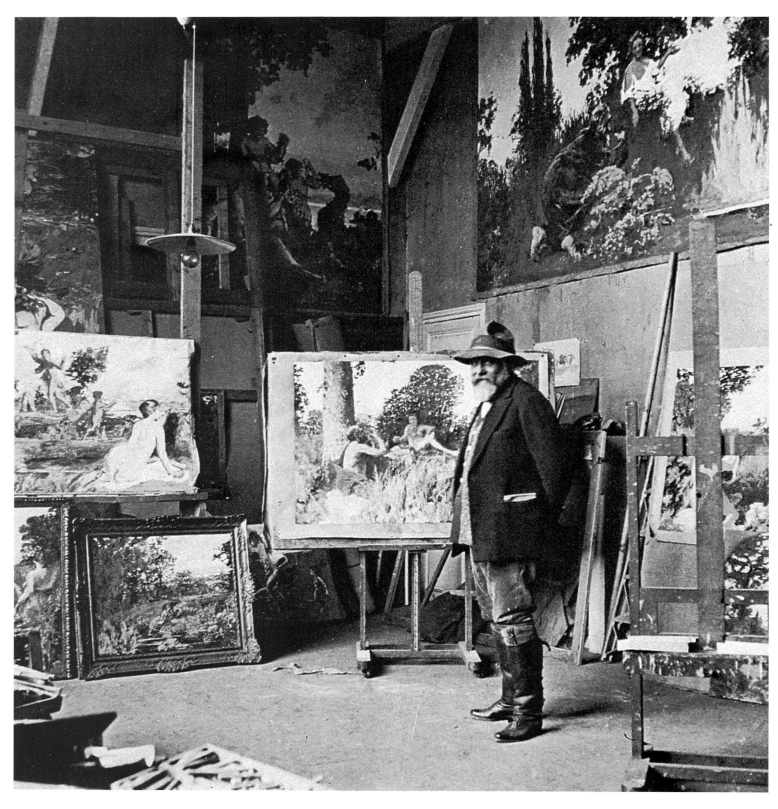

Ker Xavier Roussel
in the studio. Photograph

of the poetic quality of Mediterranean myths. As early as the 1890s, Roussel was painting landscapes with nude and half-clothed figures, in which the line between myth and reality was practically obliterated. His pastoral scenes are far from being a mere play of imagination. They look amazingly true to life and are capable therefore of striking a humorous note.

Roussel's Arcadia is indeed sparkling with the vivid colours of the French Mediterranean wielded by an artist inspired with a profound love for nature. A joyful eulogy in praise of the abundant south and life itself is to be found in Roussel's *Rural Festival*, permeated with the sweeping and exultant spirit of the ancient pagan world.

1867
Ker Xavier Roussel born at Chêne, near
Lorry-lès-Metz

1870
The Roussels move to Paris

1878
At the Lycée Condorcet, where he meets
Vuillard and, later (1882), Denis

1886
Studies under Maillard

1888
At the Académie Julian. Friendship with Sérusier,
Ibels, Ranson and Bonnard. Their circle joined
by Vuillard and Denis

1891
Participates with Bonnard and Vuillard in
the first exhibition at the Le Barc de Boutteville
Gallery

1893
Marriage to Vuillard's sister

1895
Like Vuillard, frequently visits Thadée Natanson
at Valvins

1896
Vollard commissions from Roussel a series of
lithographs, *Album du Paysage*, on which he works
between 1897 and 1899

1899
Trip to Venice with Vuillard and Bonnard.
All three exhibit at the Bernheim-Jeune Gallery
(until 1914, on a regular basis). Eventually settles
down at l'Etang-la-Ville

1900
Acquires his own manner of painting with
a picturesque and free treatment of allegoric
and mythological subjects

1901
First exhibits at the Salon des Indépendants

1902
Trip to Holland with Vuillard and the Hessels

1902–14
Spends most summers in Normandy

1904
First exhibits at the Salon d'Automne

1906
Teaching at the Académie Ranson. Joins Denis
in visits to Cézanne at Aix and Cross
at Saint-Clair

1909
Produces decorative panels for the Bernheims
and Lugné-Poë

1912
Roussel–Rodin exhibition at the Giroux Gallery,
Brussels

1913
Designs curtain for the Théâtre de la Comédie
des Champs-Elysées

1915
Convalescing in Switzerland. Friendship with
the art collector Hahnloser and his family.
Commissioned by the Art Museum in Winterthur
to paint two decorative panels

1925
Paints decorative panels for Lucien Rosengart

1926
Wins the Carnegie Prize

1930
Makes numerous lithographs. Vollard's studio
at his disposal

1932
Illustrates *Poems* by Maurice de Guerin

1936
Begins the panel *Pax Nutrix* for the Palace
of Nations, Geneva

1937
Panel *Dance* for the Palais Chaillot, Paris

1939
Goes to Geneva with Vuillard to complete
the panel at the Palace of Nations

1944
Roussel dies at l'Etang-la-Ville

K. X. roussel.

24
Mythological Subject. Ca 1903
Sujet mythologique
Oil on cardboard. 47 x 62 cm
Hermitage, St Petersburg. Inv. no. 9065

KER XAVIER ROUSSEL
By the Sea. Ca 1903
Musée du Petit Palais, Paris

The alternative title of this picture is *The Nanny-Goat* (under which it was exhibited at the Bernheim-Jeune Gallery). The painting does not illustrate any particular myth, representing rather a variation on the Arcadian theme. The nudes are interpreted by the artist as mythological characters, their poses having been borrowed from the paintings by seventeenth-century masters. The composition, showing people besporting themselves with animals, alludes to a Dionysian motif. Athenians worshipped Dionysus, who wore a black goat's skin, and called him the Kid. Thus, the female nudes depicted in the painting may be interpreted as Bacchantes.

Roussel turned to mythological subjects from 1900 onwards. Before that he treated his compositions showing people with animals as everyday scenes (*Child with a Nanny-Goat*, ca 1890, private collection, Paris). Roussel's mythological pictures, possibly created under the influence of Cross, are not devoid of details inspired by contemporary women's fashions, which demonstrates the playful humour of the Nabis. In the Hermitage picture the women's hairstyles match those which were in vogue in the early twentieth century. The subject of the work suggests that Roussel depicted the Mediterranean

coast. Some art experts date the picture around 1906, when Roussel and Denis visited Provence. But they travelled in winter, whereas the dominant colours of the landscape in *Mythological Subject* are autumnal.

The painter had been to the Mediterranean coast before 1906. As early as 1899 he visited Le Cannet, from where he and Vuillard went on to Venice. The painterly qualities of the picture and the treatment of the female figures place it closer to the works *By the Sea* (ca 1903, Musée du Petit Palais, Paris) and *Women Bathers* (1903, Bernheim-Jeune Collection, Paris), and in particular to the studies for the latter composition. Thus, *Mythological Subject* should be dated about 1903.

Provenance:

Bernheim-Jeune Gallery, Paris; 1911 K. Nekrasov Collection, Moscow (purchased at the Bernheim-Jeune Gallery through the mediation of P. Muratov); S. Poliakov Collection, Moscow; before 1917 Pavel and Sergei Tretyakov Gallery, Moscow; 1918 Tretyakov Gallery, Moscow; 1925 Museum of New Western Art, Moscow; 1948 Hermitage

Exhibitions:
1995 Ibaraki–Tokyo–Mie, no. 38

Bibliography:
Catalogue 1917, no. 4339; Catalogue 1928, no. 532; Réau 1929, no. 1098; Catalogue 1958, vol. I, p. 437; Izerghina, Barskaya 1975, no. 93; Catalogue 1976, p. 290; Kostenevich 1984, p. 200; Kostenevich 1989, nos 122, 123

KER XAVIER ROUSSEL
Child with a Nanny-Goat.
Ca 1890
Private collection, Paris

K.X. roussel.

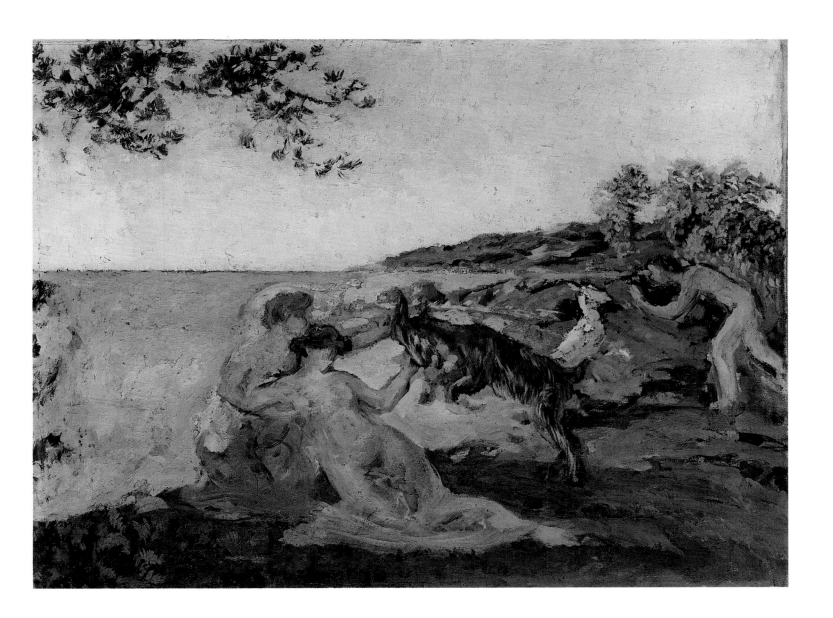

K.X. roussel.

25
The Triumph of Bacchus (Rural Festival). 1911–13
Le Triomphe de Bacchus (Fête champêtre)
Oil on canvas. 166.5 x 119.5 cm
Signed and dated, bottom right: *K.X. Roussel 913*
Hermitage, St Petersburg. Inv. no. 9165
Companion piece to no. 26

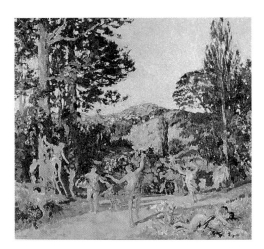

KER XAVIER ROUSSEL
Study for the curtain of the Théâtre
des Champs-Elysées
Private collection, Paris

In the early twentieth century Roussel painted landscapes with half-naked and naked figures, which can be regarded both as modern idylls and as mythological pastoral scenes. Although the subject of this picture was treated by Roussel in a modern key, the artist nevertheless followed an old tradition in representing the Bacchic dances linked with the grape-harvest, which included the attributes usual for the subject – the thyrsus, flute and timbrel.

Certain motifs present in previous mythological compositions are developed further in this picture. For example, the central character resembles the dancing figure in the painting *Cupids and a Little Dog* (1905, private collection, Paris). Roussel painted the picture, as well as its pendant (see no. 26) in 1911. That same year, it was exhibited at the Salon d'Automne under the title *A Mythological Scene*. In 1913, after Ivan Morozov had bought both works, they were repainted by the artist in brighter colours and acquired a more decorative quality. This repainting may be connected with Roussel's work on the curtain of the Théâtre des Champs-Elysées in Paris. The curtain, commissioned by the architect Perret, also represents Bacchic dances.

In the early 1920s Boris Ternovets, who directed the work of the Museum of New Western Art, wrote in his book on the Morozov collection that Roussel had repainted both canvases when he found

out that they would be placed next to Matisse's works. Ivan Morozov did not like the new versions, however. Traces of the original greyish-brown tonality are still visible along the edges of *The Triumph of Bacchus*.

Provenance:
1911 Vollard Gallery, Paris; 1913 I. Morozov Collection (purchased from Vollard for 10,000 francs); 1918 Second Museum of New Western Painting, Moscow; 1923 Museum of New Western Art, Moscow; 1948 Hermitage

Exhibitions:
1911 Paris, *Salon d'Automne*, no. 1413; 1968 Yerevan (no catalogue); 1981 Mexico City, no. 31; 1988 Tokyo–Kyoto–Nagoya, no. 36

Bibliography:
Gazette des Beaux-Arts, 1911, November, p. 379 (reprod.); *Catalogue* 1928, no. 530; Réau 1929, no. 1099; *Catalogue* 1958, vol. 1, p. 437; Izerghina, Barskaya 1975, no. 94; *Catalogue* 1976, p. 289; Ternovets 1977, p. 114; Kostenevich 1987, no. 130; Kostenevich 1989, no. 121

ADOLPHE WILLETTE
Eve's Games. Ca 1904. Fresco
for the Paris cabaret *Bal Tabarin*

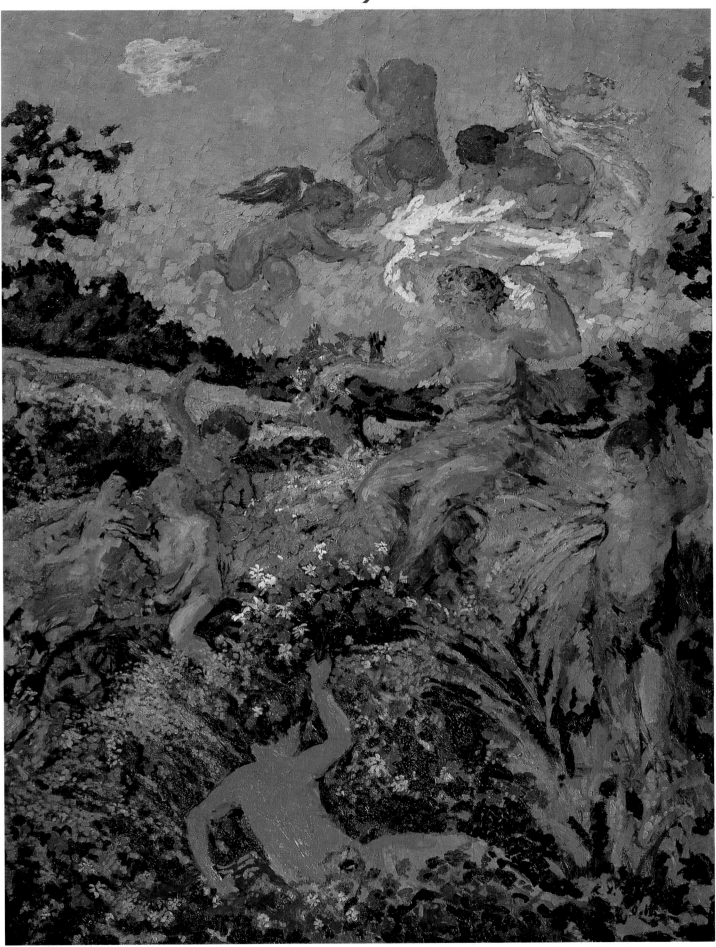

K.X. roussel.

26

The Triumph of Ceres (Rural Festival). 1911–13
Le Triomphe de Cérès (Fête champêtre)
Oil on canvas. 164 x 123 cm
Signed and dated, bottom right: *K.X. Roussel 0.13*
Pushkin Museum of Fine Arts, Moscow. Inv. no. 3408
Companion piece to no. 25

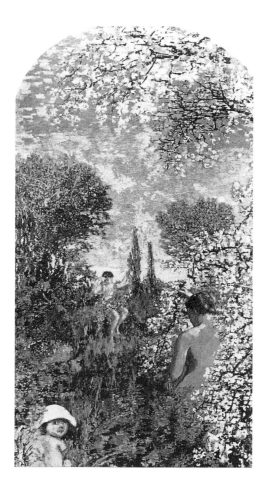

KER XAVIER ROUSSEL
Decorative panel for Lucien Rosengart's house. 1925–26
Private collection, Paris

It is hard to say how the two panels were placed in Morozov's collection. Neither of them displays any firm bias towards a position on the left or right. As they came into Morozov's possession in 1913, the paintings were not included in the catalogue of his collection, and we do not even know what their first owner called them. The traditionally established common title *Rural Festival* was given to them in the Museum of New Western Art reflecting a tendency to demythologize typical of the early Soviet period. It is more correct to call the Moscow painting *The Triumph of Ceres* and its Hermitage companion *The Triumph of Bacchus.* In comparison with the latter, this second "apotheosis" appears considerably less polished in its composition. The additional work which Roussel did on the paintings in 1913 (here mainly affecting the figure of Ceres, the cupids in the sky, the dancing boy on the left and the youth with a wheatsheaf on the right) would seem to have harmed it more than its St Petersburg pendant.

In turning to a subject which had for long years remained the undisputed preserve of academists and alien to the interests of the avant-garde, Roussel attempted to treat it in a modern way, so decorative and generalized that not all the details

can be made out with the distinctness expected in such subjects. The artist depicted Ceres with a cornucopia, riding in a chariot drawn by panthers which are steered by naked boys. Cupids are hurriedly unfurling a white veil over the goddess's head, a detail which allowed the artist to set his central character apart. Roussel treats the Baroque compositional scheme with all the freedom of which a Post-Impressionist was capable. He, of course, knew Poussin's *Triumph of Flora* in the Louvre, as well as other mythological "triumphs" of the Classical period. Among these, notably, would have been the large painting (also in the Louvre) from Rubens's cycle dedicated to Marie de'Medici that features a chariot drawn by lions ridden by boys. Both the *Rural Festivals* anticipate Roussel's work on the curtain of the Théâtre des Champs-Elysées. The detail of a boy riding on a panther reappeared in that composition.

Provenance:
Vollard Gallery, Paris; 1913 I. Morozov Collection; 1918 Second Museum of New Western Painting, Moscow; 1923 Museum of New Western Art, Moscow; 1948 Pushkin Museum of Fine Arts

Exhibitions:
1911 Paris, no. 1414

Bibliography:
J. René, "Le Salon d'Automne", *Gazette des Beaux-Arts*, 1911, Nov., p. 378; *Catalogue* 1928, no. 531; Réau 1929, no. 1097; Ternovets 1977, p. 114; Georgievskaya, Kuznetsova 1979, p. 401, no. 501 (the Hermitage painting of the same name is mistakenly reproduced on p. 399); Barskaya, Bessonova 1985, no. 200; *Catalogue* 1986, p. 156

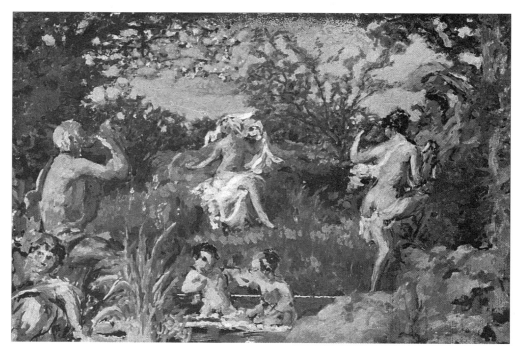

KER XAVIER ROUSSEL
The Miraculous Spring

K.X. roufrel.

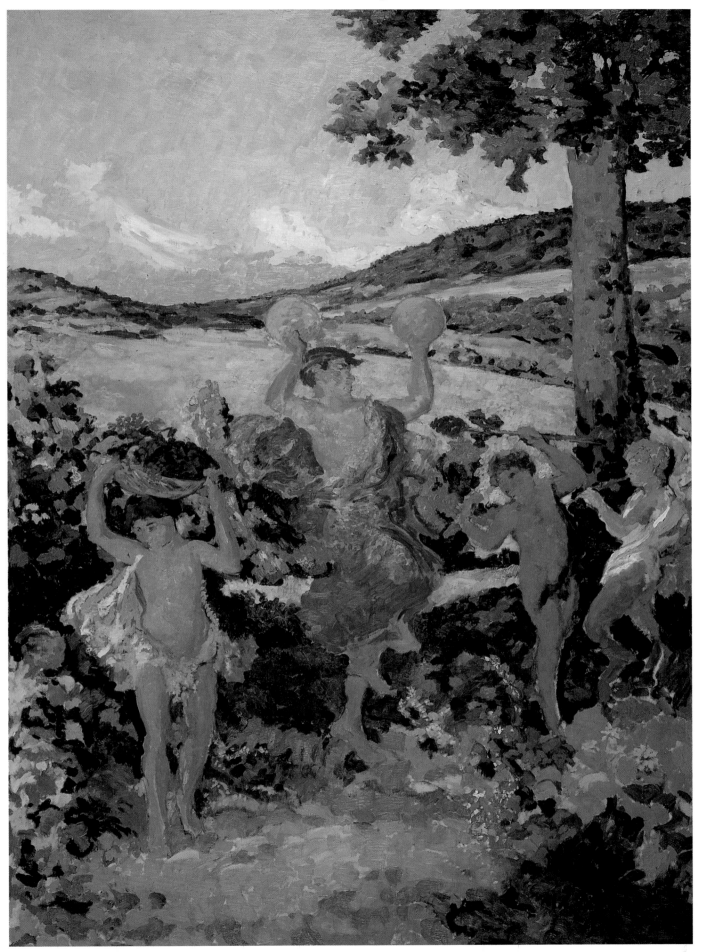

MAURICE DENIS
1870–1943

Maurice Denis

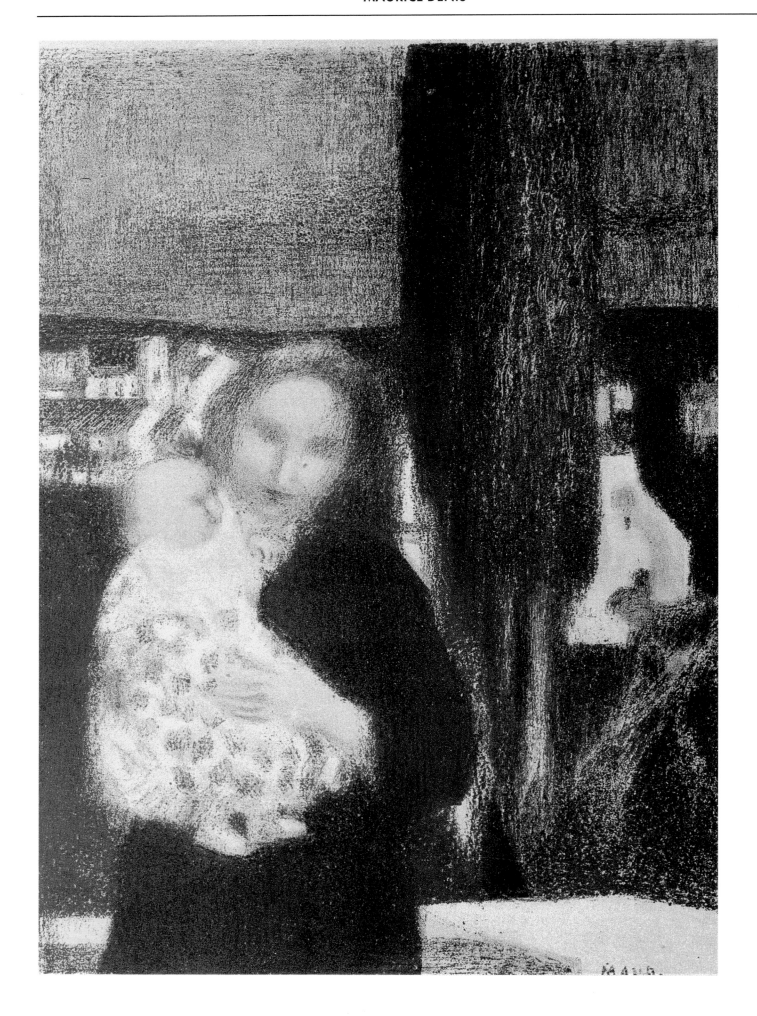

Denis was born at Granville, where his parents had fled from the Franco-Prussian War. His boyhood and adolescence were spent at his parents' home at Saint-Germain-en-Laye and also in Paris. In the course of his numerous travels Denis frequently visited Italy, for he held the art of that country in great esteem. He attended the Lycée Condorcet, which laid the foundations for his extraordinary breadth of knowledge and his future artistic associations.

As a boy Denis was ambitious. One of the first entries in his diary, which he kept till the end of his life, was a proud mention of the fact that he had won second prize for French, first prize for history and second for drawing. He was not yet 14 years of age then. Subsequently he was to win many more honours, including the membership in the Académie. His personality not being very strong, he was incapable of becoming a leader. Verkade remarked after the Nabis had formed a group, "He was like a girl tied to her mother's apron-strings". [1] Nevertheless, he was full of vitality. It was he who helped Sérusier, at the Académie Julian, to bring together a group of students sharing the same ideas. Eventually he became one of the organizers of the Salon d'Automne. He always wished to play a prominent part in the artistic life of Paris, not only as a painter, but also as art critic, theorist, instructor and even preacher.

Denis was profoundly pious from childhood. He wrote in his diary in May 1885, "Yes, I must become a Christian painter and eulogize all the wonders of Christianity; I feel that this is necessary". [2] His quest to combine art and religion, which became apparent during his Nabi period, eventually and logically resulted in his setting up the Ateliers d'Art Sacré in 1919 and joining the Franciscan order.

However, Denis was too much of an artist to remain merely a minister of religion at such a time as the late nineteenth century. For it was he who, at the age of twenty, coined the statement that first appeared in the journal *Art et Critique* under the pen-name of Pierre Louis and was to be echoed by avant-garde artists in the decades that followed: "A picture – before being a war horse, a female nude, or some anecdote – is essentially a flat surface covered with paints in a particular order". [3] This statement, slightly altered, came to express the aesthetic programme of Symbolism: "... the sounds, colours and words are wonderfully expressive regardless of any representation; indeed, regardless of the actual meaning of the words". [4]

In 1901 Denis exhibited a large canvas called *Homage to Cézanne* at the Salon de la Société Nationale des Beaux-Arts (1900, Musée d'Orsay, Paris), which could be regarded as a manifesto of the new art. It was a full-length group portrait of himself, Redon, Sérusier, Bonnard, Roussel, Vuillard and Vollard standing round a still life by the then little-known artist. The Nabis were enthusiastic admirers of Cézanne, and Denis was among his first advocates and expounders, although his own art owes little to Cézanne. He was much closer to Gauguin, not only when he was first impressed by his *Talisman*, but also years later. Incidentally, the Cézanne still life on the easel in the *Homage* belonged to Gauguin, a fact that those "in the know" were aware of.

It is only natural that by smoothing away the harshness present in the art of Cézanne and Gauguin, Denis should have gained fame quickly, while the other two did not achieve real recognition during their lifetimes. Yet this is not to say that Denis practised such artistic methods with the sole purpose of becoming successful. In the first place, there were shorter and safer ways to early fame by becoming an academic painter; secondly, such qualities as softness, refinement and prettiness were innate in Denis's character and passed on to his art. It seems probable that Denis would have arrived at the style of his own even without Gauguin's influence, although it might have come somewhat later and with some slight differences. Even before he became acquainted with Gauguin's art, Denis was strongly attracted by simplified forms, soft decorative effects and lofty themes. When visiting the Puvis de Chavannes exhibition, 17-year-old Denis was enchanted by the "wonderful, quiet and simple decorative quality of his pictures and by their compositions producing a delightful and mysterious effect on the soul". [5] Puvis de Chavannes, Gauguin and Early Renaissance Italian masters led Denis to think that "synthesizing is not just simplifying or eliminating some details of the object; but simplifying means making things clearer, briefer, more orderly, subordinating the details to a single dominant rhythmical

MAURICE DENIS
Woman and Child. 1897.
Lithograph
Hermitage, St Petersburg

[1] Dom W. Verkade, *Le Tourment de Dieu*, Paris, 1926, p. 78

[2] M. Denis, *Journal*, vol. 1 (1884–1904), Paris, 1957, p. 59

[3] M. Denis, *Théories. 1890–1910*, Paris, 1913, p. 1

[4] M. Denis, *Sérusier, sa vie, son œuvre*, Paris, 1943, p. 64

[5] M. Denis, *Journal*, vol. 1, p. 67

pattern, making sacrifices, revealing dependence, coming to generalizations". [1]

From a fascination with Puvis de Chavannes and Gauguin, Denis went on to study the art of Poussin, Raphael and Fra Angelico. He departed from the original simplicity of form, without noticing himself that it amounted to sharing the views of academicism. These changes, however, did not become apparent until the early years of the twentieth century. The 1890s were a distinct stage in Denis's career, when his painting was sincere and gently poetic, marked by a quiet elegance of style entirely his own. Only occasionally did his taste fail him at that time, something that cannot be said of the 1900s nor especially of the 1910s–1930s. At the turn of the century Denis's religious experience made him look back on the past as a time of still unshaken faith, an attitude shared by many artists and strengthened by the revival of religion in Europe, brought about by the crisis of Positivism.

In turning to biblical subjects (*The Visitation*, *Martha and Mary*), Denis was dealing with exceptionally enduring iconographic traditions. But at a time when any kind of art was expected to be imaginative and demonstrated new solutions, Denis could not confine himself to an accustomed compositional scheme. It was a great challenge to give biblical subjects a new

treatment; it was a still greater challenge to make this treatment simple and natural. Denis achieved this by making use of gently outlined forms, subtle rhythmic patterns and a skilled choice of the details of the setting. It was in such biblical paintings as *Martha and Mary* that Denis's Neo-Traditionalism attained its finest expression.

The deep-rooted tradition of portrait-painting is violated in *Martha and Mary* in that the figures in the foreground are more vague than the landscape in the background. Denis first used this device in his lithographs and subsequently it found its way into his paintings. The intention was to emphasize the religious context. The overall mood of the canvas, the obscuring of details, all the more noticeable and deliberate because they pertain to the images of Christ and other biblical characters depicted as large-scale figures, distinguish Denis's work strongly from the religious paintings of Gauguin, an artist who had obviously "stepped away" from Symbolism. Denis rather affiliated himself with the artists who "stuck by" that movement and adhered to obscure, mystic images, "smoky" in the case of Carrière, glowing with Gustave Moreau, nocturnal with Levy-Dhurmer or very light with Redon whose blend of colour and light made the faces in his canvases look ephemeral. *Martha and Mary* is a most

MAURICE DENIS
Tenderness. 1893.
Colour lithograph
Hermitage, St Petersburg

MAURICE DENIS
Snow-Covered Fields. 1895
Jean-Baptiste Denis
Collection, Paris

[1] M. Denis, *Théories*, p. 251

MAURICE DENIS
The Nativity.
Colour lithograph
Hermitage, St Petersburg

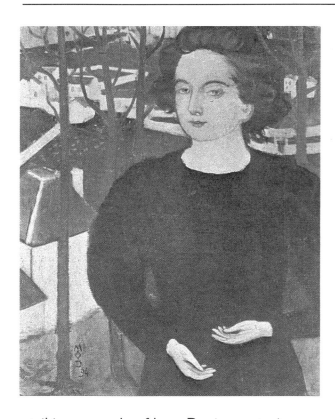

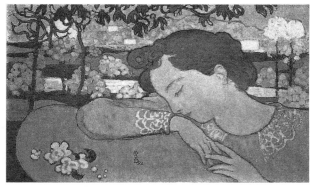

MAURICE DENIS
*A Girl Who Could
Be Called a Page*. 1894
Musée du Prieuré,
Saint-Germain-en-Laye

MAURICE DENIS
Sleeping Girl. 1892
Musée Bonnat, Bayonne

paintings mostly depict female characters. This preference indeed determined his choice of subjects. Only infrequently did he turn to dramatic episodes, for they were alien to his rather feminine talent.

Denis's portrait and genre paintings created in this same period are also imbued with an air of controlled solemnity peculiar to religious art. *Portrait of Marthe Denis, the Artist's Wife* (1893, Pushkin Museum of Fine Arts, Moscow) captures purely casual details: Marthe is portrayed adjusting her shoulder-strap, and a woman in the background is taking washing off the line. But these details only slightly obscure the classical character of the picture. *The Encounter* is reminiscent of *The Visitation* and is seen as some formal act worthy of a painter's brush. Denis's scenes of motherhood are always suggestive of the Virgin and Child. The sincerity of Denis's emotion helped him to keep up to the mark even in such idyllic pictures as *Mother and Child*. He was tempted by the kind of colour scheme that is almost sickly sweet, and at times he could not resist the temptation. This hazard was happily avoided in the portrait of his wife Marthe and daughter Noël now in the Hermitage. With great discretion Denis softened the striped pattern of the mother's dress, which is used to set off the baby's white robe. By this simple device he manages to avoid monotony, skilfully bringing into harmony the curved outlines of human figures and the rectangular shapes of the doors, windows and the frame on the wall.

The Christian art tradition is also very noticeable in a few pictures based on real events, *Sacred Spring in Guidel* being one of them. This small-scale, intensely picturesque painting is superior to many large-sized genre compositions with some story to them. It provides an impressive example of what Denis's gift as a colourist could have developed into

striking example of how Denis was trying to bridge the gap between Gauguin and Redon. Biblical subjects are often associated in Denis's early pictures with his personal experiences, an attitude similar to Gauguin's. The figure on the right in *The Visitation* is an idealized likeness of Marthe, the artist's wife. When the picture was being painted, she was pregnant. Denis treated the biblical scene as a sublime equivalent of reality, so that it acquired a special significance for him.

His marriage to Marthe Meurier in 1893 was a major event in his life. From that time onwards most of his female figures bore a resemblance to his wife. She was depicted by Denis in his religious works as an ethereal, or indeed incorporeal, creature, which in fact she was not, as the portrait of her in the Pushkin Museum of Fine Arts clearly shows. Paintings like *Martha and Mary* can be perceived as having two facets: one traditional, that of a biblical story, the other intimate and more obscure.

In both *The Visitation* and *Martha and Mary* the two female characters look uncannily alike. With regard to the former painting, this similarity may be accounted for by the fact that they are close relatives. But even if the characters are not related, Denis still deliberately adhered to his favourite types. This duplication smooths away all idiosyncrasies and transfers the painting into the realm of allegory. Denis's biblical

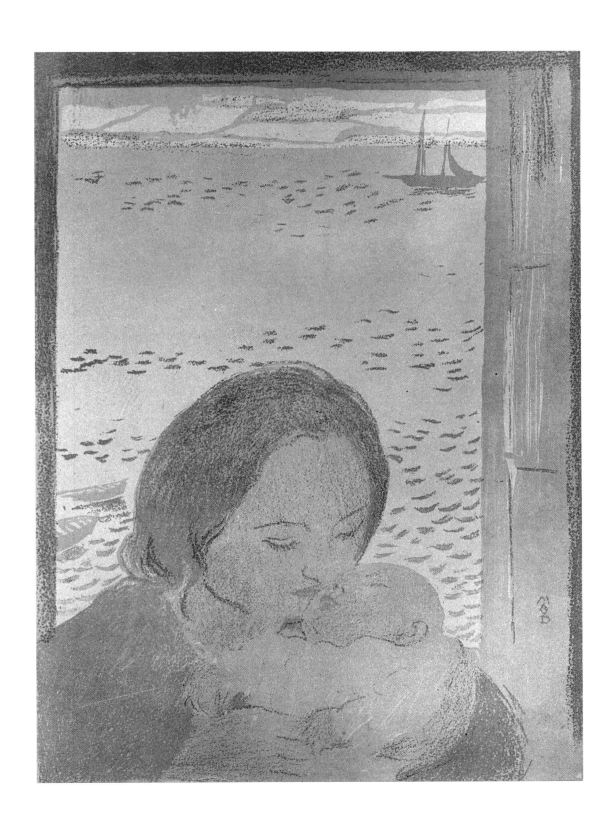

MAURICE DENIS
Mother and Child by the Sea. 1900.
Colour lithograph
Hermitage, St Petersburg

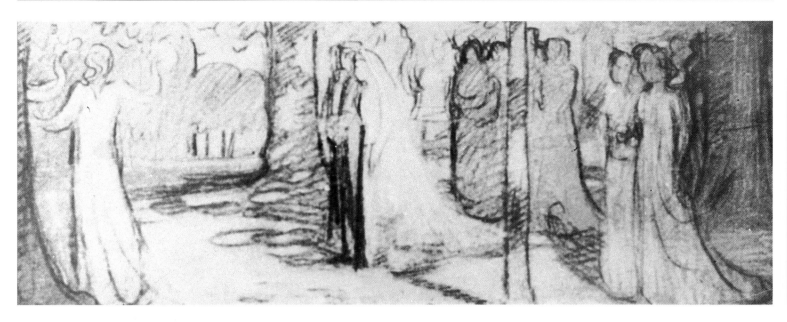

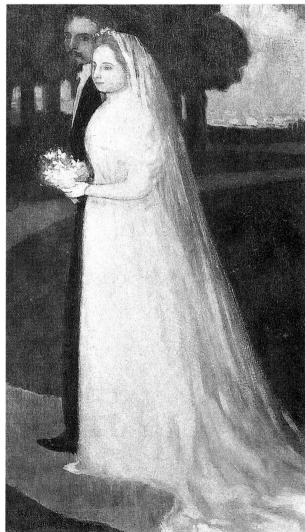

allegoric and evanescent quality and the elaborately bizarre style, as well as the numerous allusions it evokes, this painting is akin to Symbolist poetry. Though profoundly personal, it gives objective expression to a whole programme of Symbolism, which requires a measure of erudition and contemplation on the part of the viewer.

Figures in a Springtime Landscape is a splendid demonstration of how Gauguin's manner was adapted by Denis. It is not only that symbolism becomes more involved. After *Wedding Procession* or *The Visitation*, this canvas marks a divergence from Denis's earlier flatly treated paintings stimulated by his visits to Italy where he was influenced by the Renaissance painting. The scope of different allusions brought to mind by *Figures in a Springtime Landscape* is amazing: old tapestries, Neo-Impressionism, Raphael and Puvis de Chavannes. The painting is designed in such a way that all details are reduced to a single common denominator: the outlines of the female nudes and the drapery echo each other and also the contours of the trees. However, Gauguin's method of rhythmical similarities is only sparingly employed by Denis. By flattening the surface of the picture, Denis strives for a pattern of lines that would not only delineate the patches of colour, but also be one with them, striking the same chord. The delicate interlacing of streaming lines is in harmony with the subtle colour scheme that is dominated by pinkish hues. Unlike Gauguin, Denis had a desire to be liked, which is still further evidence of the feminine nature of his art.

MAURICE DENIS
Wedding Procession. 1892
Drawing. Sketch for
the painting
of the same name
Private collection

MAURICE DENIS
*The Marriage of Marthe
and Maurice Denis*. 1893
Dominique Maurice-
Denis Collection,
Saint-Germain-en-Laye

had he not subordinated it to the theory of Neo-Traditionalism and rigid rules of composition. The appearance of *Figures in a Springtime Landscape* (*The Sacred Grove*) has become a landmark in the history of Symbolism. With its

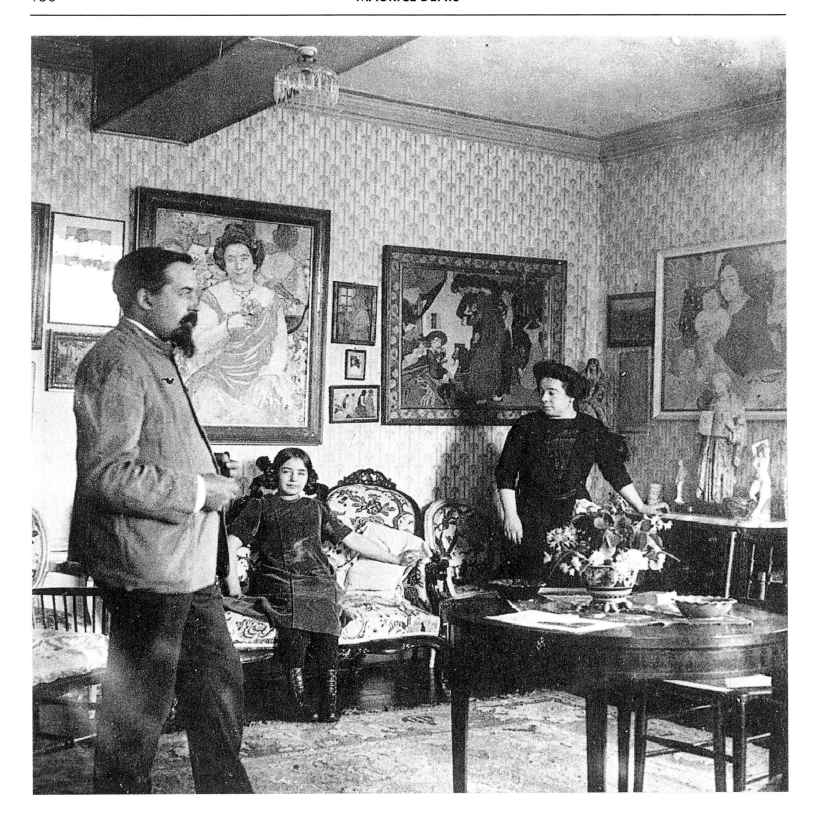

Maurice Denis with Marthe and Bernadette
in the studio. Ca 1912. Photograph

Denis saw the difference between the Symbolist wing of the Nabis, to which he belonged together with Sérusier and Ranson, and the circle of Bonnard, Vuillard and Roussel as being that, while attaching great importance to the human figure, he was inclined to give supremacy to the drawing.

From the start of the twentieth century, Denis found it increasingly difficult to retain the balance between drawing and colour. His drawing would quite often become harsh, his colour scheme crude and garish. Compared to his best works produced in the 1890s, or even *Sacred Spring in Guidel*, the twin canvases *Bacchus and Ariadne* and *Polyphemus* seem lacking in clearness and perspicuity. The bathing woman in *Polyphemus* is directly borrowed from Gauguin's *Fatata te miti (Près de la mer)* painted in 1892.

This painting was in Vollard's possession and Denis was undoubtedly familiar with it. Gauguin's influence can also be traced in the decorative and ornamental treatment of the breaking waves. However, the handling of the figures in the foreground goes against Gauguin's method. They do not seem to belong in this stylized landscape. Gauguin's precept of avoiding poses in motion is disregarded here. Degas, who was primarily preoccupied with the human body in motion, developed special qualities of drawing, ingeniously evading the rigidity of line. Departing from Gauguin's soothing balanced design and, consequently, from the principles of his own early work, ignoring the dynamic quality of Degas's pictures, Denis doomed his art to the eclecticism of academic painting, which he had rejected in his younger

Interior of Sergei Shchukin's Moscow mansion with Maurice Denis's painting *Martha and Mary* (bottom row, right). Photograph

cher Monsieur,

Je suis en retard pour vous transmettre la lettre que j'ai reçue du possesseur du tableau de Manet « le Déjeuner sur l'herbe ».

— Vous verrez en la lisant, que sans doute vous pourrez conser-ver l'espoir d'en devenir acqué-reur, malgré le refus actuel de le vendre que nous oppose M. Lejosne.

Je suis sans nouvelle de Mail-lol, mais j'ai été heureux d'apprendre que vous aviez correspondre directement avec lui.

Veuillez accepter cher Monsieur, mes sentiments les plus distingués

Maurice Denis

Maurice Denis's 1909 letter to Ivan Morozov about Manet's *Déjeuner sur l'herbe*

days. He seemed to have forgotten his own daring statement: "A picture – before being ... a female nude – is a flat surface..."

The nudes in Denis's *Bacchus and Ariadne* and *Polyphemus* are painted in a three-dimensional manner, with bulging muscles, contrasting shadows and reflexes. This approach resulted from the artist's desire to breathe new life into the ancient legend, to bring the myth up to date. The modernization, however, appears to be rather forced. Ariadne reclining on the rock calls to mind classical sculpture, whereas the bathing men and women are part of another world, the world of bourgeois fashion which rejects all legend. Polyphemus looks very much like an obese habitué of seaside resorts.

The picture almost strikes a note of caricature. Vallotton used this approach to achieve a cal-culated effect; with Denis, the same method seems to be evidence of a lack of taste, all the more unexpected since he had shown himself as an artist of subtle, indeed refined judgement. After the break-up of the Nabis the art of Denis and his fellow painters was put to a test. It is notable that while Bonnard managed to avoid a crisis, the whole Symbolist wing was affected. These artists, obsessed with cramming symbols and metaphors into their pictures in order to expound elements of Christian doctrine, a theosophical theory or literary narration, were vulnerable to inadequacies in the painterly sphere. Not that they were less gifted than the rest. That is true only of Sérusier, while Denis was exceptionally talented. However, his stylistic vacillations in the 1890s betray his uncertainty with regard to his choice of artistic direction. Denis was a man of both knowledge and ability, yet his pictures and panels increasingly came to resemble mere tinted drawings. Later on, realistic paintings, not quite what one would expect from him, such as New York skyscrapers, alternated with returns to the style of his youth, showing a preference for flat surfaces, but he never recaptured the excellence of his early canvases. At the end of his career Denis was preoccupied with the ideas of monumental art, which often seem far-fetched. The panel he painted for the Bureau International du Travail in Geneva (1931) shows an Old-Master type of Christ wearing a classical tunic preaching to labourers who might have stepped into the picture from a photograph, dressed as they are in the fashions of the early 1930s.

Over a period of fifty years Denis created a large number of monumental decorative works for private houses, theatres, churches and public buildings. Only a few of them – including *The Legend of Psyche* commissioned by Ivan Morozov – attain the level of his best easel paintings. In his old age, turning over his most important works in his mind, Maurice Denis described the Moscow series as dating from his easy and formula period.[1] Indeed, the *Legend of Psyche* series is not without a certain ease, though it is the cultivated ease of the skilfully applied and readily appreciated formula, in this case of the Art Nouveau.

Art Nouveau, which flourished at the turn of the century, aimed especially at the creation of a decorative and monumental ensemble.

[1] M. Denis, *Journal*, vol. 3, Paris, 1959, p. 214

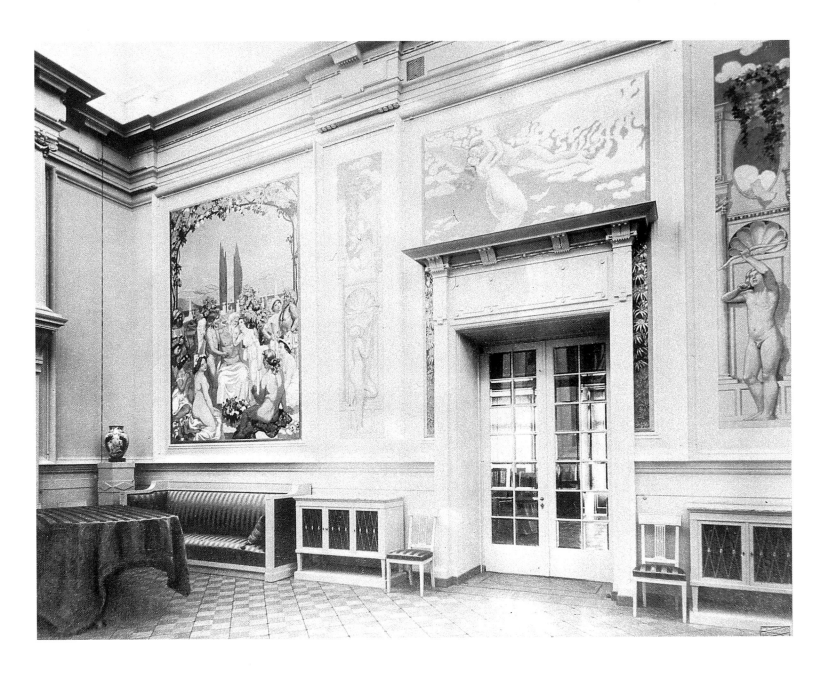

Interior of Ivan Morozov's Moscow mansion
with several panels from Denis's *Legend of Psyche* series
and furniture produced from the artist's designs

It seemed that everything – from architecture to jewellery – could be reduced to the curvilinear forms of the Art Nouveau. This movement lived and breathed with the idea of synthesis, while clinging tenaciously to the notion of elegance. The ceramics and pieces of furniture which Denis designed for Morozov's house, as well as the series of 13 panels, all belonged together and were derived from the same principles. The total effect of the interior was intensified by Maillol's statues.

In this ensemble, with its beautiful architecture sheltering applied arts, sculpture and painting, it was the latter which reigned supreme, for painting always set the tone at Morozov's. The interior decoration was centred around the five largest panels. They were similar in size and were effectively united by a shared degree of flatness, the same scale of figures and interplay of colours. Nevertheless, Denis's decorative painting is not flawless. The facial expressions of the figures are banal, the garlands, bouquets and clouds are commonplace. The combination of blue and pink surfaces is determined by the subject, but equally by the traditional principles of the Art Nouveau. Denis worked within the bounds of generally accepted standards. Similar decorative approaches are easily found in the design of posters and labels, as the individual personality of the artist becomes increasingly lost. The abundance of flesh is rather obtrusive. Only the third panel, *Psyche Discovers that her Mysterious Lover is Cupid*, is better in this respect. Here the bright pink of naked body is transformed into a pinkish-ochre by the light of the oil-lamp and the composition is well set off by the dark background. The emphasis on the centre of the canvas makes the subject-matter more intelligible. The panel is designed like an easel-painting, and that is yet another demonstration of the fact that Denis's greatest merit lay in this field.

1870
Denis born at Granville

1882
Enters the Lycée Condorcet, where he meets Vuillard, Roussel and Lugné-Poë

1884
Takes drawing lessons from Zani. Copies the Old Masters at the Louvre. Tries writing poetry. Begins keeping a diary

1885
Shows a preference for Fra Angelico

1887
Profoundly impressed by Puvis de Chavannes's exhibition

1888
Enters the Académie Julian. Friendship with Sérusier, Bonnard, Ibels, Ranson, Roussel and Vuillard, who unite to become an artistic group. Admitted to the Ecole des Beaux-Arts, class of Jules Lefebvre and Lucien Doucet

1889
Meets Redon. Influenced by Gauguin's exhibition at the Café Volpini

1890
First exhibits at the Salon. Contributes an article to the *Art et Critique*, which is to become the Nabis' manifesto

1891
Shares a studio with Bonnard, Vuillard and Lugné-Poë. Exhibits at the Salon des Indépendants. Meets Pissarro, Valéry, Debussy, Chausson. Designs stage-sets and costumes for productions of plays by Remy de Gourmont and Dujardin

1892
Meets André Gide. Publishes articles on contemporary painting

1893
Marries Marthe Meurier. Makes a set of lithographs to illustrate *Le Voyage d'Urien* by André Gide. Settles down at Saint-Germain-en-Laye

1895
Writes a preface to the catalogue of the Impressionist and Symbolist exhibition at Le Barc de Boutteville's Gallery. Autumn: first visit to Italy; cycling with Sérusier through Tuscany and Umbria. Paints a frieze of 7 panels *Love and the Life of a Woman* for the bedroom of his own house

1897

Second trip to Italy. Stays with the composer Chausson in Florence. Paints a series of panels for Denys Cochin

1898

Works on a ceiling painting in Madame Chausson's house (*Terrace in Fiesole*). Becomes a member of the Société Nationale des Beaux-Arts

1899

Trip to Pont-Aven and Le Pouldu. Makes a series of 12 lithographs for Vollard and decorates the Chapel of the College of the Holy Cross at Vésinet (*The Worship of the Holy Cross*)

1901

Participates in "La Libre Esthétique" exhibition in Brussels. Degas shows him his collection of Ingres's paintings. Designs stained-glass windows for the church at Vésinet

1903

Member of the Committee at the Salon des Indépendants. Visits Verkade in the Convent of Beuron. Verkade, Sérusier and Denis discuss art and aesthetics. Vollard publishes *The Imitation of Christ*, a 216-piece series of Denis's lithographs

1904

Another trip to Italy. Publishes numerous articles on art. First one-man show at the Druet Gallery (preface to the catalogue written by André Gide)

1905

Trip to Spain. In Pont-Aven purchases Gauguins and Bernards. Articles on Maillol and Gauguin

1906

Joins Roussel for a journey to Provence to visit Cézanne, Cross, Signac and Renoir. Makes 5 decorative panels for Mutzenbecker's house in Wiesbaden (*The Eternal Summer*)

1908

Purchases the "Silencio" estate at Perros-Guirec; subsequently spends his summer months there. Teaches at the Académie Ranson. Paints 5 panels of the *Legend of Psyche* series for Ivan Morozov and a decorative ensemble *The Eternal Spring* for Gabriel Thomas's dining-room at Bellevue

1909

Visits Moscow with his wife. Another panel of the *Legend of Psyche* series

1910

One-man show in London. The *Florentine Evening* series inspired by Boccaccio's *Decameron*

1912

Sets of panels for the Théâtre des Champs-Elysées (*The History of Music*) and for the Prince of Wagram (*The Golden Age*). Denis's articles published in a separate volume under the title *Théories*

1914

Purchases the Priory, an ancient hospital building, in Saint-Germain-en-Laye. Visits Italy to complete illustrations for *The Life of Saint Dominic*

1919

Denis and Georges Desvallières organize the Ateliers d'Art Sacré. Death of Marthe Denis

1922

One-man show in Venice. Publishes *Nouvelles Théories sur l'art moderne et l'art sacré*

1927

Trip to the USA at the invitation of the Carnegie Institute

1932

Elected member of the Institut de France

1937

Works on panels for the Palace of Nations, Geneva

1943

Run over by a car, Denis dies on the way to hospital

27
The Encounter
La Rencontre

Oil on cardboard. 37.5 x 33 cm
Signed in monogram, bottom left: *MAUD*
Hermitage, St Petersburg. Inv. no. 7710

This title of the painting survives from the time when it was in Mikhail Morozov's collection, although what represented here is not an everyday scene, but a biblical one – *The Visitation* (Luke 1: 36–56). Unlike Denis's later treatment of the subject (see no. 30), this composition is based on the Renaissance scheme in which the cousins embrace. Since the time of the Renaissance, the scene was usually presented against a landscape, often in front of the house of Elizabeth's husband Zacharias. As Elizabeth was six months pregnant at the time of the meeting, it is clear that she is the woman standing on the left.

The painting unites the sacred and commonplace aspects in such a way that the scene depicted does not look religious, hence the non-traditional name. Denis avoided a historical approach and showed the house and the women's clothes as if they were painted from life. The symbolic meaning of the details is subdued. The depiction of a dove has great significance in Christian art. Usually it stands for the Holy Spirit and is connected with the Immaculate Conception. A pair of doves generally means a union, a concord, even in compositions not related to the Bible (cf. *Sappho and Phaon* by David, 1809, Hermitage). A garden urn and a small fountain with the doves drinking from it hint at a font and hence John the Baptist, whom Elizabeth will bear. The artist places special emphasis on the urn and the fountain and links them by means of white and blue colours.

Later Denis interpreted the same subject in another manner. In *The Visitation with a Dovecote* (1893, private collection) seven doves are depicted and the scene is shown against a background of the sea (landscape in Perros-Guirec) with three sailing-ships on it, each having three sails (the symbolism of the numbers is obvious). Mary and Elizabeth are represented with halos, embracing each other. *The Encounter* was probably produced in about 1892. It is related by compositional devices to the work of a similar size *Breton Women with Large Shawls* (1892, private collection, Saint-Germain-en-Laye) and to *Red Roofs* (ca 1892,

Musée du Prieuré, Saint-Germain-en-Laye). In these works space is also constructed by means of broad, flat patches of colour, without distinct contouring.

Provenance:
M. Morozov Collection; 1903 M. Morozova Collection; 1910 Pavel and Sergei Tretyakov Gallery, Moscow (gift of M. Morozova); 1925 Museum of New Western Art, Moscow; 1934 Hermitage

Bibliography:
Catalogue 1917, no. 3957; *Catalogue* 1928, no. 149; Réau 1929, no. 782; *Catalogue* 1958, vol. 1, p. 380; Izerghina, Barskaya 1975, no. 75; *Catalogue* 1976, p. 254; Kostenevich 1989, no. 99

MAURICE DENIS
Breton Women with Large Shawls. 1892
Private collection, Saint-Germain-en-Laye

28
Wedding Procession. 1892
Procession nuptiale

Oil on canvas (relined). 26 x 63 cm
Signed, bottom left: *M. Denis*
Hermitage, St Petersburg. Inv. no. 8342

The closest analogue to this work is the 1892 picture *Procession beneath the Trees* (Altschul Collection, New York) which features some similar figures and the same landscape, but does not expound the purpose of the action so clearly as the Hermitage painting. Besides, there is a difference in the composition of the canvases: the New York picture reveals the spatial depth, while the Hermitage work, built on a frieze-like principle, spreads in breadth emphasizing the solemn, ritual nature of the scene.

Procession beneath the Trees is marked by completeness and an elaborate rendition of details, especially the tracery shadows on the path and trees, something typical of Art Nouveau artists. All this gives grounds for believing that the Hermitage painting, where the corresponding details are only slightly marked, directly preceded the New York work, which the artist dated 1892. We should assume this date for *Wedding Procession* as well.
On 12 June 1893 Denis married Marthe Meurier. For that reason some art experts date *Wedding Procession* to 1893. However, another composition, *The Marriage of Marthe and Maurice Denis* (Dominique Maurice-Denis Collection, Saint-Germain-en-Laye), painted on

24 August 1893, is an accurate portrait of the newly-weds and is completely different in manner. Moreover, the bride and groom in *Wedding Procession* cannot be completely identified with Denis and his wife: the groom in the picture has dark hair, while Denis was fair.
The scene depicted is rather imaginative than real, although it does reflect auto-biographical fact. Denis had longed for marriage with Marthe since 1890 when he met her. The artist's parents wanted him to become financially secure and Denis had to overcome his father's objections (an entry in the artist's diary of 7 February 1892 is evidence of his arguments with his parents: Denis, *Journal*, vol. 1, p. 92). Maurice Denis and Marthe became engaged in 1892. *Wedding*

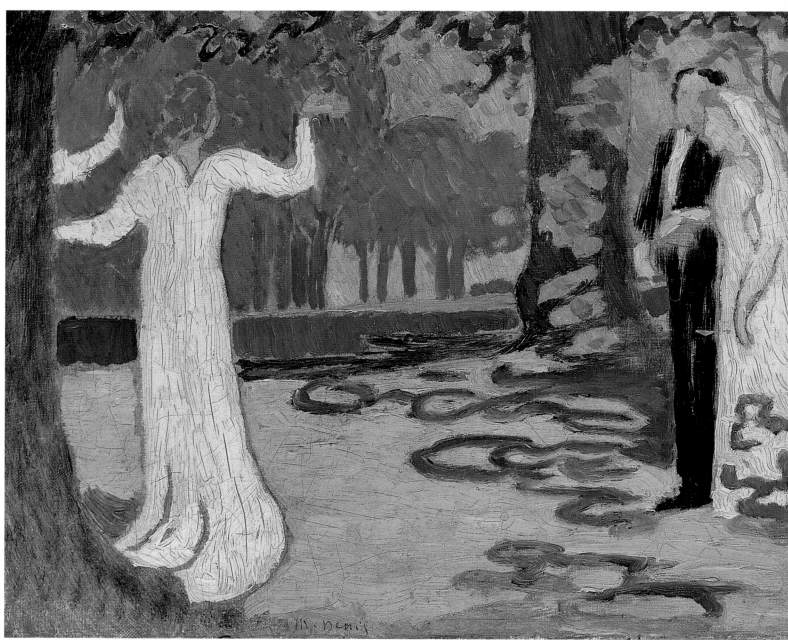

Procession and *Procession beneath the Trees* were probably painted that same year, most likely in the autumn, as is indicated by the landscape background. The composition of *Wedding Procession* repeats, with the exception of some minor details, a preliminary pencil drawing (reproduced in: U. Perrucchi-Petri, *Die Nabis und Japan*, Munich, 1976, p. 176, no. 122). The artist may have conceived the Hermitage picture as a sketch for a larger composition, which was never realized.

The gesture of greeting made by the woman on the left was later repeated by Denis in the female figure wearing a long white dress in the painting *The Holy Women at the Sepulchre* (1894, Musée du Prieuré, Saint-Germain-en-Laye).

Provenance:
Acquired 1939 through Leningrad Purchasing Commission

Exhibitions:
1995 Ibaraki–Tokyo–Mie, no. 37

Bibliography:
Catalogue 1958, vol. 1, p. 380; Izerghina, Barskaya 1975, no. 73; *Catalogue* 1976, p. 254; Kostenevich 1989, no. 102

MAURICE DENIS
Procession beneath the Trees. 1892
Altschul Collection, New York

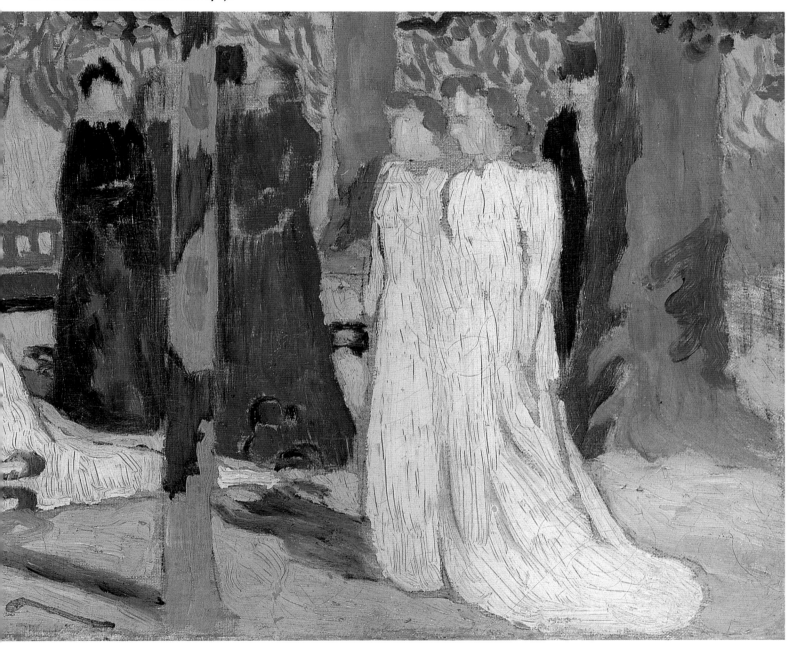

29
Portrait of Marthe Denis,
the Artist's Wife. 1893

Portrait de Marthe Denis, la femme de l'artiste

Oil on canvas. 45 x 54 cm
Signed in monogram and dated, bottom left: *MAUD 93*
Pushkin Museum of Fine Arts, Moscow. Inv. No. 3277

Although Denis painted Marthe Meurier (1871–1919) several times before their wedding in June 1893, the portrait of her in Moscow was clearly produced after that event – not, however, in the summer, as is sometimes believed, but well into the autumn, a fact proved by the bare trees in the landscape. In comparison with the Pushkin Museum portrait the earliest depictions of Marthe are less intimate and more romantic, most often presenting her against the background of an imaginary landscape. In the present case the setting was quite real: the terrace of the Villa Montrouge at 3, Rue de Fourqueux, Saint-Germain-en-Laye, which has remained almost unchanged to the present day. The Meurier family, with two daughters of marriageable age, appeared in Saint-Germain-en-Laye in 1889. A couple of years later, these girls began to feature in Denis's painting: sometimes both together, but more often Marthe on her own, in such works as *Two Sisters under the Lamp* and *Princess Maleine's Minuet* or *Marthe at the Piano*, both in private collections. In Denis's works, both then and later, Marthe quite often appeared as a character from some literary work.

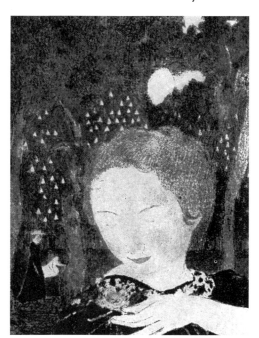

MAURICE DENIS
The Attitudes are Graceful and Chaste. 1899.
Colour lithograph

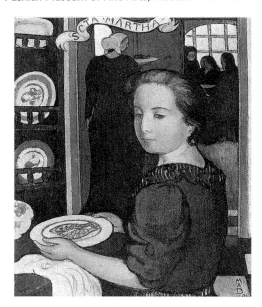

MAURICE DENIS
Sancta Martha or *Marthe at the Dresser.* 1893
Musée du Prieuré, Saint-Germain-en-Laye

In paintings from 1892 she becomes the Sleeping Beauty: *Sleeping Girl* (Musée Bonnat, Bayonne), *Sleeping Beauty in the Autumnal Forest* and *Sleeping Girl in the Enchanted Forest*, both in private collections. All these paintings were evoked to life by a play written by the artist's friend Gabriel Trarieux, *The Dream of the Sleeping Beauty in the Forest*, published that same year. The Sleeping Beauty theme also found expression in the 1893 woodcut *Woman with Closed Eyes* and the lithograph *Allegory* from the *Love* cycle, which was published by Vollard in 1899, but started seven years earlier. The link between all these works and the Moscow portrait in which the artist's wife is depicted with eyes closed is obvious. Another colour lithograph from the *Love* cycle, which Denis gave the title *The Attitudes are Graceful and Chaste*, is especially close to the painting, featuring a similar gesture – only in the lithograph Marthe is adjusting a rose pinned on her shoulder, rather than her dress. The memory of the portrait now in the Pushkin Museum came back to the artist later too, when he painted *The Angelic Salutation* (1894, private collection), in which for each of the figures he used a very similar image of Marthe with downcast eyes, as well as a background with bare trees and a grapevine twining over a wall.

The entire painting is constructed around the repetition of outlines made to resemble each other. The "heavenly" motif – the clouds – conforms to the shapes of Marthe's body and head. It is coincidence that the pinkish tint of the clouds seen in the light of approaching evening is close to the pink of her flesh. These comparisons are needed to place the viewer in that exalted frame of mind to which the artist always remained true when depicting his constant muse. The soft contours of Marthe's figure and face are set off by the jagged arabesque of the grapevine climbing the trellis. Marthe's gesture in adjusting her dress seems to repeat the movement of the servant hanging out washing. This highly down-to-earth domestic detail is intended to set off, both metaphorically and visually, the elevated character and purity of the young woman. It is noteworthy that Denis did not satisfy himself with traditional symbols, but was fond of using in that function details drawn from everyday reality. The painting which, seemingly, might have become another of the artist's idyllic works, did not in fact do so. We sense in it some hidden drama, evidently connected with the literary source which prompted Denis to produce this work. At the same time, from the point of view of portraiture, it reflects not only Marthe's external features, but also the inclination towards meditation which made her a superb model.

Provenance:
1899 Vollard Gallery, Paris; S. Shchukin Collection; 1918 First Museum of New Western Painting, Moscow; 1923 Museum of New Western Art, Moscow; 1948 Pushkin Museum of Fine Arts

Exhibitions:
1972 Otterloo, no. 9; 1972 Moscow, p. 144; 1979 Tokyo–Kyoto–Kamakura, no. 34; 1984 Tokyo–Nara, no. 15

Bibliography:
Catalogue 1913, no. 45; Tugendhold 1914, p. 3; Pertsov 1921, pp. 83, 108; *Catalogue* 1928, no. 130; Réau 1929, no. 772; *Catalogue* 1961, p. 71; W. Jaworska, *Gauguin et l'Ecole de Pont-Aven*, Neuchâtel, 1971, p. 151; Georgievskaya, Kuznetsova 1979, no. 219; Barskaya, Bessonova 1985, no. 234; Bessonova, Williams 1986, p.285; *Catalogue* 1986, p. 69

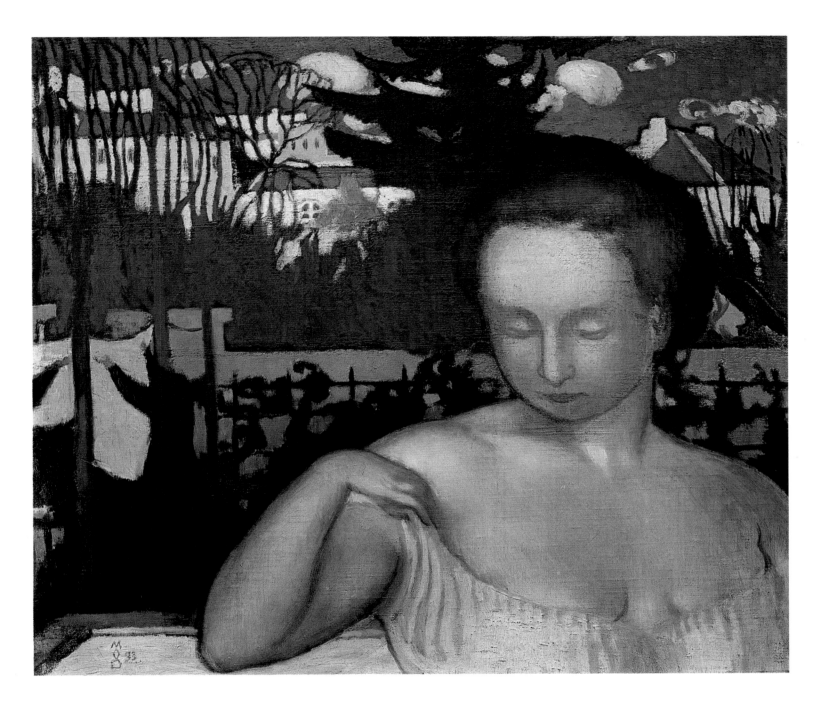

Maurice Denis

30
The Visitation
La Visitation
Oil on canvas. 103 x 93 cm
Signed in monogram and dated, bottom,
to the right of centre: *MAUD 94*
Hermitage, St Petersburg. Inv. no. 6575

The subject of the Visitation (Luke 1: 36–56) occurs quite often in Denis's early work starting with *The Encounter* (see no. 27). In the *Notes on Painting* made during his honeymoon in 1893 the artist plans a series of religious compositions, including two *Visitations* (Denis, *Journal*, vol. 1, p. 103, nos 3, 4). That same year he completed *The Visitation with a Dovecote* in which Elizabeth and Mary are represented against a small trellis-work construction – the frame of a future arbour. In the 1894 lithography *The Visitation* Denis simplified the composition and painted a latticed railing instead of this structure. He developed the same motif in the Hermitage canvas, depicting an open-work arcade, entwined with autumnal leaves, in place of the simple rectangular railing. The motif of a railing, borrowed from Japanese engravers, was popular with all the Nabis (cf. *Behind the Fence* by Bonnard, no. 1).
The Visitation with a Dovecote features in the foreground a cab with horses. The artist employed this device to indicate that Mary had come some distance. The picture is different from the Hermitage painting in the compositional arrangement of its figures and objects. In *The Visitation* Denis depicts Mary and Elizabeth full-length in the foreground. He uses, as a decorative background, the Saint-Germain-en-Laye landscape in place of Perros-Guirec. The cab is shown behind the gate, in the depths of the composition.
The Hermitage canvas displays both traditional iconographic features and ele-

MAURICE DENIS
The Visitation with a Dovecote. 1893
Private collection

ments of autobiographical significance. The roses are established symbols of the Virgin who has been called the Rose without Thorns since the Middle Ages. At the same time, the landscape in the picture is untraditionally autumnal – the Visitation is commemorated by the Church on 2 July. The reason for this is that the canvas was painted not long before the birth of Denis's first son Jean-Paul in October 1894 (he died in February 1895), and Denis often sought to link traditional subjects with important events of his life. Both Mary and Elizabeth strongly resemble Marthe Denis. Their hairstyles and Mary's hat correspond to the fashions of the day. In the Hermitage canvas Mary's figure nearly repeats that of the woman bearing a dish in the large painting *Supper at Emmaus* (1894, private collection). In subsequent years Denis painted

several compositions on the same subject, among them *The Visitation against a Yellow Sea* (G. Thomas Collection), three 1895 paintings (Lerolle Collection, Paris and J.-F. Denis Collection, Alençon), and the 1939 small-scale picture *The Visitation*. Additionally, in 1901 he created a stained-glass window on the same subject for the Church of Sainte Marguerite in Vésinet (preliminary sketches are in the Musée du Prieuré, Saint-Germain-en-Laye).
But it was most likely the Hermitage *Visitation* that was mentioned by a prominent art critic Gustave Geffroy. In 1895 he published a review of Paris artistic life, in which he admired the sense of *mise-en-scène* Denis displayed in the composition.

Provenance:
S. Shchukin Collection (acquired before 1908); 1918 First Museum of New Western Painting, Moscow; 1923 Museum of New Western Art, Moscow; 1934 Hermitage

Exhibitions:
1895 Paris; 1984 Tokyo–Nara, no. 17

Bibliography:
G. Geffroy, *La Vie artistique*, Paris, 1895, p. 254; Mithouard 1907, p. 4; Muratov 1908, p. 137; *Catalogue* 1913, no. 42; Tugendhold 1914, pp. 22, 39; Segard 1914, pp. 141, 314; *Catalogue* 1928, no. 131; Réau 1929, no. 773; Barazzetti-Demoulin 1945, p. 209; Denis 1957, p. 108; *Catalogue* 1958, vol. 1, p. 380; Izerghina, Barskaya 1975, no. 76; *Catalogue* 1976, p. 254; Kostenevich 1989, no. 103

MAURICE DENIS
Supper at Emmaus. 1894
Private collection

Maurice Denis

31
Mother and Child. 1895
Mère et enfant

Oil on canvas. 45 x 38.5 cm
Signed with two monograms, one along the vertical,
the other inscribed in the circle, bottom right: *MAUD*
Hermitage, St Petersburg. Inv. no. 8893

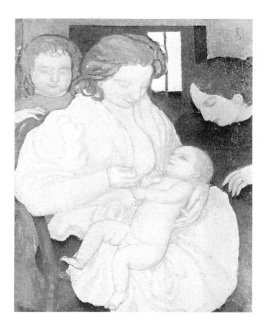

MAURICE DENIS
Maternity. 1895
Josefowitz Collection, Lausanne

Maternity is another subject that often occurs in Denis's early work. The birth of each of his children was followed by paintings showing Marthe, his constant model, with the child in her arms. But in spite of the fact that the paintings were inspired by the real events of Denis's life, the artist always linked the image of his wife with that of the Madonna as found in the works of Renaissance masters, especially Fra Angelico.

Most of Denis's works on the theme of maternity are undated, and we are uncertain as regards the time of creation of *Mother and Child,* which is close in iconography to the paintings *Washing the Baby* (1899, private collection, Paris) and *Maternity* (1895, Josefowitz Collection, Lausanne). Yet although the Hermitage work and *Washing the Baby* present Marthe in a similar dress, the pictures differ in style. In its soft manner *Mother and Child* shows an affinity with the 1895 *Maternity*, that was dated by the artist himself. Hence, we should attribute *Mother and Child* to 1895, and more precisely to the beginning of that year. Both pictures depict Denis's first son Jean-Paul.

Provenance:
M. Morozov Collection; 1903 M. Morozova Collection; 1910 Pavel and Sergei Tretyakov Gallery, Moscow (gift of M. Morozova); 1925 Museum of New Western Art, Moscow; 1948 Hermitage

Exhibitions:
1984 Tokyo–Nara, no. 16

Bibliography:
Catalogue 1917, no. 3958; *Catalogue* 1928, no. 140; Réau 1929, no. 781; *Catalogue* 1958, vol. 1, p. 380; *French 20th-century Masters* 1970, No. 1; Izerghina, Barskaya 1975, no. 72; *Catalogue* 1976, p. 254; Kostenevich 1984, p. 194; Kostenevich 1989, no. 100

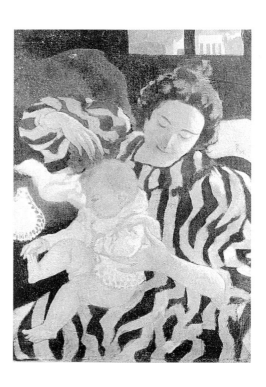

MAURICE DENIS
Maternity. Washing the Baby. 1899
Private collection, Paris

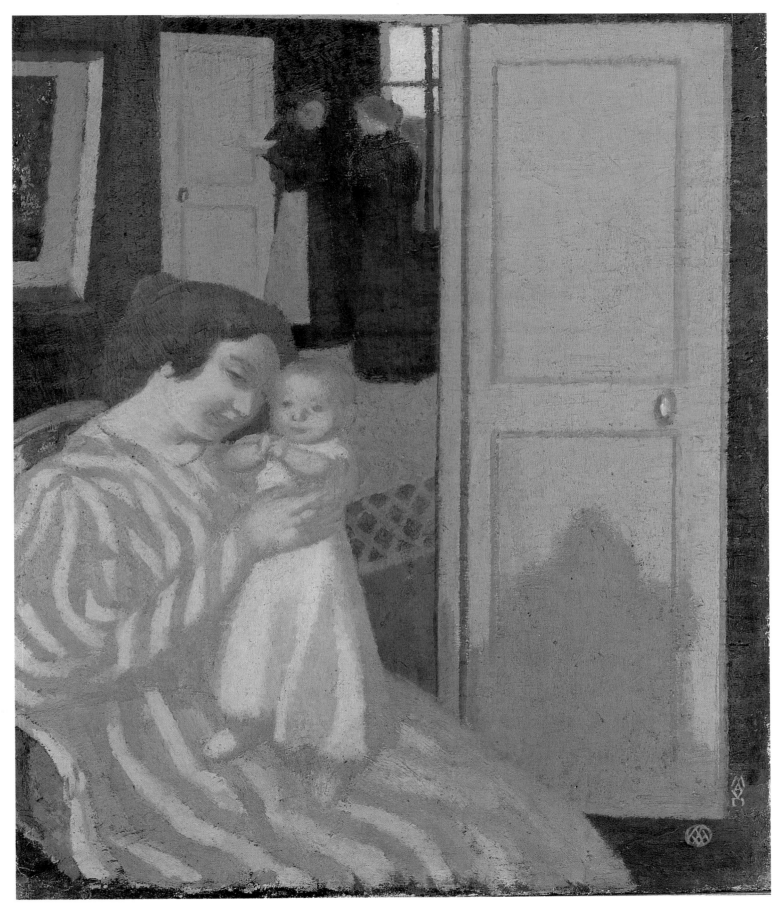

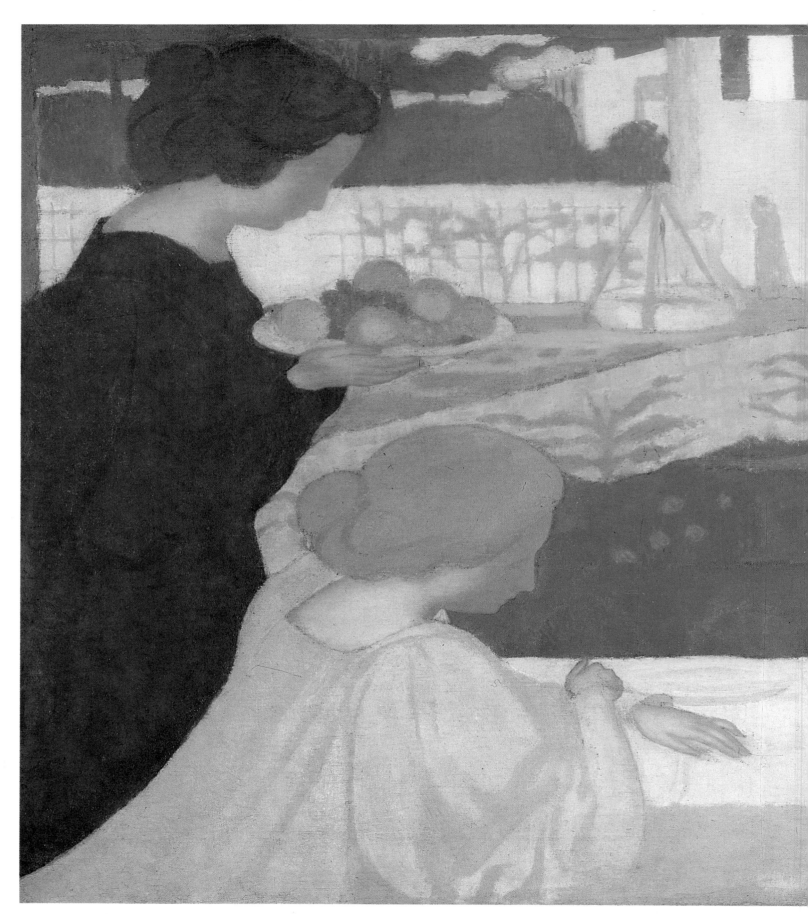

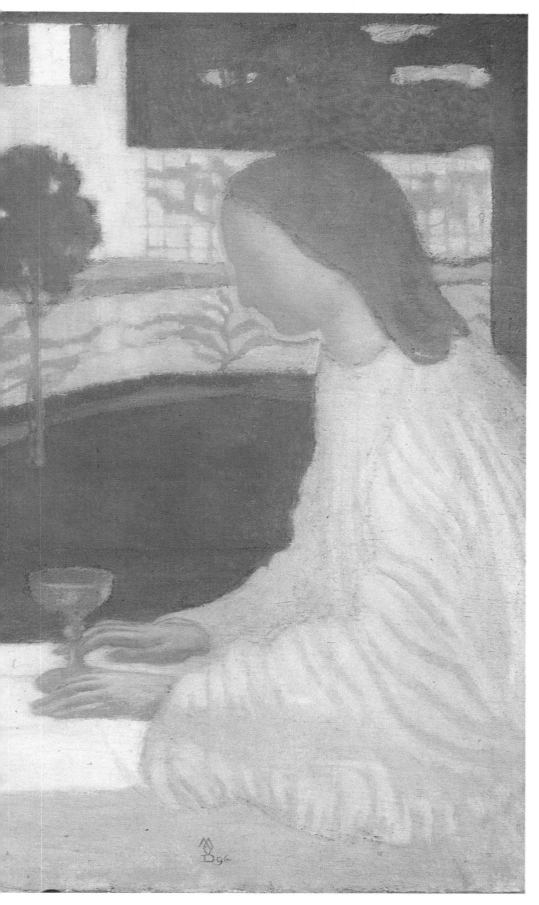

32
Martha and Mary. 1896
Marthe et Marie
Oil on canvas. 77 x 116 cm
Signed and dated, bottom right: *MAUD 96*
Hermitage, St Petersburg. Inv. no. 9124

The picture illustrates a passage from St Luke's Gospel (10: 38–42): "Now it came to pass, as they went, that he entered into a certain village: and a certain woman named Martha received him into her house. And she had a sister called Mary, which also sat at Jesus' feet, and heard his word. But Martha was cumbered about much serving, and came to him, and said, Lord, dost thou not care that my sister hath left me to serve alone? bid her therefore that she help me. And Jesus answered and said unto her, Martha, Martha, thou art careful and troubled about many things: but one thing is needful: and Mary hath chosen that good part, which shall not be taken away from her."

Denis's first work on the subject was the watercolour *Sacred Conversation* (1890, private collection, Saint-Germain-en-Laye). It depicts four figures on the terrace and a rural landscape in the background. The scene itself does not occupy much space in the composition, but the narrative clash is revealed quite clearly. Mary is listening attentively to Christ, while Martha looks at her sister reproachfully.

Another painting on the same subject, *Martha and Mary* or *Christ Visiting Martha and Mary*, was produced several years later, after Denis's marriage to Marthe Meurier. The fact that his wife's name was Marthe meant that the subject

MAURICE DENIS
Sacred Conversation. 1890
Private collection, Saint-Germain-en-Laye

MAURICE DENIS
The Angelic Salutation. 1894
Private collection

acquired special meaning for the artist. The female figures in the canvas, like those in Denis's other works of that time, strongly resemble Marthe. Martha and Mary have the same features, but they are treated by the artist as two hypostases of one image: the dark and the light that are destined to coexist. On the other hand, it is possible to distinguish in the two women depicted the artist's wife and her sister: the fair-haired Mary is closer to Marthe Denis, while Martha has something of Eva Meurier. The background shows almost the same landscape at Saint-Germain-en-Laye as *The Visitation* (see no. 30), though the arcade is painted in muted colours and nearly blends with the dark green grass, while the bright yellow house and the fence in the distance are more accentuated.

The yellow walls are shining in the rays of the setting sun. This part of the composition may be charged with a symbolic meaning. A house often symbolized a receptacle of wisdom and is therefore natural in a picture representing Mary's choice of "the good part". Mystics have considered a house or an enclosed garden to be the embodiment of the feminine principle in the universe. This symbolic aspect is also quite natural for a work

in which even Christ is clearly endowed with a feminine quality.

Other details are also symbolic. Martha, who was usually shown preparing a meal, is here represented in a more lofty key: she is bearing a plate of fruit which are traditionally connected with religious ideas: a bunch of grapes is a symbol of Christ, while an apple symbolizes the Fall, which Christ was sent to Earth to redeem. The well in the upper part of the composition symbolizes a source of true faith. The outlines of the well have something in common with the golden cup on the table, which is an attribute of Christ, a symbol of Christian faith and redemption. The cup plays an important role in such biblical scenes as the Last Supper and the Agony in the Garden. The imagery of the Hermitage work was established in the picture *Supper at Emmaus* (1894, private collection), where the iconography of Christ and the women entering is close to that in *Martha and Mary*. The treatment of the decorative background (the way of depicting bare trees and a well) was also used by Denis in the *Snow-Covered Fields* (1895, Jean-Baptiste Denis Collection, Paris).

On the reverse of the canvas there is the first version of the painting. This obviously did not satisfy the artist completely and, when reworking the scene on the other side, he added further laths to

the subframe, which changed the general spatial effect of the composition endowing it with greater lightness and airiness. In both versions Denis deviated from the original idea of a vertically-orientated construction, which can be seen in the sketch for the painting that once belonged to Vollard (now in a private collection).

Provenance:
1903 Vollard Gallery, Paris (acquired from the artist); S. Shchukin Collection; 1918 First Museum of New Western Painting, Moscow; 1923 Museum of New Western Art, Moscow; 1948 Hermitage

Exhibitions:
1896 Paris (not included in catalogue); 1903 Vienna, no. 213; 1978 Le Havre; 1994–95 Lyons–Cologne–Liverpool–Amsterdam, no. 83

Bibliography:
Mithouard 1907, p. 4; Muratov 1908, p. 137; *Catalogue* 1913, no. 43; Tugendhold 1914, pp. 22, 39; J. De Fauville, "Artistes contemporains: Maurice Denis", in: *La Revue de l'art ancien et moderne*, 1913, vol. 33, p. 272; Segard 1914, pp. 142, 314; Tugendhold 1923, p. 58; *Catalogue* 1928, no. 132; Réau 1929, no. 774; Denis 1957, p. 108; *Catalogue* 1958, vol. 1, p. 380; *French 20th-century Masters* 1970, no. 2; Izerghina, Barskaya 1975, no. 74; *Catalogue* 1976, p. 254; Kostenevich 1984, pp. 193, 194; Kostenevich 1989, no. 101

MAURICE DENIS
The Cook. 1893
Private collection

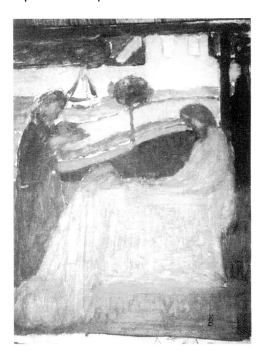

MAURICE DENIS
Martha and Mary. Sketch
Private collection

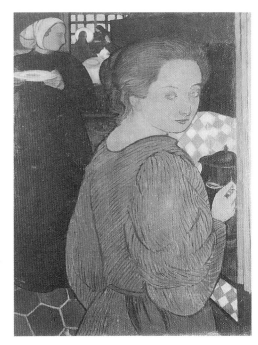

MAURICE DENIS
Martha and Mary. 1896. Sketch on the reverse of the painting
Hermitage, St Petersburg

Maurice Denis

33

Figures in a Springtime Landscape. Sketch. 1897
Figures dans un paysage de printemps
Oil on cardboard. 26.3 x 39 cm
Signed in monogram (in a circle), bottom right: *MAUD*
Hermitage, St Petersburg. Inv. no. 10271

This sketch was probably done in early 1897 for the identically entitled picture (see no. 34). It depicts the same view, but lacks the deer in the background, while the two women on the right are shown wearing white dresses rather than naked as in the completed work.

Provenance:
1977 Hermitage (gift of Dominique Maurice-Denis, the artist's son)

Exhibitions:
1979 Leningrad, no. 1

Bibliography:
Izerghina, Barskaya, *French Painting from the Hermitage*, Leningrad, 1982, no. 83; Kostenevich 1989, no. 105

MAURICE DENIS
Figures in a Springtime Landscape. 1897.
Drawing
Hermitage, St Petersburg

Maurice Denis

Maurice Denis

34
Figures in a Springtime Landscape. 1897
Figures dans un paysage de printemps
Oil on canvas. 156.3 x 178.5 cm
Signed in monogram and dated, left (on the tree-trunk): *MAUD 97*
Signed in monogram (in a circle), bottom right: *MAUD*
Hermitage, St Petersburg. Inv. no. 9657

In the catalogue of Sergei Shchukin's collection the picture was referred to as *The Sacred Grove*. But in the catalogue of the Museum of New Western Art it was entitled *Figures in a Springtime Landscape* according to the inscription made by the artist on the reverse of the canvas. The other name of the picture, also given to it by Denis, is *Springtime in the Forest*. While in Moscow in January 1909, Denis attempted to see this work and noted in his diary with regret that Piotr Shchukin, who owned the picture at that time, did not show it to him.

It is quite probable that it was under the title *The Sacred Grove* that Piotr Shchukin acquired the picture from Vollard. This name reflected the artist's dependence on Puvis de Chavannes, whom he highly esteemed and whose similarly entitled composition (1884, Musée des Beaux-Arts, Lyons; version of 1884–89, Art Institute of Chicago) was very popular in the late 19th century. However it is unlikely that Denis himself named the picture *The Sacred Grove*, as he painted another canvas under this title (1899, Musée du Petit Palais, Paris). It also shows young women in a forest: following Puvis de Chavannes, Denis turned to the theme of the nine Muses, the patron goddesses of the arts. In all probability, the painting was called *The Sacred Grove* by Vollard, who had this canvas at his gallery while the artist was working on the Petit Palais composition.

We should also mention the canvas *The Sacred Grove* or *Incantation* by Sérusier (1891, Musée des Beaux-Arts, Quimper), which was inspired by impressions of

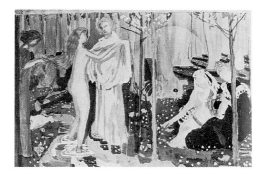

MAURICE DENIS
Virginal Spring. 1894
Musée du Prieuré, Saint-Germain-en-Laye

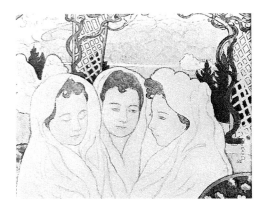

MAURICE DENIS
Triple Portrait of Marthe as a Fiancée. 1892
Musée du Prieuré, Saint-Germain-en-Laye

Brittany and by Gauguin's works. Denis must undoubtedly have seen Sérusier's painting, though using the same motif – three figures in a sacred grove – he was not to follow Gauguin's Synthetism or Sérusier's compositional principle with its fear of blank space.

Subjects of this kind were very popular with academic painters. Denis is certain to have seen the picture *Springtime* by Pierre Franc-Lamy, which was exhibited at the 1892 Salon de la Société des Artistes Français and was highly esteemed by both public and critics.

In iconography the Hermitage canvas is related to the Three Graces, but Denis interpreted the subject in an unusual way: two of the women are naked, the third is wearing a long white dress. She is writing something on a tree-trunk ignoring her companions. The letters on the trunk make up the artist's signature, something that can be regarded as part of some game. But it is quite probable that this detail reflects the age-old tradition of guessing the name of one's future husband and carving it on a tree-trunk. Daisies are also connected with fortune-telling ("he loves me, he loves me not") and a garland is a sign of fate in folklore symbolism. In some regions of France and Germany from pagan times, the advent of spring was symbolized by a girl wearing a white dress whom they called the May Rose. The pair of deer in the depth of the composition stands for the union of springtime and love. The deer, as a symbol of renewal and growth,

also personifies springtime. At the same time, it is a messenger of gods and an animal sacred to Diana, who was regarded as the patronness of brides in Classical Antiquity. Besides, the deer is a symbol of hearing (the women look as though they are listening to something). In pagan times people came to sacred groves to communicate with gods, hoping to hear a voice from above.

This painting was preceded by a series of works produced in the first half of the 1890s. First of all, we should mention *Trinitarian Evening* (1891, Dejean Collection, Mas-de-Januq), in which Denis realized the idea of combining three female figures, one dressed and two naked, and *Girls Looking like Angels* (1892) in the same collection. In the latter the artist turned to the device of tripling one image, which he would use quite often in the 1890s. In such works as *Triple Portrait of Marthe as a Fiancée* (1892, Musée du Prieuré, Saint-Germain-en-Laye), *Three Young Princesses* (1893, private collection, Saint-Germain-en-Laye) and *Orchard of the Wise Virgins* (1893, Lerolle Collection, Paris), Denis variously employed pagan, secular and Christian motifs. The *Orchard of the Wise Virgins* is related to the Hermitage canvas in

MAURICE DENIS
Nymph. 1901
Private collection

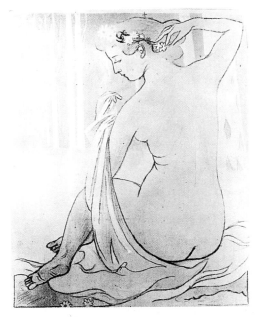

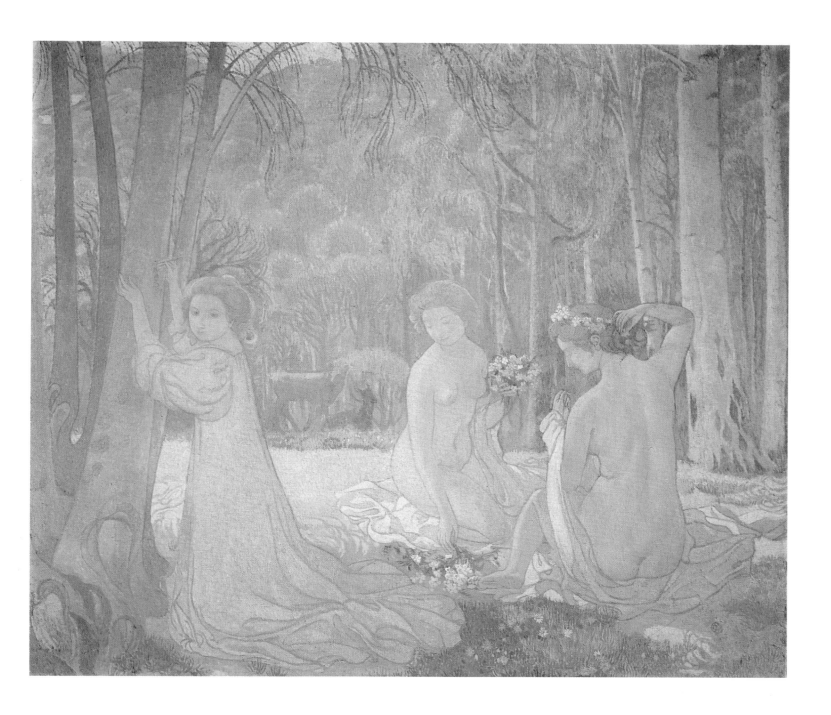

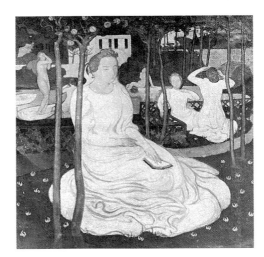

MAURICE DENIS
Orchard of the Wise Virgins. 1893
Lerolle Collection, Paris

the compositional arrangement of figures, but the title indicates that the subject is connected with the Last Judgement and the parable of the ten virgins (Matt. 25: 1–13). Lastly, we should mention the large gouache sketch *Virginal Spring* (1894, Musée du Prieuré, Saint-Germain-en-Laye), in which Denis emphasizes the motif of spring, associating the young women in a grove with the awakening nature.

As the painting was intended for the 1897 exhibition at the Salon de la Société Nationale des Beaux-Arts, it must have been completed in the early months of that year. It follows a drawing in a mixed technique (colour pencils, pastel, pen and Indian ink; 33.3 x 49.8 cm) and an oil sketch (see no. 33) presented to the Hermitage by Dominique Maurice-Denis. The drawing illustrates the course of Denis's work on the attitudes of the central and right figures. Neither the drawing nor the sketch shows deer or a garland – the composition acquired its full symbolic significance only when it was completed.

Later Denis used the motif of a girl inscribing a name on a tree-trunk in the picture *Screen with Doves* (1904, private collection, Saint-Germain-en-Laye).

The first presentation of the painting was very successful. An entry in Paul Signac's diary, made on 24 April 1897, describes the works exhibited at the Salon de la Société Nationale as superficial, but the artist made an exception of Denis's canvases, although he was not in general a great admirer of him.

Verhaeren also appreciated the picture when he saw it at the Brussels exhibition the following year.

Two years later the picture was bought by Piotr Shchukin and brought to his Moscow house in Gruzinskaya Street. He acquired it on the advice of Alexander Benois, an art critic and a painter. Benois wrote in his reminiscences: "I did my best to make Denis known to Russian art connoisseurs; I scolded them for their indifference towards the artist. My constant reproaches did not influence Sergei Shchukin, but he forced his brother Piotr to buy one of Denis's major works – *In a Forest...*"

Provenance:
1899 Vollard Gallery, Paris (purchased from the artist for 1,000 francs); 1899 (1900) P. Shchukin Collection; 1912 S. Shchukin Collection; 1918 First Museum of New Western Painting, Moscow; 1923 Museum of New Western Art, Moscow; 1948 Hermitage

Exhibitions:
1897 Paris, no. 414; 1898 Brussels, no. 109 (was on sale for 1,800 francs); 1975–76 Rotterdam–Brussels–Baden-Baden–Paris, no. 38; 1993 Essen, no. 52; 1993–94 Moscow–St Petersburg, no. 52; 1994–95 Lyons–Cologne–Liverpool–Amsterdam, no. 89

Bibliography:
A. Peraté, *La Peinture aux Salons de 1897*, Paris, 1897, p. 16; E. Verhaeren, "A Bruxelles. La Libre Esthétique", *La Revue Blanche*, 1898, March, p. 542; V. Trutovsky, "Museum of P. I. Shchukin in Moscow", in: *Art Treasures of Russia*, 1902, no. 6, p. 133 (in Russian); J. Meier-Graefe, *Entwicklungsgeschichte der modernen Kunst*, Munich, 1904, pp. 360, 362, pl. 4; *Catalogue* 1913, no. 44; Tugendhold 1914, pp. 22, 39; Segard 1914, p. 314; *Catalogue* 1928, no. 133; Réau 1929, no. 775; Barazzetti-Demoulin 1945, p. 280; Denis 1957, p. 108; *Catalogue* 1958, vol. 1, p. 380; Izerghina, Barskaya 1975, no. 79; *Catalogue* 1976, p. 254; A. Benois, *My Reminiscences*, in 5 vols, Moscow, 1980, vol. 2, p. 152 (in Russian); D.V. Sarabyanov, *Russian Painting of the 19th Century among the European Schools*, Moscow, 1980, p. 227 (in Russian); Kostenevich 1987, no. 118; Kostenevich 1989, no. 106

MAURICE DENIS
The Sacred Grove
or Study for "The Game of Shuttlecock". 1899
Musée du Petit Palais, Paris

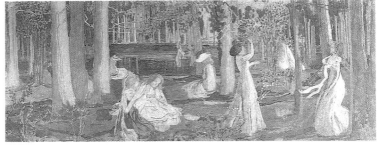

MAURICE DENIS
Trinitarian Evening. 1891
Dejean Collection,
Mas-de-Januq

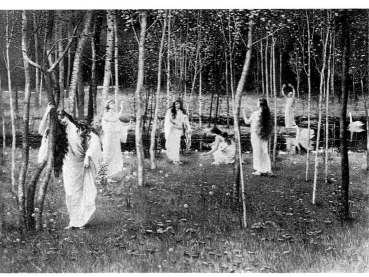

PIERRE FRANC-LAMY
Springtime

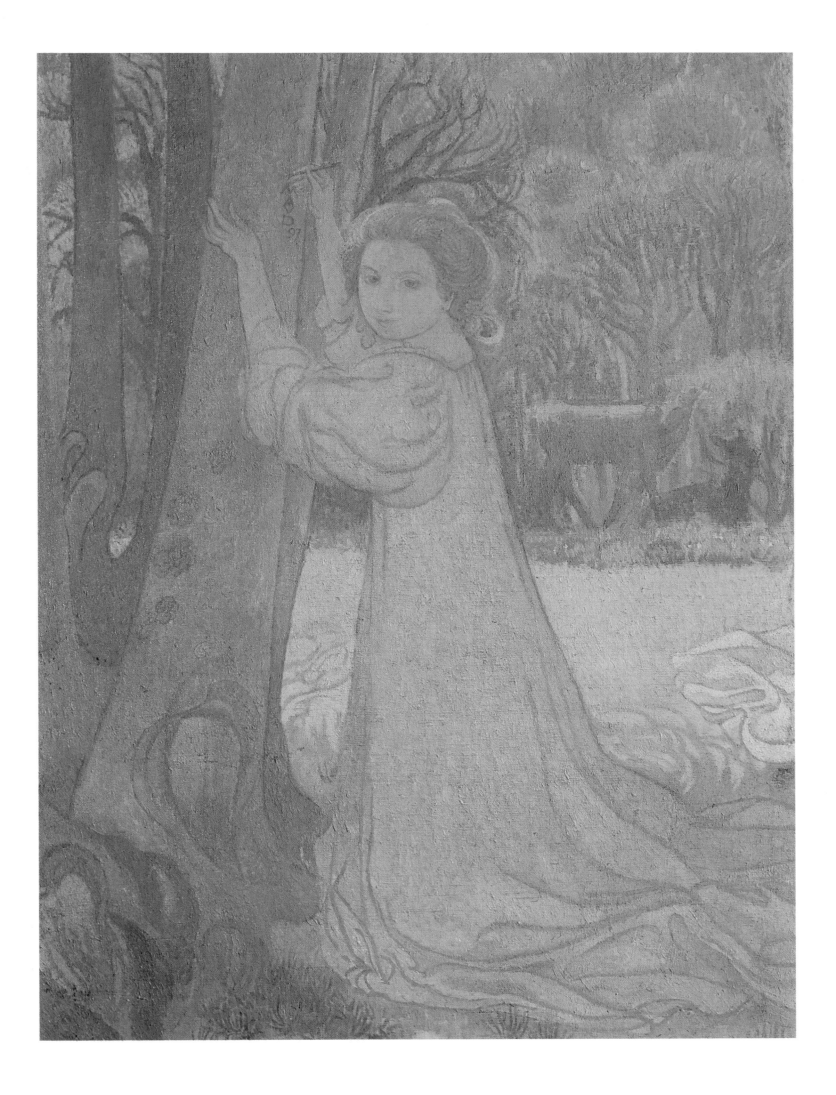

35
Sacred Spring in Guidel. 1905
Fontaine de pèlerinage en Guidel
Oil on cardboard. 39 x 34.5 cm
Signed in monogram, bottom right: *MAUD*
Hermitage, St Petersburg. Inv. no. 7711

Denis mentioned Guidel in a diary entry
made in August 1905 at Le Pouldu. While
in Brittany, the artist and his wife travelled
around Quimper department, visiting
religious festivities and processions in
Pont-Aven, Clohar and Guidel, which was
situated "in a beautiful green, ever-fresh
valley" (Denis, *Journal*, vol. 2, p. 20).
Denis probably painted the picture
in August 1905. It differs from his other
works by fresh green colours and by
the painter's obvious success in terms
of colour scheme. Perhaps *Religious
Procession in Guidel* (private collection,
Lausanne), presented by the artist to
Sérusier's wife, was painted somewhat
later.
The picture was bought by Ivan Morozov
from the 1906 exhibition at the Salon
des Indépendants and was the beginning
of Morozov's acquaintance with Denis.

Provenance:
1906 I. Morozov Collection (purchased from
the artist for 850 francs); 1918 Second Museum
of New Western Painting, Moscow; 1923 Museum
of New Western Art, Moscow; 1934 Hermitage

Exhibitions:
1906 Paris, *Indépendants*, no. 1390; 1988 Tokyo–
Kyoto–Nagoya, no. 37; 1993 Essen, no. 51; 1993–94
Moscow–St Petersburg, no. 51

Bibliography:
Makovsky 1912, p. 20; *Catalogue* 1928, no. 134;
Réau 1929, no. 776; *Catalogue* 1958, vol. 1, p. 380;
Izerghina, Barskaya 1975, no. 77; *Catalogue* 1976,
p. 254; Kostenevich 1984, p. 194; Kostenevich
1989, no. 104

Maurice Denis

Maurice Denis

36
Bacchus and Ariadne. 1906–07
Bacchus et Ariane

Oil on canvas. 81 x 116 cm
Signed and dated, bottom right: *Maurice Denis 1907*
Hermitage, St Petersburg. Inv. no. 6578

MAURICE DENIS
The Beach. 1910
Clemens-Sels-Museum, Neuss

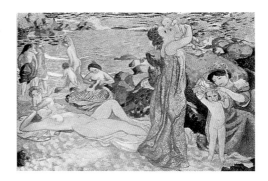

MAURICE DENIS
Bathers at Le Pouldu. 1899
Musée du Petit Palais, Paris

From 1905 to 1909 Denis painted a series of works on subjects from Classical Antiquity, most of which being created specially for Ivan Morozov. In the summer of 1906, when Maurice Denis was painting *Bacchus and Ariadne*, Morozov visited him at his studio in Saint-Germain-en-Laye. The Moscow collector bought the unfinished picture and commissioned the artist to paint a companion piece *Polyphemus* (Pushkin Museum of Fine Arts, see no. 37). In 1907, after completing *Polyphemus*, Denis evidently repainted *Bacchus and Ariadne* and dated it accordingly.

The painting is related in composition to *Bathers at Le Pouldu* (1899, Musée du Petit Palais, Paris). Denis, as he typically did, treated the myth as a modern scene. The subject is difficult to decipher at a glance, because Bacchus and Ariadne are not the central figures in the composition, being shown in the background. Denis depicts an episode, when Bacchus rescues Ariadne, king Minos's daughter, from the island, on which she has been left by Theseus. Ariadne was traditionally represented sleeping, although according to Ovid's *Metamorphoses* (8: 176–182), at the moment of Bacchus's appearance she was bemoaning her fate. Bacchus comforts Ariadne and takes her into his chariot. The chariot is not shown in the picture, but horses and Bacchus's retinue on the right suggest its presence.

The cycle, including *Bacchus and Ariadne*, was inspired by the artist's trips to Italy. In March 1904 he visited southern Italy. Some figures in *Bacchus and Ariadne* are reminiscent of ancient sculptures in the National Museum in Naples.

For example, the naked bather's posture repeats the attitude of Venus tying up her sandal, a marble statuette found in Pompeii. The reclining figure of Ariadne is associated with *Sleeping Ariadne* known from Roman copies of a Greek original from the 3rd century B.C.

Bacchus and Ariadne shows some compositional similarity to *Bathing* (1906, private collection, reproduced in: Barazzetti-Demoulin, *Maurice Denis*, between pp. 248–249), in which a bather in a white robe is depicted on the rock on the left and a sailing-ship out at sea is on the right.

Provenance:
1907 I. Morozov Collection (purchased from the artist for 4,000 francs); 1918 Second Museum of New Western Painting, Moscow; 1923 Museum of New Western Art, Moscow; 1931 Hermitage

Exhibitions:
1907 Paris, no. 376; 1968 Yerevan (no catalogue); 1981 Mexico City, no. 3; 1994–95 Lyons–Cologne–Liverpool–Amsterdam (not included in catalogue)

Bibliography:
Makovsky 1912, p. 20; Segard 1914, p. 317; *Catalogue* 1928, no. 135; Réau 1929, no. 777; Barazzetti-Demoulin 1945, pp. 77, 285; Denis 1957, p. 223; *Catalogue* 1958, vol. I, p. 380; Izerghina, Barskaya 1975, no. 78; *Catalogue* 1976, p. 254; Ternovetz 1977, p. 109; Kostenevich 1989, no. 104

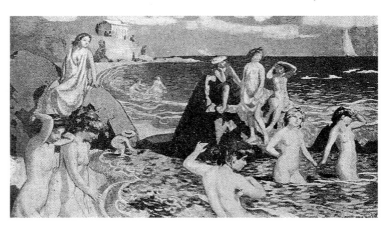

MAURICE DENIS
Bathers. 1905

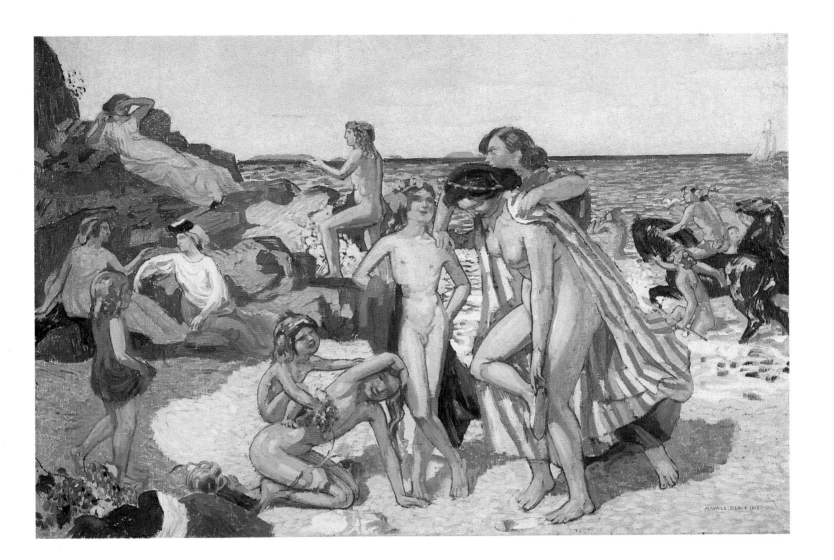

37

Polyphemus. 1907
Polyphème

Oil on canvas. 81 x 116 cm
Signed and dated, bottom left: *MAURICE DENIS 1907*
Pushkin Museum of Fine Arts. Inv. no. 3375
Companion piece to no. 36

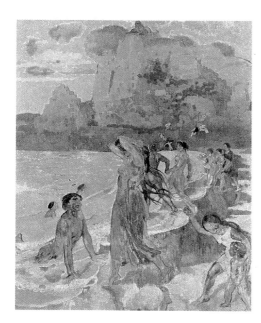

MAURICE DENIS
Galatea. 1917
Musée de Peinture et de Sculpture, Grenoble

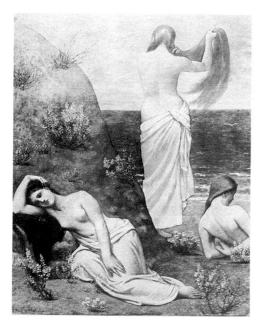

PIERRE PUVIS DE CHAVANNES
Girls on the Seashore. 1879
Musée d'Orsay, Paris

This painting was commissioned by Ivan Morozov as a companion piece to *Bacchus and Ariadne*. Given a free hand in the choice of subject-matter, Denis created not so much a work on a theme of Classical mythology in the spirit of nineteenth-century painting, as a sort of theatricalized composition in which his own contemporaries act out a plot about Polyphemus. Denis, like the other Nabis, loved the theatre and had close ties to it, especially in his early period. The arrangement of the characters in the composition indicates that the artist knew well the then fashionable methods of *mise-en-scène*, while the general ornamental quality of the painting is reminiscent of the theatrical and decorative principles of the *Art Nouveau*, above all in the depiction of the seascape, which might well be likened to backcloths created at the turn of the century.

Polyphemus was the right-hand part of this Classical pair and, although in comparison with *Bacchus and Ariadne* the sky here is more threatening and the sea darker, the line of sandy beach and cliffs continues, as it were, from one painting to the other. The canvas probably reproduces a beach in Brittany, most likely at Le Pouldu. In any case, *Bathers at Le Pouldu* (1899) features a very similar landscape, but less stylized. Denis obviously had an affection for this spot which he also depicted in *The Big Beach* (1903). Ten years after finishing *Polyphemus*, Denis returned to the motif. While in the Moscow work the object of the giant's passions – a small sea nymph, bathing in the waves – is depicted in the back-

ground, in *Galatea* (1917, Musée de Peinture et de Sculpture, Grenoble), the two figures have changed places: the young Galatea flirts with Acis in the foreground and Polyphemus far off at the top of the cliff plays a pipe. Later the artist went back to this subject once again in the small frieze composition *Polyphemus, Acis and Galatea* (1925), painted for his friend Eugène Chevalier.

Provenance:
1907 I. Morozov Collection; 1918 Second Museum of New Western Painting, Moscow; 1923 Museum of New Western Art, Moscow; 1948 Pushkin Museum of Fine Arts

Exhibitions:
1907 Paris, no. 377; 1967–68 Odessa–Kharkov, no. 9; 1982 Moscow, no. 90

Bibliography:
Makovsky 1912, p. 20; *Catalogue* 1928, no. 136; Réau 1929, no. 778; *Catalogue* 1961, p. 71; Ternovets 1977, p. 109; Georgievskaya, Kuznetsova 1979, no. 220; Barskaya, Bessonova 1985, no. 240; *Catalogue* 1986, p. 69

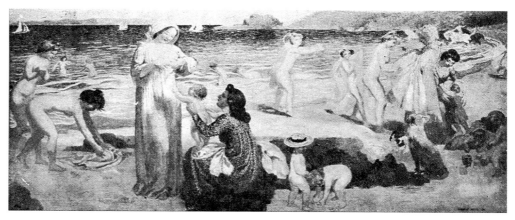

MAURICE DENIS
The Big Beach. 1903

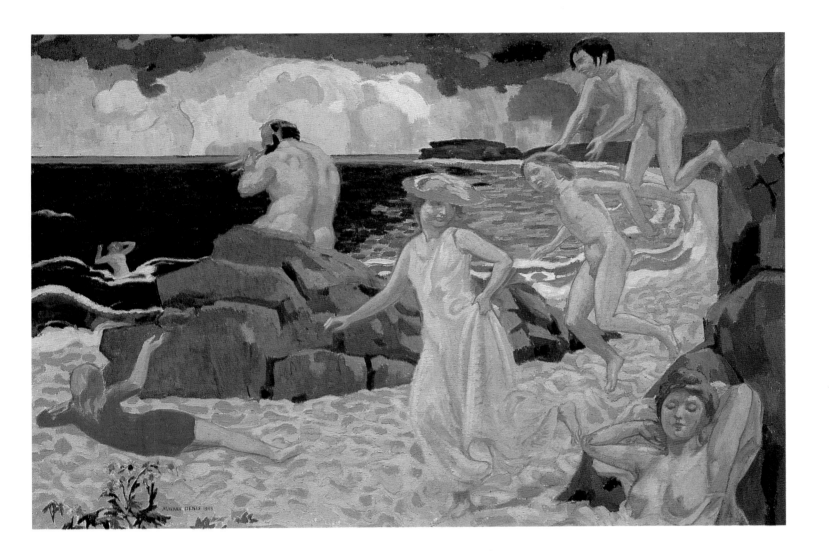

38–42
The Legend of Psyche
Histoire de Psyché
Five main decorative panels. 1907–08

Panel 1
The Flying Cupid Is Struck by Psyche's Beauty
Oil on canvas. 394 x 269.5 cm

Panel 2
Zephyr Carries Psyche to the Island of Delight
Oil on canvas. 395 x 267.5 cm

Panel 3
Psyche Discovers That Her Mysterious Lover Is Cupid
Oil on canvas. 395 x 274.5 cm
Signed and dated twice: bottom left and centre, along the edge of the medallion: *Maurice Denis 1908*

Panel 4
The Vengeance of Venus. Psyche Falls Asleep after Opening the Casket Containing the Dreams of the Underworld
Oil on canvas. 395 x 272 cm

Panel 5
In the Presence of the Gods Jupiter Bestows Immortality on Psyche and Celebrates Her Marriage to Cupid
Oil on canvas. 399 x 272 cm

Hermitage, St Petersburg. Inv. nos 9666–9670

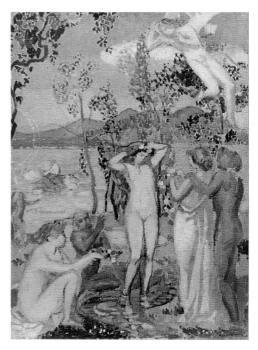

MAURICE DENIS
The Legend of Psyche.
Sketch for the first panel. 1907
Musée d'Orsay, Paris

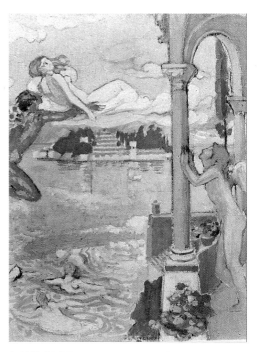

MAURICE DENIS
The Legend of Psyche.
Sketch for the second panel. 1907
Musée d'Orsay, Paris

The Legend of Psyche depicts several episodes from the *Metamorphoses or Golden Ass* by Apuleius.

People's admiration for the young and beautiful Psyche aroused Venus's anger and she sent Cupid to make Psyche fall in love with the most worthless of men. But Cupid was struck by Psyche's beauty and, with Zephyr's assistance, he hid her in his palace. Psyche was not allowed to see the face of her mysterious lover, but egged on by her wicked elder sisters, she violated the prohibition and lit a lamp at night, accidentally spilling some drops of hot oil on Cupid's shoulder. Cupid flew away and Psyche was left to wander the earth. Venus pursued her. After passing through various ordeals, Psyche descended to Hades for the water of life. Proserpine gave her a casket as a gift for Venus, which Psyche disobediently opened and was overcome by sleep. Cupid rescued her and after asking Jupiter's permission married her.

The Legend of Psyche by Apuleius is not just a fairy-tale, but an allegorical story about the Soul (Psyche) searching for union with Love (Cupid). This aspect, stressed by Renaissance humanists, especially attracted Denis's attention. Following the ancient Greeks, he regarded Psyche as an embodiment of the human soul, rather than human sexuality. He intentionally opposed his treatment of the legend to the interpretations given by Raphael, Giulio Romano and Rubens. At the same time, he avoided dramatic collisions, omitting episodes with Psyche's sisters and her misadventures after the night when she recognized Cupid.

In 1907 (most likely in spring, because Denis stayed in Germany at the beginning of the year) Ivan Morozov, by that time the owner of *Bacchus and Ariadne* and *Polyphemus*, visited, on Sergei Diaghilev's advice, Baron Denys Cochin's house in Paris to see Denis's decorative panels *The Legend of St Hubert* (1896–97). Morozov was so impressed that he commissioned from Denis a series of decorative panels for the music room of his Moscow mansion in 21 Prechistenka Street which now houses the Academy of Arts. Besides, Morozov may also have seen the five large decorative panels

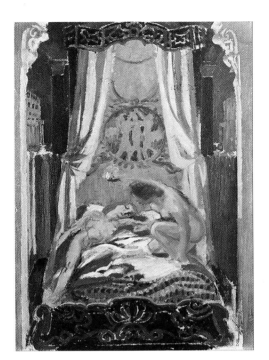

MAURICE DENIS
The Legend of Psyche.
Sketch for the third panel. 1907
Musée d'Orsay, Paris

MAURICE DENIS
The Legend of Psyche.
Sketch for the fourth panel. 1907
Musée d'Orsay, Paris

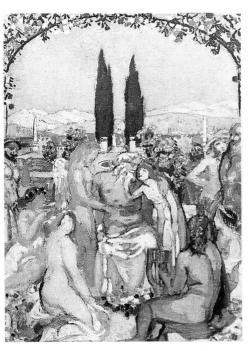

MAURICE DENIS
The Legend of Psyche.
Sketch for the fifth panel. 1907
Musée d'Orsay, Paris

Denis created in 1906 for the music salon in Mutzenbecker's house in Wiesbaden. Morozov sent Denis the dimensions and photographs of his music room and gave the artist complete freedom regarding the choice of subjects.

On 21 July 1907 Denis wrote to Ivan Morozov: "I have already thought out the subjects of the decorative panels for you... It appears to me that the story of Psyche, with its idyllic and mysterious nature, would be perfect and I have composed five scenes which are completely different from those of Raphael at the Villa Farnesina, but still in accord with Apuleius's story... Before working on sketches, I would like to be sure that you give me complete freedom and have no objection to the subject" (Pushkin Museum of Fine Arts archives).

After receiving Morozov's approval, Denis wrote to him from Italy on 14 September 1907: "Now my family and I are staying on Lake Maggiore, where I am going to continue my work on the sketches for Psyche which I started in Saint-Germain; I brought them with me so as to adorn them with the landscapes

of Italy" (Pushkin Museum of Fine Arts archives).

Denis wrote to André Gide from Fiesole on 12 December 1907: "I have been working a lot, but without, I think, great results and discoveries. I have prepared my future Psyche (the Moscow one), which will be very chaste in comparison with that of Giulio Romano".

In addition to five preliminary sketches (Musée d'Orsay, Paris) Denis produced a great number of studies and drawings during his trip to Italy (about 80): some of them were exhibited and sold at the Druet Gallery; eight drawings are in the Musée du Prieuré in Saint-Germain-en-Laye.

The five sketches now in the Musée d'Orsay were undoubtedly done in Italy, as is corroborated by the backgrounds: sketches for the first, second and fifth panels show landscapes around Lake Maggiore, while the fourth one features the Giusti Gardens in Verona.

In the early 1908, without interrupting his work on *The Legend of Psyche*, Denis devoted more time to his *Eternal Spring*, a series of four large decorative panels

(Musée des Arts Décoratifs, Paris). However, by the summer of 1908 the artist had transferred the five preliminary sketches for *The Legend of Psyche* onto large canvases. Before sending the panels to Ivan Morozov, Denis prepared them for the 1908 exhibition at the Salon d'Automne.

The artist wrote in his diary: "My life in Paris from 30 July to 21 August: every day at the Grand Palais... in this huge building which they let me use on a temporary basis". On 2 August he wrote to Mme La Laurencie: "At the moment I am engrossed in Psyche. I am alone, without my family, in Saint-Germain; in mornings I go to Paris to work in the Grand Palais, where Psyche is being kept until the beginning of September and the opening of the Salon d'Automne. If I don't complete it by that time, farewell to the beautiful plans for travelling with M. d'Indy". The letter to La Laurencie of 26 September lets us date the Moscow panels more exactly: "The Salon d'Automne will open on Wednesday or Thursday. I concern myself with what will be thought of Psyche, and, above all,

what impression it will make on me; a little more than a month has passed since I left it in rather nervous condition". After exhibition at the Salon d'Automne, the panels were brought to Moscow. In the December of 1908 they were stretched on subframes and, decorated with narrow brocade ribbons, fixed to the walls.

The panels are almost identical in composition and colouring with the sketches. The changes are insignificant: in the first panel the figures of two youths on the extreme right are depicted closer to each other; in the second the bathing women are painted slightly differently; in the fifth panel Mars is shown in another way. Susanne Barazzetti-Demoulin has pointed out that the sketches were painted mainly in Florence, at the Villa Bella Vista, that in the panel *Zephyr Carries Psyche to the Island of Delight* the island of Isola Bella on Lake Maggiore is depicted; the bed, which is shown in the third panel, repeats a drawing in the artist's album, made during his trip to Lake Maggiore. The fourth panel was inspired not only by the Giusti Gardens in Verona, but also by the Boboli Gardens in Florence.

The drawings for the figures of Psyche and Cupid were done in Rome: a girl from Campagna, who was well known in the Rome Academy of Arts, posed for Psyche, and a very handsome youth from Trastevere posed for Cupid.

It is known that in the fifth panel, Venus – a naked woman with a wreath of white roses on her head – was painted from Marthe Denis, while the model for Bacchus – a bearded man with a wreath of vines – was Aristide Maillol.

The subject of Cupid and Psyche appeared in the works of many nineteenth-century artists – from Prud'hon and François Gérard to Bouguereau. Denis used some of Bouguereau's devices in his compositions, especially in the first and fifth panels.

The Legend of Psyche combined many of Denis's artistic impressions. In this respect the cycle opposed the decorative principles of avant-garde art and was closer to academic style. In each panel Denis used classical prototypes. Thus, the first panel is reminiscent of *The Birth of Venus* by Botticelli (ca 1483–84, Uffizi Gallery, Florence): Cupid is correlated with Zephyr, and Psyche with Venus. At the same time, Psyche's pose is identical with the attitude of the *Standing Bather, Brushing Her Hair* by Maillol. While working on his composition, the artist undoubtedly thought of Raphael's *Galatea* (1515, Villa Farnesina, Rome). The second panel recalls the *Abduction of Psyche* by Prud'hon (1808, Louvre, Paris). The third panel, probably the best in the series, demonstrates the artist's use of an iconographic scheme borrowed from the Old Masters. The representation of Psyche who is looking intently at Cupid in the light of the lamp is similar to the interpretations by Vouet (Musée des Beaux-Arts, Lyons) and Subleyras (Arenenbourg Gallery, Brussels). Denis may have also seen some of Courbet's canvases, depicting Venus and Psyche. The fourth panel was undoubtedly inspired by two works from the Louvre: the sculpture *Cupid and Psyche* by Canova (1783–93) and the painting *The Sleep of Endymion* by Girodet (1793). Jupiter in the centre of the fifth panel resembles the large statue of Jupiter in the Vatican Museum, while the nude female figure in the lower right corner was probably inspired by *"Le concert champêtre"* (1508, Louvre, Paris), a painting which formerly was ascribed to Giorgione and now attributed to Titian.

Provenance:
1908 I. Morozov Collection (painted on commission for 50,000 francs); 1918 Second Museum of New Western Painting, Moscow; 1923 Museum of New Western Art, Moscow; 1948 Hermitage

Exhibitions:
1908 Paris, no. 531; 1993 Essen, nos 53–57; 1993–94 Moscow–St Petersburg, nos 53–57

MAURICE DENIS
The Legend of Psyche. Preparatory drawing for the first panel. 1907
Hermitage, St Petersburg

Maurice Denis

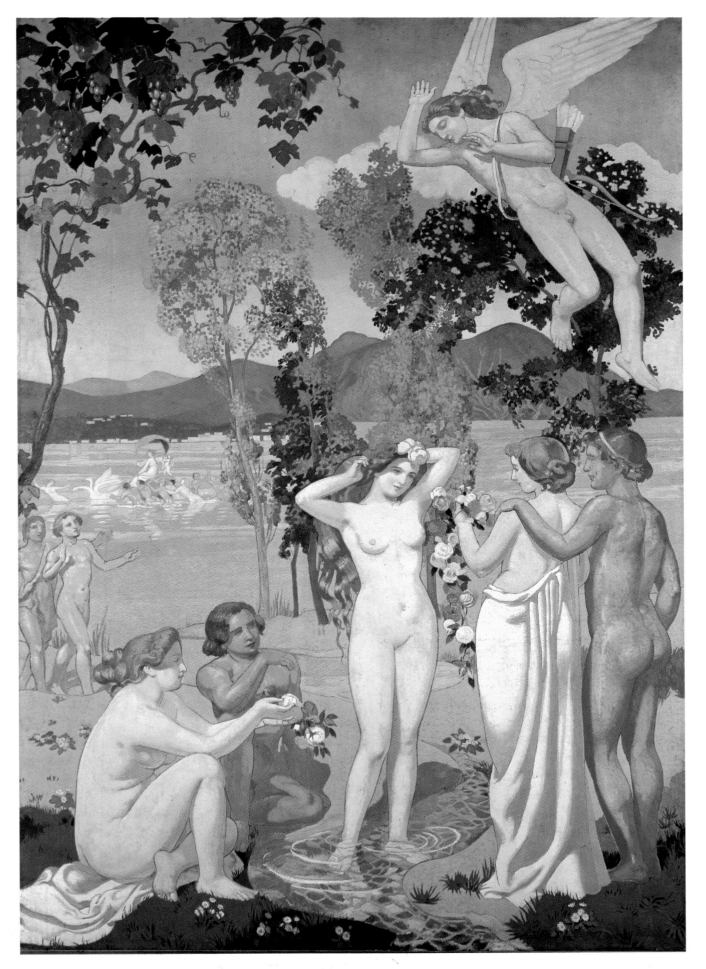

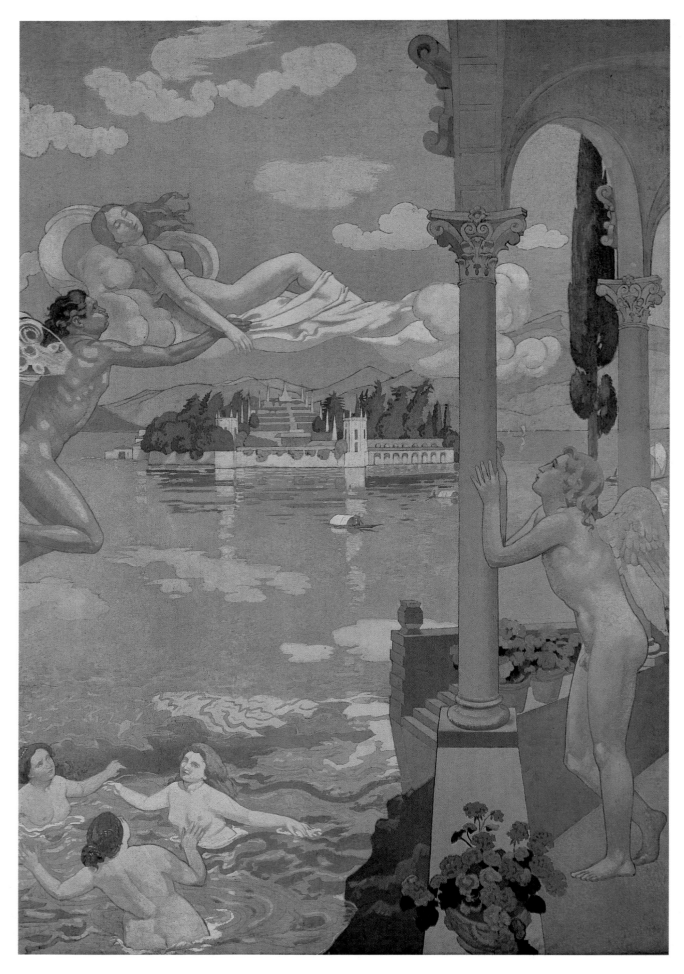

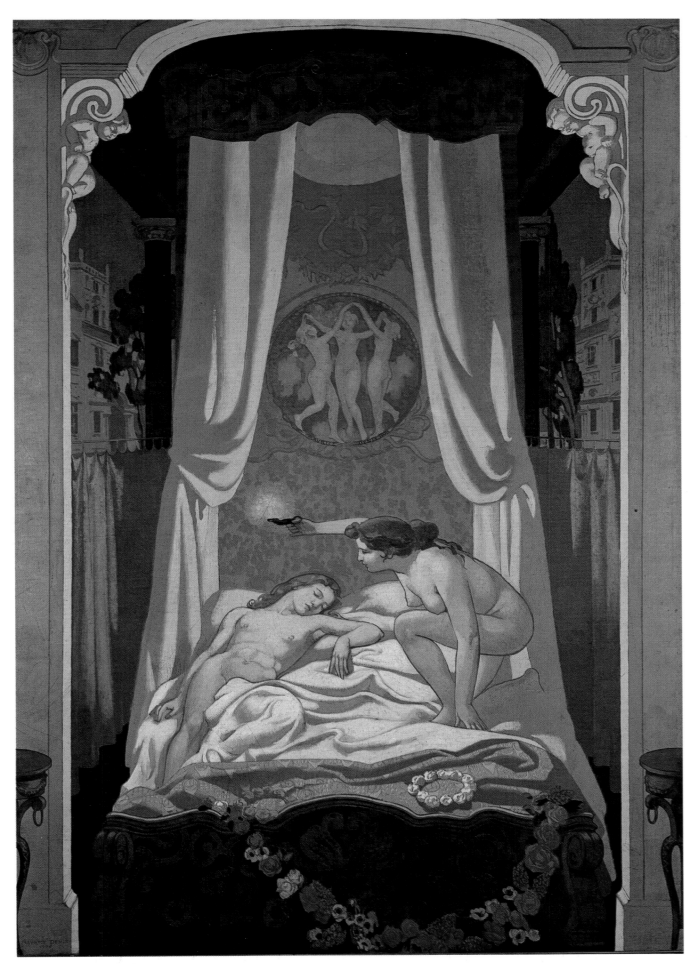

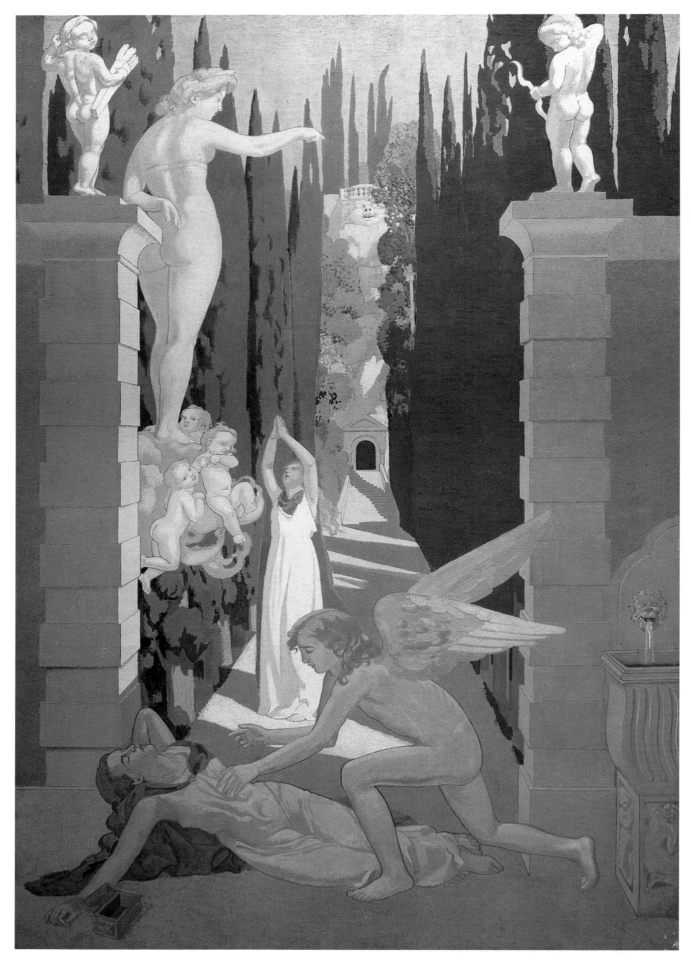

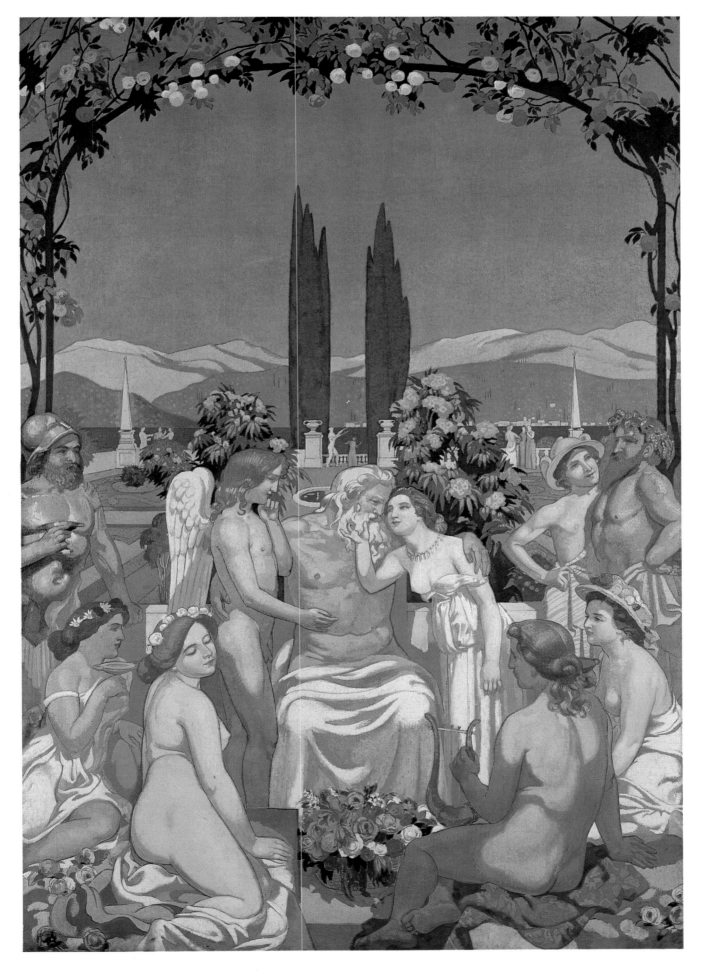

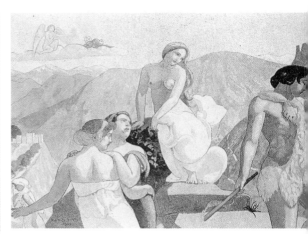

In January 1909 Denis came to Moscow on Ivan Morozov's invitation. The artist wrote in his diary: "My large decoration looks a bit isolated in a large cold hall of grey stone with mousy-grey furniture. I need something to link them. But as a whole, the scene is not without grandeur. My colours remain strong like at the Salon, but create a more harmonious unity".

The artist repainted some areas on the panels, somewhat muting the bright colours in order to make them match the surrounding architecture. He also suggested painting two additional panels (6, 7) for above the doors, two narrow panels (8, 9) for the western wall and two more panels (10, 11) to be placed on the right and left sides of the third, central panel.

Besides, he planned to paint two borders on the sides of the door.

He worked on these additions in France and they were preceded by preliminary sketches and drawings. A small oil sketch for the seventh panel is in the Musée d'Orsay in Paris; five large drawings, done in a mixed technique (pencil, charcoal, chalk, gouache), are in the Musée du Prieuré in Saint-Germain-en-Laye. One drawing for the sixth panel shows Psyche sitting, another one represents her sisters. Sketches for the seventh panel depict Psyche and Cupid.

All additional panels had been completed by the autumn of 1909 on 23 October. Emile Druet wrote to Ivan Morozov: "This week I exhibited two... of your panels by Maurice Denis... They were a great success. I gave them to be packed. You will receive them soon." (Pushkin Museum of Fine Arts archives).

In 1941, after the outbreak of war, the panels were removed from the walls and rolled up. When they were unrolled in 1951 after transfer to the Hermitage, damage of the paint layer was found to have occurred on the sixth and especially the seventh panels.

Denis was keen to create an ensemble of diverse arts in the music room in Morozov's house. For this purpose he designed long divans and made ceramic vases. He also persuaded Morozov to install large bronze sculptures in the corners of the hall and those were commis-

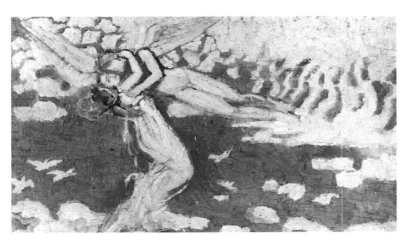

sioned from Maillol. They were *Pomona*
(1910), *Flora* (1911), *Woman and Flowers*
(1912) and *Female Figure* (1912), now all
in the Pushkin Museum of Fine Arts.

MAURICE DENIS
The Legend of Psyche. Sketch
for the seventh panel. 1909
Musée d'Orsay, Paris

Provenance:

1909 I. Morozov Collection (painted on commis-
sion for 20,000 francs); 1918 Second Museum
of New Western Painting, Moscow; 1923 Museum
of New Western Art, Moscow; 1948 Hermitage

Exhibitions:

1909 Paris (panels 6 and 7, no catalogue); 1993
Essen, nos 58, 59; 1993–94 Moscow –
St Petersburg, nos 58, 59

Bibliography:

F. Monod, "L'Histoire de Psyché de M. Maurice
Denis", in: *Art et Décoration*, 1908, vol. 24, II,
pp. 147–149, 159–162; P. Hepp, "Le Salon
d'Automne ", in: *Gazette des Beaux-Arts*, 1908,
pp. 385–386; A. Alexandre, "Un peintre mystique
au XXe siècle", in: *L'Art et les Artistes*, 1909–10,
vol. 10, p. 263; Makovsky 1912, p. 22; J. de
Foville, "Artistes contemporains: Maurice Denis",
in: *La Revue de l'art ancien et moderne*, 1913, vol. 33,
p. 276; Segard 1914, pp. 146, 175, 212, 317, 318;
Catalogue 1928, nos 137–144; Réau 1929, no. 779;
Barazzetti-Demoulin 1945, pp. 66, 67, 77, 78, 86,
152–154, 286; Denis 1957, pp. 94–96, 100; vol. 3,
p. 214; *Catalogue* 1958, vol. 1, pp. 381, 382;
French 20th-century Masters 1970, no. 3; Izerghina,
Barskaya 1975, nos 80–92; *Catalogue* 1976,
pp. 254–256; Ternovetz 1977, pp. 109–111;
K. Somov, *Letters, Diaries, Opinions of the Contem-
poraries*, Moscow, 1975, p. 112 (in Russian);
A. Benois, *My Reminiscences*, Moscow, 1980,
vol. 2, pp. 152, 153 (in Russian); Kostenevich
1987, no. 119; Ya. Tugendhold, *From the History
of Western European, Russian and Soviet Art*,
Moscow, 1987, p. 62 (in Russian); Kostenevich
1989, nos 108–120; A. Kostenevich, "A New
Discovery of *The Legend of Psyche*", *Sovetsky
Muzei*, 1992, no. 3, pp. 47–55 (in Russian)

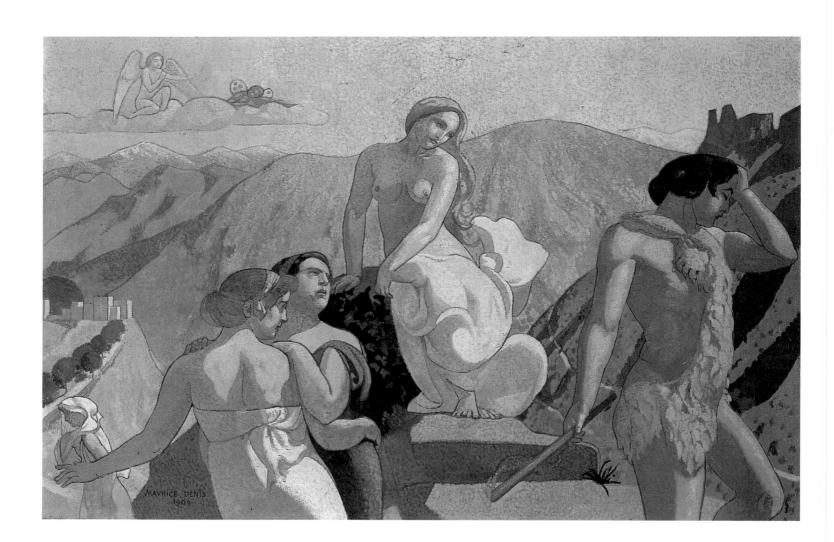

Maurice Denis

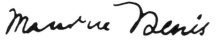

51
Shepherds (The Green Seashore). 1909
Les Bergers (Au bord de la mer)
Oil on canvas. 97 x 180 cm
Signed and dated, bottom left: *Maurice Denis 1909*
Pushkin Museum of Fine Arts, Moscow. Inv. no. 3376

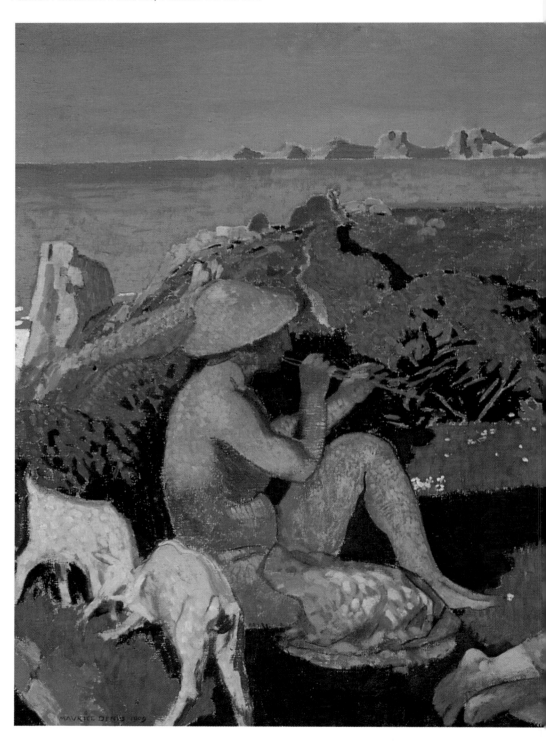

In the Pushkin Museum this painting retains the traditional title given to it in Ivan Morozov's collection – *The Green Seashore*, to which another has been added – *The Beach at Perros-Guirec*. Although this composition does depict the beach at Perros-Guirec, that title inadvertently distorts the concept of the artist who painted a Classical idyll. Denis's own name for the work, which has been preserved in the family archive, was *Shepherds*.

Denis was extremely fond of Perros-Guirec, a little spot in Brittany which he first visited with his father in childhood. He went there several times in 1888, at the very start of his artistic career, and in 1892 he stayed for some time. In the summer of the following year, Perros-Guirec was where he chose to spend his honeymoon. The place continued to hold a powerful attraction for the artist.

Like Gauguin at the turn of the 1890s, Denis perceived Brittany as a region where the past survived undisturbed and it is therefore not surprising that, later too, images of Classical Antiquity and the Breton landscape could easily blend in his consciousness. In July 1908 Denis purchased the "Silencio" estate at Perros-Guirec (it still belongs to the family) and from then on spent his summers there together with his wife and children. In August 1909 Denis's son Dominic was born at Perros-Guirec. It was probably at that moment that the artist painted this large pastoral which was immediately bought by Ivan Morozov. In the painting tranquillity and harmony reign, underlined by the gentle late afternoon light and predominance of soft outlines.

In order to stress the breadth and spaciousness of the scene, Denis not only chose a horizontally extended format, but also in every possible way emphasized

that horizontality by echoing the contours of the island, the green shore, the foreground shadows and the lines of the reclining figures.

The painting exudes reminiscences of Puvis de Chavannes and Gauguin, but also of the art of Classical Antiquity, which had been a direct inspiration to Denis's immediate predecessors. For example, the pose of the seated naked woman is closely related to that seen in Gauguin's painting *What, Are You Jealous?* (1892, Pushkin Museum of Fine Arts); but at the same time one is inevitably reminded of the figure from the frieze of the Theatre of Dionysus in Athens (a photograph of which Gauguin used for his composition). The woman reclining in the foreground is a sort of paraphrase of Gauguin's *Nevermore* (1897, Courtauld Institute, London), the difference being that Denis depicted the figure clothed. At the same time, there is here a point of contact with Emile Bernard who depicted his sister in a similar pose in *Madeleine in the Forest of Love* (1888, Altarriba Collection, Paris), one of the programmatic works of Symbolism. Among the undoubted sources of *Shepherds* is Puvis de Chavannes's painting *Girls on the Seashore* (1879, Musée d'Orsay, Paris), which Denis knew very well and regarded highly.

On the other hand, Denis employed motifs which Bonnard and Roussel were fond of using at that time. Details of the left-hand part of the picture, for example, are reminiscent of Bonnard's *Early Spring* (see no. 14) and *Summer. The Dance* (see no. 16). As a whole *Shepherds* is a painting which develops the idea of the Golden Age, a theme dear to many of the Symbolists and one which Denis had already interpreted several times: in *The Eternal Summer* (1905, private collection), *The Eternal Spring* (1908, Musée du Prieuré, Saint-Germain-en-Laye) and in works on Classical subjects.

Provenance:
1909 I. Morozov Collection (purchased from the artist for 5,000 francs); 1918 Second Museum of New Western Painting, Moscow; 1923 Museum of New Western Art, Moscow; 1948 Pushkin Museum of Fine Arts

Exhibitions:
1982 Moscow, no. 83

Bibliography:
Makovsky 1912, p. 20; *Catalogue* 1928, no. 145; Réau 1929, no. 780; *Catalogue* 1961, p. 71; Georgievskaya, Kuznetsova 1979, no. 150; *Classical Antiquity in European Painting of the 15th – Early 20th Centuries*, Moscow, 1984, no. 83, pp. 150f, 163 (in Russian); Barskaya, Bessonova 1985, no. 254; *Catalogue* 1986, p. 69; *Maurice Denis, Réunion des Musées Nationaux.* (Catalogue of the exhibition held in Lyons, Cologne, Liverpool and Amsterdam; not included in catalogue), 1994, pp. 51, 276

FELIX VALLOTTON

1865–1925

F . VALLOTTON

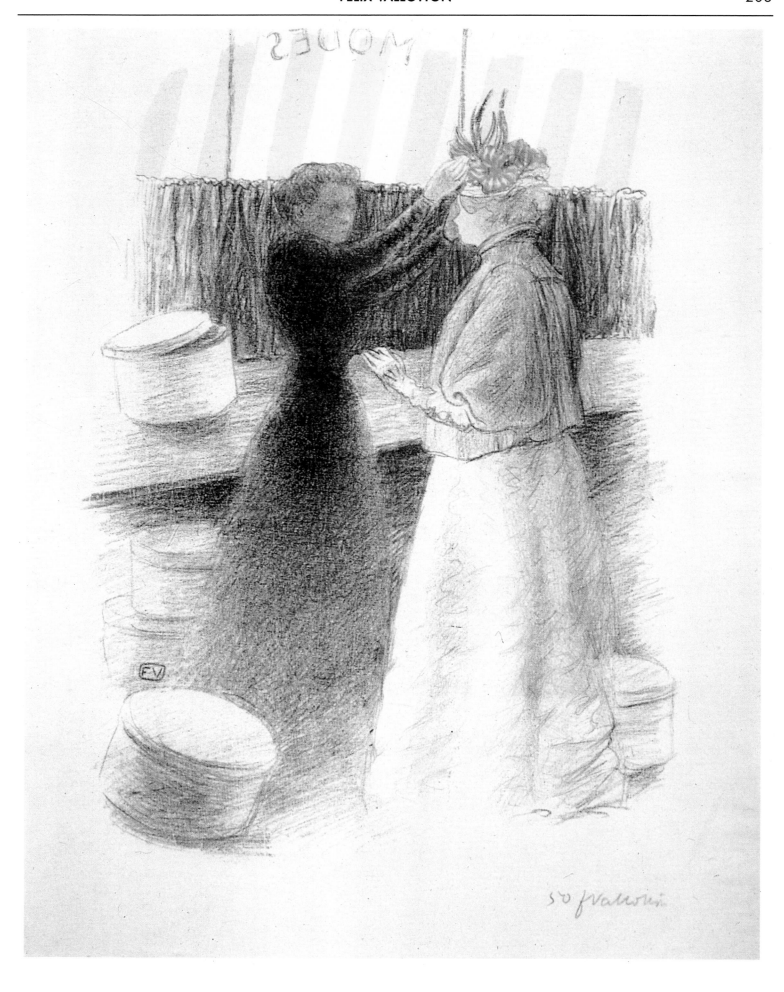

"The foreign Nabi" stood out among the members of the group, not so much because of his non-French extraction as because of a manner of painting, quite unlike that of his fellow-artists. For this reason some critics have regarded his affiliation with the Nabis as purely formal. For instance, Charles Chassé, whose book on the Nabis was published in Switzerland, the artist's homeland,[1] scarcely mentions Vallotton, whereas he sets aside whole chapters to artists who did not belong to this group at all and played a lesser part in the history of painting at the turn of the century. Nevertheless, the Nabis must have had their reasons for admitting the newcomer from Lausanne into their circle, even if they did hesitate over it.

All the Nabis' first efforts were remarkable for their maturity, but Vallotton achieved mastery even sooner than the others. His style was established very early and remained practically unchanged. While Bonnard's fledgeling canvases did not contain the promise of his later works, Vallotton displayed his talent to the full at the very outset of his career. As a boy of sixteen, he amazed his teachers in Lausanne with a study of an old man's head, executed with a sure hand. Soon afterwards he moved to Paris. His *Self-Portrait at Seventeen* (1882, Musée Cantonal des Beaux-Arts, Lausanne) was probably painted at that time. This picture is remarkable for the masterful handling of minute details and their balanced arrangement. The artist makes no attempt at pictorial effects. The portrait is austere and somewhat reserved, as was the painter himself. Looking out at us from the canvas is a boy who seems too serious for his age, assertive and independent in his judgement.

Vallotton had a hard time during his first decade in Paris. He had to do odd jobs like restoration and reproduction engravings; he also contributed to fashion magazines and various humorous publications.

A measure of fame finally came to him with his woodcuts, daring and generalized in manner, devoid of any half-tones. His portraits, landscapes, street and genre scenes revealing aspects of bourgeois life that society preferred to keep hidden are always extremely stark and highly caustic. In the 1890s Vallotton produced far more woodcuts than paintings.

As far back as 1885, when Vallotton first showed his works at the Salon des Artistes Français, they drew the attention of art critics. However, both at that time and for years to come, progressive artists who advocated the supremacy of pictorial effect and the unrestrained use of colours looked on his manner as something retrograde. "Vallotton's paintings are anti-picturesque," Signac wrote in his diary in April 1898. "This sensible young man is wrong in thinking that he is endowed with a talent for painting. He thinks that by employing a calculated and conservative technique he is imitating Holbein and Ingres, but he only succeeds in imitating Bouguereau's worst pupils. The result is ungainly and unintelligent. However, Vallotton is undoubtedly endowed with intelligence and a sense of the beautiful, which is confirmed by his woodcuts." [2]

Indeed, at first sight Vallotton's paintings and woodcuts might have been executed by two different artists. His paintings are rather meticulous, whereas the woodcuts retain only the major details, with everything that is of minor importance absorbed by blackness. Yet they do have something in common: the immaculate draftsmanship, the decorative and generalizing quality of line, which, according to the prominent early-twentieth-century art critic Jacques Rivière, "enlaces" the form. Also like the black patches in his woodcuts, colour in his paintings is distributed in extensive zones, within which the individual brushstroke, regarded as the main unit and measure of painterly activity, is scarcely detectable. Signac, who could not bear smoothness and "blew up" his surfaces with divided strokes, regarded Vallotton's brushwork as the complete antithesis of his own style and, indeed, of everything that derived from Impressionism. But the young Swiss, who had arrived in Paris when the Impressionists were still striving for recognition, did not know them, or at least had no wish to do so. That was not because he was wholly "indoctrinated" by Jules Lefebvre, Bouguereau and Boulanger at the Académie Julian; in fact, he preferred going to the Louvre and making copies of Antonello da Messina, Leonardo da Vinci and Dürer.

"I have been thinking about the Italian Primitivists, and particularly about those wonderful unknown artists in the German museums; those exquisite masters, whose brilliant ideas, put down on canvas in perfect form, have an immediate impact even today, four centuries later, yet they did not even think to sign their names for our benefit," [3] Vallotton wrote in May 1893 in the *Gazette*

FÉLIX VALLOTTON
The Green Hat. 1896.
Colour lithograph
Hermitage, St Petersburg

[1] Ch. Chassé, *Les Nabis et leur temps*, Lausanne—Paris, 1960
[2] "Extraits du journal inédit de Paul Signac. 1897–1898", *Gazette des Beaux-Arts*, 1952, April, p. 280
[3] *Gazette de Lausanne*, 4 May 1893

FÉLIX VALLOTTON
To the Lock-Up. 1893.
Lithograph
Hermitage, St Petersburg

FÉLIX VALLOTTON
Book ornament: headpiece.
Woodcut
Hermitage, St Petersburg

FÉLIX VALLOTTON
Little Girls. Woodcut
Hermitage, St Petersburg

FÉLIX VALLOTTON
The Lie. 1893. Woodcut
Hermitage, St Petersburg

FÉLIX VALLOTTON
Book ornament: headpiece.
Woodcut
Hermitage, St Petersburg

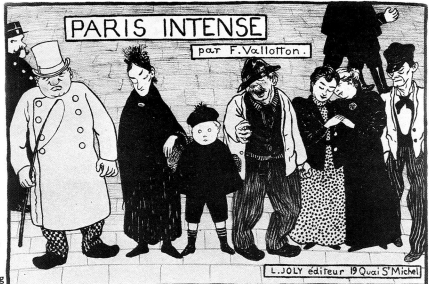

FÉLIX VALLOTTON
Title-page of the *Parisian
Types* series. 1893.
Lithograph
Hermitage, St Petersburg

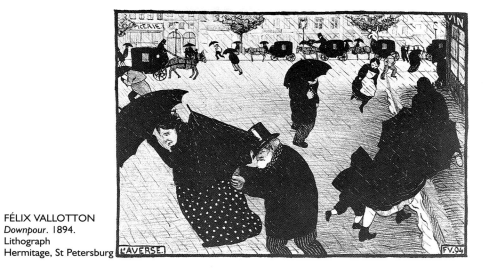

FÉLIX VALLOTTON
Downpour. 1894.
Lithograph
Hermitage, St Petersburg

FÉLIX VALLOTTON
Book ornament: headpiece.
Woodcut
Hermitage, St Petersburg

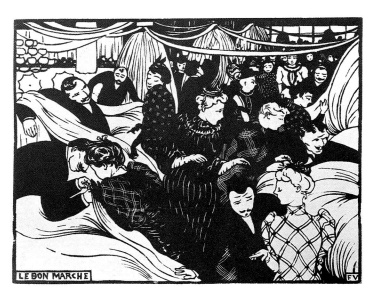

FÉLIX VALLOTTON
Bargain Sale. 1893.
Woodcut
Hermitage, St Petersburg

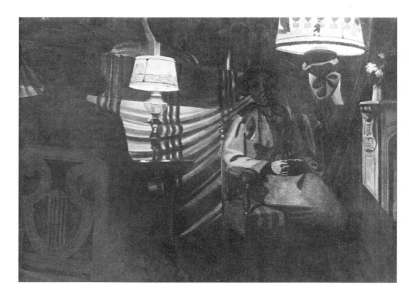

de Lausanne, to which he contributed regularly. Not only did he practice journalism, but he was also the author of three novels and six plays. In Germany or Switzerland the kind of painting cultivated by Vallotton would probably have been recognized more easily. But even in Paris it gradually found supporters. From 1899 onward Vallotton devoted most of his time to painting. His efforts were encouraged by his wife, Gabrielle Rodrigues-Henriques (née Bernheim-Jeune), a widow who had three children from her first marriage. Gabrielle was a good match, as well as being quite prosperous: she connected him with a major firm of art dealers.

As a painter Vallotton was amazingly prolific. He compiled a list of 1,587 of his paintings in the *Livre de raison*, which he kept from 1885 until his death (proof of his great methodicalness). Considering that there were nonetheless inevitable omissions, while sometimes the same entry covers several variants of a work and, above all, remembering his meticulous manner of execution, it must be conceded that Vallotton was an extraordinarily hard-working artist.

Vallotton's first efforts were limited to portraits, very conscientiously executed, painted from nature. Subsequently his range expanded with *portraits décoratifs*, usually invented, and portraits with genre elements. Vallotton's portraiture of the 1890s often displays a tendency towards narrative, and he appears to have been a storyteller with keen insight, his irony usually bordering on the malicious. When he sets down his glimpses of Paris life on canvas, his paintings come to resemble woodcuts, for they treat similar subjects in an expressive, not to say Expressionistic manner. They also reveal what united Vallotton

with the rest of the Nabis: his compositional and decorative ingenuity. *Concert* (1895, private collection), for instance, is close to Bonnard's work, even down to employing the same type of decorative motifs, only the Frenchman's smile is superseded by the sarcasm of the Swiss. Vallotton's genre paintings are for the most part set in an interior. He showed an obvious preference for closed spaces. In some portraits dating from the early years of the twentieth century the role of the interior is so significant that it is no longer a mere setting. At that time, the interior as subject-matter in its own right captured the artist's interest. True, it was later superseded by female nudes and mythological and allegoric subjects. Vallotton never gave up portraiture and also would turn quite often to the still life. The essence of Vallotton's painting is splendidly revealed by his interiors, spick and span, motionless, *nature morte* in the literal sense of the word. The human figures are just as much material objects in these *nature-morte* interiors, as the beds and the wardrobes. The mesmeric registration of objects, an almost judicially precise record of early-twentieth-century life, seems to conceal a melancholy which is on the point of developing into a fatalistic indifference. Yet what Vallotton depicted was not somebody else's life but his own, and the figures were people he himself was close to. The interior of his home in Paris found its way into a series of paintings conceived as modern versions of de Hooch or Janssen. However, the artist's irony precludes the heartfelt warmth that cheered the work of the seventeenth-century Dutch masters. Jean Cassou saw one of the major traits of Vallotton's nature as being the "bourgeois

A part of the exhibition arranged by *The Golden Fleece*
magazine in Moscow with Vallotton's paintings *Woman
in a Black Hat* and *The Dinner*. 1908. Photograph

anarchism" which was most strikingly revealed in his literary activities. What Cassou said about Vallotton's novels holds true for his interiors and many of his other pictures. "His novels do indeed give us the key. We discern mixed feelings in them: on the one hand, a bitter and grumbling spite towards bourgeois society, that is paltry, ridiculous and reactionary; on the other hand, a no less reactionary pleasure at belonging to it." [1] Sarcasm is generally found where the human element is dominant. When Vallotton turns to landscape painting, he appears in a different light. Here he is at his most Nabi, his highly decorative effects and stylistic allusions typical of all the members of the group. Vallotton's attitude, however, still remains estranged. There is something of toyland in his *Landscape in Normandy*, one of his best landscapes. Vallotton seems to hint, by employing this "playful" approach, that he is acquainted with Japanese art, but chooses to stick with the Europeans in his modelling (adding just a little Japanese flavour). He is alive to Cézanne's work and even makes use of his "plunging perspective" method, with the foreground rather than the background dramatically foreshortened, but the spirit of the Cézanne landscape is alien to him; his neat little cows could not graze in it; what they need is a cultivated countryside. Vallotton was a rare type of professional, non-Salon artist: he did not shrink from banal, very nearly pastoral motifs, although he managed to do without the traditional shepherds and shepherdesses. He never shunned deliberately poetic motifs, like a pink sunset, nor old-fashioned compositions with the emphasis on the middle. In this latter respect *Landscape in Normandy* is comparable with the works of the Barbizon school. A great museum-goer and frequenter of art exhibitions since his young days, Vallotton was able to use to his own end an intonation he caught, or a gesture he observed. This was not imitation – if it were so, there would not be the hints of parody – but a means of self-expression. In playing with a certain device, Vallotton was not afraid of looking old-fashioned and so becoming an object of ridicule. The keen sense of the present time, which he possessed to an exceptional extent, allowed him to transform a weary device. His *Portrait of a Woman* (*Woman Wearing a Hat*) is undoubtedly a parody, combining the almost uncombinable: the striking turn of the half-clothed figure and a plain, dull face topped with an elaborate flowery hat. The painter's eye seems dispassionate, yet something personal comes across

in his attitude to the woman. Annette Vaillant recollected that Vallotton's Calvinist exterior concealed a strange Ingres-like sensuousness. [2] But the intimate effect of the portrait is extinguished by mockery, noticeable even in the range of colours, which is limited here and clearly imitates that of Salon journeyman painters. On the other hand, the portraits of Haasen and his wife demonstrate that Vallotton was himself capable, when he chose, of being a painter of gala portraits. His impartiality here is almost like that of a camera. Perhaps because these portraits were commissioned, he does not seem to want anything more than an outward likeness; not a single brushstroke betrays his attitude towards the model, nor, indeed, any attitude at all. It is significant that the background details in the portrait of Haasen are far more interesting artistically than the human figure. Vallotton's art is indispensable for any student of life in that period. The accuracy of his details never needs to be questioned. The design, mood and, with rare exception, bitter astringency of his work set him apart not only among the Nabis but among other contemporaries too. His deliberate objectivity and emphatically dispassionate observation expressed in meticulous draftsmanship and inexpressive texture link him not only with the Naturalism of the nineteenth century, but also with the tendencies of the twentieth. It is natural, therefore, that public interest in his work has tended to grow whenever there was a turn towards the concrete, material aspect in the arts, be it the 1920s with their renewed materialism or the 1970s with their hyperrealism and other semi-naturalistic trends.

FÉLIX VALLOTTON
Landscape
Private collection, Paris

[1] J. Cassou, *Panorama des arts plastiques contemporains*, Paris, 1960, p. 65

[2] A. Vaillant, *Bonnard*, London, 1966, p. 109

1865
Félix Vallotton born into the family of a petty tradesman in Lausanne

1875
At the Collège Cantonal, Lausanne. Studies drawing under Jean-Samson Guignard. Discovers Swiss artists Anker, Calame and Gleyre at the local museum

1882
Moves to Paris. At the Académie Julian, Jules Lefebvre's class

1885
First exhibits at the Salon

1886
Vallotton's portraiture wins an honourable mention at the Salon. He earns his keep by making engraved copies of the Old Masters

1887
Copying Renaissance artists at the Louvre

1889
Vallotton's engravings shown in the Swiss pavilion at the Paris World Fair. Friendship with Toulouse-Lautrec, Cottet, Vuillard

1891
Contributes to the *Gazette de Lausanne* as an art critic. Tries making woodcuts, developing his own stark style. Begins contributing to the *Revue Blanche*; becomes friendly with the painters and writers associated with that periodical

1892
Joins the Nabis

1893
Makes a set of lithographs *Immortels passés, présents ou futurs*. His *Bathers on a Summer Evening* causes a scandal at the Salon des Indépendants. Meets Maillol. Exhibits with the Nabis at the Le Barc de Boutteville Gallery. Contributes to the London-based magazine *Studio*. Visits Belgium and Holland

1895
Contributes to periodicals: *Pan* (Berlin), *Chap Book* (Chicago) and *Ord och Bild* (Stockholm)

1897
Becomes close to Vuillard, Bonnard, Ranson and the other Nabis. Exhibits at the Vollard Gallery

1898
Set of woodcuts *Intimités*. Meier-Graefe publishes a book on Vallotton in Germany and in France

1899
Marriage to Gabrielle Rodrigues-Henriques, née Bernheim-Jeune. Establishes close contacts with the Bernheim-Jeune Gallery. In summer: works in Normandy and Brittany

1900
Becomes a French citizen. In summer: works at the Château Romanel near Lausanne

1901
Stays in Le Cannet (with the Natansons), Marseilles and Honfleur

1903
Exhibits at the Salon d'Automne and at the Sezession in Vienna. Works at Arc-la-Bataille

1904
Works in Varengeville. Beside painting and woodcuts, tries his hand at sculpture

1907
Writes the novel *La Vie meurtrière*, the keenest expression of his pessimism. Vallotton's play *Un Rien* produced by the Théâtre de l'Œuvre; another play, *L'Homme fort* to be put on the following year at the Théâtre du Grand Guignol

1908
Teaches at the Académie Ranson

1909
First one-man show in Zurich, displaying 75 works (girls under 16 are not allowed in)

1910
One-man show at the Druet Gallery, Paris; preface to the catalogue written by Vallotton's friend Octave Mirbeau

1911
Sunsets series

1913
Trips to St Petersburg and Moscow, then to Italy

1915
C'est la guerre, a series of anti-war woodcuts

1918
Works in Honfleur

1920
Feels despondent notwithstanding the success of his post-war exhibitions. After the war he paints mostly landscapes, as well as still lifes and self-portraits

1922
Works in Cagnes-sur-Mer

1924
Works in Cagnes-sur-Mer, Vence and Deauville. Paints landscapes of Brittany, Normandy, the Dordogne and the Loire. Illustrates Hervier and Flaubert

1925
Dies in Paris

52
The Dinner. 1900
Le Dîner
Oil on cardboard. 55 x 86.8 cm
Signed and dated, bottom right: *F. Vallotton 1900*
Gorky Art Museum, Kirov. Inv. no. 38

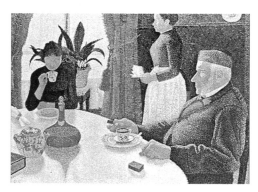

PAUL SIGNAC
Luncheon. 1886-87
Rijksmuseum Kröller-Müller, Otterloo

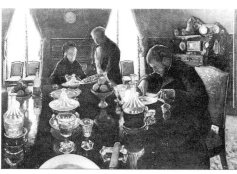

GUSTAVE CAILLEBOTTE
Luncheon. 1876
Private collection, Paris

CLAUDE MONET
Luncheon. 1868
Städelsches Kunstinstitut, Frankfurt am Main

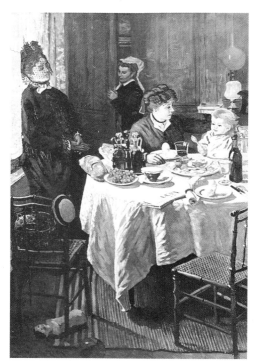

The picture is a replica of the 1899 painting on wood *The Dinner, Effect of Lamp Light* (Musée d'Orsay, Paris).

The whimsical play of silhouettes which determines the style of the picture was due, on the one hand, to Vallotton's passion for woodcuts, where the artist used sharp contrasts of black and white, and, on the other hand, to the influence of *ukiyo-e* prints. The black silhouettes of tigers, decorating the lampshade, also signify his interest in oriental art (such Chinese and Japanese paper cutouts were coming into fashion at that time). The picture represents a family dinner in Vallotton's house in the Rue Beau-Séjour in Paris. The original, now in the Musée d'Orsay, was painted soon after Vallotton's marriage to Gabrielle Rodrigues-Henriques, who was the sister of the owners of the Bernheim-Jeune Gallery. She is depicted on the right. Shown on the left is the artist's stepson Max Rodrigues, in the centre – his stepdaughter, Madeleine.

At this time Vallotton was very concerned with the rendition of the effects of illumination. One example is *Visit* (1899, Kunstmuseum, Winterthur), which also shows his wife.

The subject of a family meal, worked out in early Impressionism (Monet's *Luncheon*, 1868, Städelsches Kunstinstitut, Frankfurt am Main; Caillebotte's *Luncheon*, 1876, private collection, Paris; Signac's *Luncheon*, 1886–87, Rijksmuseum Kröller-Müller, Otterloo), often appeared in the work of the Nabis, especially Bonnard and Vuillard. Thus, Vallotton could base himself on an established tradition in turning to the theme, but unlike

PIERRE BONNARD
Breakfast by Lamplight. 1898

his predecessors and the artists from the Nabi group who experimented with colour, Vallotton preferred a graphic rather than a painterly approach.

In the middle of March 1908, after sending the picture to the Moscow exhibition organized by Nikolai Riabushinsky, Vallotton wrote to his brother: "Yesterday I sent six paintings to Moscow, care of a local art-patron; the exhibition is to open by the end of the month under the aegis of the magazine *The Golden Fleece*".

In a letter to his brother on 8 June Vallotton wrote: "I received an offer from Moscow to sell an old picture, which I would be happy to get rid of...".

The artist meant *The Dinner*, which was bought from "The Golden Fleece" exhibition by S. Poliakov, the publisher of the magazine *The Balance* (*Vesy*). There is an entry about this sale in Vallotton's *Livre de raison*.

Provenance:
1908 S. Poliakov Collection, Moscow (purchased from "The Golden Fleece" exhibition);
1919 Museum of Viatka (now Gorky Art Museum, Kirov) (purchased from S. Poliakov)

Exhibitions:
1903 Vienna, no. 229; 1908 Moscow, no. 178; 1991–93 New Haven–Houston–Indianapolis–Amsterdam–Lausanne, no. 136

Bibliography:
Vallotton 1974, pp. 132, 135, 136; Brodskaïa 1986, pp. 85, 100

ÉDOUARD VUILLARD
Woman in the Lamplight. 1892
Musée de l'Annonciade, Saint-Tropez

F.VALLOTTON

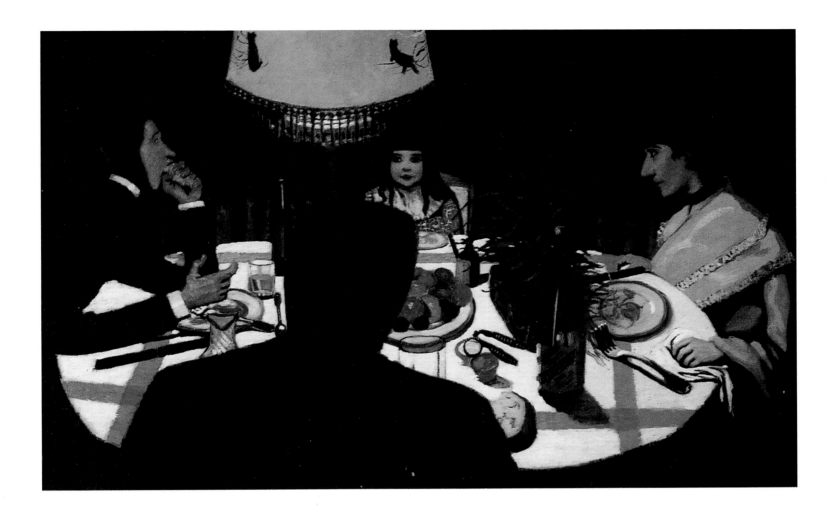

F·VALLOTTON

53
A Port
Un port

Oil on cardboard. 57 x 62 cm
Signed and dated, bottom right: F. VALLOTTON. 01
Pushkin Museum of Fine Arts, Moscow. Inv. no. 3439

In Vallotton's early work landscape played a secondary role and was constructed according to the canons of Swiss nineteenth-century Realist painting. In 1900 the situation changed: the artist began to devote ever increasing attention to this sphere of painting and his works became at one and the same time more laconic and more expressive. One might call the following year "the year of the landscape". Vallotton painted a number of views of Paris and they are all deliberately anti-Impressionistic: almost always empty of life, with precisely drawn architectural details and fairly austere in mood. Even when depicting the sights of Paris, Vallotton avoided any sort of spectacle, restricting himself to one or two carefully outlined planes and concerning himself with geometrical constructiveness to a greater extent even than Vuillard in his early interiors. The artist adhered to this same manner of working when he travelled from Paris in 1901, whether to Marseilles and the Côte d'Azur, or to Honfleur. He spent the summer of 1901 at the Villa Beaulieu in Equemauville near Honfleur.

Honfleur had been a favourite spot with the Impressionists at the dawn of their careers.

FÉLIX VALLOTTON
Gabrielle Vallotton in the Studio in the Rue de Milan. 1902
Staatsgalerie, Stuttgart

Boudin, Jongkind, Monet, Bazille and Sisley all went there. In the spring of 1864, Bazille wrote to his parents: "After arriving in Honfleur we looked for landscape motifs. They are easy to find, because this country is paradise. You'll never see lusher meadows or more beautiful trees... The sea, or rather the broad mouth of the Seine, provides a glorious horizon for all this greenery... The port of Honfleur and the Normandy costumes with their cotton bonnets fascinate me." (G. Poulain, *Bazille et ses amis*, Paris, 1932, p. 40). Since then, however, much had changed. The port of Honfleur itself no longer seemed the romantic place with sailboats flitting to and fro against a background of turbulent waves that Claude Monet depicted. The port had grown, become more commercial, and it was this business-like character which Vallotton depicted, possibly even to spite the Impressionists.

The works which the artist brought back from Honfleur and Equemauville were not painted from life, but created at the villa from memory aided by small pencil sketches. This method of working, which allowed Vallotton to be less bound to nature, explains the forced constructiveness of his landscapes, which at times remind one of the much later American trend known as Precisionism. American scholars

do not exclude the possibility of Vallotton having been a direct influence on Edward Hopper and the other artists of that circle.

The Pushkin Museum painting belongs to the series "Landscapes produced at Honfleur: jetties, gardens, trees" recorded in the *Livre de raison* under number 466. In depicting fishing-boats by the breakwater, Vallotton did all he could to avoid what was considered poetic or picturesque – for example, the fairly popular at the turn of the century undulating reflections on the water or the play of lights in the gathering dusk. People rarely appear in Vallotton's series, and if they do, they are perceived as an element of the landscape, even in *Boats in the Port of Honfleur* (1901, private collection, Switzerland) in which the "workers of the sea" are depicted from behind, the artist not considering them of sufficient interest to investigate their psychology.

One can say with confidence that before Vallotton's *Port* and its fellows there had been – at least in paintings with this kind of subject-matter – nothing comparable for uncompromising geometricism. While remaining a literal reflection of the real-life motif, the present work in some strange way reminds one of works by the Cubists who arbitrarily created autonomous structures. It reminds one not only with its play of geometrical surfaces and a certain tendency towards the monochrome, but also with the introduction of numbers and letters, as if giving some modular code for the composition. It is interesting that *A Port* later served as an important detail in another work – *Gabrielle Vallotton in the Studio in the Rue de Milan* (1902, Staatsgalerie, Stuttgart) – that is constructed around the echoing of rectangles, diagonals and slightly curving lines, so that the shapes of the boats repeat the drapery on the model in the painting shown alongside and the contours of the robe worn by the artist's wife.

Provenance:

M. Morozov Collection; 1903 M. Morozova Collection; 1910 Pavel and Sergei Tretyakov Gallery, Moscow (gift of M. Morozova); 1925 Museum of New Western Art, Moscow; 1948 Pushkin Museum of Fine Arts

Bibliography:

Hahnloser-Bühler 1936, p. 285; Barskaya, Bessonova 1985, no. 256; *Catalogue* 1986, p. 38

FÉLIX VALLOTTON
Boats in the Port of Honfleur. 1901
Private collection, Switzerland

F . VALLOTTON

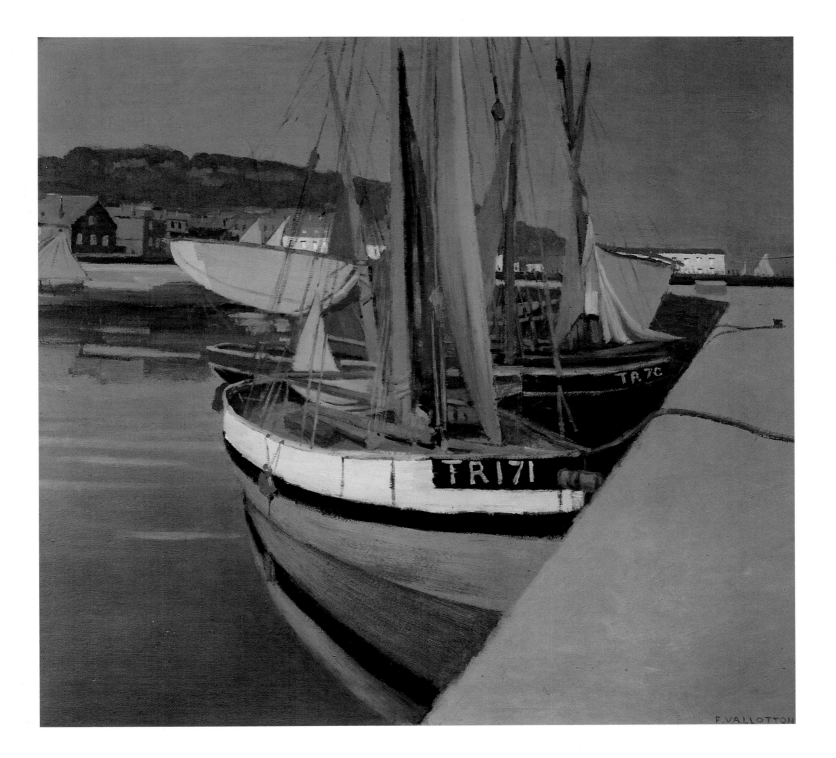

F.VALLOTTON

54
Landscape in Normandy. Arques-la-Bataille. 1903
Paysage normand. Arques-la-Bataille

Oil on cardboard. 67 x 103.5 cm
Signed and dated, bottom right: *F. Vallotton 03*
Inscribed on the reverse: *Arques-la-Bataille*
Hermitage, St Petersburg. Inv. no. 4908

This picture is one of a group of 17 land-scapes painted in the summer of 1903 in the area around Arques-la-Bataille (a small town in ten kilometres from Dieppe). In Vallotton's *Livre de raison* this series is under no. 508. The Hermitage painting, which is the most significant in the series, was done from a pencil drawing in the artist's studio (private collection, Paris).

The picture is close to the decorative landscapes Denis and other Nabis produced as early as the 1890s, and clearly demonstrates how a natural view is stylized in imitation of Japanese art. Vallotton could easily have found similar representations of a whirlpool and trees in Hokusai's woodcuts. The play of smooth undulating lines in the depiction of a stream, in the contours of the trees and shadows is supported by the rounded corners of the thin gilded frame.

It is possible that this painting was exhibited in 1907 at Vallotton's one-man show in the Bernheim-Jeune Gallery under the title *Rivulet. Normandy*. This is suggested by the stamp of the gallery, which has partially survived on the reverse.

It was obviously this picture that Vallotton mentioned in the letter of 21 March 1911 from Paris, in which he told his brother that on the way to Switzerland from Russia Haasen had bought his landscape.

Provenance:
1911 G. Haasen Collection, St Petersburg; 1921 Hermitage

Exhibitions:
1906 Paris, no. 43; 1965 Leningrad; 1988 Tokyo–Kyoto–Nagoya, no. 38; 1991–93 New Haven–Houston–Indianapolis–Amsterdam–Lausanne, no. 216; 1995 Ibaraki–Tokyo–Mie, no. 35

Bibliography:
Hahnloser-Bühler 1936, p. 286, no. 508; *Catalogue* 1958, vol. 1, p. 463; R. Koella, "Le Retour au paysage historique. Zur Entstehung und Bedeutung von Vallottons später Landschaftsmalerei", in: *Jahrbuch Schweizerische Institut für Wissenschaft*, Zurich, 1968–69, pp. 36–37; Vallotton 1974, no. 250, p. 178; Izerghina, Barskaya 1975, no. 108; *Catalogue* 1976, p. 307; Kostenevich 1984, pp. 216, 217; Brodskaïa 1986, p. 103; Kostenevich 1989, nos 141, 142

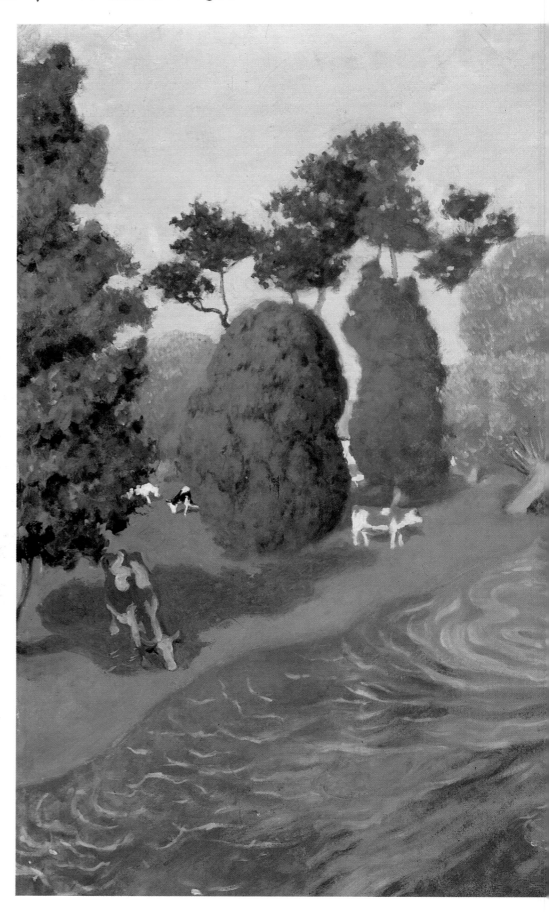

F·VALLOTTON

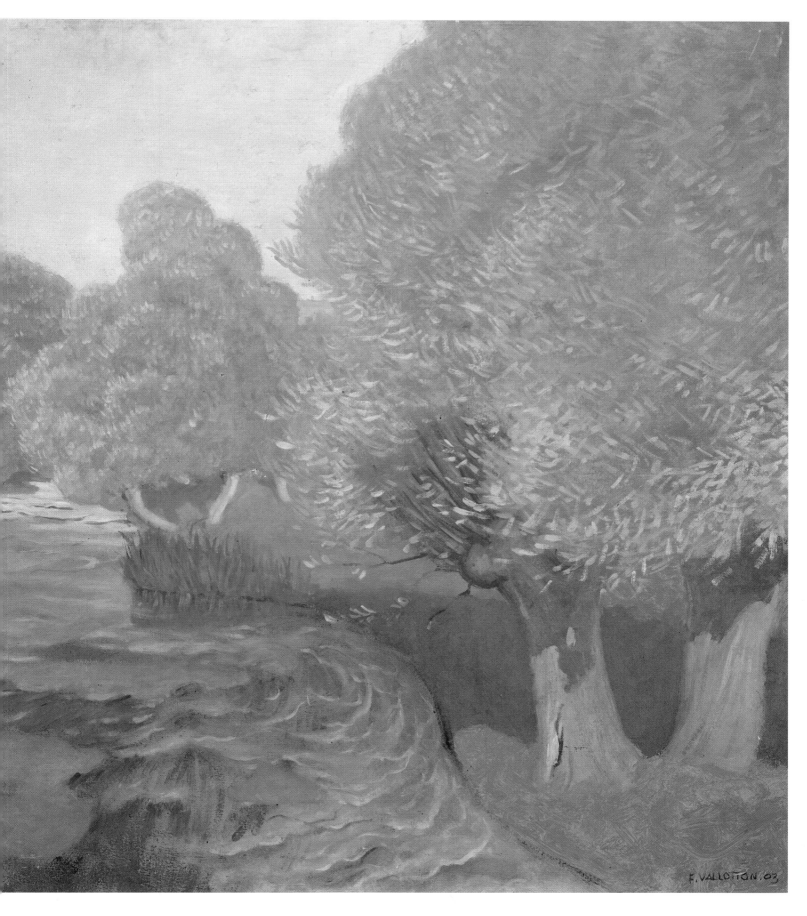

55
Interior. 1903–04
Intérieur

Oil on cardboard. 61.5 x 56 cm
Signed and dated, bottom left: F. Vallotton 04
Hermitage, St Petersburg. Inv. no. 4902

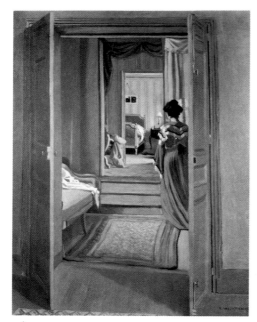

FÉLIX VALLOTTON
Interior with a Woman in Red. 1903
Paul Vallotton Gallery, Lausanne

This picture is one of a group of interior scenes, produced in Paris in 1903–04. The standing woman, reflected in the mirror, is Vallotton's wife, the daughter of the famous art dealer Bernheim. She often sat for the artist. The seamstress was painted from the model portrayed in the picture *Interior: Housemaid Sewing a Yellow Dress* (1904, Gilbert Collection, Paris). The picture was probably painted in the house in the Rue Belles-Feuilles to which the Vallottons moved in 1903. The same apartment appears in the *Interior with a Woman in Red* (1903, Paul Vallotton Gallery, Lausanne).
Although the painting is dated 1904, it may have been done in 1903, because in Vallotton's *Livre de raison*, which he kept punctiliously up-to-date, no *Interiors* are registered for 1904, but in 1903 several pictures with this title are mentioned with a note: Rue Belles-Feuilles. The Hermitage picture must be no. 523 in the *Livre de raison*. It is likely that Vallotton signed the painting later, when he sold it to Haasen, so he could have dated it 1904 by mistake.

Provenance:
1908 G. Haasen Collection, St Petersburg (purchased from the artist for 500 francs); 1921 Hermitage

Exhibitions:
1965 Leningrad; 1988 Tokyo–Kyoto–Nagoya, no. 39; 1991–93 New Haven–Houston–Indianapolis–Amsterdam–Lausanne, no. 183

Bibliography:
Hahnloser-Bühler 1936, p. 287, no. 523; *Catalogue 1958*, vol. 1, p. 463; Izerghina, Barskaya 1975, no. 109; *Catalogue 1976*, p. 307; G. Busch, B. Dorival, D. Jakubec, *Félix Vallotton. Leben und Werk*, Zurich, 1982, p. 166; Brodskaïa 1986, p. 101; Kostenevich 1987, nos 131, 132; Kostenevich 1989, no. 140

FÉLIX VALLOTTON
Interior: Housemaid Sewing a Yellow Dress. 1904
Gilbert Collection, Paris

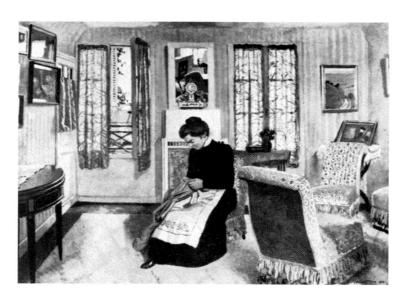

FÉLIX VALLOTTON
Woman Sewing in an Interior. 1905
Musée Levy, Troyes

F·VALLOTTON

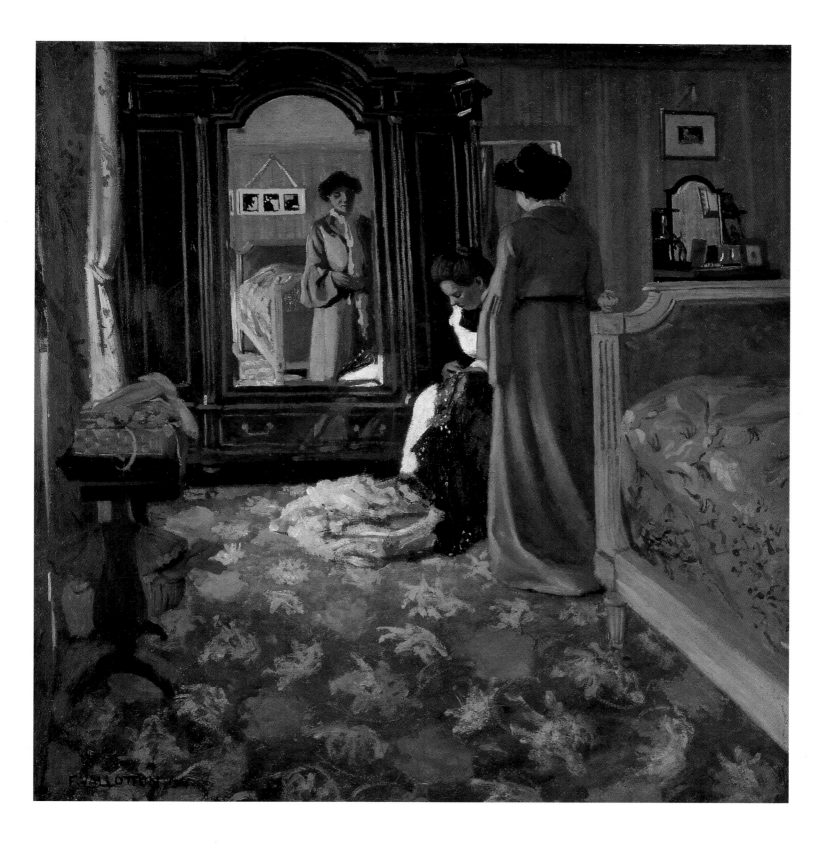

56
Lady at the Piano. 1904
Une dame au piano
Oil on canvas. 43.5 x 57 cm
Signed and dated, bottom right: *F. Vallotton 04*
Hermitage, St Petersburg. Inv. no. 4860

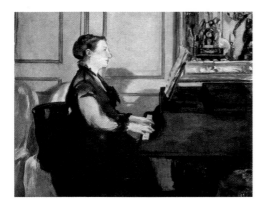

ÉDOUARD MANET
Portrait of the Artist's Wife at the Piano. 1867–68
Musée d'Orsay, Paris

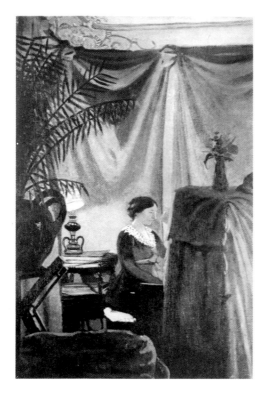

FÉLIX VALLOTTON
Gabrielle Vallotton at the Piano. 1904
Private collection, Geneva

The theme of playing music at home, which dates back to seventeenth-century Dutch painting, appeared again in the mid-nineteenth century in the works of Fantin-Latour and Whistler, Degas, Manet and Cézanne. Vallotton may have seen some of their paintings, showing a woman at the piano. While using the compositional principles of his predecessors, Vallotton was nevertheless primarily concerned with a true representation of the scene: he depicted his wife Gabrielle in a room of the country house in Varengeville, where the Vallottons lived in the summer of 1904 (from 1899 onwards the artist usually spent the summer months in Normandy). Mme Vallotton is shown in the same pose wearing the same peignoir as in the *Dining-Room in a House in the Country* (1904, Paul Vallotton Gallery, Lausanne; *Livre de raison*, no. 528).
In the *Livre de raison* the artist entitled the picture *Woman Playing the Piano in a Country Interior. Varengéville* (no. 527). It was probably this painting that Vallotton mentioned in the letter of 30 December 1909, in which he suggested that his brother, who kept some of his works, should send them to Haasen: "...you can take, for example... *The Woman at the Piano*".

Provenance:
1911 G. Haasen Collection, St Petersburg (purchased from the artist for 650 francs); 1921 Hermitage; 1930 Museum of New Western Art, Moscow; 1948 Hermitage

Exhibitions:
1904 Paris, no. 1252 (?); 1965 Leningrad

Bibliography:
Hahnloser-Bühler 1936, p. 287, no. 527; *Catalogue 1958*, vol. I, p. 464; Vallotton 1974, no. 241; Izerghina, Barskaya 1975, no. 111; *Catalogue 1976*, p. 307; Brodskaïa 1986, p. 102; Kostenevich 1989, no. 143

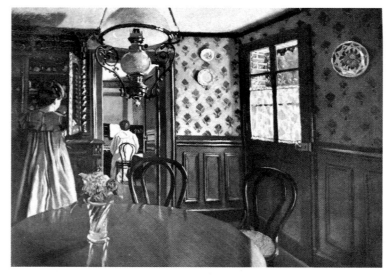

FÉLIX VALLOTTON
Dining-Room in a House in the Country. 1904
Paul Vallotton Gallery, Lausanne

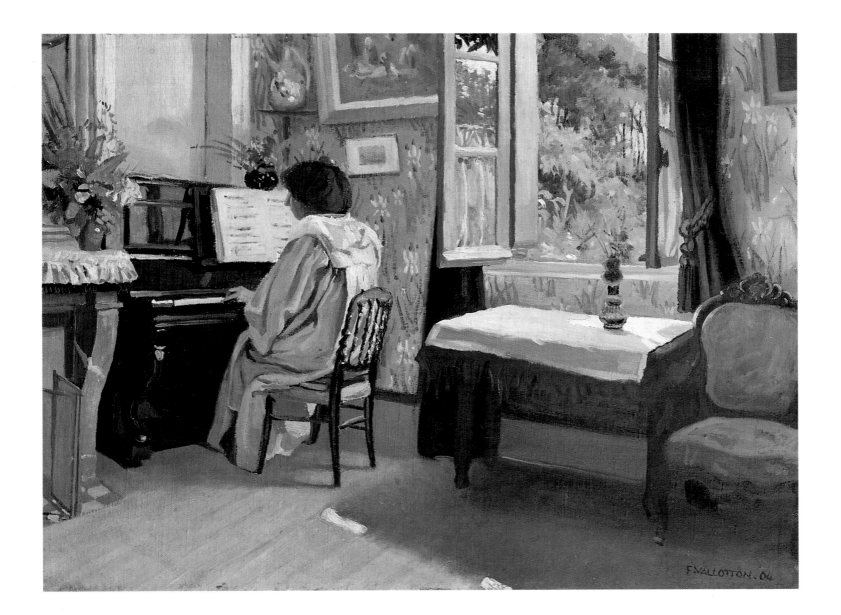

F. VALLOTTON

57
Woman in a Black Hat. 1908
La Femme au chapeau noir
Oil on canvas. 81.3 x 65 cm
Signed and dated, top right: *F. Vallotton 08*
Hermitage, St Petersburg. Inv. no. 5108

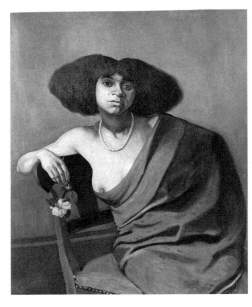

FÉLIX VALLOTTON
Mulatto in a Red Shawl. 1913
Kunstmuseum, Winterthur

In Vallotton's *Livre de raison* the picture is registered under no. 637 as *Bust of a Woman, Bare-Breasted, Wrapped in a Black Shawl, in a Black Hat with a Pink Ribbon.*
The canvas is mentioned in Vallotton's letter to his brother of 30 December 1909: "If you want to send Haasen the pictures that you have, you can take, for example... *Woman in a Black Hat...*"

Provenance:
1911 G. Haasen Collection, St Petersburg (purchased from the artist for 800 francs); 1921 Hermitage; 1930 Museum of New Western Art, Moscow; 1948 Hermitage

Exhibitions:
1908 Moscow, no. 180; 1965 Leningrad

Bibliography:
Hahnloser-Bühler 1936, p. 290, no. 637; *Catalogue 1958*, vol. 1, p. 464; Vallotton 1974, no. 241; Izerghina, Barskaya 1975, no. 110; *Catalogue 1976*, p. 307; Brodskaïa 1986, pp. 85, 102, 103; Kostenevich 1989, no. 144

FÉLIX VALLOTTON
The Red Hat. 1907
Private collection

F. VALLOTTON

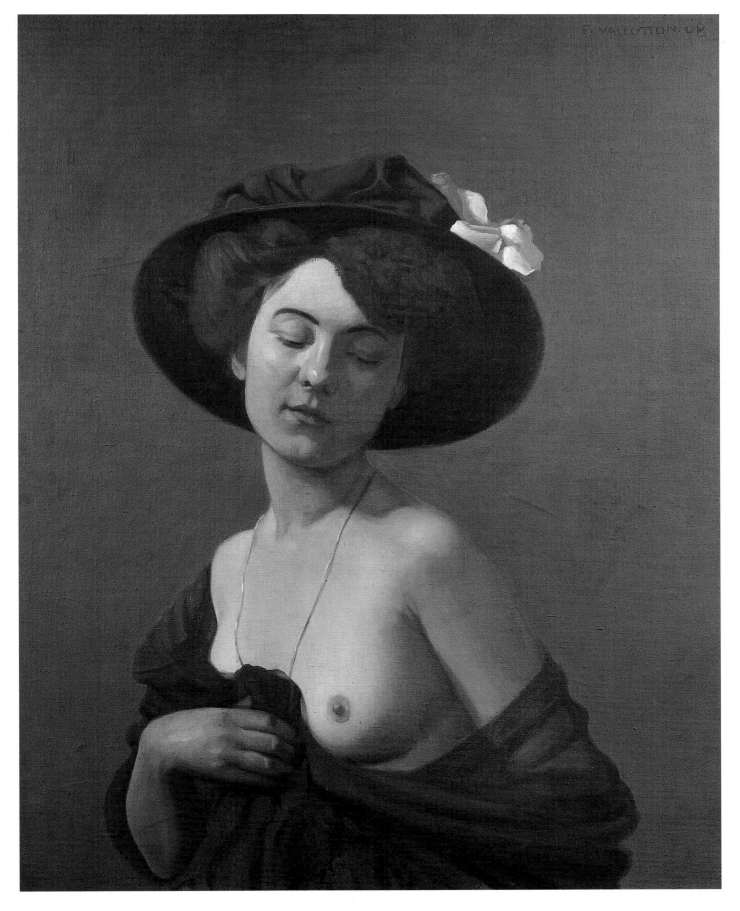

F·VALLOTTON

58
Portrait of Mme Haasen. 1908
Portrait de Madame Haasen
Oil on canvas. 80 x 65 cm
Signed and dated, top right: *F. Vallotton 08*
Hermitage, St Petersburg. Inv. no. 6765

Vallotton became acquainted with Georges Haasen through his brother Paul, who was Haasen's partner in trade. Before the artist's visit to St Petersburg, he had often met Haasen in Paris and Switzerland. On 8 June 1908 Vallotton wrote to his brother that he had agreed to paint a half-length portrait of Haasen's wife, which should be no more than one metre in size. The letter was sent from Paris. In August the artist was in Lausanne and Bern. The portrait was obviously completed at about that time, but Haasen received it only in 1909. Vallotton's letter of 20 February 1909 to his brother indicates that the artist and Haasen could not agree on the price of the picture: "I would be happy to sell the canvas to Haasen, but tell him that the price is increasing because I know that I should make use of a favourable opportunity when it presents itself; the price will nevertheless still be reasonable. If you look at the prices asked by Bonnard, Vuillard and Roussel, you will see that they are three times as high as mine, while we are as good as one another".

Provenance:
1909 G. Haasen Collection, St Petersburg (commissioned from the artist in 1908 for 1,000 francs); 1921 Hermitage

Exhibitions:
1965 Leningrad

Bibliography:
Hahnloser-Bühler 1936, p. 291, no. 656; *Catalogue 1958*, vol. 1, p. 464; Vallotton 1974, pp. 147, 164; Izerghina, Barskaya 1975, no. 113; *Catalogue 1976*, p. 307; Brodskaïa 1986, pp. 95, 101; Kostenevich 1989, no. 145

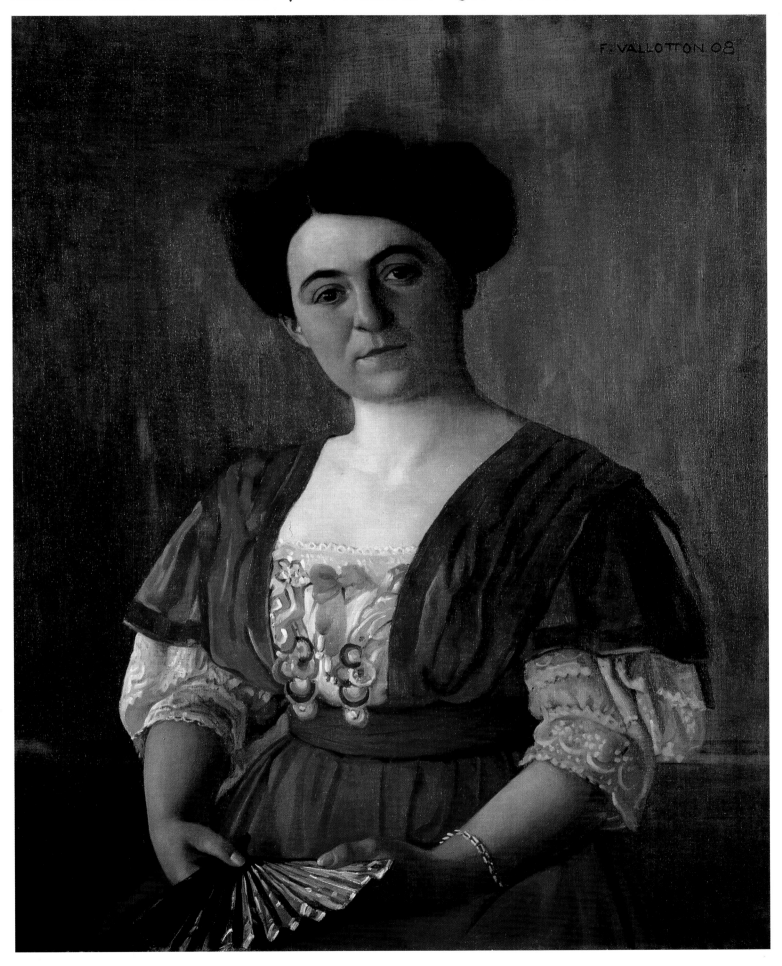

F·VALLOTTON

F. VALLOTTON

59
Portrait of Georges Haasen. 1913
Portrait de Monsieur Haasen
Oil on canvas. 81.7 x 100.5 cm
Signed and dated, top left: *F. Vallotton 1912 + 1*
Hermitage, St Petersburg. Inv. no. 4901

Georges Haasen was a collector of new painting, mainly French, including works by Bonnard, Vallotton, Marquet and Manguin. He was also an art dealer and a representative of the Swiss chocolate firm Cailler in St Petersburg, where he settled before 1906 (his address can be found in the annual directory *The Whole of St Petersburg*).
In early March, Vallotton came to St Petersburg at Haasen's invitation and stayed at his flat in house number 59/1, Kamennoostrovsky Prospekt.
On 5 March he wrote to his brother: "I like everything here and today I began the portrait; unfortunately the weather is rather gloomy... Haasen and his wife are well; they are extremely kind and cannot do enough for me".
In the next letter, undated but probably sent in the middle of March, Vallotton wrote: "The portrait is almost finished, it has turned out well and is full of attractive colourful details, because it shows almost all their apartment, which is quite a riot of colour..."
In the letter of 29 March, sent from Paris, the artist recalls the picture again: "The portrait of Haasen is a good work, a little austere, as always, but that's to do with me: I don't think life's a laughing matter".

Vallotton made the following note of the picture in the *Livre de raison*: "No. 910. Portrait of M. Haasen full-face seated, his right arm resting on a table covered with a flowery cloth, background with curtains of different colours".
The date of the painting supplied by the artist, *1912 + 1*, is not quite clear, because it is obvious that it was begun and completed in the March of 1913. It is possible that Vallotton intended to convey that he was commissioned to paint the portrait in 1912.

Provenance:
1913 G. Haasen Collection, St Petersburg (commissioned from the artist for 1,500 francs); 1921 Hermitage

Exhibitions:
1965 Leningrad; 1991–93 New Haven–Houston–Indianapolis–Amsterdam–Lausanne, no. 302

Bibliography:
Hahnloser-Bühler 1936, p. 303, no. 910; *Catalogue 1958*, vol. 1, p. 464; Vallotton 1974, pp. 205–207; Izerghina, Barskaya 1975, no. 112; *Catalogue 1976*, p. 307; Brodskaïa 1986, pp. 95, 103; Kostenevich 1989, no. 146

F. VALLOTTON

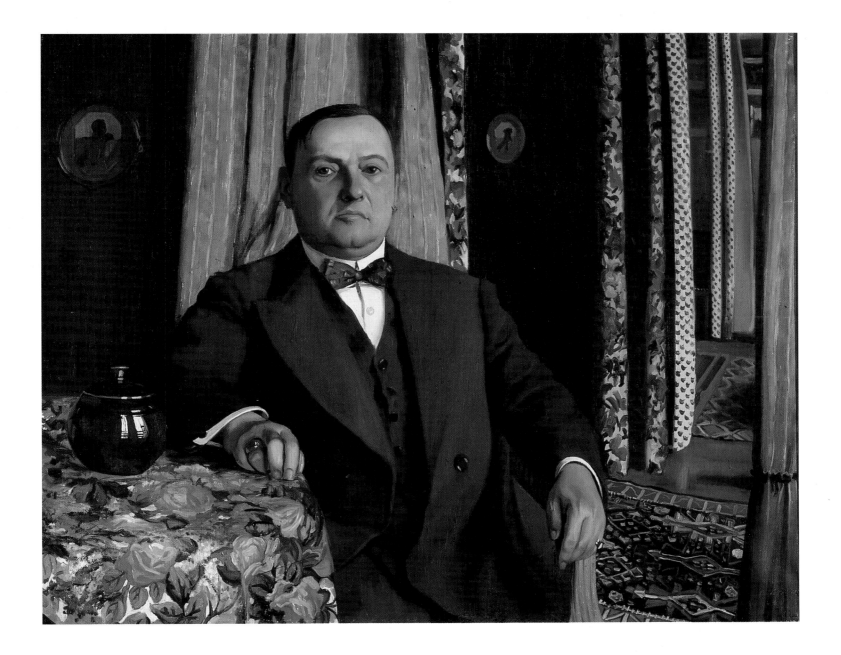

**Abbreviations used in the
bibliography and exhibitions.**

Bibliography

BARAZZETTI-DEMOULIN 1945
S. Barazzetti-Demoulin, *Maurice Denis*, Paris, 1945

BARSKAYA, BESSONOVA 1985
A. Barskaya, M. Bessonova, *Impressionists and Post-Impressionists in Soviet Museums*, Leningrad, 1985 (in Russian)

BRODSKAÏA 1986
N. Brodskaïa, *Félix Vallotton et la Russie*, Lausanne, Galerie Paul Vallotton, 1986

CATALOGUE 1913
Catalogue of S.I. Shchukin's Collection, Moscow, 1913 (in Russian)

CATALOGUE 1917
Catalogue of the Municipal Gallery of the Brothers Pavel and Sergei Tretyakov, Moscow, 1917 (in Russian)

CATALOGUE 1928
Museum of New Western Art. Illustrated Catalogue, Moscow, 1928 (in Russian)

CATALOGUE 1958
The Hermitage. Department of Western European Art: Catalogue of Painting, Leningrad–Moscow, 1958, vol. I (in Russian)

CATALOGUE 1961
The Pushkin Museum of Fine Arts: Catalogue of the Picture Gallery. Painting, Sculpture, Moscow, 1961 (in Russian)

CATALOGUE 1976
The Hermitage. Western European Painting. Catalogue. I: Italy, Spain, France, Switzerland, Leningrad, 1976 (in Russian)

CATALOGUE 1986
The Pushkin Museum of Fine Arts: Catalogue of the Picture Gallery. Painting, Sculpture, Miniature Painting, Moscow, 1986 (in Russian)

COQUIOT 1922
G. Coquiot, *Bonnard*, Paris, 1922

DAUBERVILLE (or D) 1965; 1968
Jean et Henri Dauberville, *Bonnard. L'Œuvre peint*, Paris, 1965–74, 4 vols

DENIS 1957; 1959
M. Denis, *Journal*, vol. I (1884–1904), vol. 2 (1905–1920), Paris, 1957; vol. 3 (1921–1943), Paris, 1959

DESCARGUES 1961
P. Descargues, *Le Musée de l'Ermitage*, Paris, 1961

FRENCH 20TH-CENTURY MASTERS 1970
The Hermitage, Leningrad. French 20th-century Masters (introduction by A. N. Izerghina, notes by A. G. Barskaya, B. A. Zernov), Prague, 1970

GEORGIEVSKAYA, KUZNETSOVA 1979
French Painting from the Pushkin Museum, Leningrad, 1979

HAHNLOSER-BÜHLER 1936
H. Hahnloser-Bühler, *Félix Vallotton et ses amis*, Paris, 1936

IZERGHINA, BARSKAYA 1975
French Painting from the Hermitage, Leningrad. Mid-19th to Early 20th Century (introduction by A. Izerghina, selection and notes on the plates by A. Barskaya), Leningrad, 1975

KALITINA 1972
N. Kalitina, *French Landscape Painting. 1870–1970*, Leningrad, 1972 (in Russian)

KOSTENEVICH 1984
A. Kostenevich, *French Art of the 19th to Early 20th Century in the Hermitage* (guidebook), Leningrad, 1984 (in Russian)

KOSTENEVICH 1987
A. Kostenevich, *Western European Painting in the Hermitage: 19th–20th Centuries*, Leningrad, 1987

KOSTENEVICH 1989
A. Kostenevich, *From Monet to Picasso. French Painting from the Late 19th to Early 20th Centuries in the Hermitage*, Leningrad, 1989 (in Russian)

MAKOVSKY 1912
S. Makovsky, "French Painters from I.A. Morozov's Collection", *Apollon*, St Petersburg, 1912, nos 3, 4 (in Russian)

MITHOUARD 1907
A. Mithouard, "Maurice Denis", *Art et Décoration*, 1907, July–December

MURATOV 1908
P. Muratov, "The Shchukin Gallery: An Essay on the History of New Painting", *Russkaya mysl'*, Moscow, 1908, no. 8 (in Russian)

RÉAU 1929
L. Réau, *Catalogue de l'art français dans les musées russes*, Paris, 1929

SEGARD 1914
A. Segard, *Peintres d'aujourd'hui. Les Décorateurs*, Paris, 1914

STERLING 1957
Ch. Sterling, *Musée de l'Ermitage. La Peinture française de Poussin à nos jours*, Paris, 1957

TERNOVETS 1977
B. Ternovets, *Letters. Diaries. Essays*, Moscow, 1977 (in Russian)

TERRASSE 1927
Ch. Terrasse, *Bonnard*, Paris, 1927

TERRASSE 1967
A. Terrasse, *Pierre Bonnard*, Paris, 1967

TUGENDHOLD 1914
Ya. Tugendhold, "The French Collection of S.I. Shchukin", *Apollon*, St Petersburg, 1914, nos 1, 2 (in Russian)

TUGENDHOLD 1923
Ya. Tugendhold, *The First Museum of New Western Painting*, Moscow, 1923 (in Russian)

VALLOTTON 1974
F. Vallotton, *Documents pour une biographie et pour l'histoire d'une œuvre*. Introduction, selection and notes by Gilbert Gaison and Doris Jacubec, Lausanne–Paris, 1974, vol. 2 (1900–1914)

BESSONOVA, WILLIAMS 1986
Impressionists and Post-Impressionists. The Hermitage, Leningrad. The Pushkin Museum of Fine Arts, Moscow. National Gallery of Art, Washington. Introductions by Marina Bessonova and William James Williams. Selection by Marina Bessonova, William James Williams and Albert Kostenevich, Leningrad–New York, 1986

YAVORSKAYA 1972
N.V. Yavorskaya, *Pierre Bonnard*, Moscow, 1972 (in Russian)

Exhibitions

1895 PARIS
Salon de la Société Nationale des Beaux-Arts, Paris, 1895

1896 PARIS
Salon de la Société Nationale des Beaux-Arts, Paris, 1896

1897 PARIS
Salon de la Société Nationale des Beaux-Arts, Paris, 1897

1898 BRUSSELS
5ᵉ Exposition "La Libre Esthétique", Brussels, 1898

1903 VIENNA
Entwicklung des Impressionismus in Malerei und Plastik, Sezession XIV, Vienna, 1903

1904 PARIS
Salon d'Automne, Paris, 1904

1906 PARIS, INDÉPENDANTS
Salon des Artistes Indépendants, Paris, 1906

1906 PARIS
Félix Vallotton. Galerie Bernheim-Jeune, Paris, 1906

1907 PARIS
Salon de la Société Nationale des Beaux-Arts, Paris, 1907

1908 MOSCOW
"Zolotoye Runo" ("The Golden Fleece") Salon, Moscow, 1908

1908 PARIS
Salon d'Automne, Paris, 1908

1909 PARIS
Maurice Denis. Galerie Druet, Paris, 1909

1910 PARIS
Pierre Bonnard. Galerie Bernheim-Jeune, Paris, 1910

1911 PARIS
Bonnard. Galerie Bernheim-Jeune, Paris, 1911

1911 PARIS, SALON
Salon d'Automne, Paris, 1911

1912 PARIS
Bonnard. Galerie Bernheim-Jeune, Paris, 1912

1912 ST PETERSBURG
A Hundred Years of French Painting, St Petersburg, 1912

1913 PARIS
Bonnard, oeuvres récentes. Galerie Bernheim-Jeune, Paris, 1913

1939 MOSCOW
Museum of New Western Art. Catalogue of the Exhibition of 19th- and 20th-century French Landscape Painting, Moscow, 1939

1955 MOSCOW
The Pushkin Museum of Fine Arts. Catalogue of the Exhibition of 15th- to 20th-century French Art, Moscow, 1955

1956 LENINGRAD
The Hermitage. Catalogue of the Exhibition of 12th- to 20th-century French Art, Leningrad, 1956

1959 LENINGRAD
Western European Landscape of the 16th to 20th Centuries. Painting, Graphics, Applied Art. The Hermitage, Leningrad, 1959

1965 LENINGRAD
Félix Vallotton. 1865–1925. The Hermitage, Leningrad, 1965

1965 BORDEAUX
Chefs d'oeuvre de la peinture française dans les musées de Léningrad et de Moscou. Musée de Bordeaux, Bordeaux, 1965

1965–66 PARIS
Chefs d'oeuvre de la peinture française dans les musées de Léningrad et de Moscou. Musée du Louvre, Paris, 1965

1966–67 TOKYO–KYOTO
Masterpieces of Modern Painting from the USSR. The Hermitage, The Pushkin, The Russian and The Tretyakov Museums in Leningrad and Moscow. The National Museum of Western Art, Tokyo; City Art Museum, Kyoto, 1966–67

1967 PARIS
Pierre Bonnard. Musée de l'Orangerie, Paris, 1967

1967–68 ODESSA–KHARKOV
Masterpieces of French Painting of the 19th and Early 20th Centuries from the Collections of the Pushkin Museum of Fine Arts. Museum of Western and Eastern Art, Odessa. Art Museum, Kharkov, 1967–68

1968 PARIS–MUNICH
E. Vuillard–K.X. Roussel, Musée de l'Orangerie, Paris. Kunsthaus, München, Paris, 1968

1968 YEREVAN
Exhibition of French 19th- and 20th-century Painting from the Hermitage Fund. Art Gallery of Armenia, Yerevan, 1968 (no catalogue)

1969 BUDAPEST
Szépmüveszeti mùseum. Francia Mesterek. A Leningradi Ermitàzsbol, Budapest, 1969

1971 TOKYO–KYOTO
One Hundred Masterpieces from the USSR Museums Exhibited in Japan under the Auspices of the Tokyo National Museum and the Kyoto National Museum, Tokyo, 1971

1972 MOSCOW
The Pushkin Museum of Fine Arts. Art of the Portrait in the 15th- to Early 20th-century European Painting. Catalogue of the Exhibition, Moscow, 1972

1972 OTTERLOO
From Van Gogh to Picasso. Nineteenth- and Twentieth-century Paintings and Drawings from the Pushkin Museum in Moscow and the Hermitage in Leningrad. State Museum Kröller-Müller, Otterloo, 1972

1972 PRAGUE
Od Poussina k Picassovi. Mistrovskà dila muzea A.S. Puskina v Moskve, Prague, 1972

1974 LENINGRAD
The Painting of the Impressionists from the Hermitage Collection. Catalogue, Leningrad, 1974

1975 SAINT-PAUL-DE-VENCE
La Lumière de Bonnard. Galerie Maeght, Saint-Paul-de-Vence, 1975

1975–76 ROTTERDAM–BRUSSELS–BADEN-BADEN–PARIS
Le Symbolisme en Europe. Museum Boymans–van Beuningen, Rotterdam. Musée Royaux des Beaux-Arts de Belgique, Bruxelles. Staatliche Kunsthalle, Baden-Baden. Grand Palais, Paris, Brussels, 1976

1976 DRESDEN–PRAGUE
Monet, Cézanne, Gauguin, Picasso, Matisse u.a. Meisterwerke aus dem Puschkin-Museum Moskau, der Ermitage, Leningrad, und den Staatlichen Kunstsammlungen Dresden, Dresden, 1976

1978 LE HAVRE
La Peinture impressioniste et Post-Impressioniste du Musée de l'Ermitage. Musée des Beaux-Arts André Malraux, Le Havre, 1978

1978 MOSCOW
The Pushkin Museum of Fine Arts. European Art of the 19th and 20th Centuries from the Collection of Max Kaganovitch, Moscow, 1978

Exhibitions

1978 PARIS
De Renoir à Matisse. Grand Palais, Paris, 1978

1979 LENINGRAD
Exhibition of New Acquisitions of the Hermitage, Leningrad, 1979

1979 PARIS
Paris–Moscou. 1900–1930. Centre National d'art et de culture Georges Pompidou, Paris, 1979

1979 TOKYO–KYOTO–KAMAKURA
French Painting of the Late 19th and Early 20th Centuries from the Collections of the Hermitage, Leningrad and the Pushkin Museum of Fine Arts, Moscow. City Art Museum, Tokyo; The National Museum of Modern Art, Kyoto; Museum of Modern Art, Kamakura, 1979 (in Japan)

1981 MEXICO CITY
Impresionistas Franceses de los museos Ermitage y Puschkin. Museo del Palacio de Bellas Artes, Mexico City, 1981

1981 MOSCOW
Moscow–Paris. 1900–1930. Pushkin Museum of Fine Arts, Moscow, 1981

1982 MOSCOW
New Acquisitions of the Pushkin Museum of Fine Arts: 1970–80, Moscow, 1982

1982 MOSCOW, *CLASSICAL ANTIQUITY*
Classical Antiquity in European Painting of the 15th to Early 20th Centuries. Catalogue of the Exhibition of Paintings from the Museums of the USSR, GDR, the Netherlands, France, Moscow, 1982

1983 DRESDEN
Das Stilleben und sein Gegenstand. Eine Gemeinschaftsausstellung von Museen aus der UdSSR, der ČSSR und der DDR. Albertinum, Dresden, 1983

1984 LENINGRAD–MOSCOW
The Still Life in European Painting. Exhibition of Paintings from the Museums of the USSR and GDR. The Hermitage, Leningrad. The Pushkin Museum of Fine Arts, Moscow, 1984

1984 TOKYO–NARA
French Artists of the Late 19th and Early 20th Centuries from the Collections of the Hermitage and the Pushkin Museum of Fine Arts. City Art Museum, Tokyo. Prefectural Art Museum, Nara, Tokyo, 1984

1984–85 ZURICH–FRANKFURT AM MAIN
Pierre Bonnard. Kunsthaus, Zürich. Städtische Galerie im Städelschen Kunstinstitut, Zurich, 1984

1985–86 LENINGRAD
Drawings, Watercolours and Pastels of French Artists of the Second Half of the 19th and 20th Centuries from the Collection of the Hermitage. Catalogue, Leningrad, 1986

1985–86 TOKYO–HIROSHIMA–KOBE
Retrospective de Paris moderne. Grande Galerie au Grand Magasin Odakyu à Shinjuku, Tokyo. Musée de Hiroshima. The Hyogo Prefectural Museum of Modern Art, Kobe, Tokyo, 1985

1987 LUGANO
Impressionisten und Post-Impressionisten aus sowjetischen Museen. II. Collection Thyssen-Bornemisza, Lugano, 1987

1987 SAPPORO–HIROSHIMA–FUKUOKA
Works by Western European Artists of the 19th and 20th Centuries from the Hermitage Collection. Hokkaido Museum of Modern Art, Sapporo. Hiroshima Museum. Prefectural Art Museum, Fukuoka, Sapporo, 1987

1988 TOKYO–KYOTO–NAGOYA
Barbizon School, Impressionist, Early Modern Paintings from the Hermitage Museum. Seiji Togo Memorial Yasuda Kasai Museum of Art, Tokyo, 1988

1991–93 NEW HAVEN–HOUSTON–INDIANAPOLIS–AMSTERDAM–LAUSANNE
Sasha M. Newman (with essays by: M. Ducroy, R. Field, D. Goodman, M. Hahnloser-Ingold), Félix Vallotton. Yale University Art Gallery, New Haven; Museum of Fine Arts, Houston; Indianapolis Museum of Art; Van Gogh Museum, Amsterdam; Musée Cantonal des Beaux-Arts, Lausanne, New Haven, 1991

1993 ESSEN
Morozov and Shchukin – the Russian Collectors: Monet to Picasso. Museum Folkwang, Essen. Pushkin Museum of Fine Arts, Moscow. Hermitage, St Petersburg, Cologne, 1993

1993–94 MOSCOW–ST PETERSBURG
The Russian Collectors Ivan Morozov and Sergei Shchukin. From Monet to Picasso. 120 Masterpieces from the Hermitage in St Petersburg and the Pushkin Museum of Fine Arts in Moscow. Hermitage, St Petersburg; Pushkin Museum of Fine Arts, Moscow, Cologne, 1993

1994 EDINBURGH
Richard Thomson, Monet to Matisse. Landscape Painting in France. 1874–1914, National Gallery of Scotland, Edinburgh, 1994

1994–95 LYONS–COLOGNE–LIVERPOOL–AMSTERDAM
Maurice Denis. 1870–1943, Musée des Beaux-Arts, Lyons; Wallraf-Richartz Museum, Cologne; Walker Art Gallery, Liverpool; Van Gogh Museum, Amsterdam; Reunion des musées nationaux, Lyons, 1994

1995 IBARAKI–TOKYO–MIE
French Art of the 19th and 20th Centuries from the State Hermitage Museum. The Museum of Modern Art, Ibaraki; Tobu Museum of Art, Tokyo; Mie Prefectural Art Museum, 1995

BONNARD
and
the NABIS